Hold That Pose

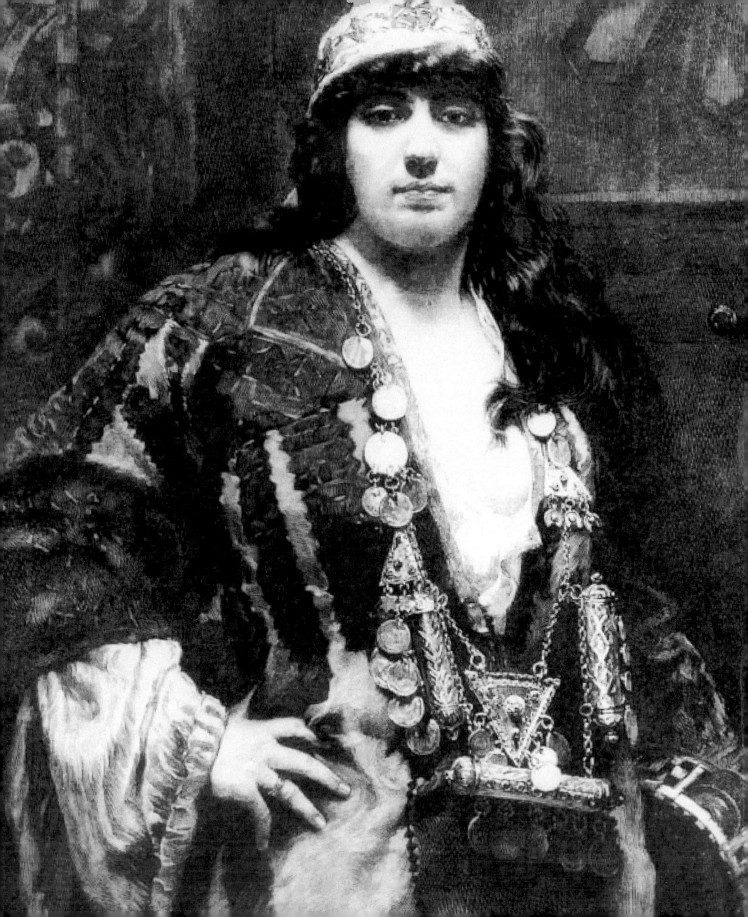

Hold That Pose

VISUAL CULTURE IN THE
LATE–NINETEENTH–CENTURY SPANISH PERIODICAL

Lou Charnon-Deutsch

THE PENNSYLVANIA STATE UNIVERSITY PRESS
UNIVERSITY PARK, PENNSYLVANIA

Published with the assistance of the
Program for Cultural Cooperation between
Spain's Ministry of Culture and
United States Universities.

Portions of Chapter 1 were published as
"The Racial Fetishism of Nineteenth-Century Spanish
Magazines," *Hiperfeira* (e-journal), 2002.
http://www.sinc.sunysb.edu/Publish/hiper/.
Sections of Chapter 3 appeared in "The Making of a Mass
Media in Spain," *Nineteenth Century Prose* 32.1
(spring 2005): 186–226. Portions of Chapter 2 appeared in
"From Engraving to Photo: Cross-cut Technologies in the
Spanish Illustrated Press," in *Visualizing Spanish Modernity,* ed.
Susan Larsen and Eva Woods (Oxford: Berg, 2005), 177–206.

LIBRARY OF CONGRESS CATALOGING-IN-PUBLICATION DATA

Charnon-Deutsch, Lou.
Hold that pose : visual culture in the late-nineteenth-century
Spanish periodical / Lou Charnon-Deutsch.
p. cm.
Includes bibliographical references and index.
ISBN 978-0-271-03203-0 (pbk. : alk. paper)
1. Illustrated periodicals—Spain—History—19th century.
2. Photojournalism—Spain—History—19th century.
I. Title.

PN5317.I44C43 2008
070.4'90946—dc22
2007008327

FOR *Dale*

Contents

Illustrations

Acknowledgments

Many thanks to the friends and colleagues who read all or portions of the early drafts of this book and supported me with their encouragement and expertise, especially Temma Kaplan, Malcolm Read, Jo Labanyi, Jordana Mendelson, Susan Martin Marquez, Randolph Pope, Kathleen Vernon, Robert Ford, Robert Sternlieb, Eva Woods, Susan Larson, Brad Epps, Richard Schneeman, and Helen Cooper. I wish to thank the State University of New York at Stony Brook for granting me a sabbatical leave during which major portions of the book were completed and for providing research funds to defray the costs of photography. To the many librarians at the State University of New York who assisted me in the lengthy process of gathering materials and photographs, I extend my heartfelt thanks, especially to Donna Sammis, David Wiener, Amelia Salinero, and Hanne Tracy. I am also grateful to Edward Van Gemert at the University of Wisconsin–Madison Memorial Library for graciously allowing me to photograph magazine images there. David Smith, John Rathe, and Thomas Lisanti at the New York Public Library were a great help in locating and retrieving books and identifying images. The burden of gathering information was also cheerfully borne by Margaret Frohlich and Nieves Alonso. As always Sarah Battaglia and Betty De Simone provided tremendous behind-the-scenes assistance. Finally, I owe thanks to the many colleagues who supported my efforts either by sharing ideas or encouraging me to persist in publishing this manuscript: Román De la Campa, Melvin Simpson, Giulia Simpson, Kathleen Vernon, Daniela Flesler, Adrián Pérez Melgosa, Adrienne Munich, Louise Vasvari, Sonia Fernández Hoyos, Juan Carlos Rodríguez, Alda Blanco, James Mandrell, Sarah Charnon, and E. Ann Kaplan. Without the editors and staff of Penn State University Press, especially former art history editor Gloria Kury, who supported my efforts from the beginning, Patricia A. Mitchell, Cherene Holland, and Ann Farkas, this book would not have been possible.

INTRODUCTION: THE GLOBE IN THE PALM OF HIS HAND

AFTER THE EARLY work of Walter Benjamin and later Roland Barthes, and, more recently, others like Pierre Bourdieu or Richard Ohmann, who recognize the intricacies involved in the "selling" of popular culture, it no longer seems necessary to defend the study of magazines as an appropriate form of scholarly pursuit. Although there will always exist a "hierarchy of legitimate objects of study,"[1] never before has the imperative to understand the production of popular culture so thoroughly occupied literary studies. The impact of print media, a hotly debated issue beginning in the early twentieth century, continues to be a focal point of cultural studies criticism even as we move on to study other media more representative of today's obsession with visualism. Some cultural critics believe that their work is justified by the mere fact that they are exposing the complexity and diversity of culture against a norm of culture that is belletristic, elitist, and geared to the educated few. The magazine was undeniably an important part of the symbolism of nineteenth-century urban life, and in deciphering its "surplus of meaning" the researcher reaps many rewards. To justify the study of magazines and other ephemera, however, it is now understood that the cultural critic must contribute to knowledge in a more positive way, for example, by exposing a nationalism that disguises itself as something wholesome, patriotic, and inclusive, or by interrogating the economic issues, specifically marketing and production, and their

relation to the technology that drove magazine production.

One of the objects of this book is to look at the various innovations in the printing industry in the late nineteenth century, to gauge their significance in the formation of new classes of citizens as Spain moved "fitfully" toward modernity. The book examines both the ideological impact and the technological transformation of image production in Spanish magazines during the Restoration.[2] In the brief period of forty years, 1870–1910, technological and manufacturing advances revolutionized Spain's illustrated press and consequently further galvanized the tastes and expectations of its urban readership. But by 1900 certain middle-class sectors as well became inured to illustrated magazines once subscription rates fell and magazines began to apply modern photojournalistic techniques that integrated text and images and catered to middle-class interests. Advancements in photomechanical reproduction allowed periodicals to showcase extensively the vicissitudes and pleasures of everyday life in urban Spain as well as world events in increasingly remote locales. The possibilities for staying abreast of the modern world via the photographed image seemed endless. The periodical participated in the construction of the very notion of the city, "creating a community of textually initiated residents,"[3] forcing readers to apprehend the familiar in culturally conditioned ways, not just in terms of "order and unity, scale

and space, light and shadow, and color and texture."[4] The weekly magazine became an important ingredient of the collective life of the city, acting like a visual and discursive testimonial to its current heterogeneity as well as a kind of souvenir of its idealized urbanity.

As technology advanced, so too the pictorial content of images available in periodicals changed in specific ways, mediating Spain's vision of itself as a nation and its place among other nations. By the end of the nineteenth century the visual field readily available to readers through print media had expanded tremendously, an indication of the growing addiction to visualism that characterized other industrialized nations already in possession of a mass media by 1900. Even before the 1868 revolution, images had invaded everyday life, especially in urban centers: they were inserted in *aleluyas* (broadsides), posters, *folletines* (serialized novels), weekly magazines, and illustrated books, and eventually they would make their debut in daily newspapers, stereographs, photo albums, *cartes de visite,* religious cards, postcards, cigarette and candy wrappers, and posters. This wide distribution implied new ways of perceiving the world that were scripted, arranged, and framed to suit the varying uses (both economic and ideological) and limitations (technological and bureaucratic) of the media but also to accommodate the vision that bourgeois and eventually middle-class urban dwellers had come to expect as part of their quotidian experience. *Hold That Pose* explores the end point of this period of transition and innovation through an analysis of several magazines and groups of images that spoke for and to the burgeoning numbers of subscribers who purchased the most popular weeklies of the period. For Spanish readers the results of this new organization and revelation of the physical world must have seemed truly remarkable and modern,

something that is difficult to imagine in today's vision-laden culture, but more easily grasped when one compares the visual culture available in 1800 or even 1850 with that of 1900.

Exalting the accomplishments of the modern periodical in his address to the Spanish Royal Academy in 1895, the dramatist Eugenio Sellés imagined that with their potential to make the world more accessible and comprehensible printed images had endowed man with truly godlike powers: "[T]he photograph copies, the buril engraves, in order to represent in the periodical's pages a living drama, with its own adornment and personages portrayed in such a way that everything appears directly before us, completely revealed to us, as if man, like the divinity, held the globe reduced in the palm of his hand."[5] By the turn of the century the larger world not only seemed more accessible, territorialized, and comprehensible to men like Sellés; its visual traces conformed to the economic needs of the new knowledge industries, capitalist enterprises very much concerned with production costs and profit margins. Marshall McLuhan's dictum, "The medium is the message," has often been criticized as simplistic, but part of what it means holds true for emerging media like photography and the illustrated magazine that developed in its wake. The visual order conventionalized in the magazine image served social, economic, and national interests in myriad ways: convening groups of subjects in common interests; educating consumers about available as well as precious commodities; garnering support for national enterprises such as wars, railroad building, industrial and urban modernization; and finally visualizing appropriate and inappropriate public and private behaviors of the citizenry. The age of photography, as Barthes noted, "corresponds precisely to the explosion of the private into

the public, or rather into the creation of a new social value which is the publicity of the private."[6] A key factor in the new visual economy was the "appearance" of photography (that is, printed images that *appeared* to be photographs) and the desire for accuracy it satisfied. The medium of photography invaded the periodical in part because readers demanded that messages be put into evidence in a more convincing way that eventually phased out other forms of handwrought representation. But the medium was also the message in the case of magazine photography, because whatever reality these images represented had to conform to the medium's complex technical possibilities for representation, and readers, whether they knew it or not, were no longer able to say with certainty exactly how any image before their eyes came to be.

Eugenio Sellés believed that the power of the press was vast; that the periodical was above all an organ for progress, capable of producing men "fit for society," imbuing even the working classes with notions and information able to redeem them from the "malignant power of shadows."[7] Modern Cultural Studies clings to this notion of the social power of the press, now, however, often spelling out its nefarious consequences rather than its redemptive capacity. Nevertheless, caution about overstating the impact, positive or negative, of the implementation of new technologies must be the guiding principle of anyone examining both the ideological and the visual effects and determinants of magazine production. Searching for technological explanations for the massification of the media at the end of the nineteenth century is to overlook the structural and social changes that were occurring in society, changes that demanded an expanded national media. For one thing, the relationship of photography to the traditional arts has often been overstated. As Peter Galassi reminds us, "[P]hotography was not a bastard left on the doorstep of art, but a legitimate child of the Western pictorial tradition," responding to social pressures to see the world differently.[8] In other words, the conventions of photography reflected social and political transformations and pressures that determined a significant shift in point of view already in place as photography in the press was making its debut. So it was not just that photography suddenly and magically allowed viewers to see or to understand the world in a different way; rather, photography responded to the desire to see the world both in a broader and at the same time more intimate and mundane way. Consumer demand for increased graphic images "spurred both manufacturers and inventors to seek new ways in which it might be."[9] The rise of the middle classes spurred consumer demand for image production, and the history of photography is "a history of needs alternatively manufactured and satisfied by an unlimited flow of commodities; a model of capitalist growth in the nineteenth century."[10]

It is always tempting to exaggerate the importance of a new technology, whether photography, television, or the Internet, when it first emerges as a recognizable social force that proponents claim advances knowledge. Opinions abound that, owing to their very novelty, the media of the nineteenth century had a greater impact on citizens than the same media today, capable of forcefully creating national stereotypes and mobilizing public hatred or sympathy for various causes. It is no doubt the case that, in addition to entertaining readers, magazines educated, socialized, and indoctrinated them, interfacing with other institutions whose aim was not primarily entertainment, so that their role was indeed multiple and complex. But print media alone

is not responsible for constituting social reality, even though it is indispensable for understanding how the sense of a nation expanded in the nineteenth century. And although the photograph transformed the world into a spectacle, it was not the technology on its own that determined the new visual regime by making the printed image a part of everyday life. Rather, photographic technology and the media in general were put to use to further specific ends. Among these ends were capitalism's expanding search for new investments and ways to market products, political agendas for garnering national support for unfavorable policies and struggles, and shadowy forces of apparatuses like the Catholic Church battling against a waning sense of religion as the defining element of national identity. In the following pages I make the argument that the expanded visual dimension of print media, especially with the regular use of the image-based news item, contributed to the formation of a public sphere with a national and even international dimension, but without taking for granted like Sellés that this resulted in a progressive, healthy homogenization of Spanish culture or even that innovations in the press were alone responsible for great shifts in public opinion whatever the consequences. The technology that increased magazine production did not simply create a demand; it responded to a demand for an unlimited flow of commodities.

As I also hope to demonstrate, the message of images discussed in the following chapters is often complex and contradictory. Magazine visuals played a double role of emphasizing differences—national and international, class and ethnic—and at the same time erasing differences and celebrating the "family" of man or the "family" of Spanish citizens and the immutability of human nature. Through visual tributes the past was venerated, celebrated, eulogized, and thrown

up as a model against a paltry and diminished present, yet the present was also heralded as an age of fantastic advances, a radical break with an outdated past, a door to a modernity that was full of possibility and wonder. Magazine editors understood that visual culture, then, could be all things to all people, and it is important, while discussing its usefulness as an ideological tool, both to avoid falling into a technologism that exaggerates its power and to be cautious about generalizations regarding the influence of images in general. That the power of the image is a key to the transformation of the magazine into a commodity is undeniable, but it was not just that the image-laden magazine was becoming a profit-driven enterprise like any other modern enterprise. The magazine became a conspicuous pawn in the advancement of capitalist ideology, which seized on the media to sell not just its goods but its philosophy, and the ways in which these transactions happened were subtle and multiple.

Hold That Pose begins with a look at the psychological and political dimensions of a category of images that held special fascination in high-end magazines during the period that these publications were at their moment of greatest success and cultural prominence. The discussion centers on female portraits that reached a pinnacle of refinement and audacious display in the 1890s in expensive illustrated magazines just as other magazines were beginning to focus on photoengraving as the defining visual of their weekly output. These images had the double effect of bringing European genre art to the attention of Spanish magazine subscribers and, through their incredible refinement and idealism, preparing readers to distinguish the engraving from the image resembling a photograph that was by contrast mundane, immediate, and "realistic," and consequently more suited to a mass-circulation

magazine. In an earlier work on Spanish graphics I examined the use of the feminine portrait as one of the chief visual anchors of the illustrated periodical. Before such engravings disappeared in the popular press and were relegated to specialized art magazines, they reached a level of sophistication and refinement that made it obvious that the hand-engraved image did not surrender easily to the mundane photograph as the visual of choice in the illustrated magazine. The refined portraits of women discussed in Chapter 1, technically speaking unchallenged in the 1870s and 80s, appeared alongside photographs in the 1890s and 1900s where they contrasted sharply with the newer photo images. At that point they became associated either with the past or with high art and stood out for their highly posed and idealistic, as opposed to realistic, content, as well as for their power to evoke sensuous reactions in magazine viewers. I chose a group of images of exotic women bedecked in coins to exemplify this high point of late-century magazine engraving, not just because of the images' technical excellence, but because though they were largely foreign imports, these images responded to the demands and sentiments of Spanish bourgeois consumers in specific ways. Because the sensuous appeal of the exotic women was heightened by their juxtaposition with the precious objects that adorned their bodies, these images occupy a special position in the fetishization of the female portrait that reached its high-water point at the end of the century, just as Spain was experiencing one of its most difficult political and military crises.

Documenting the events of that difficult period would have been the work of the army of skilled illustrators and engravers, before the use of field photography became the norm in the illustrated press. The task of tracing how

and when periodicals began to use photography to reproduce art and document political events, daily activities of the citizenry, or battles and scenes from abroad is a complicated task. The processes employed to get ink to paper were in constant flux, with new techniques rapidly replacing the old, and with traditional engraving techniques combined with newer photographic techniques in ways that are in many instances difficult to gauge and that publishers rarely documented with clarity. Nevertheless, assessing the uses of technology is key to understanding the potential of the magazine industry in arriving at the desired level of mass production. Chapter 2 looks at both the various processes that led to the replacement of manually produced, mechanically printed engravings by images that were photographed and reproduced photomechanically, and the effects that resulted from this substitution. What is evident is that the processes employed not only impacted the pictorial content and level of refinement of whatever process was utilized; they also influenced the choice of subject and the content of the text that accompanied the images. The aim of juxtaposing the images and modes of production of two important and widely disseminated magazines, the prestigious *Ilustración Española y Americana* and the more populist *Blanco y Negro,* is precisely to show the mutual influence of traditional engraving and photoengraving processes. This juxtaposition also demonstrates, to the extent possible, what made process printing using photomechanical reproduction win out in the race with xylography and other manual printing processes to supply the increasingly insatiable thirst for visual culture that marked the end of the century.

Ilustración Española y Americana was the benchmark publication for combining art with information about world events, natural wonders,

and manmade inventions and constructions, a gazette publication with rich and varied appeal. It, however, like other high-profile periodicals that emulated it—*Ilustración Ibérica, Ilustración de Madrid, Ilustración Artística, Ilustración de Catalunya,* and others—was doomed to share diminishing markets and eventually to be replaced by more modest, but also more populist magazines that featured local artists and popular entertainment. It is tempting to conclude that technological advancements that made the mass production of images and text together possible led to the leveling of culture, resulting in a democratization of the press with increased appeal to the masses. While this is an important factor in the popularization of the medium-format magazine, the idea of an organ of mass communication in Spain in the late nineteenth century remains a problematic concept. Even if we accept for a moment the notion of calling a magazine like *Blanco y Negro* a mass-circulating publication, as some have described it, it is important to discuss the interrelation between the mode of production of the magazine and its content, an issue I look at more closely in Chapter 3. A combination of factors ensured that *Blanco y Negro* was an instant success when it appeared in 1895. Apparently urban readers were receptive to the kind of news doled out in small batches, often with a heavy dose of humor and numerous accompanying pictorial images, that functioned as a kind of shorthand messaging system. Paul Aubert even credits the magazine for instilling in consumers the expectation of graphic coverage as the best way to establish the historical veracity of news items.[11] Another important factor was that reduced overhead costs and modern equipment, modes of production, and access to raw materials and markets made it possible to offer the magazine at an affordable price for middle-class consumers who

would not have been able to afford a subscription to the higher-end illustrated periodicals such as *Ilustración Española y Americana.*

Inexpensive illustrated magazines made it possible for large groups of people to understand if not constitute their common goals, customs, and morality, but it did this in ways that simultaneously excluded other large groups from what the magazines were setting up as the social norm for the nation's readers. For example, field reportage, which was increasingly accompanied by photographs shot on site, largely documented the important affairs of white European men who were most heavily featured in early photographic journalism. This focus was also in keeping with the conventions of high-end magazines that doted on engraved portraits of illustrious men. Photographs of actual women were slow to appear—although the artistic feminine portrait still dominated all types of magazines in the period studied—so that the way that "differences" between men and women were portrayed depended on the technology used to portray them. On the other hand many photographs and sketches illustrated ethnic or national differences from the European norm. As the century drew to a close, photography not only fueled the demand for visual validation of the written word in the reporting of world events, descriptions of other nations and their peoples, and scientific and technological progress; it also put into perspective the vast differences in the mores and conduct of other nations. For example, the cartoons that proliferated in the mainstream press leading up to and during the War of 1898 provided a way for the upper and middle classes to represent themselves and their moral hierarchy in a way that distinguished them from the impoverished ideals of other nations. The final chapter of this book looks at the way that popular magazines like

Blanco y Negro, as well as more specialized periodicals like the satirical magazine *La Campana de Gracia* and others, developed a stereotypical library of images to lend support to or impugn national interests and to constitute the image of a mythical Spaniard as the norm against which other peoples were to be measured. Comparing the warmongering techniques of the 1890s in Spain with those that proliferated in the United States press during the same period underscores the particularities of Spanish cartooning, but also the way in which the political cartoon came to function as a handy propaganda tool for future conflicts and political campaigns.

Most of the reasons for the success of the illustrated weekly magazine examined in the chapters of this book concern image content and production, but what also ushered in what we can properly call a mass culture in which magazines played a definitive role was the transformation in the relationship between the products that were being manufactured, distributed, and sold to consumers and the new methods for constituting ready consumers of those products in the form of advertising. Studying the formation of mass culture in the United States, Richard Ohmann suggests that significant changes in manufactur-ing, distribution, and advertisement were what propelled the magazine into such a prominent social force in the nineteenth century. The concluding section of *Hold That Pose* looks briefly at the advertising in what became the most popular magazine of the 1890s, *Blanco y Negro,* to see whether a similar causal relationship was forming between popular weekly magazines and new advertising techniques that reflected a transformation in manufacturing and business practices. Spain was, after all, just emerging as a modern industrial nation as the century ended, while America could already be called without exaggeration a consumer capitalist state. An examination of the content of magazine advertisements between 1895 and 1905 reveals that Spain had interesting parallels to and departures from the American and European models of advertising. Publicity was still in a very primitive stage in the magazine, compared with, for example, the newspaper or poster. Magazine advertising nevertheless solidifies the overall thesis of this book—that illustrated magazines were about selling, not just ideas, social norms, and images, but the magazine itself as an indispensable consumer product for an authentically modern world.

One

RACIAL FETISHISM IN THE LATE-NINETEENTH-CENTURY ILLUSTRATED MAGAZINE

Woman is well within her rights, and moreover fulfills a kind of duty to appear magical
and supernatural; she must surprise and charm; an idol, she must gild herself to be adored.

—CHARLES BAUDELAIRE, "Le Peintre de la vie moderne," 113

ONE OF THE defining characteristics of Spanish illustrated magazines of the second half of the nineteenth century was their use of mechanically reproduced engravings with women as one of the preferred subjects, sharing space with equally popular renderings of famous men, boats, buildings, and natural wonders of all types.[1] Seen from the lens of the image-laden twenty-first century, these feminine portraits strike us as the harbinger of an age of aggressive scopic fetishism rather than as the last entrenchment of cult value that Walter Benjamin assigned to the melancholic beauty of early photographic portraits. Magazine portraiture descended on Spain as a borrowed convention, flouting names that in the beginning were often not those of Spanish artists and engravers. The kind of feminine study that especially attracted the nineteenth-century European artist was a harmonious combination of manmade materials, precious objects, and corporal beauty. While one could make an argument for the fetishistic properties of the myriad images of historical male portraits, or the thousands of manmade and natural objects that studded the illustrated magazines and were sometimes expertly engraved, it is the more phantasmagoric images of female figures that seem especially to lure viewers because of their formidable size and prominent placement in the periodical, the feminine beauty of the depictions, and the aesthetic quality and technical expertise involved in their execution. These ornate exotics reflected both what Bram Dijkstra dubbed the "iconography of misogyny" evident in some turn-of-the-century art and the "slick concoctions" of beautiful and ornate women portraits of a previous era that continued to flourish in Spain into the twentieth century.[2] The consummate flâneur, Charles Baudelaire, strolling the streets of Paris in the 1860s, helped to fashion woman-watching as a sport that every artist ought to practice assiduously, and his ideas about feminine beauty haunt artistic convention throughout the second half of the century, culminating in the modernist aesthetic at the turn of the century. Woman should be the artist's idol, he counseled, and capturing on canvas her invitation to happiness should constitute his ultimate goal: "[S]he is a kind of idol, stupid perhaps, but radiant and enchanting."[3] Clothes, makeup, and jewelry are integral to

this harmonious being; no poet or artist should separate her and her costume since together they constitute an "indivisible totality." Her beauty, then, consists of her body, her clothes, which are the "pedestal of her divinity," her cosmetics, and, finally, "the metal and mineral that twist around her arms and neck, that add sparks to the fire of her glances or that softly chatter in her ears."[4] In short, feminine beauty ought to be contrived according to Baudelaire, because an unadorned, natural woman is incapable of performing her role as man's idol: "an idol, she must gild herself to be adored."[5]

As if heeding Baudelaire's advice, by the 1880s in advanced European societies bourgeois women were fashioning themselves into veritable buying machines, fueling, and, needless to say, necessary in order to fuel, the mass production of consumer goods, especially textiles and cosmetics, that capitalism facilitated. In *Au bonheur de dames* (1882), Émile Zola depicted the pursuit of these goods as a feverish activity that was an end in itself, destroying the last vestiges of artisanal craftsmen and small shop owners who all fall before the behemoth that is the Ladies Paradise department store serving up cheap goods in vast quantities. Zola's department store, like the real ones it imitated, succeeds not only because it can afford to sell cheaply what the neighboring small merchants must sell dear, but because it aggressively displays goods to seduce female shoppers who are allowed to fondle and purchase on credit the items they see so ostentatiously displayed. Women, the haute as well as the petite bourgeoisie, like the shop clerks in Zola's novel, in turn flaunted what they purchased in public, turning their bodies into the spectacle that simultaneously advertised their success as savvy consumers and as objects of the admiring male gaze. Ignoring the needs of their family and their husbands'

depleted fortunes, such women "transformed the realm of trivia and decoration into a torture garden for the men who had collectively set out to turn them into the trained seals of a consumer society."[6] Artists in turn translated and idealized the novelists' vampiric images of the consuming woman as the mythical Danae, Delilah, Judith, and the ever-popular Salome.

What the undisciplined woman consumer (and the much studied, greed-driven kleptomaniac) of nineteenth-century literature shared with the head-hunting priestesses of fin-de-siècle decadent art was a voracious drive to destroy men's fortune. Dijkstra's interpretation of this trend as an allegory for an exorcism of woman in art that participated in a "war against woman"[7] may seem far-fetched, but there is ample evidence in medical, juridical, religious, and philosophical discourses that misogynistic minds were targeting women's vanity and frivolity just as capitalism was revolutionizing the relationship between feminine beauty and material goods.[8] Schopenhauer was not alone in believing in women's natural inclination to profligacy and excess, a result, he speculated, of their utterly deficient reasoning power: "The vanity of women, even if it should not prove to be greater than that of men, has this much danger in it, that it takes an entirely material direction. They are vain, I mean, of their personal beauty, and then of finery, show, and magnificence. That is just why they are so much in their element in society. It is this, too, which makes them so inclined to be extravagant, all the more as their reasoning power is low."[9]

Baudelaire's advice to artists in his essay "Le Peintre de la vie moderne" (The Painter of Modern Life) (1863) reflected his idealization of Parisian beauties, especially of the haute bourgeoisie. His advice was fervently heeded by studio artists in Paris and other major capitals of Europe where

boulevardisme was a major pastime of idlers of all classes. The contrived beauties that Baudelaire so admired and that Schopenhauer apparently despised flourished in the pages of magazines like the profusely illustrated *L'Illustration* of Paris (1833–1944), the *Illustrazione Italiana* (1875–1962), or the *London Illustrated Times* (1855–72), where they coexisted with a different and more exotic kind of feminine masquerade that not only indexed women's innate acquisitive drives, but spoke to other fears and desires that are also important to assess. Dijkstra theorizes that it was men's "nerve-wracking enslavement to the great god mammon" that caused them to dream of "paradisiac days before woman had forced the evolutionary process into motion, before progress had become the driving force of life."[10] But the cultural result, according to Dijkstra, was not so much the paradisiac dream but a horrible nightmare that produced an obsession in both visual and literary culture with the voracious female, consuming men's gold and seed. Amid showers of gold coins, the dangerous exotics in fin-de-siècle high art, according to Dijkstra, symbolized woman's predatory nature while giving artists a pretext "to exploit the visual theme of a woman in the throes of physical ecstasy."[11]

In Spain, however, sharing space with the nightmarish figures Dijkstra studied in *Idols of Perversity* is the dream woman representing those "paradisiac days," which dominated the visual field in the press; often they appeared as beautiful Orientalized women in submissive or provocative poses. By the last decades of the nineteenth century in Northern Europe, the Orientalist genre had devolved into a cliché more and more injected with a prurient eroticism.[12] Suffice it to recall that Delacroix painted *The Women of Algiers,* a work often heralded as the zenith of the genre, which critics today associate with France's

overseas colonial enterprises, as early as 1838.[13] The Orientalist artists whose works appeared in Spanish periodicals a half century later, Frederick Arthur Bridgeman, Jean-Léon Gerôme, Attilio Simonetti, William Adolphe Bouguereau, Georges Clairin, Rudolph Ernst, and others, were at the tail end of a tradition that had originated elsewhere and had largely run its course. Thus in Spain the highpoint of the illustrated magazine studded with portraits of exotic women coincided with a mediocritization of Orientalist genre art in France and elsewhere.[14] At the same time, a more "respectable" ethnic display whose purported end was not to titillate but to educate magazine readers in the colorful variety of the world's inhabitants was also still very much in vogue everywhere in Europe, including Spain, and photography reinvigorated this pictorial tradition beginning in the 1890s.[15] The goal of this chapter is to show how these two traditions, a late Orientalism and a wondrous ethnicity-on-display, shared space and certain pictorial conventions, together forming an essential ingredient in the fetishistic, scopic regime of Spanish magazine graphic art.

THE COMMODIFICATION OF THE FEMININE IMAGE

The scopic fetishism of nineteenth-century magazine images of exotic women may be said to operate on two levels that correspond roughly to the two conceptions of fetishism with which we are most widely familiar today. The concept of commodity fetishism was first outlined in Marx's *Capital* and later refined by William Pietz, Jack Amariglio, Antonio Callari, and others who examine its manifestations in modern capitalist societies. Psychological or "phallic" fetishism

evolved beginning in the 1880s and was incorporated into Freudian psychoanalysis in the 1920s. The darling of postmodernism, psychoanalytic fetishism has also recently been elaborated in some critical arenas in the guise of a modernist, aesthetic fetishism, as studied by Emily Apter, or as imperial fetishism and feminine fetishism, concepts proposed in the work of Anne McClintock, Naomi Schor, and others. Here I am borrowing McClintock's basic insight that "psychoanalysis and material history are mutually necessary"[16] when engaging intercultural questions related to fetishism. Trying to understand an obsession with certain types of images without entertaining the material conditions under which they were produced and consumed short-circuits the discussion of social issues. The first part of this chapter consequently surveys the early stages of the mass production of works of art through improved manufacturing and printing technologies and argues that the resultant reproductions were commodified in late nineteenth-century Spanish culture. The second half analyzes the content of specific images of the female body and its accouterments as overvalued and thus fetishized objects primarily directed toward a bourgeois male spectator enthralled with sensuous representations of exotic women. The point is to show that it is useful to interrogate these two basic forms of fetishism, psychological and commodity, when analyzing the ubiquitous images of exotic Turkish, Gypsy, Circassian, and North African women draped in coins, which exemplify what, separately and with somewhat different conclusions, Anne McClintock, Homi Bhabha, and Kobena Mercer would call racial fetishism. These "metallurgical wonders" or "money trees," as one is tempted to describe them, serve a triple role: as psychological fetishes revealing an anxiety about the male gaze that is unique to a particular cultural moment and place; as traces of the relation between the commodification of the magazine image and the objectification of women; and, finally, as evidence of a cross-cultural problematic, in the case of Spain of a national sentiment of loss, nostalgia, and envy, and, ultimately, anxiety that played out on the exotic female body, then as now a symbolic good beyond viewers' reach in a physical sense.[17] The quest for the exotic that these images expose on the level of the individual viewer is a fleeting quest, "offering a promise of fulfillment that it can never totally satisfy,"[18] but collectively these images reveal another symbolic quest, equally unattainable, for colonial riches and possessions either lost forever or no longer obtainable in a Spain of diminished overseas fortunes.

COMMODIFYING THE IMAGE

Marx deployed the image of the fetish as an analytical weapon in his mature writing to critique the bourgeois commodification of objects that he described as "hieroglyphs" in the riddle of man's social labor. His use of the term "fetish" reflected not so much his interest in the material objects of so-called primitive religions (an interest sparked by Enlightenment texts such as Charles de Brosses's *Du culte des dieux fétiches,* 1760), nor in the shoes, feet, fur, and other objects that came to be regarded as modern sexual symbols in late nineteenth-century psychiatry journals. Nor was he thinking of graphic images when he conceived of the metaphor; rather he was using the religious fetish that eighteenth- and nineteenth-century anthropologists regarded as objects revered in primitive religions to move the discussion of idolatry in capitalist society to the realm of the material. In the simplest of terms,

the fetish as Marx described it is an object that people invest with something that the object does not intrinsically possess; it is the product of labor whose value has been transformed through its commodification into something "fantastic" or mistakenly conceived. What gets hidden in the process is the exploitative social relations that drive capitalism:

> It is nothing but the definite social relation between men themselves which assumes here, for them, the fantastic form of a relation between things. In order, therefore, to find an analogy we must take flight into the misty realm of religion. There the products of the human brain appear as autonomous figures endowed with a life of their own, which enter into relations both with each other and the human race. So it is in the world of commodities with the products of men's hands. I call this the fetishism which attaches itself to the products of labour, as soon as they are produced as commodities, and is therefore inseparable from the production of commodities.[19]

In short, the image of the fetish helped Marx to denounce capitalism because its modes of production inflected value-consciousness, "displacing value-consciousness from the true productive movement of social labor to the apparent movement of market prices and forces."[20]

According to W. J. T. Mitchell, Marx would look askance at the practice of crudely applying his theory of fetishism to the discussions of poems, novels, and works of art, that is, of reducing art to a mere commodity that reflects bourgeois self-deception. For this reason, it is insufficient merely to study the manifest content of literary or graphic images. Furthermore, works of art, even of bourgeois art, are never "mere

commodities." They may be transcendental, contradictory, or enigmatic, to use Marx's own terms, even if they embody patently bourgeois ideals, as in the case, for example, of Balzac's fiction, which Marx preferred to that of Zola, which had disappointed him. But Marx devised his theory of commodity fetishism before the onset of mass-produced works of art and mass-circulating magazines. Like every other commodity, magazine images are "mystical," and it is important to understand what Marx meant by this unusual term that he used to qualify the commodity but that we can also apply to magazines. Commodity fetishism is a kind of double forgetting: first the capitalist forgets that he has projected life and value into a commodity in the ritual of exchange (the value of the commodity becomes measured only in terms of abstracted human labor), and then the commodity veils itself in familiarity and triviality; it becomes understood as a natural self-evident form of social life. The deepest magic of the commodity fetish is its denial that there is anything magical about it at all. The intermediate steps of the process of establishing value vanish, and thus, as Marx put it, the commodity contains qualities that are at the same time perceptible and imperceptible to the senses:

> The mysterious character of the commodity-form consists therefore simply in the fact that the commodity reflects the social characteristics of men's own labour as objective characteristics of the products of labour themselves, as the socio-natural properties of these things. Hence it also reflects the social relation of the producers to the sum total of labour as a social relation between objects, a relation which exists apart from and outside the producers. Through this substitution, the products of labour become commodities, sensuous things

which are at the same time suprasensible or social.[21]

For an object to be classified a commodity it must be widely circulated, and the processes of its production mystified in the way that Marx described in this passage. When illustrated magazines were ushered in by the age of mechanical reproduction of images, the mode of graphic reproduction and the circulation of images took on the characteristics of every other good that needed to be produced on a mass scale for a market to expand and produce a profit. Manufacturers had to build larger and more durable presses and contract cheap labor to maintain and run them constantly in order to reduce production costs. Chemists and engravers had to perfect processes for transferring images to woodblocks and later copper or zinc plates in order to allow for large runs of reproductions that were ever more faithful to the original. Industrialists had to build paper mills and locate cheap sources of wood pulp in order to replace the rag paper that was becoming prohibitively scarce and therefore expensive. Small artisan shops producing limited runs of hand-etched engravings, mezzotints, and other types of prints of the highest quality, and matching prices, which were hand-tipped into books and magazines, were disappearing, replaced by factory-sized shops capable of mechanical reproduction made possible by new photographic techniques more suited to mass production. As the nineteenth century drew to a close, the labor time required to produce images on a mass scale dropped precipitously with the use of photographic processes and rolling presses, and the division of labor in the large publishing houses further streamlined the production process. In short, within the period of a few decades, all facets of the printing industry were revolutionized

in terms of manpower and machinery: "paper, quite precious and prestigious, often bearing seals, gives way to newspaper print; the hand press cedes to the rolling press; and the printed book with 500 copies bound in the 'Spanish style' cedes to the weekly installment, crudely bound, from which thousands of copies are printed."[22] The result was larger and more lavish magazine visuals in which the new and the old image-transfer techniques battled it out.[23] Barcelona was at the forefront of technological graphic innovation, which spurred competition between this city and Madrid in the production of illustrated magazines that catered to the wealthy. The lavish *Ilustración Artística* of Barcelona published between twelve and fifteen images per issue, many of them full-page or double-page engraved images (30 × 48 cm). By 1888, approaching the heyday of Spanish illustrated magazines, there were 135 weeklies published in Madrid alone,[24] all vying with one another for the most numerous and the most spectacular graphic prints. With the scale and processes of production considerably enhanced and industrialized, collecting magazines became both more appealing and more affordable than it had once been. New and cheap magazines began to offer images that, while not as spectacular as the large-format illustrateds, were suddenly augmenting the number of images available to a large public. Madrid's weekly *Blanco y Negro* boasted between twenty and twenty-four images, although many were very small before the end of the century, when the magazine expanded its graphic coverage.

Because of the importance of the mode of production of images in relation to those sectors of society that created the demand for them, portions of Chapters 2 and 3 are devoted to the discussion of the mechanical reproduction of works of art and their consequent "naturalization"

as they became products of an incipient mass culture. This chapter, however, is concerned primarily with one particular group of images in order to underscore their racialized dimension in relation to the subject of money, one of the overriding preoccupations of late-century bourgeois culture in Spain. As with other types of manufacture that Marx associated with capitalism, magazine images were becoming a social product. Their modes of production and circulation qualify them as a commodity that achieved the status of fetish in the Marxist sense, not just because of the revolutionary changes in technology and production that facilitated their production as a material object, but because content had became an important buying incentive. These two factors go hand in hand in determining the success, especially, of high-end magazines. Owing to their increased distribution and modernized manufacturing processes, there was something "mysterious" in their production and value that was not self-evident to consumers. On the other hand, if it is the nature of commodity fetishes not only that they are a concrete material form but that men treat them "as if they were People,"[25] my contention is that this is doubly so when the object, the commodity under scrutiny here, is in fact a close-up image of a person, a mesmerizing portrait beckoning to the viewer. Thus in looking at the fetishistic properties and effects of magazine portraiture, this chapter argues that portraits accrue disparate meanings through repetitions that are generated by what they actually appear to be, not just by what is hidden or mysterious in their production. Their value as a commodity measured in terms of the labor needed to produce them may have dropped, but their symbolic value measured in terms of the pleasure they afforded or the pain, nostalgia, and fear they indexed escalated in proportion to their numbers

and circulation. Finally, because the hundreds of exotics that appeared in illustrated magazines provided an explicit homology between sex and money, coins and flesh, and between the rescue and possession of racialized women and the need for European "rescues" of an imperialist nature, I conclude that the images studied in the following pages fall in the realm of racial/sexual fetishism that has not been adequately addressed in Spanish fin-de-siècle culture. Although Lily Litvak in *El sendero del tigre: Exotismo en la literatura española de finales del siglo XIX, 1880-1913* (1986) and *El jardín de Aláh: Temas del exotismo musulmán en España, 1880–1913* (1985) has laid out some of the territory to be covered, we are still lacking the kind of critical study that, for example, Susan Martin Márquez has been conducting on images of North African women in early Spanish film.

AVOWAL AND DISAVOWAL

Psychoanalytic discourses relating to fetishism have been the most common tool in the analysis of repetitive visual imagery. In the heady reproduction of thousands of exotic portraits that decorated the pages of late nineteenth-century illustrated magazines, we cannot yet extract a parodic or political critique of the alienated, colonized, North African or Gypsy subject, as Emily Apter believes may be the case with the twentieth-century fetishism aesthetic. In the pre-modernist period examined here, 1875 to approximately 1900, this subversive reading is not available to us. Instead, we must look for their meaning both in their relation to the desire for expanding markets, and also to their possible role in the discourse of national loss and national longing that reflected nineteenth-century European imperialistic fervor. On the other hand, while these images obviously

participated in the "Eurocentric voyeurism of 'other-collecting,'"[26] their specificity has to be untangled from, as well as related to, their status as a European (not just a Spanish) collective obsession. By the second half of the century, the Carlist Civil Wars, the Wars of Independence in the Americas, and other political upheavals such as the bourgeois Revolution of 1868 had left Spain as ill-prepared to participate in the vogue of exotic portraiture as it was ill-equipped to participate in European campaigns to divide up and colonize the rest of the world, which had fueled Orientalist art earlier in the century. For one thing, its manufacturing sector, the publishing industry included, still relied heavily on foreign imports and investment. Everywhere in Europe there was a rush to improve and purchase the technology to produce the best goods, but in Spain, where technology lagged behind the demand for luxury goods during the Restoration, many of the raw materials needed to expand the printing industry had to be imported from abroad, an exercise in acquisition that mystified even more the processes of production. To increase the market for illustrated magazines and to compete with foreign rivals, increasingly numerous and sensational images had to be readily available, and Spanish publishing houses simply could not produce quality engraving plates in sufficient quantities to satisfy the weekly demand. The major publishing houses, like the ones in Barcelona that produced the extravagant large-format *Ilustración Artística,* and its rival *Ilustración Ibérica,* routinely imported additional blocks or clichés from which engravings were made. Many of these were executed in France or Germany after paintings by Northern European artists. Thousands of these images were sold to Spanish publishing houses each year. Once it became possible to reproduce mechanically plates through

electrolyte processes, the same images would be sold and printed in rival Spanish magazines with different titles, as well as with different instructions from the magazine editors about how to "read" the images in the *Nuestros Grabados* (Our Engravings) section of the magazine.

The libraries of the Spanish bourgeoisie, in addition to the peepshow cabinets filled with bric-a-brac, family memorabilia, rare objects, and stuffed animals—part of the mania for collecting that characterized the century and which now has entered into discussions of nineteenth-century fetishism—often included floor-to-ceiling shelves of magazines lovingly collected and, at the end of each year, bound in leather. Eventually middle-class consumers, lured by the availability of modest illustrated magazines like *Blanco y Negro* and *Nuevo Mundo,* could also indulge in the prestigious activity of book and magazine collecting.[27] Still, from the prices it is clear that with few exceptions the industry throughout the second half of the nineteenth century catered to higher-end urbanites by producing high-quality, durable gazettes that begged to be collected and bound, poured over, cherished, and passed on to children. Not surprisingly, the most expensive and well financed of the illustrated magazines carried the most exoticized portraits, but these were overwhelmingly the product of foreign artists whose works were engraved on blocks or etched on plates abroad and then purchased from foreign agents by Spanish printing houses. Production of these magazines was limited because the number of those able to afford subscriptions in Spain was small in comparison with other industrialized countries. But while the circulation figures of individual magazines were extremely modest, rarely surpassing 10,000, the number and variety of magazines was growing at a record pace in the 1880s.

Recognizing the engraving as an especially multipurpose and thus valuable commodity, some magazine publishers invited readers to extract the more extravagant full-page and two-page images from the pages of the magazine by surrounding them with decorative borders and omitting page numbers, sometimes labeling them a "a gift for our subscribers." These special pages were especially popular in almanac issues released at the beginning of each year. These "gifts" to subscribers tended to increase circulation since the image would likely have found its way into the consciousness of many viewers, framed for display on walls in the homes of those whose modest income precluded the purchase of original art. Later, of course, the presence of alluring portraits in Spanish urban culture would accelerate when images of women began to decorate advertising posters plastered on billboards (today these posters have became collectors' trophies), and also as photography studios sprang up selling inexpensive portraits of royalty and famous actors, as well as family portraits. Such frameable portraits are not the sexual objects, primitive religious idols, or consumer products that we typically associate with the discourse of psychological and commodity fetishism, but they were much coveted and revered objects nonetheless, and sexual desire, invoked in the content of many of the images, was an important part of their appeal. They invited the rapacious looks of consumers because of their pictorial content, their aesthetic appeal, and their technical refinement, and they accordingly helped to transform the illustrated magazine into a permanent fixture of a bourgeois consumer society eager to Europeanize its tastes and satisfy its drive for the acquisition of mass-produced goods. They participated, in other words, in the periodical's self-promotion, surpassing in the space they occupied as well as in their technical refinement all other forms of magazine advertisement.

Even before the illustrated magazine reached the height of its popularity in the 1880s, the sexual significance of the fetish was being debated by anthropologists who were beginning to divine, in the objects acquired by merchants from Africa and other exotic locales, emblems of male and female sexual organs, in other words, displaced phalluses. however crude. This discovery eventually gave rise to a discourse of fetishism that entered the realm of emerging psychology at around the time that the highest number of illustrated magazines became available in Spain. Potency and impotency were the dual sexual projections of the modern idolater's sexuality, which resulted, according to some nineteenth-century anthropologists, in the symbolic castration or feminization of the fetishist. In his work on fetishism in nineteenth-century culture, David Simpson notes similarly how all the admonitions about trinkets, ornaments, and even figurative language reflect an effort on the part of the scientific community of the late nineteenth century to align the fetishes of modern society with gender problems: the idolater was infantile, feminine, and narcissistic, in a word, "unmanly."[28] There may have been a "marked sexual dimension to the discourse about fetishes"[29] even before the nineteenth century, but it was during this time, when the feminine portrait loomed large in the magazines' visual repertoire, that gender issues emerged at the core of discussions about fetishism in psychological discourse.

For many early psychiatrists, the fetishist's obsession was a logical consequence of a decadent society given over to unmanly pursuits. In an 1887 treatise, Alfred Binet distinguished religious fetishism, the tendency to confuse the divinity with the material object that represents

it, from what he termed love fetishism. Glossing the 1882 work of Jean-Martin Charcot and Valentin Magnan, early French psychiatrists who in 1882 published papers on sexual perversions in the *Archive de Neurologie,* Binet described the love fetish as a body part, like hair, ears, eyes, and feet, or inanimate objects like night bonnets and shoes, which possess the mysterious power to cause an intense excitation in the fetishist.[30] Everyone, according to Binet, is a fetishist in some way; it is only a question of degree that distinguishes what he called *grand fétichisme* from the more innocuous *petit fétichisme.* Petit or grand, the cause of fetishism as Binet described it is multiple. Biological factors can be significant, but the form a fetish takes is socially acquired. Typically it is an "accidental" visual experience that provokes the fixation of the fetishist, and women play a key part in that experience: "[I]n general one can say that everything that woman has invented in terms of adornments and ornaments, everything she imagines is pretty, curious, bizarre, and senseless to please man and vice versa has been the occasion of a new fetishism."[31] A physical response—generally a genital erection—coincides with an intense sensorial stimulus to spark the indelible memory that evolves into an obsession with a fetish object. But the fetishist is not seeking a physical response as much as he craves beauty, a human need for whatever is "unsuited to satisfy directly the ends of reproduction,"[32] which is why fetishism is not, according to Binet, "normal." The cultural decadence of the 1880s was exacerbating the incidence of fetishism, he speculated, because of "the need, so frequent in our times, to augment the causes of stimulus and pleasure."[33]

To Sigmund Freud is attributed the classification of fetishism as the simultaneous disavowal and avowal of male castration. As in the case of Alfred Binet, the roots of Freud's theory on fetishism are to be found in the work of Jean-Martin Charcot and Valentin Magnan, who associated fetishism with cultural decadence. This notion circulated widely in the work of other medical commentators as well, who, like Freud, often used literary texts as if they were real case studies to exemplify their pathologies. Freud's contribution was to see fetishism not so much as a biologically determined pathology or as a result of a degraded cultural ambiance but as a product of the castration complex.[34] Freud traced the etiology of fetishism to fixations of early childhood, to events prior to the age of five, when the young boy becomes fixated with, and fearful about, what is lacking in female genitalia.[35] To put it briefly, for Freud, the fetishist "is the male unresigned to the imagined amputation of the mother's phallus."[36] In normal development this fear is overcome, the mother's lack accepted and identification with the father realized, while the adult fetishist clings to the object, using it as a kind of crutch to ward off homosexuality or to substitute for an imagined loss. Marx's denunciation of monetary and commodity fetishism as reflecting the "impotence" of the bourgeoisie links commodity fetishism with the Freudian model. The difference between the Marxist model and the Freudian model is that for Freud it is not commodity fetishism that conceals exploitative social relations and renders sexuality perverse; rather, perverse sexuality expresses itself in commodity fetishism that destabilizes normal social relations.

If we were to entertain the notion of fetishism as a perversion in a classical psychological sense of avowal and disavowal, what would be the bases for speaking of magazine images as fetishized objects? Here there are two basic questions to address. First, in the circulation of thousands of

images, often in very similar poses, of "Oriental" or North African women, Jewesses, Gypsies, Circassians, and so forth, what is being avowed and disavowed? Second, is it possible, given that the idea of psychological fetishism originally evolved in order to understand idiosyncratic, individual traumas related to the fear of castration, to look at these images as a reflection of a psychosociological process occurring at the level of national identity? In other words, in what sense are cultural practices the effects of a collective psychic disorder, a sort of "communal fetishism"[37] that requires us to open up the study of fetishes to genealogical scrutiny, or "more theoretically subtle and historically fruitful accounts"?[38] As McClintock notes, some fetishes "defy reduction to a single originary trauma or the psychopathology of the individual subject,"[39] and to accept this is to expand the study of fetishism to incorporate "the vexed relations between imperialism and domesticity, desire and commodity fetishism, psychoanalysis and social history."[40] Agreeing with this, I argue that the magazine image is a social and necessarily interpersonal and intercultural object. Rather than regard magazine images simply as a sign of unfulfilled desire of a psychological nature, which could possibly be true for some individuals obsessed with collecting them, they more significantly represent unfulfilled desires of a nation moving toward modernity, but not toward a domination of the world, like the rest of Europe. As José Álvarez Junco has argued, the Spanish elite, "inspecting themselves in the mirror of the great European powers, saw in their own country only stagnation and inferiority."[41] For Spain to be able to look in that mirror at all and to understand its own stagnation and inferiority implied an expansion of image production in which I argue the imported magazine portrait played an integral role.

The conventional Freudian route would be to establish some of these images as what Angela Moorjani calls "phallic goddesses," sexually replete figures that function as a disavowal of castration and a mourning for an imaginary completeness, at the same time as they betray a dread and recognition of castration. In such an interpretation, the overendowed, sometimes gigantesque Oriental women like those in Figures 1 and 2, form part of a visual regime "which either objectifies her for a narcissistic gaze (erotism) or views her as potentially threatening to the male psyche. It is in terms of this dynamic that repressed male desire transgresses the domestic economy to fetishize the Other."[42] "Rebeca" (fig. 1), by the Italian painter Raffaello Armenise, with her round shoulder and hip, plump arm, full lips, nose, and cheeks, her left elbow resting on a rather obtrusively rotund jug, bespeaks a plenitude that justified the image's prominent position and size (23 × 35 cc) in the magazine *Ilustración Artística* in 1894.[43] In the *Nuestros Grabados* (Our Engravings) section the commentator enumerated Rebeca's erotic charms as those "of that pure Hebrew type, with almond-shaped eyes, graced with silky eyelashes, thick and sensuous lips, white teeth, graceful figure, and soft forms."[44] Ramón Molina's weekly magazine *Ilustración Ibérica* rose to the challenge of its rival the following year by featuring Armenise's "Tocadora de Guzla" (The Guzla Musician) (fig. 2), placing the guzla musician on a two-page centerfold that readers could remove for framing.[45] The sexually ambivalent musician must have seemed a welcome and at the same time disturbing phantasm juxtaposed in the same issue with images of the recent Cuban insurgency, the most pressing political problem in 1895. Surrounding the musician are summaries of the battles of Ojo del Agua and Cayo Espino, accompanied by full-page illustrations of

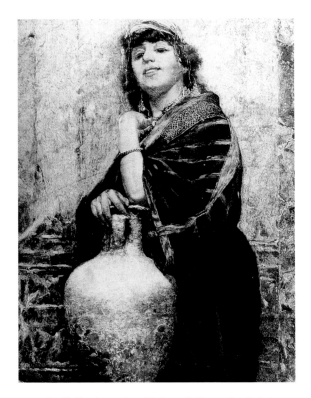

Fig.1 Raffaello Armenise, "Rebeca," *Ilustración Artística* 13 (26 February 1894), 137.

each on pages 740 and 741, and smaller sketches of Lieutenant Coronel Segura and Commander Garrido on pages 738 and 739, respectively. Psychiatrists hunting for images of a denial of sexual difference would not have to look farther than Armenise's engravings of rotund, instrument-wielding Orientalist figures towering over the external focalizer with their rounded bodies and protruding instruments. How small and stiff the soldiers in the various sketches look in comparison to the figures' monumental expanse and inviting gaze.[46] Compared with the soldiers, the fantasy figures are comforting in their plenitude. They are, to quote Marcia Ian's *Remembering the Phallic Mother,* "a kind of materialistic idealism;"[47] by which she means material signifiers

for an idealized or primal version that subjects can enjoy "in private," so that they need not be bothered with actual women. The end of the nineteenth century, the "golden age of contemporary sexology," as Robert Nye describes it,[48] witnessed the high-water mark of the translation of feminine props, which appeared everywhere in illustrated magazines, such as fur, shoes, undergarments, and leather, into rival interpretations of sexual pathologies. For example, Michael Balint, in his "Contribution on Fetishism," published only seven years after Freud's paper on fetishism, claimed that fur symbolized the vagina,[49] and one can certainly see why psychiatrists might have arrived at conclusions such as this from an examination of the hundreds of portraits of befurred Western women that were the rage in the high-end illustrated magazines of the era. Even if one rejects Balint's categorization, it is clear that these women represent something more than their label. The women in Figures 3 and 4, for example, are reported to be harbingers of winter. But Gaston Linden's "Mensajera del invierno" (Winter's Messenger) (fig. 3),[50] and Eduardo Gelli's "Flor de invierno" (Winter Flower) (fig. 4),[51] with their come-hither gazes nestled in their copiously fur-trimmed garments, likely evoked a warmer human contact than that of a cold winter blast. Shown at the Chicago Exposition in 1892, Ramón Ribera's "Después del baile" (After the Ball) (fig. 5),[52] was, according to the magazine's art editor, "psychologically and formally adjusted to modern concepts,"[53] *psychologically,* presumably, because she displayed the facial lassitude and bulked-up bust and circle of fur that in the mind of the commentator represented the epitome of a modern feminine pose and that for contemporary psychologists evoked the trauma of castration.

The visual fixation on portraits of beautiful women of different nationalities revels in the

display of inaccessible women, inviting eccentric desires that point to an impossibility that has both psychological and geopolitical meanings. In other words, we need to locate their meaning both "inside" and "outside" the subject-consumers. These rare beauties may ward off castration anxiety through their phallicity (or vaginicity in the parlance of psychologists like Balint), but at the same time as they entice, they deny their accessibility to the viewer, revealing "more an inability to tolerate the necessary incompleteness of experience than a reduction of experience to a mere part."[54] The very ubiquitousness of exotic portraits means that the Spanish collector was fixated on bits of paper, cardboard, and canvas, part of the club of nineteenth-century bourgeois collectors of objets d'art, but the images' referents are mirages, and no matter how many stacks of magazine images the collector may have possessed, the images would never fulfill the collector's desire for the experience of their referent in any material sense.

What bound the collectors' club together, however, was not simply a decadent trend or a similar trauma experienced individually, but a common historical juncture. As instructive as conventional psychoanalytic approaches to the images discussed above might be in understanding sexual obsessions, it is important to remember that we are hampered in our discussions of historical objects such as the Coca-Cola bottle, the swastika, flags, maps, crowns, and so on, which McClintock analyzes as group fetishes, if we focus solely on fetishism as reflecting individual etiologies or primal obsessions, or even as indicating gender trouble, as Emily Apter and other feminists contend, without taking into consideration the social matrix from which they arise. We doubtless need to remember that in the case of magazine images—painted by men, etched,

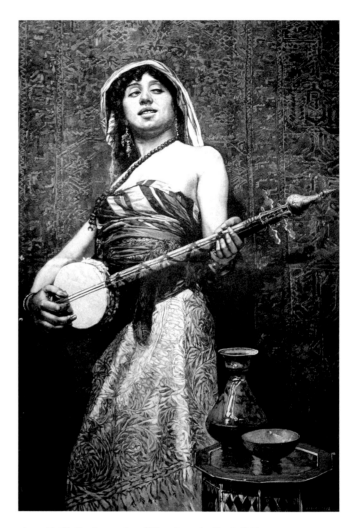

Fig.2 Raffaello Armenise, "Tocadora de Guzla," *Ilustración Ibérica* 13 (23 November 1895), 744–45.

photographed, and engraved by men, published by male magazine editors for an overwhelmingly male readership—we are referencing a male cultural system, and pointing out their compensatory function for the individual male psyche is not irrelevant. These women-images are not portrayals of feminine fetishists who adored the objects they draped on their bodies, but products of a male imagination working overtime in a

Fig.3 (upper left) Gaston Linden, "Mensajera del invierno," *Ilustración Artística* 20 (18 November 1901), 749.

Fig.4 (lower left) Eduardo Gelli, "Flor de invierno," *Ilustración Artística* 16 (13 December 1897), cover.

Fig.5 (above) Ramón Ribera, "Después del baile," *Ilustración Artística* 12 (19 June 1893), 395.

patriarchal order. The various phallic or genital substitutes are easily observable, and we could write them off as "an allegedly universal human tendency toward privileging phallic symbolism,"[55] but that alone would be insufficient to explain the social dimension of the images' popularity. According to Pietz, beyond its status as a collective object, the fetish "evokes an intensely personal response."[56] Beyond this intensely personal response that we associate with fetish objects, however, the repetitive magazine image is perverse as a collective object, and it is therefore worthwhile to link the psychic and the cultural through a discussion of the mechanics of the gaze as a national obsession. Fetishes exist out there in the world, as Pietz points out, "as material objects that 'naturally' embody socially significant values that touch one or more individuals in an intensely personal way: a flag, monument, or landmark; a talisman, medicine-bundle, or sacramental object; an earring, tattoo, or cockade; a city, village, or nation; a shoe, lock of hair, or phallus; a Giacometti sculpture or Duchamp's Large Glass."[57] But it is fruitful to explore the contours of this historical fixation not as a singularly produced, traumatic event experienced by individuals and then relived as an obsession, but as a fixation that was class-bound and specific to the cultural and political realities of fin-de-siècle bourgeois Spanish culture.

MEDIATIONS

Notions of collective psychic profiles as developed by Adorno and Durkheim have been discredited by postmodernists.[58] Likewise I won't be trying to make any sweeping statements about a mass perversion whose symptomology is the magazine image, such as the analysis performed by Dijkstra in *Idols of Perversity*. But it is not simply the status of images as the evocation of a personalized or sexualized experience that inspires magazine editors to flood the market with exotic portraits, but the images' status as objects that both avow a connection between Western and non-Western women and at the same time disavow that connection as phantasmatic. If these images touched many bourgeois men in an intensely personal way, it was not only for what they may have offered in terms of comforting psychosexual plenitude or disquieting lack at the primal level, but for what they represented in terms of loss and lack at a national level. The images can be understood, in other words, as a site of collective anxiety. While it is undeniable that the gaze is a private psychic enterprise, the mass-produced magazine expanded its meaning to encompass the social relations not just between men who consume and produce the images, but between nations. Anyone studying Spanish magazines of the 1890s, studded as they were with massive engravings and photos of weapons and warships, would have no trouble analyzing their function as integral to the discourse of nationalism and its fetishistic props. Exotic portraits of women did not operate, overtly at least, on quite the same scale, but they were also symptomatic of a particular unspoken dialogue about Spanish sovereignty and mission among the country's ruling classes and among the world's dominant nations.

Close-up images of women originally painted by Europe's Orientalist genre artists produced a complex, simultaneously uncomfortable and exciting viewing position for the Spanish bourgeois consumer. This is in part because what Walter Benjamin called the "here and now"[59] of the original work of art was many times removed from the spectator's experience. And because the

majority of these engravings, or at least the origi-
nals from which they were made, were produced
by foreigners, the geopolitical as well as the phys-
ical disconnect from the original has to be taken
into account when discussing their reception.
Spanish consumers had constantly to confront
a series of unknowns when faced with exotic
magazine images, beyond the obvious question of
whether an image was an "authentic" representa-
tion or the product of pure imagination. For this
reason magazine editors often provided readers
with glowing comments about an artist's skills
and training and especially the authenticity of his
works, such as: "He captures the true essence of
the Orient"; "He has been faithful to the images
of the real Oriental subjects"; or, conversely,
"He gives free flight to his imagination in a most
delightful way." Any response to the images is
thus overly mediated by an otherness several
times removed from daily experience, producing
an anxious pleasure in the viewer.

The first mediation occurred at the hand of
the artist who chose the subject: Did he use live
models? Did he in fact travel to the Orient to
sketch his figures, and were the women really as
appealing as they seemed on paper? Are the poses
and costumes he chose complete fictions of his
imagination? At the same time, the images were
mediated by the society in which the artists orig-
inally labored: Do Germans have an especially
reliable handle on authentic life in Bulgaria, Tur-
key, or Egypt? Are French and German cultural
productions inflected by Romantic nostalgia?
What role did historical contingencies related
to colonialist aspirations play in the depiction of
exotic locales and peoples? The next mediation
concerns the role of magazine publishers, for
example, Montaner and Simón of Barcelona's
Ilustración Artística, who imported many of the
plates they reproduced from Northern Europe:

Were their choices the product of individual
interests and tastes or simply market forces? If
primarily responding to the interests of their
readers, exactly how did they gauge that inter-
est? What part does the availability and quality of
plates in certain countries and not in others play
in the selection of images?

Finally, questions regarding reproductive exac-
titude, modes of information transfer, and tech-
nological expertise would also mediate reception:
Have the engravers been faithful to the original?
What processes were involved in the transfer
of information from the original to newsprint?
What has been lost in the translation from color
to black and white engraving? Did the image
start as a sketch, a painting, a photograph?

All these mediations complicate the question
of viewing distance, making the task of settling
on a viewing position more contingent. I am
not suggesting that all these questions surfaced at
the conscious level of the viewer. As mentioned
above, magazine images became part of the warp
of the everyday, and their mediations were most
often obscured; many readers simply imagined
them as natural, even photographic depictions of
everyday life somewhere else in the world. On
the other hand, it is clear from the accompany-
ing editorial comments that an anxiety about
authenticity and mediated effects in general
played an important role in their reception.
Magazine commentators steered their readers in a
certain direction regarding some of these ques-
tions, but, often signing with a mere initial like
B. or P., their own credentials for resolving these
questions were often undecipherable: Who are
B. and P., and by what authority do they inter-
pret the images in the *Nuestros Grabados* section
of the magazines? From the viewpoint of the
modern spectator, to further complicate things,
another set of mediations is in force. Juxtaposing

the relation between their high rate of frequency and the above historic determinants, as well as the various psychological discourses that emerged alongside them at about the same time, allows us a different (also contingent, needless to say) point of departure for understanding them.

From the classic Freudian point of view, the object of the fetish is to preserve something (most commonly designated as the mother's phallus) from being lost that was never there to begin with, denoting a lack that the fetish both covers up and reveals; just by being there the object signals the boy's fear of castration. Adopting the structure of Freud's model but expanding the cause and protagonists that he assigned to it, we could say that the collector of magazine images owns the paper image whose referent does not exist. He can never really possess anything remotely resembling the exotic females dripping with gold and silver coins like the ones discussed in the following pages, although the images became prized collectors' items nevertheless.[60] But through their seductive poses, these images do offer a fleeting, surrogate possession of the image's referent (for example, in their return of the desiring gaze), even as they appear to be an impossible phantasm. Thus the question of availability is indirectly posed in these images. Like the commodity, the exotic woman's sexual desirability is fetishized, made to appear a quality of the object itself, "spontaneous and inherent, independent of the social relation which creates it, uncontrolled by the force that requires it,"[61] and, as Catherine Mackinnon points out, "[I]t helps if the object cooperates,"[62] which many exotics clearly did. Credulity and disbelief are both evoked in the exaggerated portraits of Gypsy women, odalisques, harem women, and myriad other exotic types. Magazine images such as these, together with the ubiquitous collections of female oil portraits that decorated the private homes of the wealthy bourgeois, and, to a lesser degree, those of the middle-class consumers, came to be fetishized as erotic commodities or collectors' items within the fin-de-siècle Imaginary.[63] They were material objects, objects that appealed to the senses without turning men into Oriental sensualists, at least in the opinion of the art editor writing for *Ilustración Artística,* who handily interpreted the art of collecting portraits as a healthy male quest to seek out beauty:

—Tell me who your friends are, and I'll tell you who you are. That's what the refrain says. We aren't refrainists, but we venture to say:—Tell me what you collect, and I will explain your feelings. Do you collect beetles or snails? You are peaceful by nature. Do you collect bank notes? You are ambitious. Do you collect gold? You are a hoarder. Do you collect stamps? Either you are a child or very stupid. But what concept should we form of someone who collects portraits of beautiful women? Let us be honest; we would form a good opinion.[64]

Unlike the sensualist who can run off to Turkey and buy his fill of women and horses, whoever contemplates beauty, however manifested, "raises his thoughts to superior spheres and is the font of noble sentiments, that have a powerful influence on our way of feeling and our deeds."[65] Unacknowledged in the above editor's ecstatic espousal of portrait collecting is an envy of the "Oriental" collector who can possess the "real thing," and this unspoken desire inflected Spanish as well as European Orientalist art. In Figure 6, a sketch by Mariano Barbasán originally published in *Ilustración Artística* in 1895 and labeled "Occidente" (The West) in the upper frame and

Occidente, cuadro de M. Barbasán

Oriente, cuadro de M. Barbasán

Fig.6 Mariano Barbasán, "Occidente: Oriente," *Ilustración Artística* 14 (22 April 1895), 295.

"Oriente" (The East) in the lower frame,[66] an Oriental sultan flaunts a treasure that the Occidental man cannot possess in such abundance. Westerners, however well-heeled, are bound to a monogamy that restricts their legitimate sexual relations, something that Schopenhauer and several other of the century's philosophers considered a tragic mistake. Schopenhauer argued that the 80,000 prostitutes of London were the "human sacrifices offered up on the altar of monogamy"[67] and that monogamy was an "unnatural institution" that was bestowing undeserved rights upon women.[68] Barbasán apparently concurred, and the magazine's commentator further emphasized the injustice of this sad state of affairs by making reference to the "ugly Moor" who owns the Oriental women in his sketch:

[T]wo young women, beautiful and elegant, dominate the center on which converge the

gaze of a great number of men admirers of their charms; in the other [sketch], an ugly Moor, completely lacking in charm, is surrounded by handsome young women who gaze at him more or less lovingly, each one hoping to be the preferred object of his favors. Does not this contrast tell us with sufficient clarity the idea that inspired Mr. Barbasán to sketch these two beautiful pictures that in their seeming frivolity reveal in one of their most important aspects the deep abyss that separates the two civilizations?[69]

Obviously originally intended as a joke, Barbasán's juxtaposed sketches gloss the hundreds of harem scenes that were the stock in trade of the late Orientalists, images that advertised the abundance of women at the disposition of the lucky but cruel (and therefore undeserving) Oriental master. The tedium, solitude, and mutual antipathy of the women, the vigilance of the eunuch guards, and the indifference of the master were among the clichés that reflected the West's eagerness to demonize in its art the North African and Turkish male subject, a useful strategy in countries with serious ambitions in North Africa.[70]

At the height of the craze for Orientalist art in Spanish magazines, one symbol of the Orient became especially prominent: the one woman who stood out beyond all others as the "favorite," the "odalisque," or the slave whose metal adornments fix the eyes more closely on the body's soft skin. The Orientalist artist turns the star harem woman like the one in Figure 7 who is "Huyendo del fastidio" (Escaping from Boredom)[71] into a spectacle of wasted beauty and sensuality seen up close. An "unhappy prisoner" of Moslem society, she is "condemned to life imprisonment, often in a beautiful cage, but a prison nonetheless."[72] She and her ilk fan themselves, fondle

their hookahs, veils, or jewelry, dance with tambourines and scarves, and idly strum lutes and mandolins. Many look out in sexual challenge, not at the men who are identified as their cruel masters, but at their "Occidental" viewers, like Nathaniel Sichel's "Esclava Georgiana" (Georgian Slave) (fig. 8),[73] with her "beautiful dark eyes, curly hair, alabaster skin, and sculpted figure,"[74] or Sichel's similarly posed "La favorita" (The Favorite) (fig. 9).[75] Around the end of the century, Spanish genre artists, emulating the German painter Sichel or the other late Orientalists mentioned above, participated fully in this fetishization of the odalisque. As Lily Litvak notes, the theme was repeated "to the saturation point" in Spanish genre art.[76] Francisco Masriera, Antonio Fabrés, Francisco Beda, José Casado del Alisal, Manuel Castaños exhibited their odalisques to admiring spectators, both at the various art exhibitions in Spain and France and in the pages of magazines, especially those published in Barcelona, in which art images were in great abundance: *Album Salón* (1897–1904), *Ilustración Ibérica* (1883–98), and *Ilustración Artística* (1882–1816). Even laid out on her funeral pyre, Enrique Serra's dead odalisque (fig. 10)[77] could still evince the proper sensual response, to judge from the *Nuestros Grabados* gloss that helped restore her to life at the same time as it reminded readers of the cruelty of her master and the stink of death that emanates from her body:

> While life still stirred in the body of the beautiful harem prisoner, while her coral lips could kiss, willingly or not, her licentious oppressor, while her eyes shone with true currents of lust; while her arms encircled the neck of her master, desirous possibly of strangling him in a jealous or shameful outburst; the beautiful

Fig.7 F. Seymor, "Huyendo del fastidio," *Ilustración Artística* 5 (21 June 1886), 220.

odalisque was the queen of the seraglio and her companions were ever willing to fete her, because she despotically controlled her sultan. But cold death has invaded her body, the rigidity of her cadaver has replaced the voluptuous movements of her limbs, sculpted like those of a statue of Phidius; and here she lies, solitary, abandoned, enveloped in a cloud of incense rising from the censers, not in her honor, but to better disguise the nauseating stench of death. Such is the condition of the Turkish woman, a capricious toy that her master, a spoiled child, disdainfully discards the day it breaks.[78]

That the infidels to the south of Spain were unworthy stewards of their wealth is also a theme that dominated the political discourses at a time when many complained bitterly of Spain's lagging mission to "civilize" the world. Throughout the second half of the nineteenth century, envy of Northern European colonial expansionism was rampant in the press. Spain could no longer finance extramural excursions except on a limited basis. Calls for a regeneration that would reinvigorate Spain's lagging colonialism began long before the 1898 disasters. For an early example, we can cite O'Donnell's much-promoted "African Mission" of 1860, which exacted a great

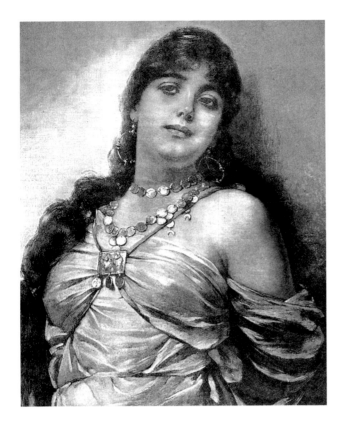

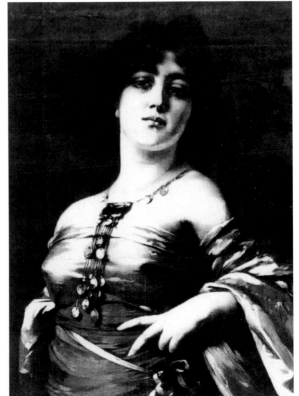

Fig.8 (above) Nathaniel Sichel, "Esclava Georgiana," *Ilustración Española y Americana* 34 (30 June 1890), 409.

Fig.9 (right) Nathaniel Sichel, "La favorita," *Ilustración Española y Americana* 41 (30 April 1897), 264–65.

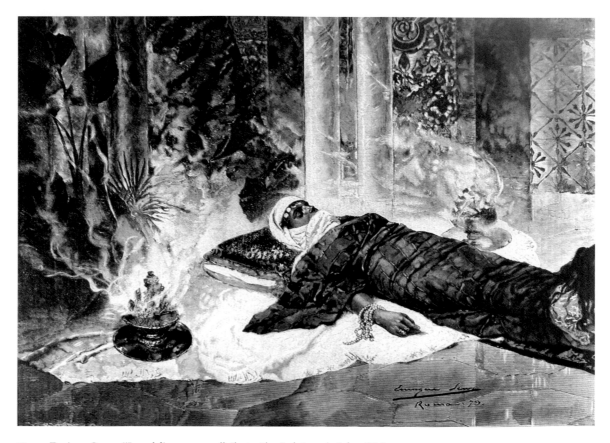

Fig.10 Enrique Serra, "La odalisca muerta," *Ilustración Artística* 1 (3 July 1882), 245.

human toll of 70,000 lives lost, but which many nationalists felt was worth the sacrifice. After conquering Tetuán, General O'Donnell claimed that his army had managed to "raise Spain from its prostration."[79] Two years before the publication of Mariano Barbasán's "Occidente" and "Oriente" sketches, Spain intervened again in Morocco, staging what has been called the War in Melilla that ended in 1894 with the treaty of Marakesh. Finally, just a few months before this image appeared, José Martí gave the order for a rebellion in Cuba, and the Spanish government was gearing up for interventions in the Antilles that would eventually lead to the disastrous War

of 1898 with the United States. The late nineteenth century marks a series of mostly failed attempts on the part of Spain to become a principal player in European expansionism or to hold onto the vestiges of its colonial holdings. It was, in short, far easier to collect magazine images than to collect or hold onto colonies.

Part of the dialectic between Western men and their possessions, the illustrated magazines' thousands of finely wrought exotics are also in dialogue with their modern bourgeois prototype, symbolizing the fundamental interchangeability of women whose accouterments place them in a concrete place, time, and class, with women

who dwelled exclusively in the male exoticist's overwrought imagination. But compared with the feminine portraits and fashion mannequins of overdressed, overcorseted, and self-centered European women that seem to demonstrate the frivolity and performativity of the feminine masquerade in the "Occident," the Orientalist genre portraits offered a different kind of fantastic plenitude and thus revealed a different kind of lack. What was being flaunted was not just femininity; rather, these fetishized portraits suggested something more tangible that transcended the lack presumably inherent in the female body. Through its shoulder- and breast-baring clothing, loosely fitting tunics, transparent veils, and inviting gazes, the exotic female body may have come closer to revealing the terrible secret about feminine physiognomy. More significantly for the purposes of the present study, it comes closer to revealing the loss that Spain, a former world empire, was still mourning. It may also stand as a reference to a past racial diversity that needed to be repressed in order for Spain to continue to constitute itself as a homogeneous nation-state, but that surfaced repeatedly in various cultural forms as a reminder of its own repressed origins. For the psychologist, the feminine masquerade functions naturally to veil female lack, but in a wider reading we could say that when the veils are drawn or partially drawn on the Oriental subject, Spain's lack becomes all the more threatening because more evident. That wondrous and inviting body so obviously displayed does not finally belong to anyone; there is an irrationality about the obsession with exotic images, a clinging to them, which delays a pursuit of the real object of desire. The images are the safe distance from which a satisfaction and wholeness is entertained; like other fetish objects they produce pleasure, but stall any real satisfaction.[80]

Quoting Franz Kafka, Henry Krips observes that "sight does not master the pictures; it is the pictures which master one's sight. They flood the consciousness."[81] It is important to understand this reciprocity when we discuss the mechanics of the gaze. These portraits define viewers as desiring subjects as much as they define exotic women as desirable objects. They stand as testimony to the lack, and a disavowal of the lack, of certain kinds of beauty, wealth, and social interactions that point us back to the spectators and away from the object itself. The evidence of this scopic reversal is rather startling: it is even sometimes contained in the instructions that magazine editors provided viewers about how to consume the images. For example, regarding Ramón Tusquets's "Gitana Argelina" (Argeline Gypsy),[82] published in *Ilustración Ibérica* in 1892, the commentator wrote: "Any man should sit up and take notice of this imposing figure. . . . She possesses a powerful attraction, like those women who captivate you from the first moment you lay eyes on them. She was shown in the Fine Arts Exhibition in Barcelona where she was very popular, as well she should be, because, truth to tell, she is one good looking woman."[83] If you experience no pleasure in the contemplation of this image, the commentator admonishes his male viewers, there must be something wrong with you. This piece of paper should have the same effect as a real woman who captivates you at first sight; in other words, *you,* the (male) reader, are being commandeered to perform a *normal* reaction to the exotic portrait. The enthusiastic editor of *Ilustración Artística,* commenting on the same image published in *Ilustración Artística* a year earlier, called it "Joven argelina" (Young Argeline Woman) (fig. 11)[84] and similarly directed readers to render due homage to the Argeline's perfections: "Regard this handsome face with salient

features, this perfectly curved bust upon which falls in silky curls thick and black long hair, this slender body wrapped in rich, brilliantly colored materials and adorned with rich jewels."[85]

On the other hand, lest their fantasy carry them too far, occasionally the helpful magazine commentator would pull his readers back to earth with a sharp reminder of the real nature of what was materially before them. A two-stanza poem accompanying the portrait of a Gypsy in the short-lived Barcelona magazine *Pluma y Lápiz* (1893) (fig. 12)[86] puts the Gypsy's beauty in its proper light for the "timorous lads" who might mistake reality and representation:

Here is a portrait of a Gypsy
Who even without blinking,
Is able to please
The most timorous lad.
 She, all human weakness
Excuses with her beauty.
But weakness forget not
That it is a portrait . . . and of a Gypsy!

COINS OF THE REALM, THE REALM OF COINS

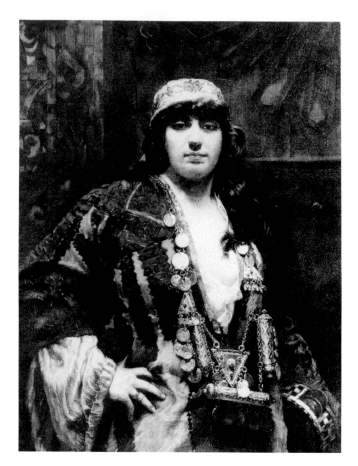

Fig. 11 Ramón Tusquets, "Joven argelina," *Ilustración Ibérica* 10 (29 October 1892), n.p.

Accentuating the beauty of the women in Figures 11 and 12 are the coins and metal cylinders that dangle from their necks to their waists and highlight their breasts; precious objects that came to be associated iconographically with skin and hair. Because of the frequency of these coined figures, one is led to ask in what way the coins evoke money in the modern sense described by Marx, and in what way they are conversely indicative of a pre-industrial, idealized wealth. Marx regarded money as the very embodiment of value rather than as an imaginary symbol of exchange value.

It had become a fetish, the object itself that was adored, a means that had become an end; "[T]he instrumentalized power of command over concrete humans in the form of control over their labor activity through investment decisions."[87] What makes money mysterious, like the commodity, is that men have forgotten that it is only a symbol, a projection, entering into the definite social relations between men. It thus became a commodity that circulated among men, a special commodity not unlike the images of beautiful, exotic women. What happens when women and

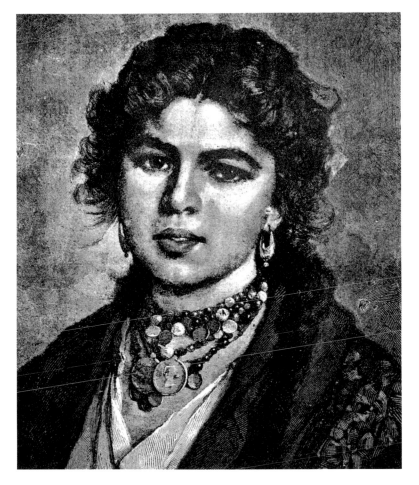

Fig. 12 "Colección de caras bonitas,"
Pluma y Lápiz (1893), 5.

coins and other precious objects are projected together is that the sexual commodification of the exotic woman is linked to the circulating object that had become the supreme embodiment of value that men craved. Women displaying coins in turn were displayed as part of the ethnographic museum with which nineteenth-century cultural anthropologists and genre artists bought their way into the public consciousness. Because of its frequency, this pictorial combination of women and coins reinforces the combined political and sexual dimensions of magazine portraiture.

During their heyday in the 1870s–90s, hundreds of images of women adorned with coins, sometimes literally weighted down with them, appeared in Spanish magazines, especially expensive magazines dedicated to reproducing European as well as Spanish art. Both the coins and the women seem to glow with the double image of roundness, of that desirable though unobtainable "there and not-thereness," and, to borrow the words of Roland Barthes, they "lubricate man's gaze amid his domain."[88] The coins in these images form a symbolic bridge

connecting the viewing subject and the fetishized object—woman—whom they adorn. There are multiple references that can be extracted from the bridge that connects the images of women and their viewers, and perhaps to privilege any one of them is to underestimate the appeal of these images. Together with the hair and breasts they adorn, the coins fall into the zone of the fetish where race, class, and gender overlap. They are not in any simple way a psychological or phallic fetish, since race, ethnicity, and questions of symbolic wealth play such a formative role in their popularity and because they enact and reflect historical and material as well as psychological ambiguity. For example, it was during this period that Spain abandoned de facto the gold standard, and considerable anxiety followed the establishment of a fiduciary monetary system with paper money, silver, notes, and bank deposits replacing gold coinage, which was largely abandoned after 1873 except during times of great crisis.[89] In 1883, around the time these images proliferated, when the rest of Europe had just converted to the gold standard, the gold convertibility of Spanish notes was suspended, and gold coins were becoming rare. The exportation of wine and minerals meant that reliable quantities of gold were flowing into Spain, but foreign transactions that required payments and dividends in gold quickly depleted the reserves. As the conflict in Cuba escalated in the 1890s, foreign investments declined, in part because of worry about the worth of the peseta once it was no longer backed by gold reserves.[90] Not surprisingly, during the final years of the nineteenth century the value of the peseta dropped against the French franc and British sterling, and gold became a much valued object.

What happened to all the gold that disappeared from the market during the last decades of the nineteenth century? If one were to judge by popular magazine images where the symbolism of objects often takes on mythical proportions, it not only fell into the hands of greedy bankers or Semitic-coded hoarders like Ernesto Zimmerman's "Avaro" (The Hoarder) of Figure 13,[91] it also assumed the guise of an ornament worn by exotics from countries whose emerging economies lacked a fixed monetary system, like the Polish artist Franciszek Ejsmond's "Joven Búlgara" (Young Bulgarian) (fig. 14)[92] or his "Joven Rumana" (Young Rumanian) (fig. 15).[93] Coins turn men like Zimmerman's hoarder into a repugnant spectacle: according to the commentator, "[F]ew sins imprint on those who feel dominated by them so accentuated and characteristic a seal as avariciousness."[94] But coins seem to have the opposite effect when associated with women; they highlight their essential primitiveness and exoticism since they are displayed as part of their wealth, while accentuating their beauty in the pleasing juxtaposition of metal and flesh. Ejsmond enhanced his Eastern beauties with a head full of coins and a lap full of the products of nature that attest to the figures' peasant nature but also to the "naturalness" of these objects in relation to women. As a peasant ornament the coins evoke a different system of value that distinguished advanced European commodity value and rural social value. The coins on the bodies of well-endowed peasants, like the corn and cabbages in their arms, also evoke a visible social as well as monetary value. It is not just anyone who wears coins draped about their bodies, but women whose wealth must be worn to be in evidence. But the coins also evoke a bitter reality for the readers of Spanish magazines, one that has little to do with charming female peasants painted by foreign artists. A cartoonist for *Blanco y Negro* explicitly made the connection between precapitalized economies symbolized by women

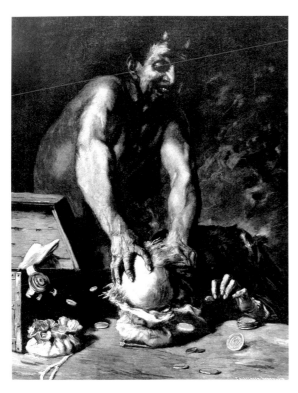

Fig.13 Ernesto Zimmerman, "El avaro," *Ilustración Artística* 16 (8 November 1897), 729.

with coin-draped bodies and Spain's modern financial woes, by depicting Sagasta's Minister of the Treasury Juan Navarro Reverter as a Cantabrian peasant with rings of coins around his neck (fig. 16).[95] Navarro Reverter had just ordered the emergency minting of hundred-peseta gold coins, largely to finance the war effort in Cuba. With such visible evidence of its wealth, asks the commentator, who would dare call Spain poor? "and there are still those who call us poor! Poor? A cornucopia!"[96] Thinking Spain rich because it was minting coins was as ridiculous as judging a peasant woman rich because of the coins she wore around her neck.

Coins like the ones in the image of Navarro Reverter offered sketch artists a shorthand way

to evoke Spain's fiscal problems and to remind readers of the escalating costs of war. Such was also the case in a series of sketches and commentary that appeared on 19 December 1896, shortly after the Spanish Treasury announced the acquisition of a major loan to be financed through Customs and repaid at 5 percent interest within eight years.[97] *Blanco y Negro*'s customary humorous take on the government's fiscal policies for once was replaced by a more serious gloss on events. The Spanish flag was appropriately colored to symbolize gold and blood, pointed out the commentator: "By an ideal coincidence, the Minister of War and the Bank of Spain are face to face, a major recruitment and the 'small' loan occur simultaneously." The result will be that rivers of blood and gold will flow together "in the direction of the war theater."[98] Here instead of a peasant woman's head bedecked in coins like the young Romanian and Bulgarian of Figures 14 and 15, or the parodic figure of Navarro Reverter, the *Blanco y Negro* cartoonist sketched coins superimposed on the heads of soldiers (fig. 17).[99] Although the recruitment of soldiers was costing Spain money and blood, coins and heads, the journalist voiced the collective hope of Spaniards that the ultimate victory would be worth the hefty price: "God grant that the two currents flowing together will produce the explosive mixture that the nation has a right to expect."[100] As was often the case with the centrist *Blanco y Negro,* a visual prompt that questioned governmental decisions was here moderated with patriotic or religious verbal appeals lest it be thought that the magazine was fomenting open resistance to government policies and decisions.

In previous eras, Marx theorized, gold and silver coins, even when serving as money, did not represent a social relation between producers; rather they were natural objects with strange

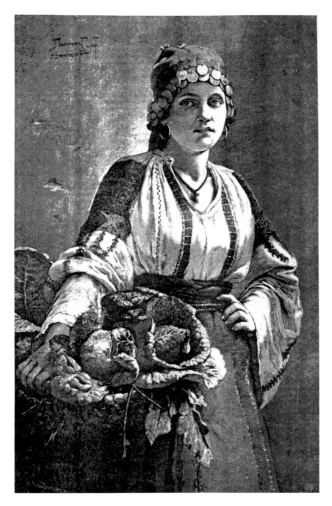

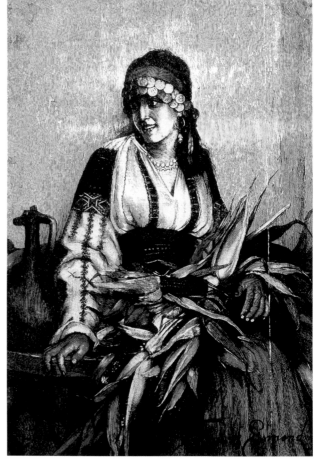

Fig. 14 (above) Franciszek Ejsmond, "Joven Búlgara,"
Ilustración Ibérica 4 (21 August 1886), 529.

Fig. 15 (right) Franciszek Ejsmond, "Joven Rumana,"
Ilustración Ibérica 15 (3 April 1897), 217.

Fig.16 (above) *Blanco y Negro* 7
(27 March 1897), n.p.

Fig.17 (right) *Blanco y Negro* 6
(19 December 1896), n.p.

social properties.[101] The coins in the pictures of exotic ethnic women likewise speak for people for whom the strange social properties of coins are still important; they evoke a different, archaic relation to money compared with that with which viewers were now becoming accustomed. The metallurgical body on display in these images then must be read as part of a historical narrative of cultural difference and diversity, but also of social standing regarding minority and ethnic differences. Beginning with Cervantes' novella "La gitanilla," Gypsies and other imaginary Oriental and exotic figures (Jewesses, Egyptians, Turkish harem women, Circassian women) have often been associated with coins in Western iconography. They flash them on belts, hair, necklaces, bracelets, earrings, and vests as charms and amulets; they seem to be in love with coins.[102] In the nineteenth century, hundreds of images of exotics draped in coins helped to distinguish between primitive and more modern bourgeois value systems; the be-coined women are marked as belonging to a "prior moment in the history of progress."[103] Gypsies and Bedouin especially are depicted in Western cultural productions as quintessential outsiders who carry their possessions on their bodies. They steal them, tell fortunes in exchange for them, put them in their mouths to authenticate their metal content, and hide them in their skirts. The coins, in sum, figure these women as having a conspicuously pre-capitalist relation to wealth that differentiated theirs from the forms of wealth that were being acquired in advanced capitalist societies. Women in advanced societies wear jewels, but not, at least not until recently, money in the form of coins. Fixation on the coined body increased in the nineteenth century, when new forms of capital transfer through stocks and the creation of the modern banking system eliminated coins

for most money transactions except, and this is an important distinction, for the indigent, like Benigna in Galdós's novel *Misericordia,* whose pursuit of coins is famous. The effect was to render coin-bedecked beauties, like those shown here, who were a favorite subject of genre artists, quaint and exotic.

Besides connoting the primitiveness of the subaltern subject's exchange system, which indicates a lack of something else (more modern modes of exchange and capital acquisition and investment), we can also read the coined body as a symbol of plenitude. The woman draped in coins has it all: the coins point to a kind of wealth that complements her beauty, enhancing her marketability. The presence of coins invariably accompanying physically beautiful bodies suggests a link between wealth and beauty, or the value of beauty, not just to the woman who possesses them both, but to the male gazer who measures the woman's value in terms of the wealth displayed on it, as well as of her capacity as an earner of coins. For example, the *Mundo Illustrado*'s graphics editor regarded the "Aldeana válaca" (Balaclavian Villager) of Figure 18[104] by G. Vastagh as a racial type akin to the Gypsy. But, "better" than a Gypsy, it turns out that she is the wife of a hardy peasant who serves in the vicinity as a peat merchant, cheese maker, raiser of livestock, occupations in which he is aided by his robust wife. The commentator goes on to specify that her "fullness" represents a complex series not only of assets but also of someone else's lack: "The marked seal of race impressed on the factions of the beautiful townswoman . . . captivates and attracts the foreigner, similar to the way our Andalusian and Valencian women do, especially for individuals of the phlegmatic Saxon race. It is the Orient that sends to the cold countries of the North its warm breath, minus the effeminacy,

that in Balaclavian women you see replaced by a great robustness, an independence of character, and her ever-volcanic passions."[105] To judge from this commentary, the cultural work of the well-endowed Romanian woman from the Carpathian mountains, after a painting by the Hungarian artist Géza Vastagh, is obviously very complex. Her wholeness points to a lack in the more "phlegmatic" races, while Southern Spanish women (at least if they are not Gypsies whom the commentator points out are inferior) share in her bountiful attractions.

The graphics editor of *Mundo Ilustrado* that same year offered an equally multifaceted and ambiguous interpretation in his comments on Charles Louis Müller's sketch of a "Siriaca" (Syrian) (fig. 19),[106] this time a woman from the Lebanese mountain region of northern Syria, adorned with coins on her forehead, breast, and wrist. Again, in the gloss the emphasis on the engraving is on the subject's inherent primitiveness: like an animal she is agile and robust, "which reminds us of the simple and enchanting grace of the gazelle combined with the strength and dexterity of the tiger."[107] Like her nomad kin, she possesses the primitive beauty of Old Testament women: "marvelous grand women capable of generous and impassioned affections."[108] Syria's traditional agricultural economy, we are informed, is now dependent on cotton, indigo, sugar cane, tobacco, wine, olives, and dates; gone are the arms manufacturers of Damascus, Latakieh, Tripoli, and Beirut. Indirectly the primitive Syrian woman also symbolizes Spain's diminished colonialist enterprises (Italian and French are the linguae francae of the district, notes the editor). The coins are useful in enhancing the woman's beauty since they disguise a physical flaw that the magazine's readers would have known to associate with less favored races:

"an adornment covered with gold and silver coins encircles her forehead, which, as we have said, has the defect of being slightly compressed."[109] Finally, the Syrian's advantage over bourgeois Western women is established by her loose-fitting clothes: "[T]he dress these women wear helps to emphasize their beauty and natural grace, without disfiguring their bodies with a skirt that is too long and bulky, nor do they imprison their breasts in knots of ribbons and bands."[110]

From this commentary it is evident that the symbolic exchange implicit in images and accompanying texts occurs not just between males (whether colonizers or would-be colonizers) and the "exotic" men and women of other nationalities who are depicted in their paintings, engravings, cartoons, descriptions, and even photographs. Rather it sparks a dialogue between artists and the men who made up the largest share of the periodical's reading public. The Orient, as Nissan Perez reminds us, "remained embedded in the private fantasies and imagination of the Westerner"; even photographers "could not free themselves from the mental image they brought with them to the Orient; they forced the hard reality into visual fantasy."[111] Included in the equation, if only indirectly, was the Spanish woman whose traces are to be found behind the enthusiastic portrayal of the exotic other woman, as either a negative or positive complementarity. Her role was to take a lesson from or give one to the *other* woman depicted in the image. For example, the commentator of Sichel's "La Favorita," (The Favorite) (fig. 9 above) describes her as a mere slave to her master's caprice. Her physical beauty "is not animated by the spiritual light of the soul that shines in the eyes of European women who are redeemed and dignified by our Christian civilization."[112] Although, according to this commentator, Western women

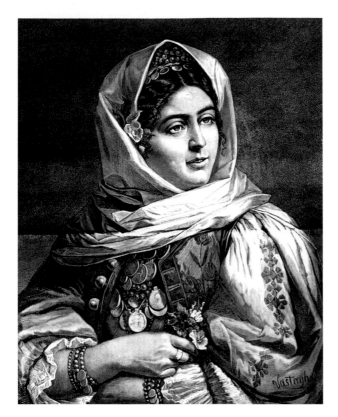

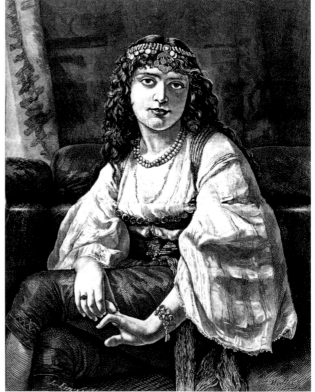

Fig.18 (above) G. Vastagh, "Aldeana válaca," *Mundo Ilustrado* 2 (26 August 1879), n.p.

Fig.19 (right) C. L. Müller, "Siriaca," *Mundo Ilustrado* 2 (1879), n.p.

lack the natural beauty of Eastern women, the Oriental subject is lacking an essential feminine asset—Christianity. The Orientalized subject thus accrues multiple meanings, including sexual meanings, that are displacements of original desires in the sense that, as Lalvani suggests, "what is repressed in the domestic order is displaced onto the body of the Other, so that the Other operates as a the site of specular desire."[113]

Although Edward Said perceptively described the Orient as the female to a male Europe, he was only nominally concerned with the implications of this fact for gender relations within Western cultures; his goal was to study the import of geopolitical expansionism on other cultures rather than the sexual colonization that can occur within a given culture as a result of its obsession with the exotic. His insight that Europe managed to collapse so many cultures into its Orientalist discourse in order to envision its world hegemony should lead to a parallel discussion of the way that Europe's (including Spain's) elites collapsed the female half of the world's population—both Western and non-Western women—into unequal but equally reductionist texts.[114] Both are there to be seen aplenty in the nineteenth-century magazines, the "objects of fetishism but never the subjects," as McClintock puts it.[115] Said noted how the Orient came to represent in Europe's eyes a place for boys and men to fulfill their sexual fantasies, but accepting his statement that Orientalism responds more to the culture that produced it than to its apparent object, we should also conclude that sexual Orientalism in magazine culture is part of a larger discourse that joined Spanish bourgeois women and exotic *other* women in a complex relation of similarity and difference. Western women, that is, the wrong kind of Western women if we read the comments about them the way their authors intended, were

equally obsessed with material wealth, sometimes symbolized by coins. They are products of undue social pressure that shoved them into corsets that disfigured their natural beauty; surrounded by consumer goods, they pursue empty lives of accumulation, collecting men and goods in an endless drive to consume.

This lesson about women's destructive excesses and drives often spilled out of the mainstream magazines directly into the more sparsely illustrated women's magazines that predictably carried the same messages and images warning against Western women's innate lust. The "Danae moderna" (Modern Danae) of Figure 20 that appeared in the satirical magazine *Mundo Femenino* in 1887[116] is captioned "Nobility, the military, the market, diplomacy, everything is converted into gold for her, and she dissipates it with her scandalous luxury." Like this one, most of de la Cerda's sketches for *Mundo Femenino* were unabashedly celebratory of women's love of luxury, personal attentions, clothing, bodily care, and men's fortunes. Surrounded by servants, flowers, laces, and adoring men, these images appealed to women to take their pleasure wherever it was to be found, all the while keeping abreast of the latest Parisian fashions and gossip.[117] The money encircling the modern Danae is not an enhancement to her beauty but a sign of decadence, a validation of Schopenhauer's assessment of female flaws.

The exotic ethnic is the opposite of de la Cerda's greedy creatures in that she exhibits her wealth on her body as part of the definition of who she is, without flaunting her acquisitiveness. Yet the exotic also suggests the intrinsic relation between the natural and the manmade in relation to women; through repetitive juxtaposition, femininity and coins come to seem like a natural amalgamation of assets. While coins and jewels

Fig. 20 "Danae moderna," *Mundo Femenino* 37 (26 June 1887), 4–5.

on the bodies of beautiful women reinforced the link between wealth and beauty, they also suggested that beauty could be purchased with money; beauty and money were co-eval objects both in the display of femininity and the purchase of women, a hard and fast truism that has plagued male-female relations probably since the time coins became symbolically associated with women. But the coins have distinct national as well as sexual connotations. Because they are stereotypically associated with exotic women more than with Western women, they enter into the realm of colonialist discourse in relation to fetishism. As Homi Bhabha has argued, all stereotypes are fetishes in the sense that they reveal a double

play between the archaic affirmation of wholeness and similarity. In terms of the exotic body, the vacillation is between the affirmation that all humans have the same "skin/race/culture," and the anxiety that is associated with the visual evidence that some are lacking that "skin/race/culture."[118] For Bhabha, the stereotype, the scene of fetishism, reveals "the subject's desire for a pure origin that is always threatened by its division."[119] The beautiful woman draped in coins functions as a sign of otherness: though her face often seems to reflect Western standards of beauty ("skin/race/culture" are disavowed and Western norms of beauty advanced), the coins and dress made her difference perceptible. At the same time, they facilitated an embrace of that difference. In the insistence of these portraits on the manifest value of the woman's body, they entered into what Bhabha calls the "bind of knowledge and fantasy, power and pleasure, that informs the particular regime of visibility deployed in colonial discourse."[120] In other words, they dramatized the difference of minority populations and foreign cultures and those "phlegmatic" races of the North. What is ironic is that the exotic beautiful women pictured in magazines were an artistic convention highly allergic to mimesis, veiling women in mystery and adornments that made them resemble shiny collectible things that the Spanish bourgeoisie was eager to collect. And the more fantastic they appeared to be, the more real, in contrast, the solemn male figures that surrounded them in the magazine's other graphics seemed.

In conclusion, like all fetishes the coins in these images are ambiguous and contradictory in many ways. In the case of coin-decorated peasant bodies, they represent a form of ostentatious wealth, one that signaled a feudal monetary system. Yet theirs is not a wealth that counted as

such among the wealthiest classes of consumers, whose gold was mostly invested in new enterprises or locked away in vaults in newly formed banks and whose women displayed their wealth in other ways rather than by wearing coins around their necks. The coins draped on ethnic beauties, harem women, and odalisques serve to highlight beautiful, soft flesh even though the coins themselves are made of a hard metal substance. They advertise the value of the owner, even if the women who wear them were really only "owned" by the creators, distributors, or consumers of the image. They are, as mentioned above, a sign of possession at the same time that they also "possess" consumers, revealing their hidden desires and anxieties. They accompany other trinkets and female adornments that seem to demonstrate the capriciousness and willful display of primitive peoples who worship objects, but as engraved paper images they more accurately make up one of the "trinkets" that the wealthy collected for their private use. Although pictorially they evoked ageless peoples for whom time and progress are static, they also attest to a pastime associated with modern life, that is, a fascination with images of charming peoples who take pleasure in wearing their wealth on their clothes and bodies.

The repetition of hundreds of images such as those studied in this chapter participated in the Spanish colonialist fantasy in equally ambiguous ways. As productions of the Northern European artistic imagination, they reflected the colonialist fantasies of nations seeking to expand their influence and empire in Africa, Asia, and the Middle East. On the other hand, as reproductions purchased from other Northern European print manufacturers for recycling in Spanish magazines, they reveal an abiding admiration for an artistic production of images whose refinement had not reached the same level of expertise in Spain. They became popular in the Spanish bourgeois press, however, not just because they were a refined, easily importable product. The content of the images spoke indirectly to the colonial fantasies that were still very much alive in late nineteenth-century Spain despite its lagging economy, something that is clear both from the commentaries written about the images and from the many magazine and newspaper editorials regarding the need for Spanish regeneration. At the same time, finally, they represent the hyper-refined vestiges of a dying art convention: the quality art engraving in Spanish magazines would soon give way to the photograph as the visual of choice, and would be relegated to the art book or the specialized magazine collection. The following chapters examine the consequences of this radical change in technology and magazine graphic content as large-format magazines like *Ilustración Artística* and *Ilustración Española y Americana* were forced to compete with more modest and populist magazines.

Two

FROM ENGRAVING TO PHOTOENGRAVING: CROSS–CUT TECHNOLOGIES

> The relation between engraving and photographic image in the informative arena would be at first one of subordination of the photographic to what is the real channel of the massive diffusion of images, since photographic images that would be abundantly used to make engravings necessarily would be translated to the graphic codes imposed on the wood engraving, and, only well advanced in the 19th century, will we see a slow emancipation of the photograph and the creation of its own autonomous language.
>
> —BERNARDO RIEGO, *La construcción social de la realidad a través de la fotografía y el grabado informativo en la España del siglo XIX, 139*

> The introduction of photography in the nineteenth century, and the visual ordering of the public domain which it had engendered, signaled an intensification and heightened functioning of the instrumentalities of vision.
>
> —SUREN LALVANI, *Photography, Vision, and the Production of Modern Bodies, 167*

> Every photograph is a certificate of presence.
>
> —ROLAND BARTHES, *Camera Lucida, 87*

THE INTRODUCTION OF photomechanical technologies for the direct transfer of information for use in illustrated magazines was transformative, easing the transition in the late nineteenth century from limited-run magazines like the ones studied in Chapter 1, which catered largely to the monied classes, to mass-produced twentieth-century periodicals targeting a much wider, middle-class readership. The radical nature of this transformation is obvious when one compares two of Madrid's most popular (in terms of circulation) weekly periodicals during roughly the thirty-year period from 1880 to 1910, a period that marks the heyday of Spanish illustrated weeklies, when the specialized handcraft trade of engraving gave way to a vast industrial enterprise dependent primarily on process halftone images.[1] The first and most traditional magazine started as *El Museo Universal* in 1857 and ran until 1869 when it folded into Abelardo de Carlos's large-format, bi-weekly, *La Ilustración Española y Americana,* the most lavish and prestigious Spanish illustrated magazine of the nineteenth century, which itself ceased publication in 1921.[2] The second is Torcuato Luca de Tena's more affordable, medium-format magazine *Blanco y Negro,*

which debuted in 1891 and ran until 1936, when it became a Sunday supplement to the *ABC* newspaper; thus the first series of this magazine outlasted the *Ilustración Española y Americana* by fifteen years.[3] Some of the issues discussed in this chapter that are pertinent to this comparison are technical, while others involve conjectures regarding the impact of printing modes on artistic expression: the date of the first images influenced by photography and the technology used to reproduce them; the impact of photography on the engraving workforce prior to and following the invention of photomechanical reproduction; the ideational content of the first images produced after photographs; the novel compositional techniques that distinguished photographs from engravings; the printed quality of the first photomechanically reproduced halftone images vis-à-vis those of line engravings, which continued to be published alongside them for several decades; editorial comments about new photo technologies; the explosion of photographic reportage in the 1890s; and the reasons for the eventual eclipse of the large-format illustrated weeklies. Because of the dearth of reliable information regarding the specific mechanical procedures employed in magazine image production, answering some of these questions is complicated, but a study of the impact of photography on an industry and its consumers is incomplete without at least an attempt to understand the underlying technology and its impact on image content.

By the middle of the nineteenth century, before either of the two periodicals mentioned above had appeared, the engraved image was already the designatory value of the illustrated magazine. Photography was looming on the horizon, and by century's end its various applications would all but replace traditional hand-engraving techniques in the more innovative magazines. It must be recognized, however, that the popularity of illustrated magazines predates the use of photography in conjunction with the printing press. Part of the reason was that improved processes for mechanical printing were by then allowing magazines to increase the rate of image production even without the aid of photography. But it was not just that improved technology and new relations of production increased the productivity of images; the demand for images was fueling improved procedures for transferring images in magazine formats, a fact that also must be stressed when assessing the impact of technology on image production. Already in 1850, long before any photographic processes were involved in the printing industry in Spain, Ángel Fernández de los Ríos, in his newly launched magazine *Ilustración,* boasted that its pages would be replete with engravings that would be the envy of readers of daily political periodicals, who at year's end would be left with nothing in return for the money they had spent. In other words, Fernández de los Ríos understood that magazines that combined print and art images would be ideal for collecting and binding because their images had enduring value, while newspapers were worthless pieces of paper once their news was digested. A visit to any antique stop today will demonstrate that De los Ríos's prediction that consumers would want to collect printed images was a stroke of genius. The problem was how to produce enough images at an affordable price to satisfy the demand not just for the images but for profits. This desire to increase the quantity of images inspired a host of technicians and inventors to seek ways to improve the speed and production of paper images, which contributed to the fevered quest to use photographic technology in the production process during the period of the Restoration.

Magazine illustrations like those of the mid-century *Ilustración* were few and costly, largely the product of printing from hand-engraved blocks of wood or hand-etched steel or copper plates; this made them a worthy object to collect but only for those who could afford this new pastime. It was to this class of consumers that Fernández de los Ríos made his appeal, optimistically expecting they would want to compound the pleasure of collecting images by subscribing to more than one magazine published by his press. Those who opted for the magazine's package subscription rate, which included *Ilustración* (1849–57), *Novedades* (1850–58), *Semanario Pintoresco Español* (1836–57), and the Second Series of the *Biblioteca Universal* (a collection of edited books that Fernández de los Ríos founded), would have altogether at the end of the year "200 volumes of permanent interest and 1,300 engravings new to Spain."[4] On an average, then, each volume would contain only six or seven art engravings, a rather paltry number compared with the hundreds of full-page engraved images included in any single volume of *Ilustración Española y Americana* by 1890, but still a significant number when compared with what was available during the eighteenth century or the decades prior to the mid-nineteenth century.

Between 1865 and 1905, an era that Estelle Jussim dubbed "The Forty Years War of the Media,"[5] photographic technologies would come to dominate all nonphotographic processes for the transfer of visual information in industrialized Europe and in the United States, but the application of these processes in Spain was slow-paced, complicated by financial as well as technological impediments. In Spain the first successful photographs, in the form of direct-positive Daguerreotypes on iodized silver plates, were produced in 1839.[6] Because of the time it took to expose the plates, up to 90 minutes in the beginning, the first images typically were of buildings and other stationary objects and were executed by scientists and other intellectuals. Early practitioners regarded themselves as experimenters and did not conceive of becoming professional photographers, even though experts now often praise their work for both its technological and its aesthetic qualities. The main concern of the earliest photographic experimenters was with fidelity to the original, the latest technological advances in photograph techniques (especially ways to improve emulsions and reduce exposure times), and the potential scientific and social applications of the new medium, rather than with its aesthetic properties and potential. Their photographs, in short, were undertaken "in a spirit of documentation and investigation"[7] without a great concern for aesthetic properties. The operative assumption at the time was that photography could not be art because the element of imagination was foreign to its execution.

Still, very quickly after its introduction, the Daguerreotype was making a splash in urban centers, where newspapers began advertising equipment and Daguerreotype services already by the 1840s.[8] Because in the early decades of photography the development processes were cumbersome, photography outside the studio or laboratory was impractical and consequently limited.[9] Field photography became feasible only once Daguerreotypes were replaced by wet collodian emulsifiers in the 1850s, a development process that permitted shorter exposure times and inaugurated modern photojournalism.[10] At first most of the professional photographers who worked in Spain were foreigners casting about for the last vestiges of a "romantic Spain,"[11] like the British photographer R. P. Napper, who traveled around Spain shooting architectural and natural scenery.

In the beginning these field photographers lacked an extensive market for their product, since procedures had not yet been refined to the point of producing mass quantities of their photographs, and since photoengraving was not yet widely available for use in the printing industry. Nevertheless, they represented the earliest vanguard of photo-illustrators and later photojournalists, who eventually scoured the world to shoot exotic scenes and world events, which they sold to those magazines with the foresight to recognize their utility as "objective" representations of reality. The magazines' professional artist-draftsmen then hand-copied the photographs according to conventions suitable for whatever engraving process they were intended. The resulting illustrations were next used by technicians to engrave blocks or etch plates according to one of several engraving techniques. Finally, the magazines' pressmen would insert the inked blocks or plates in a press and mechanically print the images.

With such a complex series of steps for the transfer of photographic information to print, the end result would in no way represent a faithful copy of the photographer's original subject and even less so the three-dimensional scene or object of which the photograph was taken.[12] One of the striking results of the final engraving, in fact, was the expansion and often exaggeration of certain forms and phenomena that might strike a note with readers seeking the novelty of the photograph but accustomed to harmonious artistic compositions. Not only would the early field photographer seek and pose the most unusual sites and figures to ensure viewer interest in the world at large; artist-draftsmen and engravers would sometimes further tamper with the photographed subject in response to the century's drive to distinguish and classify the world and enhance its most hidden wonders or to strengthen the thematic interest of the shot. The transfer of information from the photograph to paper also reflected the artist-draftsmen's (and engravers') parochial training in the conventional hand-engraving techniques that had been in use for hundreds of years. The photograph in the beginning, then, was, strictly speaking, an intermediary between an object (a tree, person, painting, or building) and the illustrator-draftsman who copied the photograph in an appropriate medium, while the engraver, the person who prepared the actual plate for pressing, was the necessary intermediary between the draftsman's sketch and the final paper image.

As improved technology reduced exposure times from minutes to seconds, photographic portraiture in a studio setting became the rage in Spain as elsewhere in Europe. Photography very quickly promised a new way of knowing not just the exotic corners of the world, but everyday city scenes and inhabitants, and ever larger numbers of people desired to expand their vision of their immediate surroundings by filtering them through the photograph that could be purchased and collected in albums. The result was the rapid expansion, what many regard as the democratization, of the local image within a very short span.[13] This success was owing not just to the apparent fidelity of photographic images but to what can be regarded as the "pleasures of the visual" in an age imbued with a "liberal faith in the idea of progress"[14] that, as we saw above, inspired Eugenio Sellés' enthusiasm for the magazine image. A fevered quest for the unusual coincided with an equally ardent quest to capture the mundane, and both impulses drove the industry to expand the line of products available to the general public. By the 1860s, in addition to individual portraits, well-to-do clients could purchase albums of household scenes, fine art, buildings,

monuments, and regional types from the photo studios that sprang up in the major urban centers of Madrid, Barcelona, and Seville. Although their number cannot compare with those in France and England, by 1863 there were thirty-nine photography studios operating in Spain.[15] The most popular products of these establishments included miniatures, stereographs, portraits suitable for albums and framing, and *cartes de visite,* which were visual reminders of a caller's identity fixed on a cardboard surface.[16] While the market for these items was limited, owing to the relatively small numbers of Spaniards as yet able to afford this luxury, they represent the first mass-produced photo images prior to the use of photography in newspapers and magazines.

Photographers working in studio settings consciously or unconsciously emulated artists, posing their subjects according to the conventions of portrait painting and fine art engraving, not surprising since some of the early photographers were themselves former miniaturists and sketch artists.[17] As Roland Barthes put it, painting is the "paternal Reference," the "ghost" that haunts even the modern photograph that shares its tendency toward "pictorialism" with the painting.[18] Photography studios were filled with props that often imitated a bourgeois drawing room, with drapes and columns, or a romantic promenade with elegant balustrades, porticos, pillars, and bowers. The photographers were not so much attempting to picture their subjects in surroundings that reflected their individual personalities as they were responding to cultural norms for individual portraits.[19] People of means flocked to studios not only to have photographs of themselves taken in these stately, if artificial, settings but to peruse or purchase images of famous actors, bullfighters, and royalty. Those without the means to commission their own

portraits or to purchase images of cultural icons could still gape at the windows where albums and portraits were on revolving display. These surrogate photo-consumers formed part of the increasing numbers of middle-class subscribers to illustrated publications, and they expected portraits after photographs, that is, engravings drawn from photographs, to be prominently featured in their weekly magazines. It was during this time that showcase-gazing became the special pleasure of urban populations seeking free entertainment, and the photography studio obliged by providing a rare, up-close look at the Spain's wealthiest and most illustrious citizens, as well as its most beautiful women. José Roure's story "En el portal del fotógrafo" (In the Photographer's Shop Window; *Blanco y Negro,* 1894)[20] already makes sport of this social convention. The showcase (fig. 21) displayed the city's most beautiful women, the narrator reported, since "the photographer never displays in his gallery the portrait of an ugly woman, just as the grocer never displays on his counter a damaged ham, even if his store is filled with damaged hams."[21] Thus it was that photography sold beauty as well as the idea of accuracy, and once beauty was for sale in this exciting new medium, few with the means could resist its temptations.

Even before Roure's story, the photograph was already such a mundane feature of the urban landscape that its conventions had come to be trivialized in the press. Beginning in the 1860s, dozens of articles had already pointed out the banality and idealization of the circulating portraits.[22] One of the characters in Roure's story complains that all the faces on display in the studio windows exhibit the same forced smile imposed on them by the photographer: "The photographer says to each of his clients 'Smile!' and everyone smiles the same way. And why?

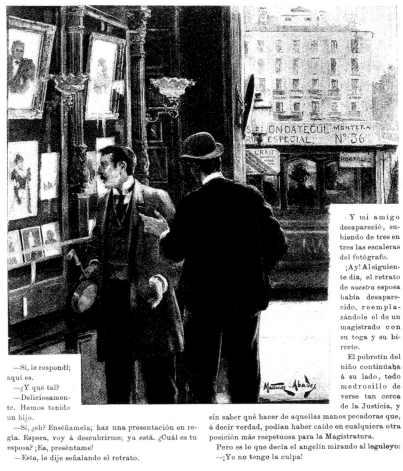

—Sí, le respondí; aquí es.

—¿Y qué tal?

—Deliciosamente. Hemos tenido un hijo.

—Sí, ¿eh? Enséñamela; haz una presentación en regla. Espera, voy á descubrirme; ya está. ¿Cuál es tu esposa? ¡Ea, preséntame!

—Esta, le dije señalando el retrato.

—Y mi amigo desapareció, subiendo de tres en tres las escaleras del fotógrafo.

¡Ay! Al siguiente día, el retrato de *nuestra* esposa había desaparecido, reemplazándole el de un magistrado con su toga y su birrete.

El pobretín del niño continuaba á su lado, todo medrosillo de verse tan cerca de la Justicia, y sin saber qué hacer de aquellas manos pecadoras que, á decir verdad, podían haber caído en cualquiera otra posición más respetuosa para la Magistratura.

Pero es lo que decía el angelín mirando al *leguleyo:*

—¡Yo no tengo la culpa!

José DE ROURE

Fíg. 21 Martínez Abades, "En el portal del fotógrafo," *Blanco y Negro* 4 (3 November 1894), 695–97.

Well, it's simple: because they're all thinking: 'How great I'm going to look!' and, confound it! the smile of human stupidity has only one form: that which appears in the portraits."[23] Roure's story documents the significance of the photograph both as a private family document and as an object that was exhibited in studio window cases for any and all to see, as well as in the hundreds of weekly magazines dotted with images after photographs. In other words, already by the 1890s the photograph had lost its novelty status through repetition and banality. With their predictable poses and forced smiles, photographs mark what Walter Benjamin described as the trivialization of the form, the loss of the "melancholic aura," or the one-of-a-kind "magical value"[24] of the first photographs before the era of photomechanical reproductions. The complaint of Roure's character that all the photographed faces had something artificial about them indicates also that, within a

very short time, the photograph was recognized as a sort of visual sleight of hand, manipulating reality for certain desirable effects intended to satisfy the vanity of purchasers.

Photography had not lost its novelty, however, as a tool in the production of magazine images; in fact it was just hitting its stride when Roure's story was published. Ever since photography was invented, magazine editors and book publishers dreamed of being able to apply a photographic transfer process in the mass printing of images, but the two technologies, photography as practiced in private studios or in the field with a camera, and the mechanical reproduction of images and text together, were not at first compatible. While photography held out the promise of the complete mechanization of visual information, "it could not itself be visually mechanized."[25] Until late in the century in Spain, there was no way to capture an image of the three-dimensional world and transform it into a printable surface suitable for magazines and newspapers.[26] With the exception of a few tentative experiments, the first serious photoengravings did not appear in a magazine until 1885, when the *Ilustración de Barcelona* published a process image by the photographer Heribert Mariezcurrena.[27] So, despite the fact that already by the 1860s the photograph had become a familiar urban artifact, its application in the printing press was limited by technical obstacles until the last decade of the century.

THE SEARCH FOR A PHOTOMECHANICAL PRINTING PROCESS

There are hundreds of different methods for the serial printing of images, but they fall into three basic categories according to the method for getting ink to paper: relief printing (in which

the ink is printed from raised surfaces), grooved or intaglio printing (in which a plate is etched, inked in its grooves, and then pressed), and planography or lithography (in which the ink is lifted from a flat surface, usually a stone).[28] All three methods predated photography and required an army of craftsmen, technicians, and artists in order to transfer an image to paper, and all three were in use in the magazine industry in different ways. The challenge was to adapt the new photographic technology to these processes in order to imprint images directly onto woodblocks, stones, or metal plates, which could then be prepared for mass printing subject to less manual intervention. Once this step was accomplished, the role of the artist-draftsman could be eliminated (or at least reduced) in the transfer process; eventually even the role of the hand engraver was eliminated. Before the invention of halftone screening, the hand engraver would have manually rendered a draftsman's creation on blocks by using a graver, or on plates by using various tools like the burin (the engraver's wedged-shaped cutting tool) or materials such as acid, to cut into the surface and create the necessary printing matrix or plate. The kind of relief printing known as xylography (black- or white-line woodcuts) was the method most commonly used in the early illustrated magazines such as *Museo de las Familias* and *Museo Universal*. It was not until the last decades of the nineteenth century that photomechanical reproduction, achieved through heliogravure (the combining of intaglio or lithographic printing and photography), and the new halftone processes (that mechanically produced a relief image on metal plates) became commonplace in the illustrated magazine in Spain.[29] However, as we shall see, the impact of photography was felt in the illustrated press long before the procedure known as

process halftone engraving completely replaced other engraving techniques.[30] Even after the halftone process became the technology of choice for use in the weekly press, engravers were still often employed in the preparation of plates; they found a special role as finishers of photomechanically produced plates that, untouched, were not always suited to the printing press without further manipulation.[31]

At first when the highly specialized enterprise of mechanical engraving and the equally complex field of emerging photography began to interface, it was only to share image content, not technological procedures. That is, photographs often imitated art engravings, while magazine engravings labeled as drawn and then engraved "from" photographs became an important feature of the illustrated press beginning in mid-century. It is no accident that around the same time that field photography became professionalized, in the 1850s and 60s, the first mass-distributed illustrated magazines began to appear in Europe and the United States: in Great Britain, *The Illustrated London News* (1842), in France *L'Illustration* (1843), and in the United States *Harpers Weekly* (1857). The instant success of these magazines was owing largely to improved engraving techniques that permitted wide circulation, not, as mentioned above, to the application of halftone photoengraving, and yet the photograph was from the start an important element in their production. The use of photographs, even in an indirect way as an intermediate image, lent illustrated magazines a contemporary feel and made the job of engravers and sketchers easier, thus saving publishers time and money. In Spain, too, photography became in a sense a shortcut to art. Original artwork no longer had to be delivered to the workshop in order to be sketched by the draftsman: a photo of an original would do just as

well. The artist-draftsman no longer was required to travel to a museum, a studio, or the field in order to execute an image; he could sit at his desk and work, with controlled lighting conditions, from a photograph that was startling in its detail. His knowledge of perspective and composition could be scant as long as he was a skilled copier and knew how to produce a drawing that would be suitable for the next step. This was the work of an equally skilled technician-engraver whose job it was to transfer the illustration to a block or plate.

The intermediate photo, then, was a time- and money-saving device for draftsmen and hand engravers long before photographic technology was advanced enough to compete directly with conventional engraving procedures. In Spain the method of choice for producing print and image together from 1850 to 1890 was either xylographic (an engraved woodblock that would be combined with moveable type and inserted in a large frame, where block and type were pressed together) or intaglio (images lifted from a metal plate whose grooves had been produced with instruments or chemicals or by an electrolysis process).[32] Owing to their precarious funding and limited technological expertise, Spanish printing houses could not produce enough printing plates and blocks to satisfy an apparently insatiable demand for large-format line engravings. As a result, many of the finest images in the pages of the *Ilustración Española y Americana* and other similar illustrated magazines were imported from abroad; these images were signed by engravers such as Stéfane Pannemaker, who had developed a process for projecting an image on woodblocks, or by Richard Bong of Berlin, among many others.[33] This fact restricted the number of prints engraved after Spanish artists and lent the magazine an international as well as a national

character, something many editors and presumably readers also regarded as desirable or at least reasonable. By importing hundreds of such plates from abroad, *Ilustración Española y Americana* could keep its workforce at a minimum and still fill its pages with high-quality engravings at a price that was relatively inexpensive.[34]

Even though in the early years of the *Ilustración Española y Americana,* from 1857 to 1869, when it was still published under the name *Museo Universal,* the usefulness of photography was with rare exceptions limited to its secondary role as intermediate image as described above, magazine editors took an avid interest in the new photo techniques, understanding their revolutionary potential, especially for the sciences.[35] This followed a long tradition in the press of enthusiastic descriptions of the Daguerreotype, which speculated on its possible applications and sacralized it as the very symbol of modernity.[36] In August 1858 Felipe Picatoste y Rodríguez offered readers a biography of Daguerre, praising his 1822 diorama[37] in Paris and summarizing the current scientific and medical uses of the new technology: "Few discoveries have made such a vivid impression on the public as did the Daguerreotype. Lovers of science and the marvelous have never experienced such great excitement as that which resulted from the admirable invention by means of which any objects placed before our eyes can be reproduced in their most minute details."[38] Combined with the microscope, the new technology could probe what was thought to be the smallest biological components of living creatures.

Picatoste also reviewed the status of an important new invention that was just beginning to be coupled with photography to produce what were called stereographs, one of the most significant ways that the general public was coming in contact with photography.[39] Originally considered a scientific instrument, the stereoscope was commercialized in the 1850s and 1860s and transformed into a popular amusement, a kind of parlor entertainment that widened viewers' horizons with "instances of imperial display."[40] Picatoste marveled at the fact that images collected recently in Egypt and Palestine could be projected on a stereoscope, creating the impression of three-dimensionality. This was one of the most exciting photographic applications of all time, not only because it rendered images three-dimensionally, but because the stereoscope could be owned by private individuals.[41] Equipped with this relatively inexpensive contraption, private individuals could intimately participate in the colonialist enterprises of England and France and would thus no longer be reliant solely on the fantasies of genre painters like the ones studied in Chapter 1. With a note of envy Picatoste reported that the illustrated magazines of Paris and London were already offering these "stereoscopic photographs" as a bonus to their subscribers who owned stereoscopes.[42]

Although Picatoste understood photography's enormous potential—"Who knows where it still will lead us?" he wondered—he did not conjecture at the time that it would invade the world of mechanical reproduction as well as that of print journalism. Print and photography were for him consigned to separate domains, the former important to the realm of ideas and the latter an appeal to the sense and pleasures of sight. Still he understood that the invention of photography was giving a permanence to life that could now be "fixed" on paper, just as the press had "fixed" ideas on paper in an earlier age: "[P]rinting managed to fix ideas: the Daguerreotype will give permanence to anything that falls beneath the inspection of the most important of the senses."[43] What Picatoste understood, then, was the future

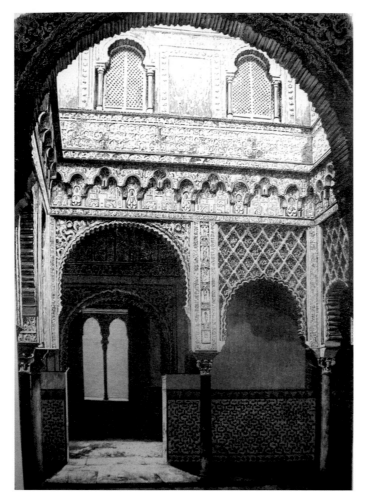

Fig. 22 "Patio de las Muñecas," *Museo Universa* 2 (15 August 1858), 117.

prominence of the regime of the visual as a form of progress, since it involved sight, the most "important" of the senses, as magazine subscribers were beginning to discover and generally to believe to be a transparent and unmediated representation of the world.[44]

Even as Picatoste was writing ecstatically about the future of photographic technology, dreaming of an objective relationship between the exterior world and the photographic

representation of that world, the photo was making its first visual appearance in magazines, not, as pointed out above, as an actual photograph but as an engraving produced after a photographic image in a multistep procedure. In the same year as his article, 1858, *Museo Universal* announced the collaboration of Charles Clifford, one of Queen Isabel's favorite photographers, in its pages. Clifford, along with other professional photographers like Jean Laurent, who started as

Clifford's assistant, or with graphic chroniclers like Juan Comba later in the 1860s and 70s after Clifford's death, would supply the magazine with hundreds of photographs that they and their collaborators had shot all over Spain. They were responding to the vogue for photo albums of local types, typography, and constructions, which were popular at the time.[45] From 1860 to 1880 most engravings listed in magazine captions as taken "after a photograph" did not differ radically from engravings of original sketches by artists working from nature. For example, a well-executed 1858 image in *Museo Universal,* showing the Patio de las Muñecas in the Seville Alcázar, according to the caption, was taken after a photograph by Pizarro (fig. 22).[46] The angles and perspective of the upper portions of the image, which in a traditional sketch would likely have displayed a different linear perspective, mark the image as sketched from a photograph. But since at the time the light source was usually restricted to available sunlight, the illustrator or the engraver has likely added detail to the inner rooms off the patio that would have been obscured in shadow in the original photograph. A sketch of a human subject demonstrates this practice more clearly. Figure 23 shows a very heroic General Prim, described as drawn from a photograph that appeared in 1860.[47] The draftsman who copied the photograph unmistakably took liberties with the original photograph, both in the foreground and background renderings and in the cross-hatched shadings, as well as in the figures of the horse and Prim himself, both of which are rather clumsily rendered. In cases such as this, rather than seeking fidelity, draftsmen and engravers used the photograph as a guide that, in their skilled (or, as in this case, not so skilled) hands, could be transformed into a more artistic, and sometimes more heroic, composition. The

Fig. 23 "El General Prim," *Museo Universal* 4 (5 February 1860), 18.

engraver working from a photograph aimed for a "clarification or *cleansing* of the scene to make its contents more *legible.* Elements of visual confusion that could cause impediments to the comprehension of the informative message are absent."[48]

It is also the case, however, that by the 1870s, the photograph originals that paid photographers and freelancers were supplying to magazines were beginning to have an impact both on engraving technique and on the subject matter of engravings. By then some illustrators, in an implied acknowledgment of the popularity of a technology that would eventually cost many of them their livelihood, were striving to make

Fig. 24 (above) Jean Laurent, "Grupo de gitanos,"
Coustumes et Coutumes d'Espagne: Études d'après Nature.
(17–35–75, Biblioteca Nacional [Madrid])

Fig. 25 (right) (After a photograph by Jean Laurent),
"Habitantes de la provincia de Segovia," *Ilustración Espa-
ñola y Americana* 24 (20 January 1880), 48.

their facsimile sketches resemble photographs more exactly, and this implied a radical departure in the deployment of shadow and detail. A side-by-side comparison of an original photograph entitled "Bohémiens ou gitanos" (Bohemians or Gypsies) by Jean Laurent, from his 1872 collection shot in situ and entitled *Coustumes et Coutumes d'Espagne: Études d'après Nature* (Customs and Costumes of Spain. Studies after Nature) (fig. 24)[49] and an engraving "after a photo" by the Laurent Studios titled "Habitantes de la provincia de Segovia" (Inhabitants of the Province of Segovia) (fig. 25), which appeared in the *Ilustración Española y Americana* in 1880, demonstrates this influence.[50] Compared with the photograph, the sketch is highly stylized: the draftsman (or the engraver) has reduced and softened the background and accentuated details in the figures' dress. Nevertheless, he has also conscientiously reproduced the subjects' squinting eyes, the deep shadows on both faces, and the woman's right foot and has included a number of background shadows, which a sketcher working from an oil painting or from nature would not likely have included since they have no visible referent. The aim, then, was to lend the final engraving the same feeling of "d'après nature," a "you are there" technique of which Laurent was understandably proud, even if, as Lee Fontanella points out, he typically sought to imitate the fine-line sketch in his photographic compositions.[51]

If the draftsman working with photographs originating from the Laurent Studios was very skilled, the angle of lighting, copied exactly, would produce a very photograph-like image, such as the compelling engraving of "Unas segadoras en la campiña de Córdoba" (Reapers from the Córdoba Countryside) (fig. 26).[52] On the other hand, adherents to more traditional xylographic engraving techniques would be more likely to interpret the photograph by using classical draftsmanship, as in the case of Figure 27, an engraved sketch entitled "Provincia de León: Maragatos del partido de Astorga" (The Province of Leon: Margaratería Inhabitants from the Astorga Region).[53] In the latter image, the illustrator has conventionally rendered the background with cross-hatched shadows. Viewers are drawn to what, for city dwellers, would constitute the subjects' most unusual accouterments: the woman's large medallions on her bodice and dress and her plaid headscarf and the man's belt and billowing pants. In short, "Reapers from the Córdoba Countryside" is aiming to convince us that we are looking at an event that actually took place and that was shot by a photographer in the field, while "Maragatos" is a reminder that images, even those that started out as photographs, are the work of skilled craftsmen knowledgeable in the subjective codes of engraving.

More startling than this cross-fertilization of engraving and photograph are examples in which draftsmen attempted to emulate photography even when working from fine-line sketches not drawn from photographs. For example, Figure 28, an engraving taken from a pencil sketch by Alphonse Legros, entitled "La pequeña María" (Little Maria),[54] is a combination of broken lines and dots evoking a rather haunting immediacy, when compared with the more commonplace portrait engravings of fictional characters whose soft lines and shadows were the norm in most images published that same year.[55] The stippled effect of María's face was achieved most likely through a lithographic process, and photography was probably not involved in the end product. Both Legros and his engravers, it seems, were consciously aiming to make María startle viewers with the kind of penetrating gaze evocative of the close-range photograph that would produce

Fig. 26 "Unas segadoras en la campiña de Córdoba," *Ilustración Española y Americana* 20 (15 July 1876), 24.

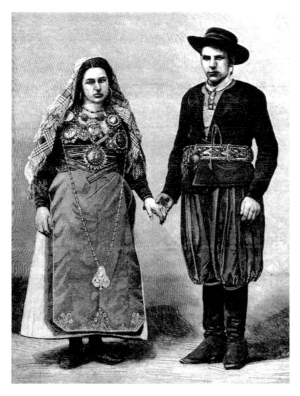

Fig. 27 (After a photograph by Jean Laurent), "Provincia de León: Maragatos del partido de Astorga," *Ilustración Española y Americana* 42 (15 November 1897), 304.

Fig. 28 (Facsimile of sketch by M Alphonse Legros), "La pequeña María," *Ilustración Española y Americana* 21 (30 January 1877), 69.

a sense of immediacy and three-dimensionality. In short, the technology was traditional, but the resulting image was a challenge to conventional engravings both because of its original content and because of the technique used to interpret the original subject.

Numerically the most ubiquitous images of the *Museo Universal* magazine in its early years were not portraits, but engravings of a large-scale, manmade object, following the convention of printed papers before the latter decades of the nineteenth century. Altogether Volume 2, 1858, of *Museo Universal* contained forty images of bridges, ships, aqueducts, dams, ruins, and railroads, surpassing all other categories of images

such as portraits and current events.[56] At first, photography emulated and helped to prolong this convention, since moving objects were impossible to shoot owing to the long exposure periods required, and thus stationary objects were the subject of choice. Beginning in the 1870s, however, the fine-line engraving that had been used for centuries to picture monuments and buildings also bore the mark of the photograph in terms of perspective and shadow, what Mary Price has called the "sine qua non of photography."[57] Depending on how much the draftsman decided to tamper with the photograph in his line rendering, the effects are especially visible in the use of light and shadow. For example,

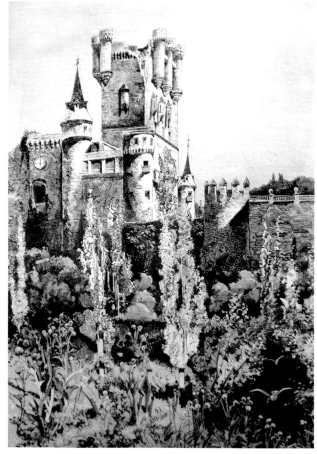

Fig. 29 (above) (After a photograph by Jean Laurent), "Iglesia de Santa María del Mar," *Ilustración Española y Americana* 22 (22 April 1878), 257.

Fig. 30 (right) "Segovia, Estado actual del Alcázar," *Ilustración Española y Americana* 22 (8 August 1878), 76.

Figure 29, an 1878 engraving of the "Iglesia de Santa María del Mar" (Saint Mary of the Sea Church),[58] after a photograph by Jean Laurent, clearly sought to emulate the photograph from which it was drawn. In the foreground are visible the shadows of other buildings, and there are also deep shadows beneath the atrium and arched windows, which would have been an unconventional rendering earlier in the century. The effect is dramatic when viewed alongside Figure 30,[59] the idealized, embellished image of Segovia's Alcázar, printed that same year after an artist's sketch. Where the church is swathed in shadows and riddled with the imperfections of the brick and stone work, the castle's imposing towers are bathed in white, and the trees surrounding the castle repeat the towers' imposing upward thrust. The shadows that appear in the engraving of the Alcázar are not consistent with actual lighting conditions, and the flowers and birds in the foreground are clearly anecdotal, adding a pastoral setting with Edenic connotations in contrast to the triumphal background.

Comparing the Church of Santa María del Mar with the engraving of Segovia's Alcázar, we can see why the photograph succeeded in putting into evidence the mythologizing effects of the engraving, thus cloaking itself in a deceptive objectivity and immediacy. It would not have escaped viewers of Napper's or Laurent's photographs that, however stiffly posed by these photographers, real Gypsies radically differed from conventional artistic interpretations—for example, Jules Lefebre's painting (engraved by Adolphe Pannemaker) of the famed Mignon, which was shown at the 1878 Universal Exposition in Paris and shortly thereafter reproduced in *Ilustración Española y Americana* (fig. 31).[60] Lefebre's painting, copied by a draftsman and engraver for magazine production, contained

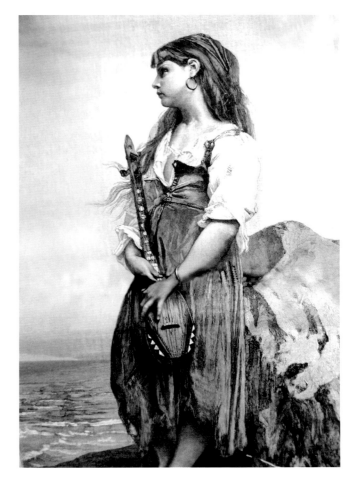

Fig. 31　Jules Lefebre, "Mignon," *Ilustración Española y Americana* 22 (15 October 1878), 220–21.

many conventional Orientalist touches such as the open blouse, the angled musical instrument, and the wistful look that came to characterize the female Gypsy portrait. As we have seen in Chapter 1, from the 1870s to the turn of the century most illustrated magazines helped readers to interpret the countenance of figures such as Mignon by including a section in the magazine called *Nuestros grabados* (Our Engravings). In this example, the editor of *La Ilustración Española y Americana* makes us privy to the subject's most

private thoughts, enhancing the artist's "power-ful fantasy"[61] by praising Mignon for being the perfect expression of her poetic/musical version. In other words, while as a visual subject she is parasitical to the operatic *Mignon,* the editor's interpretation is simultaneously parasitical to the engraved image: "The beautiful fiction of the poet is fulfilled completely: after the music that sang of her, and the great artist who created the type and gained for her universal popularity, this painter has now fixed, for all time, the true features of the legendary young woman, translat-ing with sure strokes the poetic invention of a powerful fantasy."[62]

Mignon and its gloss represent a key moment in the use of pictorial images in serial publica-tions. The engraved image, created by an artist who was not necessarily visualizing his work as it would appear in a magazine, was still often seen as an accessory to a text; in this case the artist was imagining either the character in an opera by Ambroise Thomas (1866), or Goethe's famous poem by the same name in *Wilhelm Meister.* Now transposed to a magazine, a second kind of text offered compensatory connotations to supple-ment what was not obvious in the graphic itself. This text was intended for readers who were not necessarily familiar with the literary or operatic work that had inspired the original artist or for those who, conversely, enjoyed reviving feelings of an earlier moment. The interplay between text and image was at this juncture very complex, especially in the case of interpretive and inter-preted engravings such as this.

In contrast to these engravings, images that purported to be photographs, while invariably captioned for identification purposes, were not typically accompanied by fanciful interpretations such as that tagged onto Mignon. Presumably this was because they aimed to produce what

Roland Barthes called a "continuous message,"[63] by which he meant images that professed to be a mechanical analogue of reality, visual reports free of subjective modes of communication. It is useful to keep in mind, of course, that, like a painting or engraving, the photograph is a com-pression of three-dimensional planes into two planes. The resulting image is also determined by variations in lens aperture, negative quality, and paper quality, so that it is an exaggeration to think that a photograph is an analogue of reality. Still, the seeming objectivity of the photograph (however it was reproduced for the magazine) left less room for the type of hermeneutic fantasizing that characterized the Our Engravings sections of illustrated magazines, where readers learned how to react sensorially to images and to assess the skill and techniques of artists. In short, commen-tators felt more at liberty to fantasize about an engraving, a subjective artistic product after all, than about a photograph, and it was their special task to validate the artistic skills of the original artist for their readers.

The "photographic" image (the quotation marks a reminder of what this word means in terms of early magazine production), on the contrary, either "spoke for itself" or corrobo-rated information supplied in an accompanying article. Claiming that an image was "de foto-grafía" (after a photograph) sufficed as a guaran-tor of the authenticity of what was transmitted. Its pictorial accuracy was unquestioned, and the complex manipulations required in order to transmit it to a piece of magazine print in a form that closely resembled the original photograph as well as the original subject were technical ques-tions that likely did not concern most consumers. Because photography was a mechanical means of representing reality, it became a metaphor for objectivity and fidelity to an original.[64] Gradually,

however, readers became more discerning and grew eager to see images that were not obviously touched by a draftsman's or engraver's hands. As it became possible to transmit more accurately original photographs through photomechanical means, images that showed the intervention of craftsmen working with pen and ink or engraving tools were becoming less acceptable as transmitters of reliable information about three-dimensional reality. The forms and pleasures of symbolic abstraction that were the norm until the 1870s were giving way to a demand for fidelity of transcription; "[T]he photograph unquestionably stood for the thing itself. It was not viewed as a message about reality, but as reality itself, somehow magically compressed and flattened onto the printed page."[65] This seemingly objective power of the photograph is, of course, a fiction since many subjective manipulations were and are still involved in all aspects of the printing of photographs.[66] As Mary Price explains, even though photographic transcription is a direct procedure involving the eye more than the hand, it will always be the case that "a discrepancy may be remarked between reality as it is perceived by any viewer and the photograph of that reality."[67] On the other hand, even if the camera does not show the constancy scaling that our visual systems apply to the information on our retinas, the camera shows true perspective, which we don't see. Despite manipulations applied to photographs, in some respects they give a more true view of what is on our retinas, and thus what is "out there," than does our visual perception.[68]

In the 1890s magazines were increasingly eager to have readers appreciate the relative truth value of photograph and engraving, sometimes by juxtaposing them. In the case of images after a photograph, however, it is not always possible to tell what information was contained in the original and what enhancements were subsequently introduced by the draftsman and the engraver working from the photograph. It is also difficult, as Francesc Fontbona notes, to tell whether any photographic processes were used in the reproduction of an image, whatever its original form happened to be.[69] Very little written information regarding the draftsmen's procedures and directives is available, so that conclusions about this common practice remain speculative. Although it is tempting to conclude that the manually worked image was ideologically more suited to furthering political and social agendas since the draftsman or engraver could subtly emphasize certain portions of a photograph in the production of the block or plate, it is important to remember that (as we shall see in Figures 40 to 42 below, depicting the Spanish-American War), photographers often posed their shots to serve the same ends. For example, the two technologies were cooperative in producing war reportage that helped the government to galvanize support for the nation's war efforts. The ubiquitous war photograph brought home the realities of Spain's imperial struggles even if it served only as an intermediary image that was copied and/or transferred by a draftsman and engraver. Both photograph and hand engraving, feeding off each other, responded to and generated an intense demand for visual evidence, making visible not just the natural and the constructed world as static and timeless realities as had been the case earlier in the century, but also the activities of men as they constructed, altered, and destroyed all that was about them. Thus photographs stoked the ocularcentric regime that characterized the ambitious nineteenth-century bourgeoisie at the same time as they furthered the interests of the bourgeoisie both ideologically and economically.

One of the demands of this class was to "see" events in which it did not need to (and

may not have wanted to) participate, to possess more reliable evidence than the mere words of the reporter or the sketch of an illustrator who typically was not present at an event that he pictured. It was soon discovered that the camera could incorporate an expansive photographic horizontality that was able to capture crowd scenes from a considerable distance. Already in the 1870s, multiple negatives and wide-angle lenses popularized large panoramas of Spanish rural and town scenography. In the case of *Ilustración Española y Americana,* such vistas increasingly included crowds of anonymous subjects shot with a camera in the field and then either rendered by a sketch artist in the intermediary stage to be engraved on a block, projected directly onto a block as an aid to the engraver, or etched on a plate through heliogravure. Typical of 1890s group shots are the "Entusiasta despedida" (Enthusiastic Send-off) images of troops embarking for foreign ports or the crowds that saw them off; such images dotted the illustrated magazines, many taken from photographs.[70] Most readers probably did not question their possible manipulated effects when the words "after a photograph" accompanied them.[71] From 1890 to 1898 images of these elaborate send-offs of inscripted soldiers (some of them staged by the government) flooded the periodicals, just as photographic technology was finally up to the task of expanding the range of its lens, and just as the time-saving process of producing images photomechanically became possible. It was during this time that the marriage of real events and technology was consummated in ways that we associate with the modern printing industry: suddenly photographs could appear in newspapers only hours after an event was shot.

One of the most obvious advantages of the photograph was its ability to capture posed groups of people; previously such groups would not have been sketched owing to the difficulty of gathering large numbers of people together in one place for the time required to sketch them with any sort of facial and proportional accuracy. With fast-paced improvement in photo processes, especially the discovery of dry-plate processes that quickly substituted for the more cumbersome wet plates, it was suddenly possible to "see" what groups of colonizers, adventurers, or indigenous peoples in Europe's far-flung foreign empires looked like, and the fascination for group shots grew prodigiously in the 1880s and 90s. Figure 32, a typical group image published in 1880, pictures Ferdinand de Lessep's Commission that presided over the building of the Panama Canal, photographed on location by Alfredo Orillac, the *Ilustración Española y Americana*'s correspondent in Panama.[72] This image demonstrates how adept the magazine's artists and technicians were becoming at combining photographic processes with hand processes. While it is clear that the original was a photographic portrait, the draftsman or engraver has been careful to ensure that each man's face is clearly visible and individualized; thus the portraiture character of the image has been maintained and perhaps even enhanced. On the other hand, in shots of anonymous groups of individuals whose identity mattered less than their collective role, engravers might feel more comfortable preserving the shadows that the sun would have naturally cast in order to achieve a more photo-like image, such as the bottom engraving of Figure 33, a photograph of a group of soldiers being honored for military valor in Dos Caminos, Cuba, in 1895.[73] By grouping the soldiers, wearing their hats, in the noonday sun, the photographer has obscured their faces but has accentuated their shoulders, whereas in the shot of the de Lessep Commission

Fig.32 "Panamá." *Ilustración Española y Americana* 24 (22 February 1880), 117.

the men's heads (and therefore their individual identities) are emphasized. Not needing to individualize the visages of the soldiers, whose names are tellingly omitted from the caption, the magazine's draftsman or engraver has conscientiously translated the shadows of the original. Consequently the effect of on-location photography is very pronounced in the engraving of the soldiers compared with that of the de Lessep engineers, whose surnames are listed in the caption below the photograph. The aspect of the commanding officer, Antonio Gila Garzón, pictured above and to the right of the group of anonymous soldiers in the original layout, makes the distinction very clear (fig. 34).[74] Gila's features are fully

rendered; the lighting on his face resembles the conventions of line drawing more than of field photography, thanks to the intervention of the magazine's technicians.

According to Peter Galassi, by the nineteenth century the classic perspective of line engravings with structures and typography, often devoid of human subjects, was shifting to a narrower conception of a slice of space and a slice of time in which viewers were incorporated through a point of view as participants "in the contingent experience of everyday life."[75] Galassi's argument is that photography reflected, not merely created, this dramatic shift in point of view to a one-point linear perspective influenced by

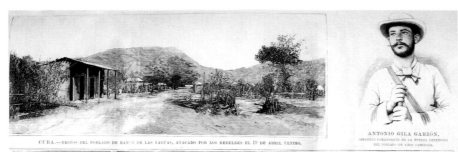

CUBA.—RESTOS DEL POBLADO DE RAMÓN DE LAS YAGUAS, ATACADO POR LOS REBELDES EL 1º DE ABRIL ÚLTIMO.

ANTONIO GILA GARZÓN,
SARGENTO COMANDANTE DE LA FUERZA DEFENSORA
DEL POBLADO DE «DOS CAMINOS».

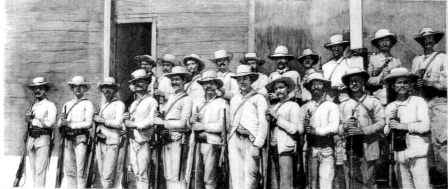

CUBA.—GRUPO DE SOLDADOS QUE DEFENDIERON VALEROSAMENTE EL POBLADO DE «DOS CAMINOS», PREMIADOS CON LA CRUZ DEL MÉRITO MILITAR.

Fig. 33 (above) "Cuba: Grupo de soldados que defendieron valerosamente el poblado de 'Dos Caminos,' premaiados con la cruz del mérito militar," *Ilustración Española y Americana* 39 (30 May 1895), 329.

Fig. 34 (right) "Antonio Gila Garzón, Sargento comandante de la fuerza defensora del poblado de 'Dos Caminos'," *Ilustración Española y Americana* 39 (30 May 1895), 329.

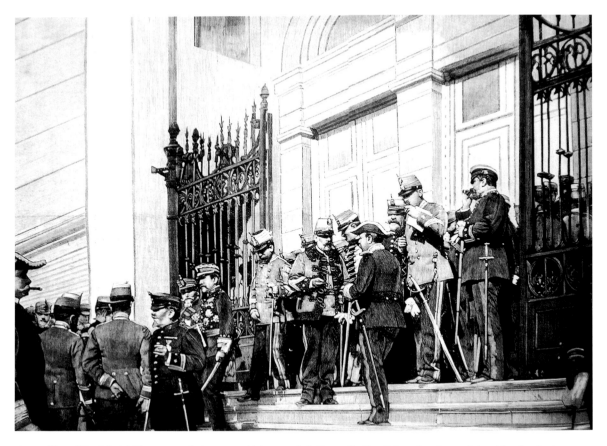

Fig.35 "La salida: Madrid banquete de las armas (del natural)," *Ilustración Española y Americana* 38 (15 March 1894), 144.

eighteenth-century pictorial art. Whether we accept Galassi's argument about the origins of modern photographic perspective, the fact is that in some instances journalistic photography began to suggest a viewer who was a privileged participant in an event; the camera's "eye" functioned as a surrogate for a presumed in situ viewer.[76] Readers would of course acknowledge that they were not in fact there, at the point of the camera's eye, but would be convinced that *someone* was there since, as Barthes suggests in the epigraph to this chapter included in *Camera Lucida*, "every photograph is a certificate of presence." The photograph as opposed to the engraving

was the undeniable testimony to something real; according to Barthes, its uniqueness suggests to viewers proof that "the thing has been there."[77] Intimate group shots also began to take on a more unposed informality that would have been inconceivable a few decades earlier, as magazines moved toward a modern photojournalistic content that provided a mixed verbal and visual communication of a message. Figure 35, "La salida: Madrid banquete de las armas (del natural)" (Exit from Armed Forces Banquet in Madrid [taken from life]), is significant because of its compositional unstructuredness and because it represents a technically complex stage between process (that

is, photography-assisted) and manual engraving.[78] It also suggests impending movement, a sense of temporality and dynamism that we can think of as a prelude to photographic montage and film,[79] as opposed to the fossilized and static urban shots of the classical engraving depicting past events. It clearly falls into the realm of photojournalism, capturing an important, unstaged event with a camera, a practice that *Ilustración Española y Americana* claimed to have initiated in its pages.[80] In this case the image started out as a photograph of an event, which was then most likely photomechanically reproduced on a metal plate, either through heliogravure or a process halftone engraving, rendering continuous tones instead of lines in some areas of the image. The engraver, however, has not altogether disappeared from the picture. He has taken the photomechanically produced plate and retouched the architectural detail and some of the clothing in order to provide a more pleasing visual effect; photomechanical processes at this point were still in their infant stages and did not always render wide tonal swaths very evenly. The aim was presumably to produce a convincing facsimile of the photograph, but the end product still needed to be pleasing to the eye. The tiny lines that in "Salida" are evidence of the diminishing trade of the hand engraver would disappear altogether within a few years, when all but art magazines specializing in traditional graphic arts switched to halftone processes to reproduce images of historical events. These halftone processes were at last able to produce a facsimile of a photograph without the intervention of engravers.

The old techniques did not surrender easily to the new, however, as can be seen in innumerable images that are unsatisfactory reproductions of original paintings or blurry photographs improperly reproduced with the new halftone processes.

In the late 1880s, Barcelona's *Ilustración* was offering numerous images of artworks that were direct photoengravings. But the qualitative difference between halftone photoengravings and xylographic engravings explains the preference on the part of some magazines for the latter, decades after photomechanical images were introduced and became common. The difference becomes especially evident when works by the same artist are printed using differing technologies. For example, in its May 1905 issues dedicated to Francisco de Zurbarán, *Ilustración Española y Americana* offered a sampling of two reproductive techniques, indirectly making a statement regarding the magazine's stubborn use of xylographic engraving (or photomechanical images taken from engravings, as the case may be) when other magazines were relying increasingly on direct photomechanical reproduction. Photography might have been used in the transfer of both images, but one of them shows a much more direct intrusion of manual labor. When the engraving of Zurburán's "Aparición de San Pedro Apóstol a San Pedro Nolasco" (Saint Peter the Apostle's Apparition to Saint Peter Nolasco) (fig. 36)[81] is compared with that of Zurburán's "Santa Catalina" (Saint Catalina) (fig. 37), [82] in the following issue, the differences are striking: the line engraving of Santa Catalina surpasses the continuous tone image of San Pedro Nolasco both in clarity and chiaroscuro effects. In the latter image, the result of a halftone printing procedure, the shadows bleed together and produce swaths of uneven, muddy gray. In contrast the reproduction of Santa Catalina is crisp and well defined, its lined effects very obvious.[83] Neither one comes close to resembling the original painting, of course, but the one with the most obvious hand retouching is clearly more suitable for the medium in which the image appeared. It was very much the case that for readers of

APARICIÓN DE SAN PEDRO APÓSTOL Á SAN PEDRO NOLASCO.

Fig.36 (above) Francisco de Zurbarán, "Aparición de San Pedro Apóstol a San Pedro Nolasco," *Ilustración Española y Americana* 49 (22 May 1905), 308.

Fig.37 (right) Francisco de Zurbarán, "Santa Catalina," *Ilustración Española y Americana* 49 (30 May 1905), 313.

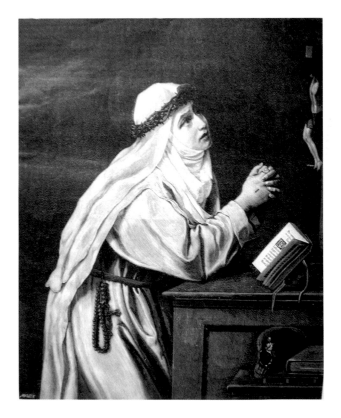

turn-of-the-century periodicals, their knowledge of art objects was still much conditioned by the medium used to transfer the message about the original, and decisions made as much by skilled technicians and illustrators as by original artists were what determined the final effects of an image. Photography had not completely supplanted the line engraver who, as in this case, was brought in to save the Santa Catalina image from the smudgy appearance of San Pedro Nolasco.

More important than image quality or engraving techniques, however, is the contrast in truth value between engraving and photograph as this was perceived by late nineteenth-century magazine readers. Cohabiting the same media, the truth claims of the engraving after a photograph vis-à-vis the engraving after an original artist's sketch seemed at the time entirely irrefutable. Their very juxtaposition helped to foster the notion of photographic realism, something that did not escape the editors responsible for enticing readers with new and noteworthy cultural phenomena and historical events. For instance Figure 38, a 1905 photomontage of the Sultan of Morocco, is subtitled "Fantasía y realidad" (Fantasy and Reality).[84] The caption clarifies that viewers are to understand the photograph on the right, a continuous-tone image photomechanically reproduced, as the rendering of someone real, while the image on the left, an artistic version that also has been photomechanically reproduced but that started off as an original sketch, was pure fantasy.

The imaginary sultan gallops on a steed with a broad chest; his weapon is thrust menacingly forward, and his sword swings prominently at his hip. His flowing garment and hair, and even the windswept background, all contribute to the sense of velocity and determination. In contrast the photographic version of the sultan looks pitifully stationary: huddled in his robe covering him from knee to neck, the squinting sultan hardly gives the impression of a fierce warrior. His horse looks equally unheroic in comparison with the white steed to the left; its shadow is a mere sliver of black against a pebble-strewn landscape, while in contrast the imaginary horse casts an impressive shadow on the sand. The *Ilustración Española y Americana* layout editor showed his enthusiasm for the fantasy sketch by superimposing it over the edge of the photographic version of the sultan, but this symbolic hierarchy was not to last. The reality was that magazine editors quickly realized that the untouched photograph could be used in the same way as the art engraving, to aggrandize or belittle its subject, and as photography reproducible through fine-line halftone processes became more economical, permitting a streamlined workforce and large runs, it would eventually edge out the sketch as the most prominent and expected visual of current events. Significantly, in the same year that saw the two sultans of Figure 38 vying for readers' attention, *Ilustración Española y Americana* eliminated altogether its *Nuestros grabados* section from its pages, in part because by that time manual engravings were becoming more sparse, and photographs were increasingly being embedded in the features that they illustrated. Thus comments about the photographer's skill, verisimilitude, or artistic merit were deemed superfluous.

HOLD THAT POSE

In its early stages, field photography adopted many of the conventions of the long-standing commerce in field illustration of events: in other words, the photograph did not suddenly produce the demand for reporting of world events

Fig.38 "Vista de un campamento marroquí (Mehal-la)—El sultán en marcha.—Fantasía,—Realidad," *Ilustración Española y Americana* 49 (8 July 1905), 12.

accompanied by images; rather, it responded to a demand already in place by facilitating faster, more convincing, and more seemingly "modern" field reporting. As Bernardo Riego has pointed out, the visual communication of world events via the informational sketch was already a tradition in magazines long before field photography was viable as a mechanical process. But even though the field illustrator and the magazine technician played as important a role in consolidating the expectation for visual coverage of events as did the photographer, every innovation in the transfer of visual information expanded the reading public's expectations about the way events were communicated, and this fact led to the loss of the sketch's historical credibility. The decade of the 80s, was, in Riego's words, "the beginning of the end of informative scenes based on drawings."[85] The images photographically produced in Barcelona's *Ilustración* of the 1884 earthquake in Andalusia were the harbinger of a new age of photographic reporting.

Capturing the rapid-action shot had long been one of early photographers' most elusive desid-erata. When dry-emulsion methods were refined, permitting the use of less cumbersome field equipment, and as exposure times consequently decreased from minutes to seconds, activities shot in the field became more varied, and photographers could venture into more precarious locales, namely, war zones in Cuba and the Philippines in the 1890s. Despite improved technologies, however, engraving and artistic convention continued to influence photography, and posing and composition were very much on the mind of the photographer even in what were touted as spontaneous action shots. A comparison of three war shots demonstrates the various levels of photographic composition that were commonplace during the Cuban struggle, providing direct evidence that convention, not just events, was determining the visual syntax of the informational image. The first, Figure 39, is a photographic image published in *Blanco y Negro* in 1895; it is titled "Soldados en emboscada, armados de Mauser" (Soldiers Preparing an Ambush, Armed with Mausers).[86] It is clear from even a casual glance that the photographer carefully

posed his subjects for heightened visual and emotional effect. On careful inspection it also seems likely that the men are actually standing in front of, and possibly on top of, a manmade structure that has been cleverly disguised with tropical foliage. That same year a second version of the image was manually sketched from the same photograph and published under the title "La guerra en Cuba—Guerrilla de tropas españolas en la manigua" (The War in Cuba—Spanish Guerilla Troops in the Jungle) by *Ilustración Española y Americana* (fig. 40).[87] Here the illustrator who interpreted the photograph doctored the original by adding stalks and palm leaves to the scene and by enlarging tree trunks to create the illusion that the men are truly surrounded by lush jungle greenery. Both versions are highly posed: the men's faces are prominently featured, with careful attention to their state of concentration that accentuates their battle readiness. With the engraver's help, however, the *Ilustración Española y Americana* sketch is a more heroic and artistic portrait than the *Blanco y Negro* photograph from which it was drawn.

In the second example, a war photo taken in Santiago de Cuba in 1897, the photographer Gómez de la Carrera also composed his shot by placing subjects in what seem to be implausible positions for an authentic battle scene. His photograph was then photomechanically reproduced in two slightly different variations, first in *Ilustración Artística* (fig. 41),[88] in which the top part of the photograph was cropped either because of space restrictions or to lend the photograph a more compelling intimacy. Eleven months later the same photograph appeared in *Ilustración Española y Americana,* with the tops of the trees visible in the original photograph now included but without the smoke from the guns that the soldiers are firing.[89] The effect in both images is more realistic than that of Figures 39 and 40, especially in the version of the image reproduced in *Ilustración Artística,* which included the smoke from the gun report (fig. 41), but there is still a simplicity and composition that lends an artificial feel to the images. Each man's body is a discreet entity, and as they are bare headed, the men's facial expressions are clearly visible. The fallen soldiers with their arms outstretched, one facing up and the other facing down, still grasp their weapons; even in what appears to be simulated death they remain soldiers. It is also impossible to tell whether the smoke from the gun report was manually added to *Ilustración Artística*'s image or manually eliminated from the image produced in *Ilustración Española y Americana,* but a comparison of these two images provides a stunning clue that magazines were tampering with image content in order to produce desirable effects. For his part the photographer, positioned to the side of the men in what appears to be a bare and open space, silently accentuates his own precarious position in the line of fire. In the *Ilustración Artística* Our Engravings section, the magazine editor emphasized that this photograph needed no introduction because it showed what war was "really" like: "suffice it to see the images to understand the truth and importance of the scenes that they represent and that require no explanation because they are episodes that the campaign in Cuba offers with such frequency and that the daily press has described repeatedly in great detail."[90]

In contrast to both of the previous images, Figure 42, a photomechanically reproduced photograph also shot in Santiago de Cuba, offers a more likely battle scenario whose composition is controlled by events and not entirely by a photographer or magazine editor anxious to achieve compositional perfection.[91] Here all the clutter of war surrounds the soldiers who are huddled

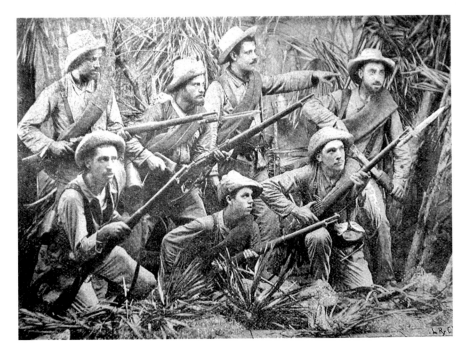

Fig.39 (above) "Soldados en emboscada, armados de Mauser," *Blanco y Negro* 5 (28 December 1895).

Fig.40 (right) "La guerra en Cuba," *Ilustración Española y Americana* 39 (15 December 1895), 353.

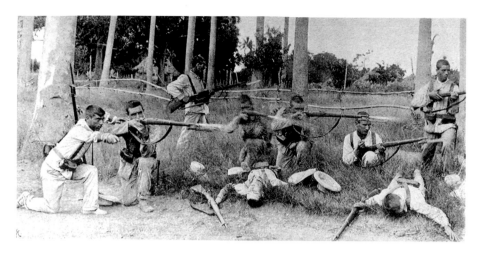

Fig. 41 "Guerra de Cuba, Sargento de Sigüenza en el combate de Ceja del Toro y defensa del convoy de Viñales," *Ilustración Artística* 16 (8 February 1897), 103.

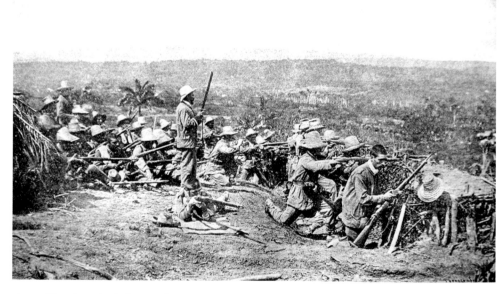

Fig. 42 "Santiago de Cuba, Desdacamento rechazando un ataque del enemigo, en Alto Songo," *Ilustración Española y Americana* 39 (22 November 1895), 293.

together, their faces partially blocked by their hats. In this example, the effect of authenticity exceeds the impulse for representation, despite the improbable position of the two figures in the center left of the photograph. All three types of compositions in Figures 40–42 were popular in the 1890s, when most magazines still maintained a staff of draftsmen to help execute engravings from photographs and to touch up photographs for desired effects. This arrangement would become less common as the printing processes became more mechanized and as readers became more discerning of photographic tampering.

Although its highly refined art graphics continued to demonstrate that photomechanical halftone engraving by itself was still no match for the engraver's skill in working with traditional manual engraving processes, after the turn of the century the *Ilustración Española y Americana* went into decline, ceasing publication in 1921. According to Jean-Michel Desvois, this occurred because the magazine lacked the capital of competitors such as *Blanco y Negro,* which had purchased the newest German presses, hired operators from Germany to man them, and used almost exclusively photomechanically reproduced images, while *Ilustración Española y Americana* stuck stubbornly to the more traditional xylographic techniques especially to reproduce art.[92] In 1907 Juan Pérez de Guzmán, in an article entitled "El grabado por la fotografía y la química" (Engraving Using Photography and Chemistry), justified the preference for the older techniques by claiming that xylography "eternally will recognize, amid all the evolutions of the century, its lasting and acknowledged superiority."[93] Another reason cited by Desvois is the competitor's lavish use of color compared with *Ilustración Española y Americana*'s "absence of color and its didacticism, vis-à-vis the light fare of its competitors"[94]

Desvois is correct about the editorial content but not about the use of color, a mistaken notion also perpetuated by Pedro Gómez Aparicio, who claimed that *Blanco y Negro* was the first weekly to produce color graphics in 1897.[95] In fact several other magazines by that time were including occasional images in color, among them *Ilustración Ibérica,* which, in 1891, the same year that *Blanco y Negro* was launched, was using two to three color images per volume. In its first years of publication *Blanco y Negro* produced no color images, while *Ilustración Española y Americana* was offering its readers a half dozen delicately colored chromotypogravures, full-page bichromatographic reproductions of works by foreign artists such as that of Figure 43, "Fiel mensajera" (Faithful Messenger), from plates imported from the famed French concern Imprimerie Boussod, Valadon, & Compagnie.[96] Because some of these images were either tipped in as unnumbered pages or inserted separately on high-quality paper that blocked the bleeding from the reverse of the page, they were suitable for framing, and editors often invited readers to extract them from the magazine for decorative purposes. This doubtless added to the magazine's allure.

Color represented an extravagant expense, but it added beauty and exoticism to the magazine. In accordance with convention, it was therefore coded as something cosmopolitan, frivolous, and, usually, feminine. For nearly a decade, from 1890 to 1900, all of *Ilustración Española y Americana*'s chromotypogravures depicted aristocratic women stepping out on the town, well-dressed children playing with expensive toys, and charming and elegant domestic scenes, most of them produced in France. By contrast *Blanco y Negro* did not fully develop its chromatic photoengraving skills until later. Its first timid use of color was in monochrome photoengravings,[97] and even when

Fig. 43 Vittorio Matteo Corcos, "Fiel mensajera," *Ilustración Española y Americana* 35 (30 July 1891), 52−53.

at the turn of the century it expanded its use of color—bichromotography in 1897, trichromatic images in 1899, and shortly afterward cuadrichromal images[98]—the hues were in the beginning poorly separated, the red inks casting an unnatural hue over many subjects, and the greens faded and unnatural.[99] Yet *Blanco y Negro* enjoyed a huge success even before it refined its use of color printing.[100] So the answer to the riddle of its popularity and the demise of the *Ilustración Española y Americana* or other large-format illustrateds must lie mainly in content, reader taste, and affordability, and possibly in its more portable size, rather than in its technical refinement.

As a more portable periodical, *Blanco y Negro* had an advantage over the more cumbersome large-format papers that had all but disappeared in the early twentieth century. However, it was in large part because of its more encompassing reader appeal that *Blanco y Negro* superseded its more elegant rivals. For example, *Blanco y Negro*'s color engravings, while including mostly female figures, offered a great variety of images of working- and middle-class women, which appealed to a much wider readership than did the imagery of other magazines. Thus, even though *Blanco y Negro* followed the lead of other illustrated magazines in reserving color for the apparently more colorful sex, its populist appeal and inexpensive subscription rates allowed it to expand its local market at a time when the costly and more elitist *Ilustración Española y Americana* was losing readers.[101]

It is also not the case, as Desvois claims, that the *Ilustración Española y Americana* was not using advertisements to help defray printing costs. Advertising appeared in its very earliest numbers, and by the late 1890s it began using photography to advertise products such as imitation pearl necklaces sold by Kepta or a product called Racahout de los Arabes Delangrenier, a children's breakfast drink imported from Paris. But by 1907, evidently to reduce costs, its two- to four-page advertisement supplement was printed on cheaper paper either appended to the end of the issue or unglamorously inserted as a protective sheath surrounding the issue. By contrast *Blanco y Negro*'s advertisements were much more "nuts and bolts" (false teeth, stoves, baby carriages, elixirs, soaps, and other household objects) and considerably more numerous, leading some critics to suggest that the magazine had been created primarily to sell goods.[102] By the turn of the century *Blanco y Negro* also published a section called "Anuncios telegráficos" (Telegraphic Notices), brief and

inexpensive ads that included real estate listings, charging 1 peseta for ads of one to ten words, and 10 céntimos for every word beyond that. *Blanco y Negro* was also one of the first magazines to offer process photographs rather than line engravings of dress models. In contrast, the more staid *Ilustración Española y Americana* relegated dress ads to its sister publication *La Moda Ilustrada.* Its more dignified pages appealed especially to a male clientele concerned with world events, fine art, scientific discoveries, and, above all, the life and deeds of famous men. Portraits of distinguished gentlemen, only a minor presence in the early years of *El Museo Universal,* became the dominant graphic feature of *Ilustración Española y Americana* in its declining years, surpassing the number of images of manmade constructions and second only in number to line engravings of works of art. As Claude le Bigot, speaking about the editorial content of the magazine, put it recently, its "pantheon of celebrities is above all a universe of men;"[103] *Ilustración Española y Americana,* then, was nothing if not a pantheonic men's periodical. Women figured heavily in its fine art engravings in its declining years, in other words, as the fetishized, refined objects of beauty like those reproduced in Chapter 1, but the number of photographs, sketches, or art portraits of real women was as negligible as the likely number of women subscribers to the magazine.

Desvois is correct in pointing out that the much cheaper *Blanco y Negro* (20 céntimos in 1891), compared with the expensive 1 peseta for *La Ilustración Española y Americana,* was a draw for readers, but what he does not emphasize—which is fundamental in explaining its eclipse in favor of *Blanco y Negro*—was the reader appeal that the latter possessed in other ways. Significantly it appealed more directly to families with an emphasis on modern life and its vicissitudes,

often depicted with cartoon figures, as in the sketch of the infamous "Tren botijo" (The Jug Train) carrying middle-class passengers to their summer holidays fig. 44).[104] Its "Sección Recreativa" (Entertainment Section), formerly the spot occupied by "Un poco de todo" (A Bit of Everything), appealed to customers of all ages with a potpourri of word puzzles, charades, chess moves, and jokes. Instead of serialized novels, it offered what it called "novelas telegráficas" (telegraphic novels), short fictions that could be read in one sitting. Its lead stories had a contemporary feel, with occasional features on living conditions, such as the photograph in Figure 45, captioned "La miseria en Andalucía," (Misery in Andalusia), which appeared on the cover of the 9 June 1894 issue.[105] Given its editorial policy that stressed the "blanco" (white) rather than the "negro" (black) side of contemporary life, scenes of poverty in *Blanco y Negro* were rare, but catastrophe scenes that were becoming a mainstay in magazines devoted to photojournalism were increasingly featured. Unlike many Spanish periodicals, including most women's magazines, *Blanco y Negro* occasionally took a pro-feminist stance, for example, in its 1901 article "El feminismo" (Feminism), which attributed women's intellectual advancement to the feminist movement and indirectly called for equal rights reforms.[106] While the magazine stretched its artists' imaginations to offer heroic sketches of those it described as "fighting for the fatherland" (See "Un práctico en la manigua" [A Recruit in the Jungle] by Narciso Méndez Bringa,[107] and "Luchando por la patria" [Fighting for the Fatherland] by Estevan, for example),[108] its wartime photography, as we shall see in Chapter 4, offered a greater naturalism and immediacy that were lacking in its competitors. Even though technically its photographs were often not as accomplished as its larger

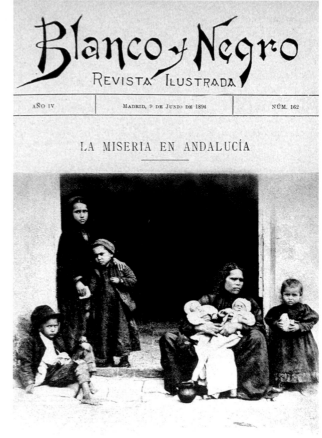

Fig. 44 (above) "El tren botijo," *Blanco y Negro* 4 (8 September 1894), 577.

Fig. 45 (right) "La miseria en Andalucía," *Blanco y Negro* 4 (9 June 1894), cover.

format competitors like *Ilustración Española y Americana,* it was from the beginning a much more gender-inclusive magazine. Even in its wartime reportage the role of women was not forgotten, as in Figure 46, an image of the "cantinera del bataillon" (Battalion's Vivandière), Dolores Cisnero.[109] Nothing was better for the tired or wounded soldier, glossed the reporter in the accompanying article, than to hear "that sweet echo of the feminine voice without which nothing grand or complete can be accomplished."[110]

Finally, *Blanco y Negro* fostered a star system through countless promotional images of actors and other performers, often combining photographed heads with cartoon bodies. All turn-of-the-century illustrated magazines doted on the monarchies of England and Spain, and *Blanco y Negro,* with its numerous photographs of royalty, was no exception. But it also created other kinds of royalty, like the queens of the carnival or the kings of the bullring, who were painted, sketched, and photographed by Spanish artists, thus lending the magazine a local and populist flavor. For dramatic effect, photographs were often cropped, as in the image of the bullfighter of Figure 47,[111] eliminating the background and forcing viewers to focus on the figure of interest, an uncommon montage in the more sedate, large-format illustrated magazines such as *Ilustración Artística* or *Ilustración Española y Americana.* By the turn of the century, every article in *Blanco y Negro,* no matter how brief, was illustrated with a sketch or cropped photograph. This decoupage technique quickly became a hit with other popular magazines, which helped to distinguish them even more from periodicals slanted toward high art. *Blanco y Negro* was also proud that it was becoming the "eyes" of world events and often bragged of the impact of its graphic content.

Writing in 1899, Gabriel España explained the appeal of the weekly by pointing out that after a week of news items repeated time and again in the daily newspapers, the public deserved to see images. For him, "it is only right that its illustrated weekly amplifies and completes (the news) by means of documented information via the sketch, the photograph that enters through the eyes."[112] Although *Blanco y Negro*'s format remained half the size (23 × 40 cm) of the bulky *Ilustración Española y Americana,* its photographs eventually became very professional looking, and photojournalism took on its modern features just in time for the press to acquire its present identity, one that is obsessed with bizarre and catastrophic events. Much of the daily print media published at the time required a diachronic activity: it took time to read *El Heraldo* or *El Imparcial,* and that time was ritualistically savored by readers of daily papers. The photographs and brief news entries of *Blanco y Negro,* in contrast, provided an antidote to the newspaper for those not willing or able to invest time in the traditional ritual of newspaper reading. The inclusion of so many images of current events, facilitated by photomechanical processes, fueled a shift in the way the public was beginning not only to consume, but to define current events. If something was true, it should be validated with a photo-image. The photograph thus became, in large part thanks to *Blanco y Negro,* a privileged form of communication, the axis around which the news text was beginning to revolve, rather than having the image revolve around the text, as had been the case earlier in the century and was still the case with magazines like *Ilustración Española y Americana. Blanco y Negro*'s images did not merely complement or augment the information communicated in the text; they were the primary vehicle of communication for an event or scene.

Fig. 46 (above) "Dolores Cisnero: Cantinera del bataillon,"
Blanco y Negro 5 (30 November 1895), n.p.

Fig. 47 (right) "El hombre del día: Rafael Guerra
(Guerrita)," *Blanco y Negro* 4 (7 July 1894), n.p.

Fig. 48 Ilustración Española y Americana 51
(8 December 1907), 336.

Ilustración Española y Americana, meanwhile, which had been at the forefront of magazines in offering informational sketches of world events, had reached a level of technical refinement that surpassed that of all its rivals, as can be seen in the 1907 train-wreck photograph of Figure 48.[113] It therefore could have become the twentieth-century Spanish magazine of great photographic achievement, the equivalent of *Look* or *Life* magazine in the United States, but its publishers chose a different path. Clinging to its traditional content, it continued to offer its readers images, now mostly as photographs, of famous men or pretentious and retrievable art, like the two-page color supplement entitled "Nueva vida" (New Life) after a watercolor by Sánchez Germona (fig. 49), which the editors invited readers to extract from the volume and frame on bristol board.[114] For the *Ilustración Española y Americana* and the other great illustrateds such as *Ilustración Artística* and *Ilustración Ibérica* of Barcelona,

however, there would be no "Nueva Vida" after the second decade of the new millennium. The same can be said in general for xylographic engravings, which, until the end of the century, required sketchers and hand engravers to produce the quality prints that made up their mainstay visuals, even after process engraving assisted them in the transfer of images to blocks and plates. Both draftsmen and engravers were then replaced by photoengraving specialists, which considerably cut production costs and time. As Francesc Font-bona concludes, xylography had lost its battle against the photoengraving; bowing to market forces; magazine editors

saw clearly that ordinary magazine illustration had to be entrusted to photoengravers rather than xylographers. It was more rapid, economical, and faithful, since the images were reproduced photomechanically without the necessity of manual translators. Xylographers

Fíg. 49 Sánchez Germona, "Nueva vida," *Ilustración Española y Americana* 49 (8 January 1905), 16.

would continue to exist, at least for a few years, but as creative artisans of charismatic images, destined to supply magazines with quality supplements, and thus the greater part of their activity was severely curtailed.[115]

The grand illustrateds with their foreign and high-art engravings and arch conservatism were ceding markets to the new, smaller format and more locally attuned magazines like *Blanco y Negro,* "more suited to exceed the limits of bourgeois consumers and situate themselves in the eye of the hurricane of the struggles for Spanish modernization."[116]

Three

TORCUATO LUCA DE TENA'S *BLANCO Y NEGRO* AND SPAIN'S MOVE TOWARD A MASS MEDIA

[I]n a country where the proportion of illiterate is disheartening, the engraving constitutes
an important cultural and pedagogical element of unquestionable value.
—BENITO PÉREZ GALDÓS, *La Esfera* (9 January 1915), n.p.

IN THE MID-NINETEENTH century, what Walter Benjamin famously called the aura of the unique image began to fade as the mass reproducibility of works of art became possible.[1] Even the most remarkable and finely executed reproductions, like some of those included in Chapter 1, lacked the originals' presence in time and space that made them unique. The mass reproducibility that depreciated the work of art was not merely owing to the advent of photography, as Benjamin suggested, since long before its invention newspapers and magazines were capable of the serial reproduction of images. It was the application of photographic techniques to the mechanical reproduction of images in the daily and weekly press, developed in the last decades of the nineteenth century, that truly revolutionized the dissemination of images. The implications of the invention of photomechanical engraving, as we saw in the previous chapter, exceeded the mechanical and aesthetic spheres in which they are usually considered. The illustrated magazines of the 1860s and 70s, still dependent upon traditional intaglio and xylographic engraving techniques, were already publishing images

specifically made to be copied. The problem was that these images could not be reproduced on a mass scale. What the new technology and machinery of the 1890s facilitated was the true mass production of artwork that was essential for the expansion of magazine circulation destined for the now more numerous middle classes. New photo technologies would transform as well the daily newspaper, hitherto largely devoid of images. By the 1930s the result was in all but a few respects the modern-format newspaper, with illustrated supplements that combined leisure reading and photojournalism, illustrated fiction and scientific illustration, image-driven advertisements and photo portraits of the famous and powerful, photo reproductions of high art and sculpture and cartoon sketches of every possible variety.

Long before the 1930s, as the images in Chapter 2 attest, photography had influenced the content of the illustrated weekly periodical. During the period 1880–1900, engravings drawn from photographs and, increasingly, photoengravings were inviting the reader to believe that events, scenes, things, and people could all be brought before him or her in realistic detail, that

the world was shrinking into the comfortable armchair lit with wonderful new electric lights. As Beaumont Newhall put it, "The fever for reality was running high."[2] Photoengravings became the viewer's surrogate eyes, reaching out to an exterior world with an astounding fidelity that validated what readers believed to exist *out there.* The contrast between engraving and photograph forestalled questions regarding the extent to which political expediency or editorial policy influenced the way photographic visions of the world were selected and manipulated. Because the photomechanical reproduction of images made it possible for increasingly large numbers of people to enjoy this illusion, it played an important role in the democratization of the press. By the end of the nineteenth century, the growing urban classes, inured to press media, could see projected back to them their own faces, shapes, and voices in the form of magazine reporting and graphics. Periodicals were at last able to respond to the novelist Benito Pérez Galdós's worried statement in 1897 that the middle class was but a "formless agglomeration" of individuals made up of superior and inferior categories, the product of the disintegration of two "families," as he called them: the ascending masses and the descending aristocracy.[3] Magazines aimed, partially through the massive infusion of locally produced images, to picture this mélange of classes as something positive, even though in reality it was a fantasy, just like the exciting image of the modern woman on the cover of *Blanco y Negro,* the magazine that is the focus of this chapter.

In the 1870s, capitalism was entering a new phase in industrial countries such as England and France, resulting in a thorough transformation of the publishing industry by 1900. The years 1879 to 1900 also saw the groundwork laid for a mass media in Spain, although the transition was slower owing to political and technological obstacles. In 1900 Spanish industry still was, in the view of the economist Gabriel Tortella, "more backward than British or even French industry had been at the beginning of the nineteenth century."[4] Still, during the twenty years leading up to the end of the century, the number and quality of newspapers and magazines increased yearly, and their directives became more diverse, with Republican, anarchist, and working-class papers competing with state and conservative elite publications, although the former were unable for financial reasons to compete in terms of the utilization of graphic images.[5] While Spain's literacy rates lagged behind those of Northern Europe, ever larger numbers of people, especially in urban areas, were able to read and purchase newspapers and magazines. By 1887, more than one thousand periodical publications of all types were published in Spain.[6] Transportation and means of communication had by then improved and made the delivery of media faster and more reliable.[7] Better printing machines, for the most part purchased in Germany, and engraving technologies, also at first a largely foreign import, assisted the press during its transition to a fully integrated information industry.[8]

In the first half of the nineteenth century, in the era of the pre-market press, a periodical could be produced by a handful of workers and a wealthy patron, but by the end of the century any serious contender in the newspaper and magazine industry required several hundred employees, a modernized plant, and a significant outlay of capital, all of which were required to ensure success, defined in terms of market share and financial solvency. For a magazine to survive beyond its two- to three-year debut, press owners had to struggle aggressively to make its production cost-efficient, its workforce well regulated and efficient, and its

management attentive to profit margins, circulation, distribution, and competition. The few entrepreneurs who were able fully to adapt to the new capitalist mode of production were cognizant that success could be achieved only if the industry became truly mechanized. According to the media expert Jean-François Botrel, the result was a revolution in communication that impacted even the illiterate masses: "Thanks to the mechanization, the lowering of costs, and the massification of production that this mechanization permits, communication by means of printed material came to seem like something normal and common."[9] With the appearance of José Gaspar Maristany's and Fernando Roig's *El Museo Universal* (and its continuation *La Ilustración Española y Americana*), Spain saw at last a "Spanish illustrated magazine that combined news of the day with a monumental vision of its national past."[10] In its pages the Spanish bourgeoisie, which "presented a social profile quite different from that of previous decades," would be consolidated, and its vision of the world celebrated. During the same period, publicity gradually accounted for a larger portion of magazine and newspaper income. In the better financed periodicals, advertisement accounted for 1–10 percent by the 1880s, growing to 20 percent in the 1890s, and 40 percent in the 1900s. The periodical was a commodity that came more and more to seem like a necessity for large numbers of people, and as a result, readers were becoming commodified, in the sense that their attention was being sold to advertisers who took up increasingly more space in magazines and newspapers.

IN THE HANDS OF ALL

It was during this time, May 1891, that the entrepreneur Torcuato Luca de Tena launched

Spain's first moderately priced illustrated weekly magazine with what one source reports was an initial outlay of only 3,000 pesetas.[11] *Blanco y Negro* enjoyed a sudden and meteoric success by combining images and text to sell ideas as well as products, including the notion of a shared community, with appeals to centrist and nationalist concerns. Augusto Martínez Olmedilla recalled vividly his astonishment at reading the first issue: "*Blanco y Negro* didn't resemble any of the similar publications of the time."[12] It was, to be sure, nothing like its predecessor, *El Semanario Pintoresco,* which Bernardo Riego classifies as a "popular encyclopedia."[13] Its mission was not to document every modern invention, art object, and discovery, but to provide a shorthand documentation of modern life. Like the *género chico* (one-act plays) that Deborah Parsons points out were becoming the spectacle of choice because of their brevity and popular appeal, *Blanco y Negro* beguiled its readers with a kaleidoscope of perceptions of Madrid life that could be consumed with a minimum of intellectual effort.[14] Nor did it attempt, at least in the beginning, to provide the very best facsimiles of high art or to be the modern "museum" for the bourgeois class, as was the ambition of *Ilustración Artística* or *Ilustración Española y Americana*. With its weekly fare of sketches, photographs, cartoons, and short articles, its equal celebration of the new and old, what *Blanco y Negro* created was a way for the reading public to envision Madrid as an exciting and heterogeneous city, where women as well as men, the elite as well as the middle classes, could see themselves displayed. Like Galdós, the great conjurer of Madrid's streets in his fiction, Luca de Tena came to recognize that Madrid was "a city formed by the convergence of flesh and stone, memory and myth, materiality and performance, delusion and fantasy."[15] Among

the differences between the way that Galdós displayed the city in his contemporary novels and the way that *Blanco y Negro* imagined it was the rose-colored lens through which the magazine's artists chose to view the diversity of Madrid's street life. For both, "the city and its inhabitants . . . are mutually constitutive,"[16] but consumers of the magazine could bask in the illusory fiction of a modern city where visual pleasures were accessible to all as was the magazine itself. *Blanco y Negro* could be found, as one fan put it in his congratulatory remark, "in the hands of all, never sullying the whitest and finest hands nor sullied by the crudest and dark-skinned hands."[17]

The inspiration for the format of the magazine was *Die Fliegende Blätter,* a German satirical magazine published in Munich from 1844 to 1944, which Luca de Tena came upon in his travels in Europe.[18] Despite the sizable competition *Blanco y Negro* faced—135 weeklies in Madrid alone by 1888, according to Pedro Gómez Aparicio[19]— and its relatively crude initial format and pictorial content, the magazine stepped in to fill an important gap. Its success in establishing a multiclass readership was owing to Luca de Tena's sizeable infusion of capital, along with a modern mode of production that allowed it to keep subscription prices low and to increase substantially its circulation compared with more expensive and therefore limited-run illustrated magazines.[20] While the popular magazine *Madrid Cómico* was using the more time-consuming lithography process, and *Ilustración Española y Americana* was for the most part using xylographic processes for its images, Luca de Tena was determined to produce a magazine by using almost exclusively the new photoengraving techniques used by magazines like *Die Fliegende Blätter.* Equally important, however, its visual and editorial content fused the interests of many classes of readers, giving face to

the "formless agglomeration" that was to make up Spain's emerging middle classes in the first decades of the twentieth century.

For most of the nineteenth century, the Spanish publishing industry was plagued by a lack of economic resources and was heavily dependent upon foreign technology and equipment. The lack of capital investment meant that founding a serial publication was at best a precarious undertaking, which explains the small runs and short duration—in many cases only a few years—of the majority of weekly periodicals. Most of the machinery and even the manpower to run it were imported from abroad at considerable expense to publishers. The rolling press, in use since the mid-century in England, the United States, and France, was slow to take hold in Spain. In 1894 there were only seven rolling presses in Spain that could print more than 10,000 pages per hour; most were still flat presses with a limited-run capacity.[21] Until the end of the century when the Spanish paper industry was finally able to supply most of the country's needs, paper as well had to be imported from abroad.

Experiments devised to stabilize or increase funding sources in large measure failed miserably. For example, in 1880 the "Sociedad Anónima del periódico La Europa" (La Europa Anonymous Society) formed to sell 600 shares to investors in order to fund a paper whose sole goal was to make a profit.[22] Despite the unanimous condemnation in the established press, this "periódico-lotería" (lottery periodical), as it was nicknamed, went forward, so named because subscribers automatically became part of a lottery, were assigned a number, and stood to win 1,000 *reales* if their number matched the national lottery number in the next drawing. The reaction to the paper in the mainstream press was so negative that it died within a period of months, but the experiment

was a harbinger of great changes to come in the press. A decade later *Blanco y Negro* launched its own version of the "periódico-lotería" in its very first month of publication, when it inaugurated its "Concursos mensuales con premios entre los suscriptores" (Monthly Contests with Prizes for Subscribers). Entrants had to provide numerical solutions to a series of mind-teasers. The contestant whose tallied number came closest to the number drawn in the national lottery would receive a prize, calculated in tenth shares of the national lottery, and his name or pseudonym would appear on a list of winners in the magazine. By this time, other types of contests were also becoming popular, among them photography contests that nearly every illustrated periodical sponsored from time to time.

As expanding markets became a priority and advertising a necessity, competing magazines accused one another of corrupting the media by turning it into a profit-driven industry.[23] The great secret was emerging that despite their protestations magazine publishers might be concerned with goals other than merely providing a public service or furthering the interests of a political party. Luca de Tena was quick to acknowledge that he would charge his readers whatever price was necessary to keep his magazine afloat, but vehemently denied that his sole interest was to profit financially from his magazine. At this time it was still unacceptable to admit to publishing a periodical for material gain. In its tenth-anniversary issue, Luca de Tena was still seeking to put to rest the "false legend" that he had launched his magazine for the express purpose of earning a profit through advertising. His claim was that for a long time *Blanco y Negro* included no advertising whatsoever and therefore could hardly be accused of being "a periodical for advertisements published without them."[24]

Such protestations are, of course, somewhat disingenuous. By its fourth year *Blanco y Negro* devoted approximately 30 percent of each issue to advertisements, which included between two and three pages at the beginning and five or six pages at the end. The percentage of advertising coverage fluctuated during the following years, for example, decreasing significantly during the period 1898–1900 and disappearing altogether for a few years in the early twentieth century. Yet the paper flourished, in part because it had managed to increase dramatically its circulation during the war years through superb photo reportage and was able to depend on other revenues in addition to advertisement.

Such gimmicks as the "Concurso mensual" (Monthly Contest) and the classified section called "Anuncios telegráficos" (Telegraphic Notices) helped to increase circulation, but the initial response to the magazine was favorable, mainly because it was so reasonably priced compared with the much larger folio-sized periodicals such as the *Ilustración Española y Americana* or the *Ilustración Ibérica,* priced at 1 peseta per issue.[25] In its first two years of publication, readers could purchase *Blanco y Negro* on a weekly basis at kiosks and cafés for 15 céntimos or have it delivered at approximately 11 percent below newsstand prices.[26] Domestically the cost per trimester was 2 pesetas and annually 7 pesetas.[27] Luca de Tena boasted in the second issue that 25,000 copies of the magazine had been sold the previous week, and by 1901 the run was 60,000, reaching 90,000 by 1910. Producing an illustrated magazine at such a low cost to the public was possible because of an initial capital investment drawn from family fortunes, which allowed him to increase circulation for several years without showing a profit. The affordable price alone, however, would not have sufficed

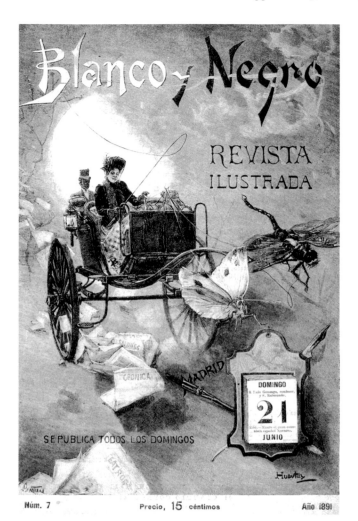

Fig.50 *Blanco y Negro,* 1 (21 June 1891), cover.

of the day including actresses, women singers, writers, and historical figures like the vivandière Dolores Cisnero of Figure 46.

The engraving by the Spanish watercolorist Angel de Huertas featured on the cover of each issue during the first year of production established a modern woman as the magazine's chief visual anchor: cracking her whip she appears to be riding off into the future, with her footman riding in back, not in front, in a tilbury drawn by a white butterfly and a black dragonfly, while below her swirl newspapers and notices of the day (fig. 50).[28] The title, *Blanco y Negro,* signaled the magazine's intention to focus on the contrasts of modern life, "laughter and tears, the serious and the festive, the formal and the caricaturesque, the sad and the happy, the grave and the trivial, all that white and black that surrounds us from the day we are born."[29] However, qualifying his statement, the editor expressed the hope that the "blanco" (white or pleasant) side of life with its many "bondades" (boons) would prevail, which in effect was the case until the height of the Cuban crisis. This policy meant adopting a festive tone even about the most serious events. In its first years, world events involving catastrophes or wars were rarely discussed, or if mentioned, were saccharized with jokes and aphorisms. Commenting on the civil war in Chile, the editor of the Modern Life section joked that extensive reports on the struggle published in the daily press were "so contradictory that they resemble a report of a bullfight judged by the enthusiasts of enemy matadors."[30] Cartoons satirizing important political events abounded, typical among them the 1892 cartoon-summary of January events (fig. 51)[31] that depicted attacking Arabs, communist bombs, political upheavals, and a scandal over a rise in the price of bread, serious problems affecting the nation, but treated lightheartedly in

to attract a large following if the content had been less appealing to a wide range of readers, including women, to whom the magazine made special appeals. For example, the "Vida moderna" (Modern Life) section each week featured one or more aspects of contemporary urban life: a recipe for "Huevos 'high life'" (High-life Eggs), news of the summer exit for northern vacation ports, the San Isidro processions and other celebrations, snippets of information about the luminaries

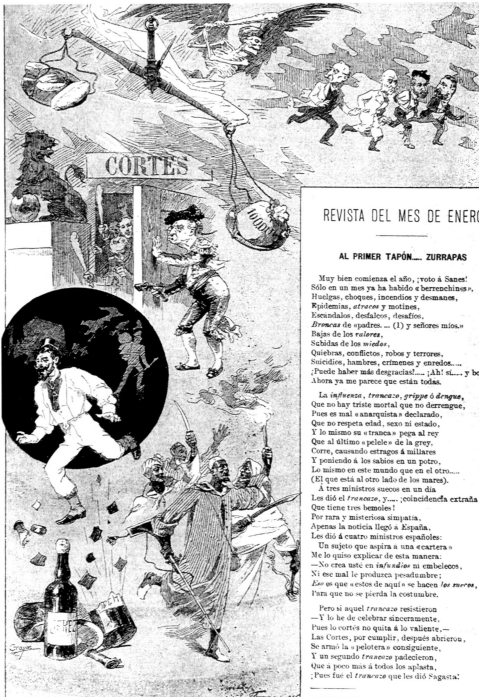

REVISTA DEL MES DE ENERO

AL PRIMER TAPÓN..... ZURRAPAS

Muy bien comienza el año, ¡voto á Sanes!
Sólo en un mes ya ha habido «berrenchines»,
Huelgas, choques, incendios y desmanes,
Epidemias, *atracos* y motines,
Escándalos, desfalcos, desafíos,
Broncas de «padres. ... (1) y señores míos.»
Bajas de los *valores*,
Subidas de los *miedos*,
Quiebras, conflictos, robos y terrores,
Suicidios, hambres, crímenes y enredos.....
¡Puede haber más desgracias!..... ¡Ah! si..... y bodas.
Ahora ya me parece que están todas.

La *influenza, trancazo, grippe* ó *dengue,*
Que no hay triste mortal que no derrengue,
Pues es mal «anarquista» declarado,
Que no respeta edad, sexo ni estado,
Y lo mismo su «tranca» pega al rey
Que al último «pelele» de la grey,
Corre, causando estragos á millares
Y poniendo á los sabios en un potro,
Lo mismo en este mundo que en el otro.....
(El que está al otro lado de los mares).
Á tres ministros suecos en un día
Les dió el *trancazo,* y..... ¡coincidencia extraña
Que tiene tres bemoles!
Por rara y misteriosa simpatía,
Apenas la noticia llegó á España,
Les dió á cuatro ministros españoles:
Un sujeto que aspira á una «cartera»
Me lo quiso explicar de esta manera:
—No crea usté en *infundios* ni embelecos,
Ni ese mal le produzca pesadumbre;
Eso es que «estos de aquí» se hacen *los suecos,*
Para que no se pierda la costumbre.

Pero si aquel *trancazo* resistieron
—Y lo he de celebrar sinceramente,
Pues lo cortés no quita á lo valiente,—
Las Cortes, por cumplir, después abrieron,
Se armó la «pelotera» consiguiente,
Y un segundo *trancazo* padecieron,
Que á poco más á todos los aplasta,
¡Pues fué el *trancazo* que les dió Sagasta!

(1) De la patria.

Fig. 51 "Revista del mes de enero," *Blanco y Negro* 1 (6 September 1891), 275.

most instances. Accompanying the cartoon was a poem enumerating the miseries of the preceding month, among them strikes, epidemics, fires, protests, robberies, suicides, and hunger: "Have I missed any disasters? . . . Ah, yes . . . and weddings! Now I think I've mentioned everything."[32]

BLANCO Y NEGRO'S HAPPY FAMILY

Devoid of photojournalism and intent primarily upon entertaining readers, *Blanco y Negro* in its first years resembled an ambitious version of the more specialized *Madrid Cómico*. Making light of grave events, the magazine's signature skill, instilled a sense of comfortable distance between world events and those not directly involved in them, sparing readers the political rankling that characterized Spain's daily newspapers. This does not mean, however, that other important issues, such as the reinforcing or the blurring of class distinctions, were not integral to the magazine's content. If anything, *Blanco y Negro* infused its pages with information, albeit in jocular style in most instances, about class conflict. In appealing to a wide market, *Blanco y Negro* wasn't really breaking down class divisions; it is more accurate to say rather that it trivialized them. For example, the 20 March 1892 issue included passages and figures from *El problema social* (*The Social Problem*) (1890), a satirical work by Nilo María Fabra based on the imagined consequences of the triumph of Communism followed by an anarchist dissolution of the government.[33] In one excerpt "Comrade Espáñez," Fabra's protagonist, reports how wonderful it feels to be liberated finally from the "tyranny of collectivities" now that the anarchist manifesto has triumphed. Stepping out into the street to relieve himself, something he is now able to do with impunity thanks to

his "liberation," he is fired upon by another individual exercising his individual freedom in the new order. Comrade Espáñez reacts by arming himself with as many weapons as he can find, "feeling in his full rights as an individual" to escalate the violence.[34] Continuing his excursion, he purchases the Communist newspaper *The Exterminator,* where he reads reports of a fire set by anarchists in the Puerta de la Humanidad, formerly the Puerta del Sol. It seems the world has come to this, he concludes; social progress can be only achieved through violence. The more accurate, if unstated, message of Fabra's satire is that maintaining the status quo is the sanest response to social unrest, an ideological stance that best characterizes *Blanco y Negro*'s unstated editorial policies in the 1890s.

It is not an uncaring bourgeoisie that is the target of many of these satirical pieces on what was known at the time as "the social question"— even though the bourgeoisie comes in for its share of lampooning—but rather the proletariat poised to strike back at their oppressors using violent means. In other words, *Blanco y Negro* indulged in the kind of ridicule common in the state-sponsored press, which often portrayed workers' organizations and struggles as farce. In a typical example, Eduardo de Palacio's parody of a labor meeting in the April 1892 issue ends with a conversation between two men, their spats, high hats, and canes signaling their elite class status. They have just attended a political rally filled with talk of violence against the bourgeoisie. When asked what he thinks about the "social problem," one of the men responds "Ah, yes . . . , well . . . , it has demonstrated the necessity of the cremation of the working classes."[35]

Not all jocular images of working-class subjects depicted raging anarchists. In fact, the predominant graphic take on the working class

told quite a different story, often of contented factory workers enjoying the simple pleasures in the company of wife and children. Such images served two ideological purposes: they strengthened the cult of the "ángel del hogar" (domestic angel) by showing working-class women happily attending to domestic responsibilities, and they idealized the factory worker by showing him not at hard and often dangerous labor, as was actually the case, but enjoying his leisure time surrounded by loved ones. In the rapturous vignette "¡Ya somos tres!" (Now We Are Three!) by Álvaro Alcalá Galiano, featured on the cover of the 16 February 1895 issue (fig. 52),[36] a construction worker lunches on the ground during the noon-hour break, his wife by his side feeding their new baby.[37] The author of the caption identifies the artist Alcalá Galiano as the "Count of Real Aprecio" (possibly undermining the saccharine tone of the piece, since the translation of "Real Aprecio" is Real Appreciation), who has demonstrated his skill at depicting the life of humble workers. Their happiness, he further reports, immunizes the couple from the temptations of luxury surrounding them: "[T]he couple are far from the life of merry activity, and, separated from the street by the rustic barricade that surrounds the worksite; they listen indifferently to the rumbling of luxurious carriages and the chatter of passersby, intent solely on the face of their child and his adorable little hands."[38] This happy worker, the commentator exults, would not trade his workingman's lunch "for the most succulent on earth." Accustomed to hard labor, he is "content with his day's work that offers him such sweet solutions of continuity."[39] Obviously family "continuity" was the theme of the image, but the unstated preoccupation was also with the continuity of a working class ignorant of class consciousness.

Blanco y Negro reveled in this type of "blanco" or "light" graphics of Madrid types and in platitudes about happy workers who wouldn't trade their life for all the riches of the world. At the same time, it lampooned the nouveau riche who struggled to climb the social ladder like the vulgar Juan Pérez Pulga, who in one issue is suddenly transformed into the obnoxious Juan de Pérez y Pulgar, disguising his humble roots by adding the "y" (and) between his surnames and transforming Pulga (flea in Spanish) into a more dignified Pulgar (thumb) in his family name. More idealized portraits of Madrid popular types were also scattered throughout every issue, creating the image of Madrid as a heterogeneous city that celebrated its diversity and the bustle of its streets, something that the popular artist Narciso Méndez Bringa sketched with special gusto. Among the crowd of street vendors in Méndez Bringa's "La lista grande" (The Long List) (fig. 53)[40] is a young boy hawking the newspaper with the list of Christmas lottery numbers for sale; the paper is being eagerly snatched up by the crowd pressing around him. Behind him, Madrid appears as an ebullient, vibrant city where top hats rub shoulders with humble headscarves and carriages vie for space with fishmongers. Frequent features such as the "Fotografías instantáneas" (Snapshots) and "Tipos callejeros de Madrid" (Madrid Street Types) featured middle-class shopkeepers, hairdressers, delivery men, street hawkers, florists, seamstresses, and especially entertainers, all seemingly happy to be where and who they are.

Not limiting itself to society pages devoted to images and descriptions of balls and theater debuts, *Blanco y Negro* delighted its readers by depicting and gossiping about all types of popular entertainment and activities, from the perennial "Tren botijo" (Jug Train) transporting

¡YA SOMOS TRES!

COMPOSICIÓN Y DIBUJO DE D. ALVARO ALCALÁ GALIANO

*Fig.*52 (above) "¡Ya somos tres!" *Blanco y Negro* 5
(16 February 1895), cover.

*Fig.*53 (right) Narciso Méndez Bringa, "La lista grande,"
Blanco y Negro 4 (29 December 1894), 858.

middle-class passengers to summer vacations (fig. 44)[41] to open-air tertulias and pilgrimages, bullfights, flamenco revues and dance hall shows. It also treated readers to numerous graphic depictions of the hobby of woman-watching, a subject that never seemed to lose its popularity in the illustrated magazines of whatever artistic ambition and refinement.[42] According to Álvarez Junco, people learned what it meant to be Spanish in the first half of the nineteenth century when they were bombarded by neo-Catholic propaganda about a seemingly homogeneous religious heritage. By promoting a local and secular meaning of identity based on shared interests, especially leisure interests, rather than one based on shared values emanating from a religion-oriented past, in the second half of the century Spanish magazines helped to forge the identity of the modern city dweller for whom entertainment and gossip were more vital activities than was religion. This is particularly true both for *Blanco y Negro* and for its rival *Nuevo Mundo,* whose readers were presumed to be interested not only in Spanish and European royalty, world events, and local politics but in circus shows (especially the Parish Circus), café culture, bullfights, and all manner of trivial happenings on the street.

Despite the frivolity evident in its first years of publication, as its popularity grew *Blanco y Negro* began to take itself more seriously. In fact, in its second year of publication it underwent several radical transformations that eventually consolidated its image as Madrid's most panoramic and ambitious illustrated magazine, one that selectively fused features of the old-fashioned gazettes, the more high-brow art magazines, weekly news chronicles, satirical rags, and gossip magazines. Among the changes that year were the introduction of an occasional feature called "Arte nuevo" (New Art), with a special focus on Spanish

painters, and a new weekly section entitled "Efemérides ilustradas" (Famous Birthdays), features that with time would be renamed but that would remain a central part of *Blanco y Negro*'s offerings in years to come. The daring woman with whip in hand who had been the magazine's trademark visual disappeared: on the cover of each issue in 1892 was a portrait of a famous man whose anniversary the magazine celebrated in its pages. Most were Spanish kings or famous authors, among them Felipe V, Calderón de la Barca, Charles I, and José Zorrilla, although a few foreign luminaries such as Johannes Gutenberg shared in the glory. Later in the year the "Lo que dicen las estatuas" (What the Statues Have to Say) feature, indirectly participating in what has been dubbed the "monument fever" of the era,[43] shifted the focus from famous men to statues of famous men and mythological figures that city dwellers passed on their way to work or during their promenades and shopping: the Duke of Olivares, Neptune, Calderón de la Barca, Charles II, Álvaro de Bazán, and Apollo. Now, in addition to hearing of the exploits of past greats, subscribers read of the triumphs and indignities of the Spanish state as seen through the eyes of their less than glorious living descendants. Readers could bask in the idea that while Spain's imperial glory may have been eclipsed, there remained, in the form of statues, a storehouse of memorable heroes to remind them of the nation's rightful place in the history of the world *and* a host of magazine articles touting the past exploits of these heroes as a form of civic and national pride.

NOTING COLOR

The greatest triumph commemorated in 1892 was, predictably, the "discovery" of

America. Marking the 400th anniversary of Columbus's transatlantic voyage, a spate of features that year discussed or graphically depicted his exploits, some in a serious and laudatory fashion, others in the jocular tone that was by then the magazine's hallmark. Columbus's Genovesan origins were generally omitted: "[E]verything about him is obscure: his family, lineage, calculations, profession, arrival, and history," wrote Manuel del Palacio in his eulogistic poem.[44] This, even though Pope Leon XIII had written a letter to the archbishops and bishops of Spain, Italy, and the Americas identifying Columbus as "a man born in Liguria."[45] Rafael García Santisteban opined that Columbus's glory should rightly be shared by Queen Isabel I, who after all sacrificed her jewels to fund his expedition.[46] Modesto Lafuente had Columbus share honors with the "benevolent and kindly" Cardenal Pedro González de Mendoza, who first lent his ear to the proposed expedition, and to the Dominican priest Diego de Deza, later the Archbishop of Seville, who became Columbus's host and protector.[47] In that same issue editors published no fewer than five portraits of Columbus, together with an account of his departure from Palos, a fragment of a comedy entitled *El nuevo mundo descubierto por Colón* (*The New World Discovered by Columbus*) by Lope de Vega, and a selection from Columbus's diary describing the disembarking and claiming of land in the name of the King and Queen of Spain. Thanks to this steady diet of hero worship in the press leading up to the October 12 commemoration date, Columbus was dusted off as the preeminent symbol of Spanish exploits, contributing to the mythification of past triumphs that reflected Spain's growing nationalist ardor and its unease with European expansionism, this despite the often jocular style of the reporting.[48]

The fervor surrounding the Columbus centennial tributes in literally every national newspaper and magazine in 1892 was bound to inspire *Blanco y Negro*'s satirical writers. Manuel Matoses poked fun at the conferences organized by provincial governments to celebrate the discovery.[49] Luis Royo Villanova wondered whether the Pope was on the verge of canonizing "San Cristóbal" and summarized the views of detractors who scoffed that "Columbus had been no more than the founder of modern ultramarine commerce."[50] The September 25 issue included Juan Pérez Zúñiga's account of festivities in the town of Valdepitorros, where the mayor had erected a statue of Columbus bearing aloft a wineskin; Pérez Zúñiga speculated that no enterprise of this sort could possibly have succeeded without wine.[51] Included in the festivities would be a musical contest to reward the best song about Columbus's arrival in Ribera de Curtidores and a literary contest on one of three topics: Is pea-bean coffee the one most preferred by men? Do the widows of macaws have a right to widowhood? Is it true that Columbus's sailing companion Pinzón was addicted to tiger-nut drink? The Valdepitorros festivities included an art exposition of ultramar objects from the Bazaar of the Americas and regattas in the mayor's well, followed by a municipal banquet with American dishes such as "albóndigas del Canadá" (Canadian meatballs) and "ponche a la mejicana recién ordeñado" (freshly milked punch à la Mexicana); popular Indian dances; and a parade of horsemen in costumes resembling Columbus and his family, the Catholic kings, and sailors from the Pinta, Niña, and Santa María.[52]

Among the sketches that accompanied descriptions of the festival in Valdepitorros is the cartoonist Ramón Cilla's depiction of a pair of partially nude dancers reportedly demonstrating

one of the popular Indian dances mentioned in the text (habaneras, guarachas, guajiras, tangos, and zorongos) (fig. 54).[53] Such grotesque caricatures, while shocking to modern sensitivities, were not an unusual sight in nineteenth-century illustrated periodicals. Beginning in the 1870s, more serious periodicals such as *El Museo Universal,* forerunner of the prestigious *Ilustración Española y Americana,* had taken a keen interest in ethnicity and regularly featured groupings of "natives" in their natural settings, and this practice continued into the twentieth century.[54] Although these ethnographic depictions, more respectable than those of *Blanco y Negro,* dominated the mainstream press throughout Europe, even in the most sedate periodicals cartoonists were at liberty to distort the black body for comic effect. The greater the geographic distance from Spain and the darker the skin of the subjects depicted, the more license cartoonists took in their caricatures. The message of ethnic caricatures, however, was often ambiguous if not contradictory: some stressed the immense cultural and physical differences of the peoples of remote lands compared with the civilized white Europeans. Others, on the contrary, waived differences to demonstrate that similar customs prevail in even the most remote locales of the world, as evidence of universal human tendencies such as masculine bravery and ingenuity, or feminine maternalness or greed. Finally, others stressed the tendency for subaltern societies to imitate in grotesque fashion the customs and dress of their colonists. For example, the image published in 1898 in the satirical magazine *El Gato Negro* (fig. 55)[55] manages to relay several messages at once: the exaggerated dress of the "negrita" (young black woman) sipping a drink in a Barcelona bar imitates a European fashion from another era, which the cartoonist has accentuated in such a way as to

highlight the absurdity of the woman's attire. The remark of the cigar-smoking dandy to his friend, "But what, Are you dedicating yourself to courting young Black women now?"[56] suggests not just the absurdity of Africans dressed in Western clothing but the impropriety of unaccompanied women sipping drinks in a bar and white men socializing with women of another race. At the same time, however, the picture hints that some human impulses are blind to racial difference and therefore universal.

The distorted Valdepitorros revelers are similarly much more complex figures than they at first glance appear to be. Obvious to any modern reader is the fact that they resemble stock caricatures of African tribal dancers, with rings in their noses that mark them as "savages" in the idiom of nineteenth-century iconography. In their movements, however, the dancers seem to be imitating the then-popular "cakewalk," a dance that originated in rural North America among black plantation slaves. The form for the cakewalk may have derived from a ritual procession of the Seminole Indians, while the dropping of the hands and bending backward of the body resembled certain dances of the African Kaffir, although there are many different possible origins of this American dance. Part African, part indigenous American, and part parody of upper-class ball dances, the cakewalk eventually crossed from black to white society and was imported to France, where it became wildly popular around the time this image was generated. Ever intrigued by the fads of its neighbor to the north, Spanish magazines as well caught the "cakewalk" fever within just a few years. The humorous magazine *Barcelona Cómica* published several small vignettes during the Cuban uprising, one of Cuban women doing the cakewalk with Spanish soldiers in 1896, and another of Afro-Cuban

men with cakewalk hand gestures, dancing to the script "Let's dance, niño, let's dance, 'cause they say Weyler is coming."[57] In 1903, *Blanco y Negro*'s major competitor, *Nuevo Mundo,* published a nine-frame collage depicting the cakewalk, which it claimed was the rage in aristocratic salons, especially during carnival.[58] The photograph sequence is followed by a musical score for Terpsichore. Not to be outdone, Barcelona's *Ilustración Artística* that same year published a cartoon by Tom Brawne entitled "El Cake-Walk en su país de origen" (The Cakewalk in Its Country of Origin), together with a photograph of a Parisian version of the cakewalk from the Branger-Doyé studios (fig. 56).[59] The commentator's description of the dancers' "grotesque exercises" published in *Ilustración Artística* fits the image published several years earlier by *Blanco y Negro* of the dancers of Valdepitorros: "The characteristic step of the *Cake Walk* evokes the image of a dog obliged to stand on its rear legs: the dancer advances with short hops, hands gathered towards the chest and executing the most violent and exaggerated contortions, to the sound of a strange music of the *banjo* players."[60] The high-stepping "indios," or rather the white residents of Valdepitorros smeared in bootblack, as Pérez Zúñiga improbably describes them in his piece, reflect the sustained fascination with ethnic otherness that marked popular journalism in the late nineteenth century. How-to vignettes, such as those mentioned here, also show how fads originating in the popular classes were percolating upward and also circulating from country to country via the popular graphic magazine.

This fascination with exotic otherness and the popular classes often spilled over into depictions of Spanish regional types. Among the frequent features of *Blanco y Negro* in its first years was the "Nota de color" (Color Note), brief articles

by the Malagueñan poet Salvador Rueda, illustrated with sketches of exoticized figures, often of Gypsies such as "Perico the Gypsy," "Queen Mercedes," or "Anacleta the Flamenco dancer." Unlike the so-called Oriental Gypsies that abounded in elite periodicals such as *Ilustración Artística* or *Ilustración Española y Americana,* the Gypsies decorating *Blanco y Negro*'s pages are invariably Andalusian types, often crudely rendered by the magazine's artists.[61] Rueda's eulogistic portraits are evidence of the new tendency of dominant Spanish culture to capitalize on its colorful Gypsies, who had by this time acquired the status of world tourist attractions, especially for wealthy British and French travelers. Who better than a savvy Andalusian businessman like Luca de Tena to recognize their rentability and give them a prominent exposure in Madrid society. These images simultaneously allowed Spanish middle-class readers to understand and accept an idealized version of Spanish multiculturalism that was further validated in the dozens of stylized photographs of local types such as those of Jean Laurent, which dotted the periodical. Rueda's quick studies, not unlike the highly articulated engraving of Mignon (fig. 31), sought to capture the "essence" of Gypsy spirit over which Spaniards had a certain cultural claim, judging from the prominence given to them in *Blanco y Negro*'s pages. As I argue elsewhere, this Gypsy "essence," which in Northern Europe was already a generic representation of Spanishness, was beginning to find favor with the general public, thanks in no small part to the myriad images of happy-go-lucky Gypsies that appeared regularly in the pages of *Blanco y Negro*.

The Laurent studio photographs of "real" Gypsies, while providing an antidote to the stylized Gypsy that was so popular in the pages of *Blanco y Negro*, also belonged to the category

LA ETIQUETA AL COLMO, POR MR. G. RI

—¿Pero qué? ¿Te dedicas ahora á hacer el amor á las negritas?

Fig.54 (upper left) *Blanco y Negro* 2 (25 September 1892), 612.

Fig.55 (above) G. Ri., "La etiqueta al colmo," *El Gato Negro*, 1 (26 March 1898), 4.

Fig.56 (lower left) *Ilustración Artística* 22 (30 March 1903), 223.

TIPOS POPULARES ESPAÑOLES

Fig.57 "Tipos populares españoles," *Blanco y Negro* 3 (23 September 1893), cover.

of popular ethnic types, although they served a slightly different purpose. The photograph presented itself as an analogue of a physical dimension, often leaving the impression that what was important was the documentation of a truth forever captured and preserved in the photograph. Thanks to these photographs, *Blanco y Negro's* bourgeois and middle-class readers could measure the "true" gulf that separated them from the rural and regional Spanish types that the Laurent studios were supplying to illustrated magazines. Typically showing a man and a woman posing stiffly in regional dress against a stark or blank background, these photos served as a reminder

to urban dwellers of vanishing costumes and traditions kept alive now thanks to print media serving as a faithful repository of Spanish cultural diversity. Together with the sketches of local types by the artist Joaquín Araujo, they turned the magazine into a veritable encyclopedia of Spanish regional types. Their contribution to the creation of a Spanish nationalism is complex. In their "tipismo" (typicality) they evoke the local-color sketch so popular in the literature of the first half of the century; thus they respond to a nostalgia for a fading past. Magazine editors, however, called on readers to embrace their Spanishness, situating them, however improbably, in contemporary historical events. Of the two "Campesinos de la Provincia de Toledo" (Rustics from the Province of Toledo) (fig. 57),[62] for example, the commentator constructs the following imaginary scenario: "Here we have the Toledan pair in their party finery, as if the photographer had surprised them upon leaving church or en route to visit the imperial city the Cristo de la Luz and the famous Custodia of the Cathedral. Today, perhaps they are required to dress in mourning after having lost some member of their family in the horrendous flood of Villa cañas, although in such great national disasters, mourning touches equally the greater Spanish family."[63] Part travelogue, part news item, and part nationalistic appeal, the remarks of the commentator folded the highly posed Toledan couple into the nation's "greater family" of citizens.

By turns demonized and idealized, Moroccans, especially Moroccan men, were also an object of intense interest in the years preceding the Spanish-American War, when racist images of black Cuban soldiers began to share space with North African caricatures. The stereotyped Arab male, a popular icon in the Spanish press long before *Blanco y Negro* began publication,

embodied fanaticism, violence, tyranny, and backwardness; in short, he belonged to a belligerent race that should be kept in check. Sketch artists kept the magazine supplied with images of soldiers stationed at the Spanish garrisons of Melilla and Ceuta, ever watchful for the "grito de guerra" (war cry) of Rif Kabilas, like the one in Figure 58,[64] at war with the sultan. Rif soldiers, according to the Andalusian journalist José García Rufino writing in 1892, are a "race of fanatic warriors" born to live in "perpetual struggle and constant agitation."[65] As we have seen, the two images of the sultan in Figure 38, one an art engraving and the second taken from a photograph, attempted to register a realistic version of the Moroccan, but in the 1890s such jolting reality-check images were still the exception. More typically, magazine editors called on readers explicitly to contrast the fierceness and treachery of Moroccans with the bravery, nobility, and civility of Spanish soldiers. Facing off on subsequent pages in 1893 is the artist Araujo's alert and well-equipped Spanish soldier guarding the Spanish fort, and a sensuous and slightly sinister-looking, bare-shouldered Moroccan soldier guarding a mosque (Figs. 59 & 60).[66] Descriptions of the previous African War of 1860 and subsequent skirmishes along the northern coast of Africa appealed to a patriotic zeal that was waning in many parts of Spain (especially among those populations most often conscripted and unable to afford indemnity fees), even among some politicians. The result was a prolonged campaign in the press to demonize Moroccans by emphasizing their warlike, threatening presence so close to Spanish shores. This tendency was especially prevalent in 1893 when this image was published. Fresh recruits sent to Melilla that year had invaded the area surrounding a mosque, which provoked a series of armed attacks by

Fig.58 "El grito de guerra: Jefe de Kabila excitando a los suyos al combate," *Blanco y Negro* 3 (1 November 1893), 723.

the Berbers and resulted in fierce fighting and numerous Spanish casualties.[67] Demonstrators in several Spanish cities demanded reprisals, and talk of war escalated. Although depicted in the press as popular outcries, Álvarez Junco points out that these protests were "spearheaded by the upper middle classes, possibly professionals and intellectuals, in many cases with liberal or even Republican tendencies,"[68] a description that fits well one of *Blanco y Negro*'s targeted audiences and its self-styled "liberal" director Luca de Tena.

Blanco y Negro was at the forefront of appeals to past valor that flooded the pages of all the illustrated magazines during this period. In "¡El moro, el moro!" (The Moor! The Moor!), the

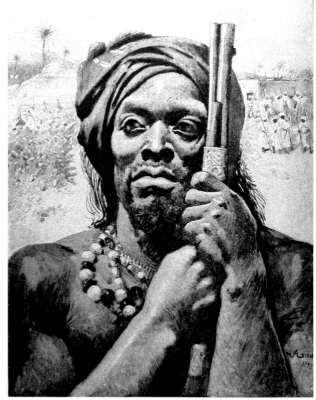

Fig.59 (above) *Blanco y Negro* 3 (9 December 1893), 809.

Fig.60 (right) *Blanco y Negro* 3 (9 December 1893), 810.

NOTA DE ACTUALIDAD

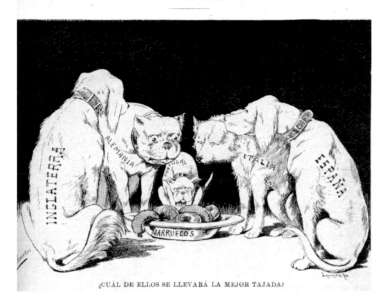

¿CUÁL DE ELLOS SE LLEVARÁ LA MEJOR TAJADA?

Fig. 61 "¿Cuál de ellos se llevará la mejor tajada?" *Blanco y Negro* 4 (23 June 1894), 401.

former soldier José Ibáñez Marín recalled an 1888 expedition in which a disheartened and weary group of Spanish soldiers suddenly rallied when faced with the enemy. Such patriotic vignettes worked by linking an appeal to Spanish manhood with racial superiority and territorial sovereignty, a topic that is further explored in the following chapter. Gaining sight of Ceuta from the crest of a hill, the battalion of tattered soldiers accompanying Ibáñez Marín

> exhibited once more a manly animation . . . experiencing something inexplicable, imperious, and sublime running through their veins, something that transformed and inflamed them, awakening illusions and grandeur, the rewards of a less paltry and sad future than the one offered today to good patriots by the current batch of statisticians. The phrases of those rude soldiers embodied the aspiration of

a race, the ideal amassed by strong and honorable generations, that we will have to accomplish, despite the pencil pushers, qualifications, pusillanimity, and meanness of those both inside and outside the house.[69]

By "outside the house" ("fuera de casa") Ibáñez Marín was referring to foreign interests that at the time were carving up Morocco, much to the chagrin of Spanish nationalists such as the ones who had organized the street demonstrations calling for retribution the previous year. "¿Cuál de ellos se llevará la mejor tajada?" (Which of Them Will Take the Biggest Slice?) asked the cartoonist Laporta (fig. 61),[70] as the Spain-dog stands slightly farther back in the pack of eager canines from England, Germany, Italy, and Portugal, all of them eyeing the plump sausages labeled Morocco. Laporta's cartoon suggests that the threat to Spain's colonialist aspirations

in Morocco come from neighbors to the north more than from the Kabilas attacking the sultan from the south.

A MARVELOUS AND MODERN FLUID

By 1893 *Blanco y Negro,* while still eulogizing the famous and dead, was increasing its coverage of the living luminaries of the day as well as their less than illustrious compatriots. Luis Royo Vilanova's weekly installment of "A ocho días vista" (Seen in the Last Eight Days), a satirical recap of events of the preceding week adorned with cartoon caricatures such as those in Figure 44, offered a potpourri of "lite" news items reported with wit and insider jokes. The goal was the right mix of select happenings attended by the stars of society and witnessed (or imagined) by magazine reporters, and large populist events like the bullfight, which affected large numbers of readers. The goal of *Blanco y Negro* was, despite the professed liberal leanings of its founder, not to serve a particular party or philosophy but to increase circulation by the most efficacious means possible, and this in turn secreted an ideology that was essentially conservative in vision. By then Luca de Tena had purchased two rolling presses, "two magnificent and advanced rolling press machines identical to the ones employed by *The Illustrated Figaro,*"[71] and had contracted for professional photographers to supply a growing demand for images of living politicians, intellectuals, and men and women in the entertainment industry. But just as the magazine was poised to become the prototype of the modern magazine dedicated to cultural news, entertainment, and lifestyles of both the rich and famous and Madrid's "popular" classes, Spain was edging toward a disastrous struggle to hold onto its last

colonies in Puerto Rico, Cuba, and the Philippines. As we shall see in more detail in Chapter 4, from 1895 to 1899 the magazine underwent another radical content transformation to reflect the somber mood of the times. Straightforward reports of bombings in Barcelona and political disturbances elsewhere in Europe also mirrored the growing fear of anarchism that prompted government-sponsored papers to portray social change as dangerous to national stability. Angel de Huertas's airy engravings of charming feminine sirens surrendered to sketches of battles and soldiers. Politics dominated the editorial pages, and a more serious tone all but replaced the satire that was relegated to the "A ocho días vista" section. This section, as we shall see in the following chapter, was subsequently all but eclipsed by the serious events of the day that called for a new kind of journalism.

At one with the majority of daily newspapers and sister publications, *Blanco y Negro* clouded Spanish colonialist ambitions with a steady diet of righteous and paternalistic pronouncements. Inhabitants of Cuba and the Philippines were either naive children blind to the fact that their connection to Spain was beneficial, or "true savages"[72] and "Spain's ingrate children,"[73] when large numbers of Cubans joined the revolt and guerilla tactics inflicted significant losses on the Spanish army. A swift and complete victory over the insurgents was repeatedly predicted even up to the last months of the war in 1898,[74] although complaints about censorship and army preparedness crept into the editorial pages. Cuba, often referred to as Spain's "most beautiful island" during the early military campaigns, became an inhospitable place full of "endemic illnesses,"[75] where brave Spanish soldiers perished while protecting the remnants of the empire. Through it all, the magazine lulled readers into believing in

Spain's rightful stewardship of the islands because of its might as a modern military state, its superiority and responsibility as a civilized nation, its racial affinity with the inhabitants, and, above all, its right as original colonizer to tap the natural resources.

One of the sidelines of the sudden interest in current events was a surge in the number of commemorations of past wars in which Spanish soldiers had triumphed, together with fictional accounts of individual valor such as the short stories "Marcha militar" (Military March)[76] or "Los dientes de la vieja" (The Old Lady's Teeth),[77] about battles waged during the Carlist Wars. Narrations of the previous Cuban rebellion and the generals who suppressed it that led to the September 1878 Zanjón Peace Accord were especially popular and helped to reassure readers of Spain's ability to cope with the new uprising. Art images of soldiers increasingly were featured as the magazine's principal visual anchor, either on the cover or in full-page images, among them B. Gili Roig's "Un héroe del dos de mayo" (A May 2d Hero), illustrating Juan Pérez de Guzmán's description of the aftermath of the War of 1808.[78] The popular artist Enrique Estévez was commissioned to produce sketches representing scenes of Spanish bravery, which included "De avanzada en la Manigua" (Advancing in the Jungle);[79] "El médico Orad en Cuba" (Doctor Orad in Cuba);[80] "A las filas" (To the Ranks);[81] and "Luchando por la patria" (Fighting for the Fatherland).[82] Less idealized perhaps but much more numerous were hundreds of sketches and photographs of lieutenant colonels and admirals, modern weaponry and ships, military maneuvers and encampments. The increase in war imagery, nevertheless, did not result in a wholesale emphasis on the "negro" or "dark" side of life. In fact, in 1897, although it did not altogether abandon news of the war, *Blanco*

y Negro once again increased its coverage of the "blanco" side of life. Between 1895 and 1897, the general editorial line was still one of optimism and high spirits, with frequent predictions of "the rapid extinction of rebel groups,"[83] which characterized the rhetoric following the 24 February 1895 uprising known as the "Grito de Baire" (The Cry of Baire) in Cuba.

Although by 1896 the magazine had adopted a more sober tone with political commentary and photojournalism replacing the "tipos callejeras" (street types) of previous years, circulation continued to increase during the war years; this indicated, if not a more sophisticated readership, at least one that demanded to be well informed about international events. In March 1896 *Blanco y Negro* flexed its muscle by alleging that its circulation far exceeded that of its rival *Nuevo Mundo*, with average press runs of more than 45,000.[84] This repeated assertion was in part a response to its rival's claim that it, and not *Blanco y Negro*, was "the periodical with the largest run of any illustrated magazine."[85] Bolstered by his success and eager to surpass all his rivals such as the fledgling *Nuevo Mundo*, in August of that same year Luca de Tena announced plans to construct a four-story, 13,000 square foot plant on Serrano Street, one of the costliest locations in the city, which would house all new machinery, including rolling presses and the most modern photoengraving equipment, purchased in Germany. When work on the new plant was completed, *Blanco y Negro* would at last occupy what Luca de Tena imagined as "the place that the culture of the Spanish public deserves" in the European press.[86] This costly and risky move was in response not just to increased circulation but to Luca de Tena's unbridled ambition and matching economic resources. It was his success in previous business ventures that helped to forge his plans to convert

Fig. 62 *Blanco y Negro* 9 (4 February 1899), cover.

the magazine into a capitalist enterprise like any other. With this challenge to revolutionize the magazine industry before him, he became more interested in the daily workings of the press than in the cosmetics and oil processing plants in which his family had made their fortune.[87]

The move to Serrano Street was completed in 1899, at which time the magazine produced a special number with an image of the "Casa de Blanco y Negro" (The Blanco y Negro House) on its cover, followed by a self-congratulatory "inventory of our resources."[88] *Blanco y Negro* was, José Gutiérrez Abascal (also known as Kasabal) boasted, the only Spanish magazine to occupy its own publishing plant. Designed by the architect

José López Salaverri, the neoplateresque building was a marvel of technological and spatial design (fig. 62).[89] With its two forty-horsepower steam engines, elevators, photoengraving department, library, reading rooms, administrative offices, and sumptuously decorated reception rooms, the new plant resembled a palace dedicated to modernity, as befitting a magazine striving almost compulsively to have something new to offer its readers in every issue. Eusebio Blasco described it as such in his glowing tribute: "This White and Black palace, these thousands of *duros* spent on such stairways, galleries, offices, salons, whose sketches are included in these pages, represent the triumph, the apotheosis of the modern chronicle and image."[90]

By this time *Blanco y Negro* had a workforce of 105 employees and 756 correspondents and news agents, and in its inventory of resources it dwelled on the advantages that its happy "family" of workers enjoyed. Luca de Tena was especially proud of the salaries he paid his full-time workers in the plant, which he claimed exceeded those of other periodicals and helped to maintain a steady and highly skilled workforce.[91] The floor where machinists worked was well lit and spacious, with "all manner of conveniences," including good ventilation, bathrooms, and a lunchroom with a steam-heated stove that employees could use to heat their food. Intense but indirect lighting in the type-setting room meant that typesetters did not have to strain their eyes, an accommodation that José Echegaray predicted would more than pay for itself: "[T]he worker's retina has to be cared for; the marvels of electric light should not be a convenience only for the rich." Emilio Burgos expanded on Echegaray's comments with a description of the perfect fit between intelligent worker and machine, which was among the magazine's chief assets:

An intelligent workforce, active and select, occupies the diverse workshops mounted in the house; they run the complicated machines, putting brain and brawn to the service of the idea of capital and, in short, contributing with dignity to the result of the common labor required by this contest of the intellect in its most minute and insignificant details.

The *Blanco y Negro* operator is not, consequently, that miserable, vulgar worker whose physical strength is the only attribute that is esteemed and remunerated, nor that routine worker who day after day performs the same task like bees and beavers.[92]

Blanco y Negro employees were not drones, according to Burgos, because they were assigned a variety of activities and, if gifted and hard working, could hope to land a supervisory role, perhaps as operator of one of the complicated German machines that were the pride of the enterprise.

The Serrano plant functioned almost completely on electricity, a singular achievement, which inspired José Echegaray to compare the entire enterprise to a great electric clock: "[E]verything wound in perfect unison, as if it were a giant electric clock in which the pieces, large and small, were subject to the flux of what we could call a marvelous and modern fluid."[93] The strength of any industry, he continued, should be measured by the power that circulates through it, and with its more than sixty voltage-storing batteries, the new plant could keep humming all through the day and night, storing excess energy for the following day. Electricity ran the clocks, the 300 incandescent lights, the ventilation fans, the hydraulic lifts, most of the machinery such as the paper-folding apparatus, and even, wonder of wonders, an apparatus for lighting cigars: "One could even say that the thinking is electric; people discuss, print, sketch, engrave, and work electrically. And the general impression is one of cleanliness, order, harmony, and light."[94] All this, he marveled, without government intervention: the administration *of Blanco y Negro* boasted that it was an independent capitalist enterprise, run "not by government mandate, not by the laws of the State, not by the powers that be, but by the free and intelligent activity of men, the creators of this important industry." If a national regeneration is to occur in Spain, in the opinion of Echegaray, "That is the only way!" Reform must come from the public sector (of private individuals) that he referred to as the "social mass," and it must be based on individual effort and achievement. *Blanco y Negro* thus advertised itself as a prime example of the positive benefits of free enterprise. In fact, underlying the entire "inventory of resources" was the message that the salubrious effects of industrial modernization and worker-employer cooperation fostered better, more efficient, business practices and ensured success. It must be said, nevertheless, that the topic of financial solvency or profits was pointedly absent from the discussion in the special inventory issue, nor was any mention made of the less than "convenient" nightshift workers who stoked the fires, or the tedium of working in the typesetting and press rooms that no amount of electricity could abate.

The vast *Blanco y Negro* "family," whose writers and administrative hierarchy are pictured in the pages of the "inventory," was now in possession of a "house" worthy of its capitalistic mission. The mysterious physical forces that supplied its energy surged from beneath the building upward. Not surprisingly, Luca de Tena located the head of the great "house" and its administrative officers on the upper floors, while he

installed the machinery on the lower level. It was, in the words of the architect Vicente Lampérez y Romea, only appropriate that this giant, harmonious body be arranged anthropomorphically to reflect its masters: "The physical forces are transmitted by unseen arteries up from the lowest levels where they are created; from the upper stories descend the intellectual forces: written ideas and artistic thoughts, and when the two forces meet, fused together in the tight embrace of the steal musculature of those presses, they spit out, in mountains of paper, the product of the labor of the house."[95]

A HUMOROUS "REGENERATION"

In the wake of the 1898 defeat, the Spanish press on the whole became introspective, and the word "regeneration" entered the editorial lexicon with increasing insistence. *Blanco y Negro* participated marginally in the debates, as in the above passage that promoted individual enterprise as the key to regeneration, but quickly saw its fortunes hinging on a fare lighter than earlier, which after 1898 again became the signature style of the magazine. Spain that year was in the grips of important parliamentary elections pursuant to the war, and the political coverage included testimonials, platforms, and biographies of candidates. But gradually the jocular tone of the early years of production crept back into even its political coverage. For example, in his article "Feminismo electoral" (Electoral Feminism), José de Roure poked fun at the notion of a feminine electorate when it was well known that women already ran the government, since they were their husbands' "ministers" and "caciques."[96] In his May 1899 editorial "Madrid se divierte" (Madrid at Play), Ginés de Pasamonte began by quipping that it

is not Spain's fault "if regeneration and diversions turn out to be a bit arduous," by which he meant that entertainments like the bullfight or jai alai weren't entertaining any more during an age of "regeneration," just as "regeneration" was a concept more than a reality: "And then we could say: 'in Spain we do not enjoy ourselves, but we are regenerating,' in other words, the reverse of the well known refrain: 'In my house no one eats, but we laugh a lot.'"[97]

Reports of sensational robberies and murders, together with natural catastrophes like fires, floods, and earthquakes, substituted for the war reportage of the last decade of the nineteenth century and by 1903 were a mainstay of the magazine. The discursive and pictorial sensationalism of the war reportage, examined in the next chapter, ceded to a rising sensational coverage of all sorts of unexpected events. Graphic photographs of the aftermath of collisions, train crashes, and fires satisfied readers' craving for more instantaneous coverage of events and kept the magazine from becoming exclusively a vehicle for satire. Sensationalized crime reporting, which had its spectacular debut after the notorious Crime of Fuencarral Street in 1888, took the guise of dramatized stories appealing to readers' emotions and curiosity, coupled with a craving for narrative and denouement. Talk of regeneration was mostly left to more serious publications, and entertainment spectacles became popular once again: reports on activities in the hippodrome, the bullfight arena, descriptions of fine-art exhibits, balls, and other public events filled the pages. Images of gay Gypsy women telling fortunes, dancing, or putting flowers in their hair reemerged as the stock visuals. Finally, *Blanco y Negro,* as mentioned in Chapter 2, fostered a star system through countless promotional images of actors and other performers, often cropping

photographs as in that of the bullfighter of Figure 47, or combining photographed heads with cartoon bodies, the new rage in collage layout. Royal family shots shared space with the queens of the carnival or the kings of the bullring, who were painted, sketched, engraved, and photographed by Spanish rather than foreign artists and artisans. A large portion of the artistic images of rival magazines were still produced by foreign artists, thus lending *Blanco y Negro* a flavor much more local than that of its competitors. This perhaps helped the magazine increase its middle-class readership and become by 1910 what it bragged it was: the "most popular" Spanish illustrated magazine.

The reading habits of turn-of-the-century consumers were decidedly different from those of the first half of the century, when periodicals were still largely geared toward a serious reader who thought of his or her reading not as a mere pastime but as a solemn and ritualistic intellectual pursuit. By 1900, serious political discussion was for the most part the reserve of the daily newspaper, while the illustrated magazine, with its extravagant sketches and photographs, gossip columns and trivia, contained a light portion of "novedades" (the latest happenings) that appealed to a readership more eager for entertainment news than for political debate. It is for this reason that the leading intellectuals of the first decades of the new century scorned weekly periodicals like *Blanco y Negro,* because of its leveling of classes, its banality and questionable taste. The exchange between Ramón del Valle Inclán's barber and Doña Terita the pharmacist in the theatrical piece "Las galas del difunto" (The Dead Man's Finery) (1926) only thinly disguised the author's disdain for any collector of *Blanco y Negro* volumes, an attitude shared by many of Spain's elites:

Barber: And the scalpel is not unanimous in terms of the Press! You have good and bad. Doña Terita, if you want a pleasant distraction, help yourself to the whole collection. It's the pride of yours truly, and the ornament of the establishment.

Apothecary: In my opinion that publication has some excellent items. A bit of everything! Portraits of the most celebrated celebrities: the Royal Family, Machaquito, Imperio. The celebrated Coronel bull! The greatest phenomenon of the Spanish bullfight arenas, who took fifteen lances and killed eleven horses! It publishes the best photos of weddings and baptisms. And a store of recipes: for cooking, for repairing all types of glasses and porcelains, for solutions, for stain removers![98]

In 1910 *Blanco y Negro* published its one thousandth issue, a first for any Spanish weekly magazine, and Luca de Tena's ambitious project to field a popular magazine with wide class appeal was proclaimed a great success on the page of tributes included in the issue. The popular novelist Vicente Blasco Ibáñez beamed "[T]his magazine has popularized the works of painters and sculptors, contributing to the formation of the public's good taste," and General Marcelo de Azcárraga added "I have seen it in everyone's hands, never having soiled the whitest and finest hands nor soiled by the darkest and roughest hands."[99] Ever proud of his labor force, Luca de Tena boasted of his largesse in dealing with the working class but also of his decision to prohibit worker unions in his plants: "We are, of course!, lovers of [the working] class, and we have striven without outside pressures for their betterment, without the impositions of those dedicated to stirring them up instead of sustaining and educating them."[100] The family of workers still included

some hired in 1891: Emilio Burgos Montenegro who started as a cashier was now the director of personnel; José Burgos began as a humble machine operator and now was in charge of the stereotype shop that produced the magazine's graphics; and José Alcaraz was a sketcher who now was in charge of the color graphic machines. Luca de Tena's happy family receives "all necessary means in order for them to progress and be educated," as well as a share in the profits and medical and pharmaceutical benefits (unspecified in the article); what need had they of unions? Such beneficence, concluded Luca de Tena, had "naturally" inspired the contempt of groups that had on occasion tried to disturb the wonderful "fraternity that reigns in our house."

Four

CARTOONING THE "SPLENDID LITTLE WAR" OF 1898

Cuba isn't called Cuba anymore,

Because it's changed its name,

And instead of Cuba it's called

"The Cemetery of Spaniards"

—*Blanco y Negro* 6 (28 March 1896), n.p.

IN *MATER DOLOROSA*, José Álvarez Junco defines nationalism as a sentiment that binds people together in a common identity, affording them a sense of stability and entitlement to occupy the territory that they cohabit based on common interests and goals. This feeling is both something learned osmotically and taught surreptitiously, arising from groups who desire to bind themselves to shared communities of like-thinking individuals and the institutions responsible for cultivating citizens to serve political and economic interests. It is easy to get the impression that the unspoken mission of newspapers and magazines during the last decade of the nineteenth century was to bridge the gap between the two, that is, to align the political and economic interests of Spain's ruling classes with those of the middle classes whose patriotism and consumerism needed to be ignited during the political debacle at the end of the century. Even if the ruling public and the reading public were not in the main those who fought the actual battles, their collusion was crucial to selling the war to the oppressed people who were conscripted to fight.

In this one sense the mainstream press was a great success, in the main rallying the reading public around a set of issues and values that promoted the interests of the ruling parties. The other side of nationalism, which slips so easily into a rancid xenophobia, is the conviction of superiority and racial destiny, since nationalists vociferously profess love for their country and collectively find reasons to project that sentiment through unfavorable comparisons with other nations, comparisons that are often saturated with racist and masculinist overtones. This chapter surveys especially these two common byproducts of Spanish nationalism in the political cartoons that proliferated in both conservative and left-leaning magazines during the Spanish-Cuban-American War of 1898.

Although, as Alda Blanco has pointed out, in canonical literature of the second half of the nineteenth century, Spain's imperial past as well as its more immediate campaigns and losses with few exceptions were greeted with an enigmatic silence,[1] in some forms of popular culture a concerted campaign was waged to stir patriotic

sentiment by ridiculing Spain's presumed enemies, documenting its former glories, and rallying citizens around an anti-Yankee campaign. One-act plays (known as "género chico") performed in metropolitan theaters were an ideal vehicle for stirring anti-American sentiment, seducing spectators into believing in their moral and cultural superiority over North Americans. The government adroitly exploited this form of entertainment to reassure the public of Spain's military superiority, to appeal for funds, and to recruit volunteers.[2] Bullfighters, CID Campeador, Bernardo del Carpio, Don Quijote, Jesus Christ, Juan Español, the maternal Lady Spain, and the ubiquitous Spanish lion "symbolizing nobility, generosity, and courage" were all commandeered by playwrights as well as journalists and politicians to represent a righteous and fearless Spain, "while the enemy was the pig, denoting commercial greed, cowardice, and vulgarity."[3] At this juncture an unfounded triumphalism gripped the popular press, which was intent upon pitting Spanish altruism and spiritualism against a crass American materialism and greed. In other words, Spain's residual aristocratic ideology was pitted against a more advanced American capitalist ideology. This contrived war of propaganda operated like any other campaign that magazines were just starting to employ to sell products to the public. Such campaigns were waged through the emerging strategies of commercial advertisement: exaggerations, distortions, lies, stereotyping, and ever more sophisticated and numerous images. Cartoons, together with the poems, aphorisms, and labels affixed to them in the weekly magazines, demonized enemies in ways that complemented and sometimes even surpassed in sensationalism the written accounts of events that filled the daily news reports. One of the objects of this chapter is to show that in their

drive to ridicule or demonize the enemy, visual images that became the common fare of weekly magazines accomplished more cultural work than their creators may have intended.[4]

For the reading populace the role that the press played in shaping a nationalist stance toward the war was unusually prominent: editorials, cartoons, photographs, sketches, chronicles, and dispatches cobbled together in the weekly magazines promoted widely varying responses of anti-imperialism, self righteousness, moral indignation, racism, and xenophobia, all of which point to a hierarchical sense of nation. Appealing overwhelmingly to nationalist sentiment, the weekly press became a hotbed of misinformation, national self-congratulation, and the most jingoistic and bellicose rallying cries that painted the Cuban campaign as a grand patriotic effort and clouded the economic and political interests at stake. In performing this patriotic sleight-of-hand, the press also fostered the notion of Spain as a long-suffering parent whose rebellious children had gone astray, in this way interfacing with the domestic discourse that played well to the middle classes, which were evolving into the special target audience of the new-styled weeklies, as we have seen in Chapter 3. Spain's "sons," the story went, would gladly fight the war for their "father" or their dolorous "mother" and return the beautiful but errant "daughter" Cuba and "son" Puerto Rico to their rightful home, safe from an illicit and dangerous liaison with an American interloper whose sole motive was commercial gain. It was Spain's parental duty to civilize the children it had long since brought under its tutelage, and this included even the most recalcitrant and ungrateful of the lot, who had failed to imbibe the notion of Spanish parental authority. A troubled Mother Spain and her mascot lion lost weight and composure throughout

the political upheavals of the century to become the "mater dolorosa" (dolorous mother)[5] who needed to be revived or regenerated after the loss of her children during the War of 1898. This tragic family drama played well to the reading public imbued with the rhetoric of the nation as a family under siege. The family, in other words, had become useful as an ideological apparatus beyond its role in maintaining a conservative sexual ideology. The story, one should recall, was different for the less affluent but more numerous populace, largely illiterate, whose families were actually being torn apart by the war: "[T]he people, as we know, lacked schools, feasts, rituals, symbols, monuments. In excess were caciques, discriminatory military service, daily administrative inefficiency, and arbitrariness. This explains many peoples' distancing from the State and their skepticism regarding patriotic appeals."[6] As we shall see, this skepticism toward Spain's symbolic "family" of colonies found expression in the press as well, but only in a very limited way. The press for the most part avoided open opposition to Spain's involvement in the Cuban conflict, serving the political aims of government by firing up patriotism in the 1890s.[7]

One of the novelties of the War of 1898 was that it became a war of pictorial images as well as weapons. Cartoons and war journalism were important ingredients in the "Splendid Little War,"[8] as it came to be nicknamed in North America, and the "Disaster," as it was aptly named in Spain.[9] Of course all modern wars depend on images to garner the support of those who end up fighting and paying for them, but support for the War of 1898 depended on visual images disseminated in newspapers and magazines more than had any other previous war either in the United States or in Europe. The political cartoon on both sides of the Atlantic became an "experimental laboratory"[10] for the propagandistic battles played out in twentieth- and now twenty-first century struggles.[11] In the United States this holds true both in the case of the much vilified yellow journalism of William Randolph Hearst's *New York Journal* and Joseph Pulitzer's equally sensationalist *New York World,* as well as that of more balanced competitors like the *New York Herald,* or the *Chicago Tribune,* which lent the U.S. Congress the support it needed to launch the war effort. Spanish journalists, while quick to adopt the term "yellow journalism" to describe their despised American counterparts, often held themselves to what they boasted was a higher standard of journalism. The "insolent and ill-mannered . . . swarm of dirty and ragged" American journalists, suggested Daniel Ortiz writing for the satirical magazine *El Gato Negro,* are swarming around Havana looking for inspiration for their "invented" stories. They should be "bathed and shaved and sent back to the bars of New York."[12] But steadily the sensationalized tactics of the American press found their match in Spain's daily newspapers, as well as in popular magazines like *Blanco y Negro* and *Nuevo Mundo,* which in the main supported the war as a question of Spanish honor. The press of both countries inflamed their mutual imperialist rivalry through a barrage of demeaning political cartoons. Comparing the symbolism of these images offers a glimpse into the darker side of political cartooning in general: "Take a step back from the particulars," comments Richard Goldstein about today's political cartoons, "and you can sense the anxiety that animates the cartoon wars."[13] Those anxieties concern not just imperialist losses and gains, for there is also a long history of bigotry in editorial cartooning that gets surreptitiously written into images of a nation's enemies and heroes.[14]

As we saw in Chapter 3, Spanish magazines, consumed with topics relating to the struggles leading up to the Spanish-American War, adopted a somber tone by the mid-1890s. Toward the end of 1895 as the Cuban conflict escalated, *Blanco y Negro*'s publisher Luca de Tena decided that instead of summarizing news items from daily newspapers for his weekly recap of events he would contract his own correspondent, named Lasheras, to send him dispatches, photographs, and sketches from Cuba, a practice that marked *Blanco y Negro*'s move into modern photojournalism. In his inaugurating dispatch, Lasheras promised that his chronicles would avoid tedious battle descriptions: "I must not forget that I am a representative of a popular illustrated magazine, for which graphic data gathered in the field with maximum guarantees of authenticity are more interesting than doctrinaire articles or daily and minute dispatches on the war."[15] Clearly Lasheras had been briefed by the magazine's editor-in-chief and recognized that popular journalism should include a mixture of war news and information on the local "habits and customs" of the inhabitants, including the social life of Havana and other cities: "My chronicles will be light, perhaps even incoherent; my only goal is to spark at any cost reader interest and achieve the most absolute variety in my reporting. National types, panoramas, monuments, and customs of the island; scenes from the Spanish encampment . . . pictures of this and that; the sketch, in short, and the photographic camera brought to the barracks."[16] In this way Lasheras's war chronicles could provide a dose of entertainment mixed with war reportage that would show Cuba as more than just a war zone. This tactic would indirectly promote the importance of holding onto possessions in the Antilles and at the same time instill in his readers a

sense of stability that Cuba by then was far from experiencing.

Lasheras's introduction suggested that increased attention to the strife in Cuba would not challenge the editorial policy of the magazine to prevent its famed "blanco" coverage from reverting to a dismal "negro," but from this date forward *Blanco y Negro* became much more international in scope, with images dispatched from abroad, many of them related to the war, accounting for a fourth of its graphics. As its war reportage increased, and as a picture of the enormity of the rebellion and the "face" of the enemy emerged, some journalists developed a more critical attitude toward a government that very quickly had moved to censor news releases from Cuba and to misinform the public about military matters, even though there was still no serious questioning of the need for military engagement. In late 1895 *Blanco y Negro*'s journalists complained that a resolution to the February-March uprising had not come as swiftly as the government had promised. Cartoons depicted government officials with padlocked lips,[17] and complaints about censorship escalated. If a resolution were so near, wondered one anonymous writer, why were warships still embarking for Cuba? "To be a patriot these days, one has to be deaf, mute, and blind."[18] Before his assassination in 1897, Prime Minister Cánovas del Castillo curtailed the press coverage of the war on several occasions. For example, in January 1896 after the daily press began pointing out the deteriorating conditions of the Spanish soldiers, he imposed a blackout on reporting sanitary conditions of the troops. As a result, devastating events like the 9,000 who perished in the Pinar del Río campaign went largely unreported.[19] Later that same year the *Heraldo de Madrid* was able to recount the staggering number of deaths that had taken place in

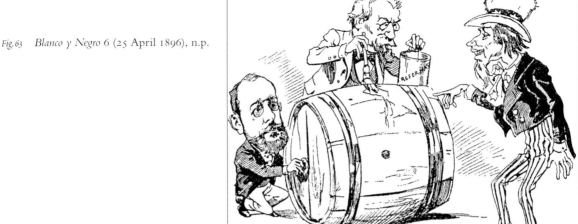

Fig.63 *Blanco y Negro* 6 (25 April 1896), n.p.

Matanzas, Villas, and Pinar del Río, but *Blanco y Negro*'s graphic artists and journalists remained largely silent about casualty lists even after they were at last reported in the daily press. *Blanco y Negro* confined its reportage to the comings and goings of contingents of soldiers and ships, endless descriptions of the physical surroundings in which the soldiers were fighting, and patriotic pronouncements about Spanish valor, the magazine's specialty as we have seen.

While antiwar sentiment heated up in some liberal, anarchist, and socialist periodicals, by 1896 the establishment press, *Blanco y Negro* a prime example, had adopted an overwhelmingly hawkish editorial policy. In the early months following the March 1895 separatist uprising in Cuba, the magazine rallied halfheartedly for reforms in the American colonies: "[W]hat is needed in the Greater Antilles is to foment public works and provide work for the innumerable poor filibusters who are asking for eight

hours of a free Cuba."[20] But by 1896, proposed reforms had to be forgotten: "Let's put out the fire first," commented one editor; implementing reforms in Cuba as the war was spreading to the whole of the country was senseless. It was like trying to repair a leaky barrel, as Ramón Cilla's cartoon pictured an ineffective Cánovas del Castillo trying to do in Figure 63.[21] Stamping out the insurgency was a matter of resolve more than of military might, which was never in doubt until the specter of American intervention arose. Once images of the American naval fleet and weapons began to appear alongside Spanish fleets in the pages of all the major illustrated magazines, the struggle took on a new urgency, yet defeat remained unthinkable. The shiny black boot of Figure 64, poised to snuff out the life of a spider labeled Sherman, a reference to the U.S. Secretary of State John Sherman, showed the way. The artist Mecachis (Eduardo Sáenz Hermúa) entitled his cartoon "La mejor

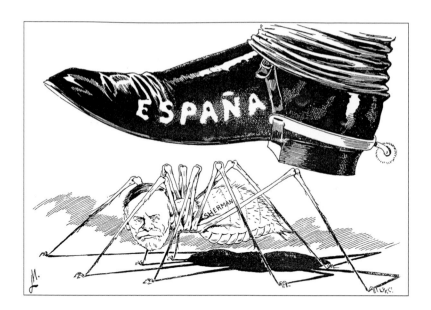

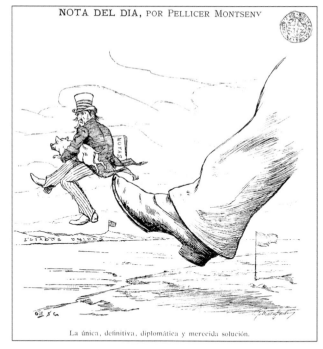

Fig.64 (above) Mecachis (Eduardo Sáenz Hermúa), "La mejor diplomacia," *Blanco y Negro,* 6 (2 March 1896), n.p.

Fig.65 (right) Josep Lluis Pellicer Montseny, "Nota del día," *El Gato Negro* 1 (23 April 1898), cover.

diplomacia" (The Best Diplomacy) with the running caption "Anything less than this are just half measures."[22] Three years later, the Spanish army was in a state of prostration, and, according to Louis A. Pérez, military operations had virtually ceased,[23] yet appealing images like the cartoonist Josep Lluis Pellicer Montseny's version of the Spanish boot, Figure 65, published in April of that year in *El Gato Negro*,[24] continued to suggest that Spain still had the solution at hand for solving the Cuban crisis. The boot, claimed the byline, was "the only, definitive, diplomatic, and merited solution." But just as Pellicer's boot was kicking Uncle Sam, who was clutching his pig, back to the United States, in real life the Spanish navy was only weeks away from defeat, and total surrender would occur in just two months.

THE WHITE MAN'S BURDEN

1895–96 mark the first years of satirical cartoons and attacks against the United States for meddling in Spanish affairs. These injected new life into the humorous caricatures of Cuban insurgents that for several decades were stock features in virtually every magazine that specialized in popular graphic art. The mood of most cartoons and editorials reflected the government's generally optimistic propaganda regarding the outcome of a possible engagement. Spain was symbolized as a giant Spanish lion or bull looking brave and noble alongside fat American pigs. By the beginning of 1898 *Blanco y Negro* had become one of the principal Spanish sources of anti-American sentiment fueled by its weekly political cartoons satirizing Afro-Cuban insurgents and imperialist Yankees, who were their erstwhile supporters and a handy scapegoat for every modern evil. The aim of many cartoons and editorials was to show that the United States was exploiting ignorant Cuban natives to further its imperialist agenda, a not unreasonable accusation but one that obscured Spain's own exploitation of pro-Spanish Afro-Cubans in the war effort. Painting the conflict as a clash of races also avoided confronting what Manuel Moreno Fraginals and Antonio Elorza have shown were the complex economic motives and actions of the Cuban Creole landowners, some of whom favored annexation with the United States, as well as the ambiguous role of the Island's bankers and mercantile classes. Playing the race card also helped to obscure the class conflicts in Spain arising from the war effort. By demonizing Afro-Cubans and imagining them as incapable of self-government, Spanish journalists, whether out of ignorance or malice, misled their readers regarding the complex interests both in Cuba and in Spain that had led to the insurrection. As Elorza put it: "'[W]hite ideology' permits one to overlook the problematic issues when approaching the problem of Cuban independence. On one side, whites, Spaniards, and landowners; on the other, ferocious Negroes, Cubans, and miserable arsonists."[25] Writing about Spanish political cartoons of the war, Miguel Rojas Mix reminds us that they are by definition the most Manichean of tools available to magazine editors, short on subtlety and prone to facile stereotyping: "[F]or Spanish cartoonists the United States are the villains in the guise of pigs and they appear surrounded by the Jew (rapacity), the Negro (barbarity), and sometimes the Asian (the yellow threat). . . . Both the heroes and villains carry a heavy symbolic weight associated with the values of their respective identity and the images of the enemy's alterity."[26]

The press of each nation was also quick to condemn the damage to the nation's extended "family" from the belligerency or from sustained

neglect of the other, and each responded by censuring the racism of the other's policies. Denouncing American interference, a journalist for the *Ilustración Española y Americana* nicknamed "Santiáguez" accused his friend "Jonathán" (the United States) of trying to kidnap his "idolized daughter Perla" and seize his "good son Puerto Rico." The United States was hypocritical in accusing Spain of cruelty to Afro-Cubans, he complained. After all, Spain had stood by politely when Jonathán abused his country's racial others: "[Y]ou forget the many instances when we held back as you rampaged with blood and fire the land of the red skins and tolerated the lynchings, and frequent and shameful applications of popular justice."[27] Santiáguez appealed to a racial affinity between inhabitants of its colonies and those of Spain by reminding readers of their shared language and family traits. Tinged with Schlegel's racial theories regarding an innate Mediterranean character, he reminded Jonathán that Spaniards and Cubans shared a passionate nature that "gives itself over with easy abandon to spontaneous expansions of passion," while the American is "taciturn, unsociable, and cold, bound to calculation; in short, for me, a son of the land of the Sun, the serenity of the skies, the brightness of the colors, the exuberance of Nature, and the portentous working of light and heat enchant and fill me with jubilation."[28] Americans, on the contrary, share the more somber character that Schlegel and other *volkisch* philosophers had assigned stereotypically to members of the Aryan race: "[Y]ou prefer the Northern climes with their dense mists, vague shadows, and melancholic scapes." How could Spain's passionate daughter "Perla" ever embrace this cold and calculating man of the North? No, he concludes, these races should not be mixed; Pearl "desires no other love" than that of her father.[29]

Ironically, at the same time that many Spanish journalists and cartoonists vilified Afro-Cubans as unworthy of their father-motherland, support was mounting for the notion of a single race defined by language and united under one Spanish flag. While in 1882 Cánovas del Castillo, probably influenced by the works of Ernest Renan, had proclaimed that the notion of the "fatherland" was "the work of God," unrelated to geography, race, language, or religion,[30] by the 1890s essayists assiduously collapsed Cuban-Americans (the Creole class at least) and Spaniards together into a single race by virtue of their shared language in order to justify Spain's stewardship of the islands. The former president and famed orator Emilio Castelar reminded the readers of *La Ilustración Española y Americana* in 1896 that Cuba was a region, not a nation, that naturally fell under the aegis of the "mother fatherland" Spain because of a shared language, which Castelar argued was the defining element of nationhood: "The fatherland is the origin from which we spring, the race to which we belong, the cradle in which we are rocked, the hearth that spreads the charm of its poetry over our entire existence, the temple that inspired our first hopes that, like clouds of incense, were dispersed with our first orations: language, that form of the idea, that heaven-sent verb repeated by the soul, and all that is and will be, and cannot but be, eternally Spanish in America."[31] By exalting the Spanish language, "the most sonorous, the richest that men have spoken in the modern world," Castelar not only justified the campaign against Cuban insurgents; he fostered the idea of the nation as an inalterable concept that binds its citizens together primarily though the glue of language, "the ring of gold minted by so many geniuses, in which is wed the Spanish spirit with the American spirit and the American spirit with

the Spanish spirit eternally, as it is in the annals of today as it will be in the annals of future history."[32] The aging and deluded Castelar still dreamed of a free confederation of states uniting Argentinians, Mexicans, Columbians, and other states under a central Spanish authority, "with a higher authority than that of our ancient captains, with the authority of reason and right, and with a glory more illustrious than the glory of our conquests, with the glory of democracy and progress."[33] Geography, then, was not the defining element of the "patria"; rather, what bound the people together was the spirit born of a single language that united all the Spanish-speakers into a single nation irrespective of locale or independent status. For this reason Castelar sought to convince readers that it was essential to hold onto the Antilles as the "golden chain" that linked the continents where the "Spanish race" thrived, a link that would survive only if Spanish-speaking peoples were "Spanish forever." Spain, he concluded, must win the battle to preserve dominion over the Antilles "and unite the Spanish race in America beneath the indispensable advocation of the mother-fatherland."[34]

Race was also a touchstone topic for North American essayists and cartoonists during the Spanish-American War, and comparing the reactions of both countries is instructive for how racial stereotypes helped to solidify each country's imaginary moral rectitude. Intervention in Cuba and Puerto Rico, as well as debates about annexing Hawaii and wrenching control of the Philippines from Spain were, in this era of social Darwinism, billed as the humanitarian response of an Anglo-Saxon race alone up to the task of the "white man's burden"[35] of educating the illiterate masses of less civilized nations incapable of self-government. The prevailing political rhetoric of the United States in the years preceding the conflict with Spain had been one of nominal respect for national sovereignty and aversion to territorial conquest. But the opportunities afforded by the Cuban conflict and events in the Philippines were too good to pass up, and certainly America had by then a long-standing preoccupation with the affairs of Cuba.[36] The popular promotion of the "Cuba libre" ideal that mobilized popular support for intervention was a thin disguise for the actual designs of the United States ever since the promulgation of the Monroe Doctrine.[37] The trick was, as Albert Katz Weinberg points out, how to put a positive spin on expansionism when the humanitarian ideal had been one of nonaggression. The solution was to justify intervention on humanitarian grounds, painting the inhabitants of Cuba, the Philippines, or Hawaii as in need of (even if unappreciative of) civilizing invading forces. Nationalist expansionist fervor was thus linked to humanitarian paternalism; the "hard love" of the Anglo Saxon would slowly transform the poor races of tropical locales, for this was their "manifest destiny" and a humanitarian necessity. Cartoonists for *Harpers Weekly* supplied the necessary images to accompany this paternalistic message: in one, Uncle Sam holds up the scales of justice with a peace dove on one side and a sword labeled "War" on the other. Below, a quote from George Washington spells out the nation's responsibility: "It will be worthy of a free, enlightened, and at no distant period a great Nation, to give to mankind the magnanimous and too novel example of a 'People always guided by an exalted justice and benevolence.'"[38] The cartoonist Charles Nelan would later publish a version of Uncle Sam for *The New York Herald* benevolently fitting out the natives of Cuba, Puerto Rico, the Philippines, and Hawaii with "one size fits all" jackets for the whole "family," a message with ambiguous

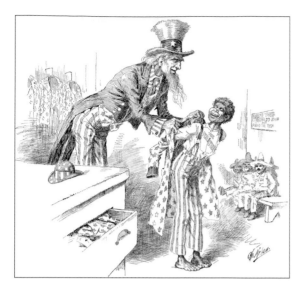

Fig. 66 "Bazar de ropas hechas norteamaericanas para todas las medidas, razas, y gustos," *Blanco y Negro* 8 (18 June 1898), n.p.

connotations. Should all races receive the same "jacket"? An argument could be made for both sides of the intervention debate. The same cartoon was given a negative spin when reprinted in *Blanco y Negro* in 1898 (fig. 66) with the caption "Bazaar of Ready-Made Clothes, Jackets for Every Size, Race, and Tastes."[39]

Some American cartoonists were more explicit in depicting America's "exalted justice and benevolence" as misguided benevolence or imperialism, a benefit to peoples unworthy of democracy, and a burden to U.S. labor. Even as the press vilified Spain for its ill treatment of Afro-Cubans, dozens of cartoons planted doubts in the American public's mind about the value of conquered peoples and the cost of civilizing them. In the category of "the white man's burden" that spawned many cartoons in the years following the publication of Rudyard Kipling's poem by the same title, the cartoonist William H. Walker showed a caravan of white men, with Uncle

Sam in the lead, on the stooped shoulders of the world's dark-skinned poor. Another cartoon outlined "What the United States Has Fought for" by juxtaposing two panels, the top depicting the people of the Philippines, Hawaii, Puerto Rico, Cuba, and Panama as victims of Spanish oppression, industrial slavery, and the Spanish yoke, miraculously converted in the bottom panel into wealthy bourgeois, money bags from the U.S. treasury in hand. The cartoon "Taking Up the First Installment of the White Man's Burden" showed native Filipinos weighted down with huge barrels of beer shipped from the United States.[40] Several of Nelan's cartoons for the *New York Herald Tribune* reminded readers that America's imperialism would come at a hefty price because, the cartoons implied, it was just possible that the conquered peoples were not able to be civilized. Congress should take heed of Nelan's "Troubles Which May Follow an Imperial Policy," showing a Filipino native with a sizable ring in his nose shooting spears at an American judge.[41] Even the liberal press, though tending to be more critical of both U.S. and Spanish imperialist motives, had occasion to question the wisdom of allowing Cuban insurgents to govern the Island once Spain was defeated. A few months before the armistice was declared, *Nation* magazine, echoing the consensus of many Republican politicians, posed the question succinctly in regard to the postwar administration of Cuba: a strict policy needed to be put in place for governing the Island once it was taken. It was unthinkable that the band of "brigands and half-breeds" led by Máximo Gómez could rule the country. The "wealth-producing" inhabitants of the Island must be put in charge: "Our declared purpose is to pacify the island, to make it free and independent, to establish a stable government, and then to take hands off. Government, according to our

theory and our principles, means the government of the majority, and if the insurgents do not agree to this, we must put them down, and this we shall infallibly do."[42] In short, explains Pérez, Cuba "was far too important to be turned over to the Cubans"[43]; the official consensus was that disorder and anarchy would prevail in the wake of independence and that Cuba should not be turned over to Cubans even after the Spanish army was defeated.

American cartoons provide evidence that, despite populist cries for a "Cuba libre" that flooded the press, it is a mistake to think that there was overwhelming public support for U.S. intervention. One of the principal objections to the war on the part of many American papers was the onus it would place on the working class, and this issue was taken up by cartoonists in a variety of ways. André Bowles's cartoon in the Saint Paul, Minnesota, *Broadaxe* revised the refrain "The White Man's Burden" to read "The Poor Man's Burden," implying that U.S. imperialism and economic interests were being furthered at the expense of American labor. Bowles pictured the "cheap labor" and "increased production" as foreign workers squeezed into the Republican Party's portfolio, which was being handed over to a fattened capitalist riding on the back of an American laborer. An accompanying poem made the anti-imperialist message more explicit: "Pile up the poor man's burden. / He still some more can bear; / Let loose the Imperial Eagle, / While of wealth we steal our share."[44] About this same time, the Keystone View Company began manufacturing a series of popular stereographs depicting a soldier weighed down by the white man's burden, consisting of dark-skinned children draped in an American flag. The message of these cartoons and stereographs was not so much that America erred in becoming

an imperialist power, but that safeguards needed to be put into place to protect American workers against greedy industrialists who were seeking cheap sources of labor. Cartoons accordingly hinted that the United States was taking on more than it could chew. In a before-and-after sketch, Nelan pictured Uncle Sam looking monstrously overweight, his belly ready to burst its contents, which were partially hidden but easily discernible beneath the stripes of his pants: Puerto Rico, the Philippines, Ladrone (modern-day Guam), and Santiago. The caption is in the form of a letter to Sam's doctor: "Dear Doctor, After four months' use of your Great Humanitarian Expansion-Specific, you wouldn't know me. I am getting fatter and fatter and never felt better in my life. Yours truly, US."[45] In another cartoon Sam stares at his 1898 Thanksgiving menu with greedy eyes: "Consomme Cuba, Roast Philippine, Salad Puerto Rico, Desert Ladrone," shouting "Bring on the Whole gol darn bill o' fare!"[46] Uncle Sam, such cartoons implied, needed to watch his waistline.

At the same time that Nelan and fellow cartoonists depicted Spain as a sissy ill-equipped to handle the American bull, they also castigated Spain for oppressing its colonial subjects, so that Spain would appear in some images as a large, sinister, and swarthy figure partially shrouded in a great Spanish cloak. Thus cartoonists alternately portrayed Spain as an ineffectual, quixotic warrior or grubby little bullfighter whose fighting days were over, and as a malevolent power and bully that owing to its abuse and neglect deserved to lose its colonies. Spain's abuse was often linked to its racism and repression of Afro-Cubans, while the U.S. press painted a picture of American racial egalitarianism, at least in its soldiering, with images of brave African-American soldiers. For example, the "Forgotten Heroes" of Captain

Taylor's U.S. Cavalry Troop C at the Charge of San Juan, painted by Fletcher Ransom, was reproduced as a black and white process engraving in *Harpers Weekly* in 1898.[47] Later that year *Harpers Weekly* published a curious sketch showing a sedate woman rubbing shoulders with a black soldier—"At the Lunch Counter" somewhere near the Long Island Training Center.[48] Racial strife, such images suggested, was a thing of the past; Negroes were an integral part of American society.

Accusations of Spain's abuse of Afro-Cubans in a post–Civil War America seething with racial tensions were bound to attract the attention of Spanish journalists who, beginning in 1890, were suddenly much more attuned to their North American counterparts than formerly. Nor was America's hypocrisy regarding issues of race lost on Spanish cartoonists. As the conflict heated up, the mainstream press sought ways to justify Spain's sovereignty in Cuba, and especially its treatment of Afro-Cubans, by painting the United States as a backward, racist civilization whose stance on justice, tolerance, and honor was hypocritical. What motive could Americans have to meddle in the problems of a country like Cuba, awash in a bloody civil war, when its own population was mired in poverty? was the frequent challenge. Ricardo Becerro de Bengoa, writing for *Ilustración Española y Americana,* echoed the unanimous conclusion of Spanish journalists regarding U.S. motives: "Basically, for the businessmen of the North the question of Cuba is just another phase in the cult of the dollar. To dominate commercially the island, so that once emancipated it is no longer subjected to Spanish duties and tariffs; and once in the power of an independent government, which owes so much to the United States, represents an excellent opportunity. Numbers speak."[49] What

America should be doing, according to the editors of *Ilustración Española y Americana,* is fixing its domestic problems instead of trying to control world markets because "the laborers of that land are becoming worse off each day, and the number of poor that swarm to the principal urban centers augments incredibly."[50]

To accompany this accusation, *Ilustración Española y Americana* reprinted a sketch from the North American journal *Frank Leslie's Weekly,* showing the lynching of a Negro in Texas, with the running caption: "La civilización en los EE. UU. de Norte-América: Un lynchamiento en Tejas" (Civilization in the United States of North America: A Lynching in Texas) (fig. 67).[51] The magazine's engravers have superimposed the word "Justice" in large letters on the scaffolding on which the lynching is to take place. Two pages further on, a second image of the same lynching shows a group of men now lighting a fire beneath the scaffolding. The lynchers, the byline reported, are heating metal to burn the shoulders, knees, and feet of the victim. A civilization that makes a mockery of justice, the doctored images implied, was not worthy of its name. In the same issue, Pedro de Novo y Colson outlined in detail the cruel extermination of indigenous populations.[52] There is no doubt about it, he wrote: "Americans have for their slogan the Latin axiom *Finis coronat opus* that is making them rich, while the Spaniards have a different slogan: *Audaces fortuna jurat,* which makes them heroes."[53] More directly and crudely critical, in his "Medallas yanquis" (Yankee Medallions), the *Blanco y Negro* humorist Joaquín Xaudaró dwelled on U.S. duplicity regarding its mistreatment of native and African-American populations and its hypocritical benevolence toward Afro-Cubans whom it was supplying with weapons, by juxtaposing the series of contrasting panels of Figure

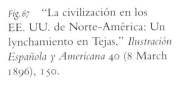

Fig. 67 "La civilización en los EE. UU. de Norte-América: Un lynchamiento en Tejas," *Ilustración Española y Americana* 40 (8 March 1896), 150.

68.[54] On the left, a malevolent Uncle Sam orders a lynching of a black thief, while on the right he extends a hand to an Afro-Cuban "brother." Below this on the left, Sam pursues Indians on horseback, while on the right he hands a bomb to a Cuban insurgent. On the left, he uses an Indian bound to a tree for target practice, while on the right he weeps at the cruelty of war. Finally in the last set of images on the left, he pays musical tribute to the Stars and Stripes before a congress of white patriots, while on the right he cheerily assists a sailor to hoist a Spanish flag. In short, Yankee colonization of Cuba would be no different from British colonization of North America, a message that *Don Quijote's* cartoonist delivered in 1898 (fig. 69), by picturing "Yankee Colonization" as a swift boot from Uncle Sam to the rear of a shocked Afro-Cuban dressed in rags.[55]

The Spanish press also consistently criticized the United States for using racial others to fight its wars, at the same time vilifying African-American soldiers with scenes similar to those showing the activities of the bloodthirsty Mambises. On the cover of its 2 June 1898 issue, *Gedeón's* cartoonist depicted the "Ejército humanitario que por espíritu de humanidad envían a Cuba los Estados Unidos para poner coto a nuestras inhumanidades" (The Humanitarian Army That in a Spirit of Humanitarianism the United States Sends to Cuba to Put an End to Our Inhumanity") (fig. 70).[56] The American soldiers, white and black, are throwing hand-held fire bombs, raping women, lynching men, and picking the pockets of fallen Spanish soldiers. Ironically, though the mainstream Spanish press often belittled the American government for the poor recruits it sent to Cuba, it neglected to mention that Spain had deployed its youngest, poorest, and least-trained soldiers to fight the insurgency. Behind the frequent attacks against America for its abuse of Southern blacks and support of Afro-Cuban insurgents was Spanish elites' own unrecognized racist attitudes. It was perhaps logical for Spanish journalists and cartoonists to come to the conclusion that U.S. interests

Fig. 68　Joaquín Xaudaró, "Medallas yanquis," *Blanco y Negro* 8 (4 June 1898), n.p.

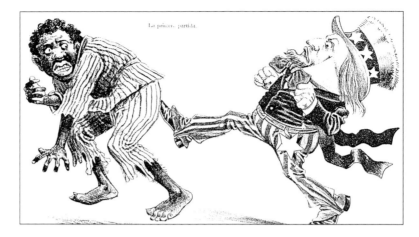

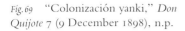

Fig. 69 "Colonización yanki," *Don Quijote* 7 (9 December 1898), n.p.

in Cuba could only be racist, economic, and imperialistic rather than humanitarian, when their own inference about Spain's former slaves was that they were either worthless or dangerous and cruel. When the point was to exalt the white Spanish recruit, Afro-Cuban insurgents, though in some images muscular and fierce looking, were ineffective, no match for the skill or bravery of the Spanish soldier. For example, the sketch artist for *Ilustración Ibérica* heralded the bravery of the soldier Francisco García Fernández by showing him (fig. 71)[57] in the cartoon "Hazaña" (Feat), simultaneously fending off four black soldiers. By contrast the cartoonist Ramón Cilla, in a series of vignettes published in *Barcelona Cómica*, suggests that the typical insurgent's reaction when faced by a Spanish soldier is a cowardly retreat. Figure 72 is captioned "If he sees a great group of soldiers approaching, well, at least one soldier, he has no option but to beat a retreat, honorable, of course."[58] *Madrid Cómico* published another set of Cilla cartoons depicting the despicable behavior of the Mambises, the "representatives of civilization, beauty, and human progress," blowing up houses, burning towns, assassinating prisoners,

robbing travelers, and, in the last vignette, humbly being hand-fed sweets by Uncle Sam.[59]

Humor aside, many images of Afro-Cubans in satirical magazines like *Campana de Gracia*[60] played to the readers' racial panic, such as M. Moliné's cartoon entitled "Questió Negra" (The Negro Question) (fig. 73),[61] in which "Those Struggling for Cuba's Well-Being" are wild savages who gleefully torch sugar plantations and kill women. Such images reveal the ambivalence of the left-leaning press regarding the Cuban insurgence. *La Campana de Gracia,* even while railing against the conscription practices of the Spanish government, clearly rejected the radical separatism of the Cuban insurgents, imitating the mainstream press by painting the struggle for independence as a threat to the Spanish nation.[62] On its 9 March 1895 cover (fig. 74),[63] *La Campana* relayed this double message by picturing the ones who would gain by the war against insurgents (employers, the government, the wealthy) and those who would lose (the poor soldiers). Above them all floats the specter of a bloodthirsty Afro-Cuban separatist with a torch labeled "Separatisme" (Separatism) in one hand and a

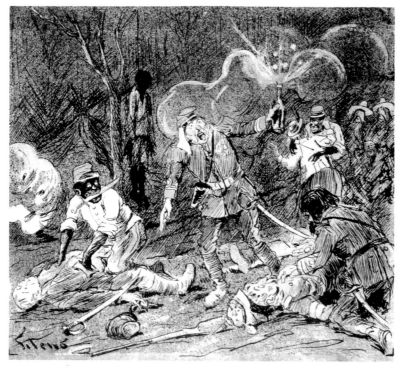

Ejército humanitario que por espíritu de humanidad envían á Cuba los Estados Unidos para poner coto á nuestras inhumanidades.

Fig.70 "Ejército humanitario que por espíritu de humanidad envían a Cuba los Estrados unidos para poner coto a nuestras inhumani-dades," *Gedeón* 4 (2 June 1898).

dagger in the other, while the specters of fever and vomit float above the soldiers' heads, symbolizing the yellow fever and typhoid that were killing more soldiers than actual combat. In late 1897, in a desperate attempt to put an end to the struggle that was clearly heading for a resounding defeat, Prime Minister Sagasta announced reforms in Cuba and appointed Ramón Blanco governor of the Island, promulgating at the same time an autonomous constitution. On 1 January 1898, just as a home-rule government was assuming power in Cuba, *La Campana de Gracia* published a cartoon that left little doubt about the cartoonist's negative assessment of Sagasta's plan for Cuban autonomy (fig. 75).[64] The image is tagged with the following inscription: "They

withdrew Weyler, they gave them autonomy, they turned the Christmas lottery prize over to them, and, imagine, they're still fat-lipped!"

Editorially the socialist and anarchist press opposed the war on the grounds that American ambitions reflected an imperialist agenda and Cuban nationalism would not result in an improvement for the Cuban working classes.[65] Their use of frightening images of black insurgents helped to make the war appear inimical to the interests of the working classes. The barbarous black subjects pictured in satirical magazines like *La Campana de Gracia,* similar to those in Madrid's *Gedeón* and *Don Quijote,* with their threatening poses and exaggerated features, also echoed the fear of the "Africanización" of Cuba

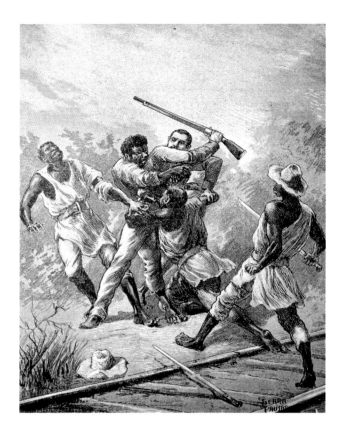

Fig.71 (above) "Hazaña del gastador del batallón de Reus, Francisco García Fernández," *Ilustración Ibérica* 13 (21 December 1895), 801.

Fig.72 (right) *Barcelona Cómica* 9 (25 January 1896), 3.

Pero si estando en tan noble empresa entretenido, se ve venir un grupo numeroso, de un soldado lo menos, entonces no hay más remedio que emprender una retirada, pero honrosa, eso sí

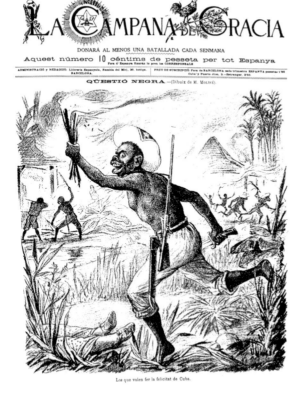

Fig.73 M. Moliné, "Questió negra, Los que volem fer la felicitat de Cuba," *La Campana de Gracia* 26 (24 August 1895), cover.

propagated by the Creole class of the Island.[66] This sentiment had long since entered Spanish political discourse and the general press, not only in the satirical magazines of Madrid and Barcelona, but in Cuba as well. In fact, caricatures of Cuban insurgents, referred to as Mambises, had appeared in journals such as *El Moro Muza* (1859–77), *Don Junípero* (1862–66), and *Juan Palomo* (1869–74) during the previous Cuban uprising of 1868.

High-end illustrated magazines in Spain avoided the more extreme racist images that were appearing in satirical magazines like *Campana de Gracia,* but the subtle debasement of blacks

appeared in many forms in these magazines as well. The fear of granting too much power to nonwhites in Cuba was occasionally echoed in images that were derogatory of Afro-Americans, for example, *Ilustración Española y Americana*'s sketch of the 1874 New Orleans senate with its newly elected black senator (fig. 76),[67] reprinted from *Le Tour du Monde.*[68] The cartoon is both a sarcastic take on corruption in the United States and an indirect statement about the future of an uncivilized nation in which blacks would gain too much power. With politicians such as these, wrote the commentator, it is only natural that many Americans "feel more sympathy for the arsonists, dynamiters, assassins, and violators of women and children that devastate the Island of Cuba, than for us." Thus the racism of conservative papers reflected the fear of a change of colonial power that would negatively impact Spain's commercial and national interests. At the same time, the scare tactics used to denounce the insurgents abroad provided the conservative press with an opportunity to denounce the political dissension at home (notably in Barcelona) that was destabilizing the Restoration government. Similarly, but with opposite ends, the antiwar rhetoric and racist vignettes showing dangerous insurgents pictured in the leftist press, especially of Barcelona, were one of several strategies employed to discredit the government for its mishandling of foreign affairs. In both cases, images of nonwhite subjects were a stand-in for national debates about the oppression (or dangers) of the working class, the commercial and industrial interests of the ruling oligarchy, and the future of the Spanish nation facing the prospect of losing its last colonies and even conflicting regionalist interests.

After the 1898 ceasefire, it was no longer necessary to project images of poor black American

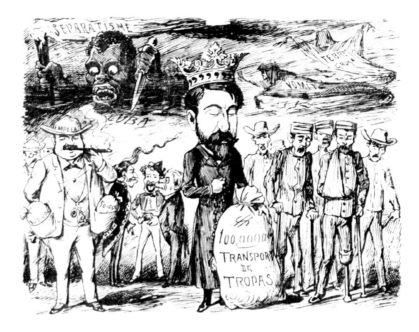

Fig.74 "La questió de Cuba," *La Campana de Gracia* 26 (8 March 1895), cover.

soldiers or Indians and treacherous Afro-Cuban insurgents for the purposes of sparking the patriotism and support of the Spanish public and denigrating Yankees, but race was still an issue that could be used to make political hay. In June 1898, seven months before the Paris treaty was signed, *Blanco y Negro* published a short story by Emilia Pardo Bazán entitled "Entre Razas" (Between Races), with accompanying sketches by Angel de Huertas that dramatized the humanitarian attitude of Spaniards toward peoples of African descent. The narrator is a gentleman count who has taken it upon himself to show a Yankee around Madrid. At the American's insistence, the two find themselves in a disreputable bar one night when a "negrazo" (large Negro) passes by the table where they are seated.[69] When the Spanish count comments admiringly that the black man is a great "specimen," scarcely a compliment to be sure, the gross American makes an off-handed comment that such a Negro would

make a "good slave." The American is later found stabbed to death in a dark alley of Madrid. The unspoken message of the story, however, is not about the justice of the black man's vengeance, but the contrast between the civilized, humanitarian attitude of the Spaniard in contrast to American barbarity and racism, the same message that *Blanco y Negro* and other magazines had so faithfully been communicating to its readers for nearly five years.

The much-ballyhooed Spanish humanitarianism, however, did not exactly translate into the celebration of a racially diverse Spain. During the repatriation of Spanish soldiers and their Cuban loyalists, *Blanco y Negro* editors pleaded for corporations and the state to live up to the nation's standard of Catholic humanitarianism by caring not just for Spanish soldiers but for relocated Afro-Cuban soldiers now at odds with their countrymen, in order to justify "their faith in justice and the goodness of Spain."[70] The

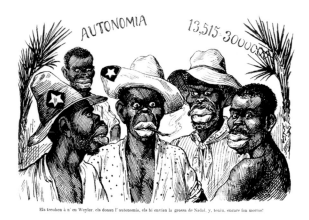

Fig. 75 "¡Malviatje!" *La Campana de Gracia* 29 (1 January 1898), 7.

"noble and faithful" black soldiers should, out of gratitude and justice and for the sake of national decorum, be protected. Perhaps, suggested an editor of the *El Heraldo de Madrid* in 1898, they should be allowed to form a regiment assigned to Africa, since in Spanish cities where they would likely be relocated they would become "sure victims of malevolent people, or at least the object of impertinent curiosity. . . . Spain was ever benign with the inferior races, . . . establishing as a fundamental principle of its relations with them a sense of fraternity between men, since we are all sons of the same father and the same mother, called Adam and Eve."[71] Reasoning that the black sons of Adam would feel more at home in Africa was an indirect acknowledgment that the sense of the Spanish nation was not based on a linguistic uniformity as Emilio Castelar had claimed in 1896, but on an imaginary racial purity that might idealize its others in words or images, but that would not translate into deeds.

BY HONOR BOUND

The war loomed large in the daily lives of Spaniards, in no small part because of the constant barrage of war reportage and editorials appealing to the nation's patriotism and execrating the leaders of the United States. For the Spanish as well as for the U.S. reading public, this was the first war in which the press played a pivotal role, "the first war in which the press demonstrated its fearful power, as manipulator of facts and consciences."[72] The press in general, however, was succeeding in manipulating popular opinion to match the special interests of the government and monied classes in Spain just as in the United States.[73] Both American and Spanish journalists distinguished themselves for their deception in this regard. Félix Santos goes so far as to suggest that had the Spanish press maintained a more critical and objective stance on the Cuban crisis, Spain might have been spared a humiliating and costly war: "[I]t is possible that if the more influential press would have maintained a critical position of opposition to a suicidal war, things might have turned out very differently, and Spain might have been spared countless human and material losses, never mind the humiliation that this struggle supposed."[74] Instead, the mainstream press carted out the most inflammatory patriotic rhetoric. Dozens of cartoons impugned the United States for its opportunistic imperialism, inspired by greed, and countered the image of a money-grubbing Uncle Sam with a noble and brave Spanish subject, like the sturdy Asturian peasant poised with a huge mallet labeled "Valor español" (Spanish Valor) standing over a diminished and cowering Sam, included in Álvarez Junco's *Mater dolorosa*.[75] Republican magazines like *Don Quijote* expressed a genuine disappointment and shock that the United States, formerly held up as a liberal and democratic state, was in the end just as hypocritical and imperialistic as any other world power. On 22 April 1898 the magazine's voice of Sancho laments to Don Quijote: "Just as naive, nay more naive than your lordship, have been all the governments

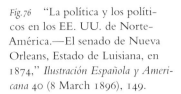

Fig.76 "La política y los políticos en los EE. UU. de Norte-América.—El senado de Nueva Orleans, Estado de Luisiana, en 1874," *Ilustración Española y Americana* 40 (8 March 1896), 149.

of Spain for a long time now. They believed the North Americans to comprise a nation, and never suspected they were a vile and hypocritical people. Stupid and stupider we've been, my lord, and our leaders even dumber, for a long time those . . . , why name them? have wanted to take over the Antilles, and even the whole rest of Central America."[76] It is unclear to what extent this constant barrage of images exalting Spanish might and spitting out hate against the United States actually substantially influenced public opinion, and Santos's claim about their decisive power is likely overstated. Their very frequency, however, does suggest that there was a need to bolster Spanish confidence in its probable absence, and the ubiquitous war cartoons surely did constitute an attempt to comfort and reassure the reading public, just as the images of beautiful exotic women that we saw in Chapter 1 afforded a comforting surrogate for Spain's stalled colonial expansion.

In the United States the notion of honor was associated with desirable future goals that were imperialistic in nature: the humanitarian civilizing of backward peoples as well as the demonstration of new U.S. might in a world arena. Spanish honor, in contrast, was an invocation of the past, a call for men to reenact the nation's glorious deeds. The jingoist Spanish press urged men to support the war effort as their patriotic duty, the new religion that middle-class Spaniards were ascribing to in larger numbers: "Whatever happened to that chivalrous people ready to give their lives for Christ, homeland, and king before tolerating an offense to their faith or stain on their honor?" asked Juan Vázquez de Mella.[77] The moment of passivity and diplomacy was over; whatever the risks and consequences, the war had to be confronted for the sake of honor accrued in Spain's glorious past. So zealous were Spaniards about maintaining their honor, claimed a journalist for *Ilustración Ibérica,* that they gladly volunteer to go to war: "as if to a crusade to Palestine to wrench Christ's sepulcher from the infidels."[78] Once war was declared, even Republican papers like *El Motín,* whose journalists argued forcefully against the army's conscription policies and the financing of the war, appealed to Spanish honor: "[A] country like the United States, made up of the 'bandits'

Fig.77 "A lo que vamos llegando," *Gedeón* 4 (16 March 1898), cover.

of all other nations, will have to be taken on. . . . Those who are going to fight for our honor: soldiers, sailors, the people, would be offended if we proclaimed anything less than 'Spain knows that all will do their duty.'"[79] Spain is a "race of patriots," and to ask "Why sacrifice oneself for one's country?" is like asking "Why sacrifice oneself for one's father or mother?"[80] The family's honor was at stake, and no sacrifice was too great to redeem it.

On the other hand, cartoonists often have a way of looking behind patriotic and masculinist rhetoric to make hidden connections obvious and to serve up ridicule to proponents and opponents of national causes in equal doses. Cartoonists for *Gedeón* magazine, "'The periodical with the smallest circulation in Spain,'" as it bragged on its cover, were particularly adept at pointing out the ironies of the Spanish-American War,

that is, the relation between affronted manhood and economic motives. On its 16 March 1898 cover, the analogy was crudely made by picturing a Galician peasant proudly showing off his wares, fresh eggs from Galicia, Castile, and Aragon, to a strutting Uncle Sam holding a sack of money in one hand and a set of bull's testicles in the other (fig. 77).[81] The cartoon is titled "A lo que vamos llegando" (What We're Coming to), with a bottom rejoinder "Ya enseña cada cual lo que tiene" (Finally everyone shows what he's got). The message is clear: chicken eggs are no match for bull testicles, and the proud look on the peasant selling them is unwarranted. But more significantly, the "testicles" that Uncle Sam grasps between his legs are really bags of money; money denotes masculinity that in turn represents power, just as coins, as we saw in Chapter 1, are synonymous with femininity and add to women's attraction. In both cases, money and flesh together bespeak a wealth that translates into power.

Spanish journalists described the presence of the *Maine* in the harbor of Havana as a particularly grievous affront to Spanish honor and manhood, even though they did not go so far as to gloat that its sinking was the work of Spanish sabotage. Pamphlets called for the return of the hard-liner General Weyler, who by this time had been replaced by the more conciliatory General Blanco García. Many journalists were crying foul, insisting that the government's decision to withdraw Weyler would only prolong the struggle, which journalists were beginning to suspect was not going to turn out well for Spain once the United States was involved. Yet faced with lagging public sentiment, most magazine editorials continued to rouse the public to adopt the position of a chivalrous nation whose honor had been offended and who must be aggrieved. The appeal to Spanish honor was heard in Cuba

as well: a circular turned over to Captain Sigs-
bee during a bullfight in Havana urged Spanish
loyalists to defeat the insurgents: "Spaniards! Viva
Spain with honor! What can you be thinking
allowing us to be insulted in this manner? Don't
you see what they have done by withdrawing
our valiant and beloved Weyler, and that by this
time we already would have put an end to the
unworthy insurgent rabble who trample our flag
and our honor?"[82] Even after Spain's resounding
naval defeat, the *Correspondencia Militar,* the offi-
cial state magazine dedicated to military affairs,
predicted a sure and certain victory for the army:
"[W]e must have confidence in this Army, . . .
because today the Army is the only glory that
remains to Spain, and with its legendary heroism,
and heroic resolution, it will find a remedy to
cure the ills that consume the nation."[83]

A MAN'S WORK IN THE WORLD

Appeals to honor in the United States also
masked the ulterior motives of the U.S. gov-
ernment. The many interests at stake in the
U.S. intervention in Cuba have slowly emerged,
and yet it remains difficult to assess their relative
consequence. The historian Kristin Hoganson
emphasizes U.S. political interests: "Democrats
and Republicans alike thought that clamoring for
war would help their parties win future elections.
Added to this ambition was the hope that war
would unite the country after the divisive presi-
dential election of 1896."[84] Walter LaFeber and
Paul Kennedy have argued that economic inter-
ests were the most compelling factor, but John
Offner warns against taking too economistic a
view of the U.S. intervention; so many other fac-
tors came into play, including the belief in racial
superiority and, on the part of some, a genuine

desire to spread democracy and freedom.[85] Politi-
cal cartoons suggest that honor and manhood
were also clearly at stake and in part explain the
swift action on the part of Congressional jingoes
to appropriate the whopping sum of $50 million
for a defense appropriation (which represents
approximately $3 billion today) in 1898. Once
U.S. honor was affronted, it would be unmanly
to pursue peaceful diplomacy. McKinley under-
stood this all too well, when in March and April
1898 newspapers published a variety of articles
questioning his manhood. Many journalists
cautioned against military intervention in Cuba,
"changing their tone only after the U.S. naval
inquiry announced that an external mine caused
the *Maine* explosion."[86] Among those who
argued against going to war were journalists who
claimed that Spain was a "weak and unworthy
foe."[87] What value in conquering a sissy like
Spain, shown in U.S. caricatures as an effeminate
figure, often a Gypsy or bullfighter, and clearly
lacking in manly muscle? "Spain is a third-rate
and declining Power," *Nation* magazine reminded
its readers. "We shall never be able to 'point with
pride' to this war as we point to the Revolution-
ary war, or the war of the rebellion, or the war
of 1812, when we engaged in contests which
the world believed to be beyond our strength or
resources."[88]

President McKinley did not of course
thoughtlessly jump into the war because of sen-
sationalist journalism and the urging of Congres-
sional jingoes. Rather, the administration entered
the war when it was finally convinced that there
was no other way to wrest control of the Island
from Spain and to keep Cuba from declaring
complete independence,[89] and when it under-
stood that there was much to be gained by estab-
lishing itself as a world power. As Louis Pérez
has perceptively noted, citing the *Maine* as the

"accident" that sparked the war, which is how it is read in many historical accounts, obscures the motive of intentional territorial expansionism.[90] Nevertheless, in reckoning the events of the war, many politicians of the day understood, or at least promoted, the declaration of war as a righteous and manly act. Backing away from the war after the "affront" of the *Maine* was unthinkable: a nation that was unwilling to go to war for a just cause, warned Theodore Roosevelt, would soon go down before nations that preserve the "manly and adventurous qualities" that he thought were key to the survival of the nation: "It is an admirable thing to possess refinement and cultivation, but the price is too dear if they must be paid for at the cost of the rugged fighting qualities which make a man able to do a man's work in the world."[91] Such pronouncements came not just from the "manly" Roosevelt, who constantly badgered American men to a life of action, but politicians on both sides of the political aisle who understood U.S. intervention as justifiable even if they worried about a future course for the Island's governance after the war.

In the official discourse, then, which quickly translated into thousands of cartoon images, the war on both sides of the Atlantic was all about manliness. The image of Roosevelt before the American public bolstered the notion of the "manly and adventurous qualities" of Americans sent off to fight the war in Cuba, symbolized by Roosevelt himself as a fearless leader.[92] In contrast to the King of Spain, typically shown as a pathetic little boy with a crown too big for his head, the press depicted Roosevelt as a warrior charging forth with his Rough Riders, in images made famous by the artist Frederick Remington and published in *Harpers Weekly* and other magazines. In contrast Sagasta, whom the U.S. press understood as the architect of Spanish

foreign policy, was sketched smoking cigarettes or hashish that clouded his perception of American strength; playing the fiddle while Rome burned; or filling the head of the king with fanciful stories of Admiral Cervara's exploits; in short, living in a dream world of misinformation. Sagasta's dreams of help from European nations were just so many "Castles in Spain" that, as we know, never materialized. Ironically, while after the explosion of the *Maine* dozens of cartoons appealed to Americans to rise up and defend the nation's honor, the same plea, when applied to Spaniards, was caricaturized as foolhardy by the American press. The cartoonist Charles Nelan depicted Spanish honor as a relic of a past, a cover-up for self interest and villainy, while he exalted American humanitarianism, the former labeled "the Past" and the latter "The Present" (fig. 78).[93] Uncle Sam's face is a study in integrity and stature; the demonized Spaniard, resembling a rendition of Cesare Lombroso's criminal type, exhibits the unsavory character of "Spanish Honor," the scare quotes indicating Nelan's skepticism. When the battles were over and the peace treaty signed, a cartoonist for the *Philadelphia Inquirer* pointed out that a peg-legged Spanish peasant on crutches had "Very little left but honor,"[94] a meaningless, even laughable concept given the consequences of the war, as Nelan shows in his cartoon "Satisfying Spanish Honour."[95] In short, we can summarize the American concept of honor during the Spanish-American War as might makes right; power and honor were synonymous concepts for the newer, more prosperous nation, while for Spain honor represented an archaic concept associated with duels, quixotic misunderstanding of the modern world, and unwarranted arrogance.

A singular challenge to American manhood and honor was contrived by Hearst in

Fig. 78 "A Comparison: The Present: The Past," *New York Herald* (19 June 1898), 2.

collaboration with the artist Frederick Remington and the journalist Richard Harding Davis, whom Hearst attempted to send to Cuba aboard his yacht *Vamoose* to send back dispatches on the progress of the war. The *Vamoose* made several unsuccessful attempts to sail from Key West to Cuba, but in the end the journalists settled for booking passage on the steamer *Olivette,* which served as a hospital ship during the war. Once in Cuba and bored with the apparent lack of sensational military confrontations, Remington reportedly telegrammed Hearst that he wished to return to the United States since everything was quiet on the front. Hearst famously replied (a response later challenged and still unsubstantiated): "You furnish the pictures, I'll furnish the war." Whether the telegrams were as history recorded them, Remington and Davis devised other ways to satisfy Hearst's thirst for sensational reportage. In February 1897 Davis sent a dispatch to Hearst about an incident on board the *Olivette,* which Spanish authorities had searched for Cuban insurgents. Among those searched was a Cuban woman who was escorted to a private room by another woman to undergo a body search. In Remington's sketch of the event (at which he was not present), a completely nude woman is surrounded by three men performing the search on deck. Although Davis had reported the incident accurately in his verbal account, Hearst decided to rewrite the chronicle to narrate Remington's image, adding the sensational headline: "Does Our Flag Shield Women?"[96] Although the hoax was quickly reported in the rival *New York World,* it fueled other appeals to American men to rise up to protect the weak and oppressed. Sketches of starving Cuban children published in the *New York World* whipped up angered responses and calls for intervention, as well as eliciting funds to finance protests against

General Weyler's decision to move a large sector of the population to internment camps.

In the U.S. press a fattened Uncle Sam became the symbol of success and therefore of admiration. And as Sam started to gain in stature (physical as well as moral), the cartoon version of Spain shrunk in size and began to appear more pathetic. In one cartoon Nelan shows Spain as a small child in a highchair taking the "medicine" that a hefty Uncle Sam administers. Holding his stomach, Spain laments "It's fearful hard, but I guess I'll have to swallow it."[97] One consistent way Spain's masculinity was impugned and America's aggrandized was by depicting Spain as a slightly built bullfighter overwhelmed by an American bull. The bull, long a traditional symbol of Spanish might, was in the hands of cartoonists a symbol of U.S. fighting strength and bravery. The *Harpers Weekly*'s cartoonist F. T. Rilmarof shows a colossal U.S. bull charging a panicked Spanish bullfighter. The caption, "Not the Kind of Bull They Were Looking for," is subtitled "Caramba! They said he wasn't half as big as he looks! That he was all bluff! That he wouldn't fight! But– !!???!!."[98] Clearly, all the images of pitiful Cuban displaced persons, pathetic Spanish leaders, and mighty American bulls did not "make" a war, but they did paint the war as justifiable, understandable, inevitable, and crucial to American interests, as it is still regarded in most textbooks today.

Predictably, in Spanish cartoon versions of the struggle, similar symbols for Spain's cultural military might are served up as evidence of an eventual Spanish triumph. In Figure 79, the toreador, a caricature of General Weyler, bravely turns his back on a small bull representing a rebellious Cuba while he brandishes a cape labeled "20,000 soldiers."[99] In 1896 when this cartoon appeared, hope was still running high that Weyler could crush the rebellion with the deployment of new recruits. With her lion by her side and a document labeled "sovereignty" in her hand, a stately Lady Spain warns an obese President McKinley, dressed as Uncle Sam, that he and the squabbling parrots, symbolizing the U.S. Congress, shall not have Cuba. Echoing Sagasta's speech to the Congress of 2 April 1895,[100] Lady Spain warns the intruders "that misguided whim, they shall not fulfill, while there remains one of my sons to die, and one piece of steel with which to kill" (fig. 80).[101] Three years later the picture was not so rosy, and yet a cartoonist for the satirical magazine *El Gato Negro* depicted Juan Español thrashing a grubby Uncle Sam as he attempts to seize a money pouch labeled "Cuba" from beneath Juan's legs. The caption, a tribute to José de Zorrilla's legendary Juan Tenorio, reads "It was not my fault, A mad delirium / of the yankees, on the verge of insanity, / put them within arms reach: / they were aware of my skill and bravura" (fig. 81).[102] A few weeks later in his editorial of 7 May 1898 in the same magazine, Daniel Ortiz reported that 2,000 American women had requested to serve in the war against Spain, and why not, he wondered: "[I]t's only logical that in a country where the men are chickens, their place should be taken by women."[103]

The Spanish popular press generally suppressed Spain's economic motives for engaging in the conflict and insisted instead that the campaign was a question of honor. Most journalists and cartoonists, on the other hand, were quick to understand the "dishonorable" motives of the United States, painting the war as a conflict between Spanish honor and the American dollar. This move, like the issue of race discussed above, obscured Spain's economic interests that were very much at stake in the Cuban conflict. *El Gato Negro* published F. Xumetra's cartoon of

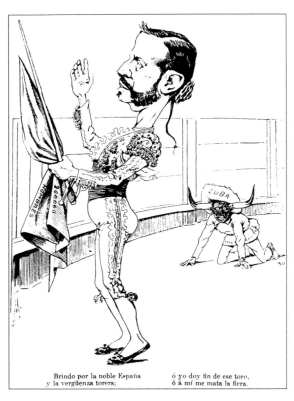

Brindo por la noble España ó yo doy fin de ese toro,
y la vergüenza torera; ó á mí me mata la fiera.

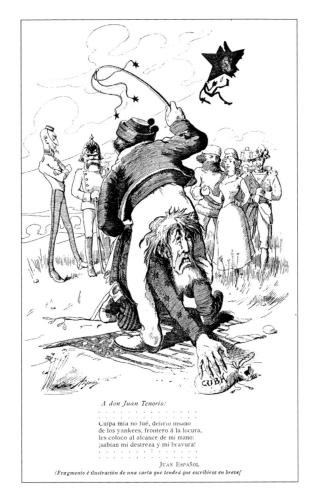

A don Juan Tenorio:

.
.
Culpa mía no fué, delirio insano
de los yankees, frontero á la locura,
les coloco al alcance de mi mano:
¡sabían mi destreza y mi bravura!
.
.

JUAN ESPAÑOL

(Fragmento é ilustración de una carta que tendrá que escribirse en breve)

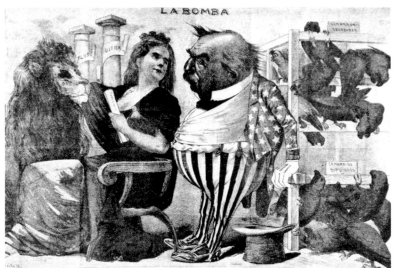

Fig. 79 (upper left) *Blanco y Negro* 6
(17 October 1896), n.p.

Fig. 80 (lower left) "La bomba," *Blanco
y Negro* 6 (16 May 1896), n.p.

Fig. 81 (above) *El Gato Negro* 1
(23 April 1898), 11.

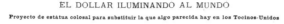

EL DOLLAR ILUMINANDO AL MUNDO

Proyecto de estátua colosal para substituir la que algo parecida hay en los Tocinos-Unidos

POR F. XUMETRA

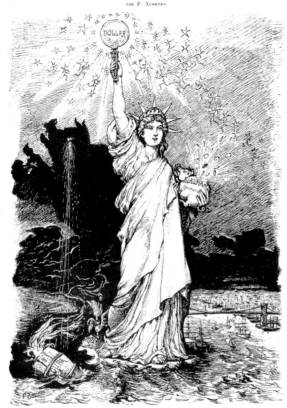

Fig. 82 "El dollar iluminando al mundo," *El Gato Negro* 1 (4 June 1898), n.p.

the Statue of Liberty holding aloft a beacon with the word "Dollar" radiating its light over the Caribbean while her other hand holds a piggy bank exploding with coins (fig. 82).[104] In the background a cloud in the shape of a pig sprays a liquid on a flaming barrel labeled "Cuba," which is floating in the water. The subtitle of Xumetra's cartoon completes the message: "Project for a Colossal Statue to Substitute a Similar One in the United Pigs." The cartoonist Mecachis (pseudonym of Eduardo Sáenz Hermúa) shows Uncle Sam fomenting Cuban unrest by feeding a pig

labeled "Insurrección cubana" (Cuban Insurrection) with beets, warning "Whoever Takes Someone Else's Pig Loses His Feed and Loses the Pig" (fig. 83).[105] Mecachis followed a year later with a sketch of a Yankee delivering a rowboat of munitions to an eager Afro-Cuban waiting with open arms (fig. 84).[106] As in the United States, in the Spanish press Uncle Sam was the single most frequent symbol of the United States during the Cuban conflicts of 1895–98, but hatred for the Yankees was also fueled by projecting an image of Americans as pigs. As in ancient Judeo-Christian symbolism in which swine symbolized hypocrisy, gluttony, and greed,[107] the pig as used by the Spanish press in the 1890s was a symbol of American greed, excess, and grossness. It became Uncle Sam's pet, following him around, or carried by him wherever he went. An overweight President McKinley presented one cartoonist with an easy target to collapse into a single figure: Uncle Sam (symbolized by the flag and Uncle Sam's high hat), an overweight President McKinley, and the American pig (fig. 85), substituting "Tocinos-Unidos" (United Pigs) for the United States.[108] To produce an American, according to F. Xumetra, all you had to do was grind up a pig, pour the mush into a mold, and out pops a live Uncle Sam (fig. 86).[109] The cartoonist Mecachis's recipe for producing "Yankées," which appeared in *Blanco y Negro* in 1896, includes more ingredients: sheep entrails, mud, potato peels, filth, bark shavings, sawdust, and pork go into the slurry (fig. 87).[110]

SOLDIERS OF MISFORTUNE

Few well-established Spanish newspapers and periodicals saw through the nationalistic rhetoric to condemn the war and the role the press and the Catholic Church played in garnering support

Fig. 83 "Refrán de actualidad,"
Blanco y Negro 6 (7 March 1896),
n.p.

for the government. As we have seen, even those that did were not above publishing the type of insulting stereotypes that belittled American culture in an attempt to whip up national pride. But there were exceptions, especially in the years just prior to the declaration of war, among them socialist, republican, or anarchist papers like *El Socialista, La Campana de Gracia, El Motín, La Mosca, El Pueblo, El Baluarte, La Tramontana,* and *El Nuevo Régimen*.[111] It is therefore obvious that the attitude of the press did not reflect "the entire spectrum of Spanish society at the end of the century."[112] While a smattering of newspapers and magazines around Spain such as these denounced official government responses to the Cuban conflict, Catalunya is where the most critical articles and cartoons appeared from 1895 to 1898, in part because Catalan commercial and colonialist interests in the Antilles surpassed those of any other region of Spain, and in part because

of the continued antagonism between the centralized government and Catalan separatist parties. Although the conflict affected Catalunya more drastically than other regions of Spain, throughout the 1890s there was no common stance to the Cuban crisis among the various political factions and established commercial bodies (for example, the Fomento del Trabajo Nacional de Barcelona, La Liga de Productores de Cataluña, and the Unió Catalanista). Even within these factions, positions shifted as the party in power in Madrid alternated and as the struggle escalated and it became clear just how much Spanish industry and agriculture stood to lose if Cuba gained complete independence and Spain's commercial rights and tariff regulations were eliminated. For a brief time the Catalan press rallied behind Sagasta when the United States finally declared war, but before and after 1898 complaints about the administrative mismanagement

Fig. 84 "Misericordia yankée,"
Blanco y Negro 7 (29 May 1897), n.p.

of Cuba outnumbered calls to support the government. After the bombing of the battleship *Maine* and the destruction of the Spanish fleet, many in Barcelona, liberals and conservatives alike, realized that a victory in the war with the United States was impossible and that it was time to cut losses and accept a peace accord, however humiliating and devastating to the commercial interests of the region.

The final defeat and subsequent peace accord provided an opportunity for Catalan editorialists to criticize further the bungling of the Cánovas and the Sagasta governments for their failure to effect timely reforms in colonial administration and to recognize Spain's military weaknesses. But a measure of self-criticism accompanied the attacks. For example, incisive articles castigated Catalans for participating in such an inept government. Journalists for *La Renaixensa* placed the blame on Catalunya's indifference to all but its momentary materialist well-being: "[T]he Castilian 'españolismo' of many Catalans has meant that Catalan politics has been misunderstood for many years and all has been lost for the salvation of Cuba. If within the Peninsula certain principles of liberty and spontaneity in the development of national life had predominated,

we would not have confronted such great difficulties."[113]

If there was one issue, however, that coalesced the ire of all Catalan factions—republicans, conservatives, Carlists, socialists, and anarchists alike—it was the disparity caused by the current system of military draft. Even journalists and politicians who did not object to the established draft complained bitterly that a disproportionate percentage of noneligible Catalan men were being drafted. Repeated complaints and calls to the Ministry of War to reform the system or to investigate erroneous drafts, which reportedly numbered as many as three thousand, resulted in little amelioration. In 1895, the lawyer Narciso Verdaguer Callís railed against the central government in *La Veu de Catalunya* in no uncertain terms for its failure in this regard:

The war is awash with blood and ruins, and meanwhile, in Madrid the politicians, gathered around the editorial rooms of the city's presses, pass their time arguing whether the war in Cuba was provoked and promoted by the Sagasta or the Cánovas party. And our people, miserable, ignorant, consent to having their money, their blood, and their honor

DOCUMENTO IMPORTANTE

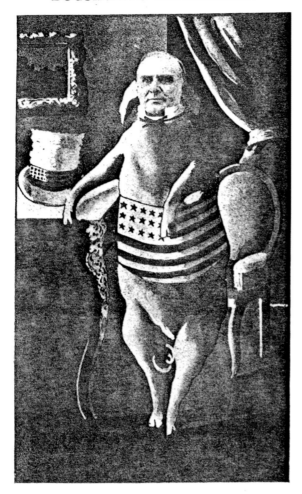

Verdadero y auténtico retrato de

Mr. Mac-Kinley

Presidente de los Tocinos-Unidos.

Fig. 85 *El Gato Negro* 1 (4 June 1898), 11.

administered by these people who, with the most scandalous impudence, confess to guilt for a war that is bleeding an entire Spanish generation, pushing us to the saddest of bankruptcies.[114]

Verdaguer Collís's anger, like that of most Catalans, stemmed from the fact that conscription was easily avoided by the wealthy for an indemnity fee that was out of reach of the working classes.[115] Editorials in *La Renaixensa, El Diluvio, La Regionalista,* and *La Veu de Catalunya* complained bitterly of the disproportionate conscription of Catalan soldiers.[116] Mañé y Flaquer, a journalist writing for the *La Veu de Calaunya,* echoed the sentiments of both the regional deputation and the satirical press, arguing that "those who were pushing for a war of vengeance, extermination, and unconditional submission of the rebels were the ones who had nothing to lose in it."[117] Similarly, the more radical Republican paper *La Esquella de la Torratxa* frankly stated that Cuba was the "cash cow" of many Spaniards but not of the "poor soldiers" who would be called on to fight the war.[118] Echoing the socialist cry "O todos o ninguno" (Either all or none), Barcelona's most strident satirical magazine, *La Campana de Gracia,* offered in July 1898 a sketch of a group of battle-weary soldiers receiving heavy enemy fire, subtitled "No més que 'ls que no tingueren 300 duros" (Only those who can't pay the 300 duros) (fig. 88).[119] The *La Campana de Gracia* images famously questioned the injustice of the recruitment system "that severed the nation in half, sending to die in the war only the sons of the popular classes while the bourgeoisie avoided it by paying the 1,500 pesetas to be exempted."[120] When once the war began and defeats quickly followed, the ruling economic powers of Barcelona: the Sociedad Económic de Amigos del País, and the Cámara de Comercio, as well as the consortium of left-wing and workers' papers that published a joint manifesto in *La Renaixensa* in June 1898, called out for the government to sign a peace treaty. The "voice of Catalonia" that had called for autonomy for Cuba and Puerto Rico

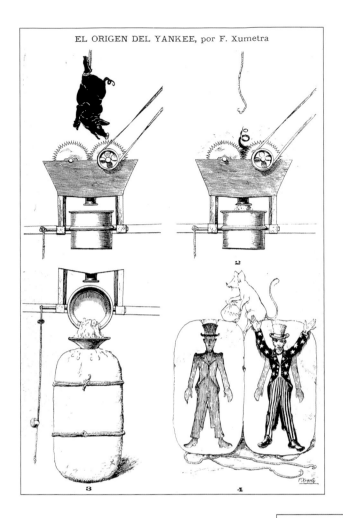

Fig. 86 (above) F. Xumetra, "El origen del Yan-
kee," *El Gato Negro* 1 (21 May 1898), 8.

Fig. 87 (right) Mecachis (Eduardo Sáenz Her-
múa), "Máquinas para fabricar Yankées," *Blanco y
Negro* 6 (11 April 1896), n.p.

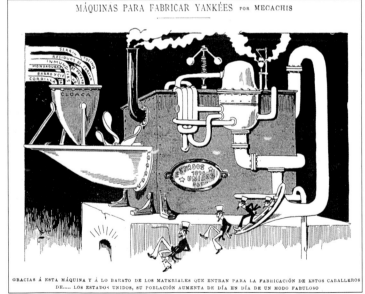

had not been heard; it was "too late to remind the government of the blood and treasures that would have been saved if Spain had accorded autonomy when the insurgents requested it."[121]

In Madrid the most vociferous objections to the war appeared in *El Socialista,* where one journalist wrote in 1898 that "the bourgeois press that has found in the war an excellent subject to sell a lot of paper has worked more than anyone, and by the most undignified means, to insure we go to war with the United States. . . . the rich speak much about patriotism and national honor but have taken special care to exempt their sons from military service with a fist full of pesetas."[122] In his editorials in the same paper, the editor Pablo Iglesias repeatedly railed against the economic interests that stood to gain by a war with the United States: transatlantic companies, merchants who rob soldiers in Cuba, newspaper publishers raking in the money from their sensationalist war reportage, military personnel looking for medals, moneylenders, and all who can make a business from the war machine. Miguel de Unamuno's famous protest, also published in *El Socialista,* urged workers to resist the war, "whose moral and material progress is not at all hindered by the insurgents but by those who send them to fight."[123] Yet it is important to emphasize that while many left-leaning and populist magazines recognized this truth and complained bitterly with "a surprising capacity for denunciation" of unjust inscriptions, few voices were raised in favor of full Cuban autonomy.[124] *El Motín* criticized Spanish leaders for the unjust draft policies and their mishandling the war, lamenting that "the idea of honor has been lost among our leaders; for them honor consists in conserving power." But once war was declared, *El Motín,* like most other magazines, decked itself out with patriotic salutes to the conscripted soldiers

and joined the chorus of voices that judged the United States "a nation formed of bandits from other nations."[125]

Centrist periodicals like *Blanco y Negro,* meanwhile, rather than making strident protests against the government's unjust conscription practices, sold instead the idea that, patriotism aside, anyone with the means had a moral responsibility to "redeem" a loved one from service if it were within his or her power to do so. In Rafael Torrome's short story "Mejor moneda" (The Best Coin) of 30 July 1898, a numismatic enthusiast is torn between his love for coins (one of the era's obsessions, as we have seen) and his love for his nephew. In a twist worthy of O'Henry, just as Don Tadeo makes the painful decision to sell part of his collection to pay for his nephew's exemption from the draft, his nephew hands him a rare coin, the price he was paid to "sell" his services to another family more willing to part with its wealth. Alone in his study amid his prized coin collection, Tadeo laments "I'm a miserable wretch; I've given the best coin to the Mambises."[126] The same message circulated in a number of stories about soldiers in the 1890s. With similar pathos, Leopoldo Alas's 1886 story "El sustituto" (The Substitute) addressed the injustice that poverty or wealth determined who must serve in the military. But the protest fades into the background after a redemptive gesture on the part of the story's wealthy protagonist makes him the true hero. Eleuterio, the gifted poet-son of the local magistrate who has been called up in the draft, is about to be substituted by Raimundo, a poor lad seeking to retire a long-standing debt his family owes to the family of the poet. By selling himself to Eleuterio's father, Raimundo is able to rescue his mother and siblings from destitution, liquidating his mother's debts and even leaving her with enough money

to buy food and supplies during his absence. As he prepares to write a poem about patriotism and service to the homeland, Eleuterio is suddenly faced with the enormous and unjust price that his substitute has had to pay to free him from his patriotic duty. Overwhelmed with guilt, Eleuterio volunteers his services to fight in Africa alongside Raimundo. When his substitute dies unheroically, Eleuterio adopts his identity so that in turn when he, Eleuterio, dies a hero, Raimundo's family can benefit from the fanfare and widow's pension that his deeds have earned him.[127]

Alas's story does not so much impugn the practice of paying for a substitute as it questions the circumstances in which the price is paid. And although Raimundo's sacrifice to liquidate his mother's debt by substituting for Eleuterio is portrayed as a noble sacrifice, he quickly proves to be a useless soldier: he dies unheroically, plagued with dysentery and fevers, while the brave Eleuterio predictably dies with "elegance" and "distinction," which readers would expect from a man of his class. Pierre Vilar points out that the "literary sensitivity" to the moral problem of the substitute in stories such as these had no effect on military policy, which continued to be unconcerned with the problems of enlisted servicemen.[128] That wealthy families were wise to purchase their sons' exemption from the draft was abundantly clear shortly after the 1898 armistice, as images of returning soldiers began to bring the reality home to more than just the devastated families. Liberal and conservative, socialist and Catholic papers alike mourned the end of the war as a great national tragedy. But comments about the inequality of recruitment practices were greatly overshadowed by the scope of the country's loss, especially in liberal-conservative periodicals: "[A]s the smoke of honor lifted, for conservative papers it is a moment of silence, for the Republican papers an occasion to insist on the responsibilities and martyrdom of the people."[129] Nevertheless, while some mainstream papers remained silent about the personal sacrifice of war unjustly exacted from the poor, sketch artists of all stripes focused on the pathos of repatriated soldiers. Their images indirectly suggested that Spain's war of honor was ill fought, and the sacrifices it imposed on its poorest citizens too great. The anarchist cartoonist Josep Lluis Pellicer Montseny, one of the few who systematically painted the war in negative terms long before the final defeat, dotted *La campana de Gracia* with visions of wounded, emaciated, and mostly barefoot soldiers, including a skeletal figure, with the caption "Y lo que n'hem tret" (And What We Got Out of It) (fig. 89).[130]

The casualty figures from the War of 1898 were staggering, but not the result of battle losses such as might be expected from this engagement. The overwhelming number of soldiers who perished in Cuba died of diseases brought on by unsanitary living conditions, malnutrition, and insufficient medical attention. Two generals, 141 officials, and 2,018 soldiers died in combat, while 440 officials and 53,000 conscripted and volunteer soldiers died of yellow fever, malaria, typhoid fever, tuberculosis, and other diseases.[131] Spain's defeat was predictably seen as a catastrophe by Republican and conservative papers alike, but there was little agreement about the reasons for the defeat and especially about whom to blame. Republican periodicals like *El Motín* squarely blamed the Spanish government: not enough soldiers had been sent to Cuba, claimed the journalist Cazalla, because the government was afraid of leaving its precarious institutions unprotected and the poor would have risen up if even more soldiers were conscripted: "If

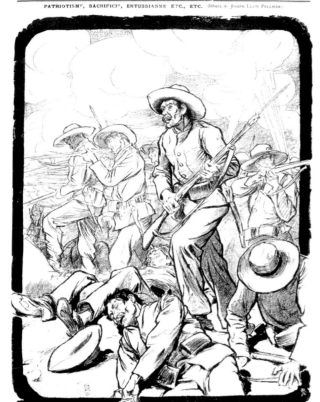

PATRIOTISMᵒ, SACRIFICIᵒ, ENTUSSIASME ETC., ETC. (Dibuix de Joseph Lluís Pellicer.)

No més que 's que no tingueren 300 duros

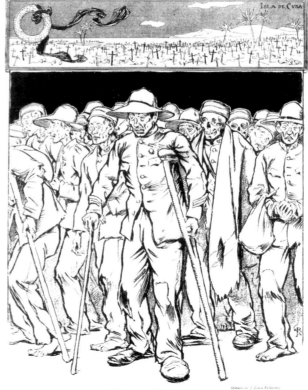

Y lo que n' hem tret

Fig. 88 (above) Josep Lluis Pellicer Montseny, "Patriotisme, scacrificio, entusiasme, etc., etc.," *La Campana de Gracia* 29 (7 July 1898), 5.

Fig. 89 (right) Josep Lluis Pellicer Montseny, "Final: Lo que hi hem deixat: Y lo que n'hem tret," *La Campana de Gracia* 29 (24 September 1898), 5.

Spain had a government that identified with the people, there would be 100,000 more soldiers in Cuba, 50,000 more in Puerto Rico, 20,000 more in the Philippines, and the Bay of Manila would have been defended, and the ridiculous taking of the Marianas by a dozen Yankees would not have taken place."[132] The audacious journalist "Carrasquilla," (José Rodríguez La Orden) also vehemently opposed to the war, published poem after poem in Seville's *El Baluarte,* complaining of the inadequate training of recruits, the draft system, the influence of the Catholic Church, and the ineptitude of both conservative and liberal politicians, the "bandits of frock and long coat" for whom "the colonies were always a boon."[133] *El Socialista,* which had berated the government both before and after the war, mounted an aggressive campaign in 1899 to force the government to increase its aid appropriations for returning soldiers. In its weekly columns with bylines entitled "Páguese a los repatriados" (Pay the Repatriated), "La Semana Burgués" (Weekly Bourgeois Report), and "La Repatriación" (The Repatriation), writers bitterly complained about the government, the church, and the bourgeoisie, the latter for insisting that vanquished officers be paid without mentioning the miserable condition of enlisted soldiers.[134] Meanwhile, *Ilustración Española y Americana* included stark photographs of wounded soldiers on the *Montserrat* and *Alicante* steamships, but glossed over the blame for their poor treatment. In a lengthy editorial

the spokesman Emilio Castelar blamed both the radical right and the left for the country's defeat, reserving special blame for Hispanic-American journalists who had fueled animosity toward Spain in Latin America.[135]

True to its moderate political stance, *Blanco y Negro*'s writers remained more circumspect. The comings and goings of repatriated soldiers were dutifully described and graphically represented, but the magazine seemed more interested in picturing the idyllic settings where the soldiers were to be hospitalized when they first arrived, than in publishing photographs of the wounded soldiers themselves. Panoramic vistas of Vigo and Coruña showed readers the more "blanco" ("pleasant" in the magazine's editorial idiom) side of the repatriation: "We will limit ourselves today to offering our readers several vistas, very curious and completely unedited, of the picturesque hospital of San Simón where the troupes arriving at Vigo will be stationed."[136] Responsibility for the defeat was couched in generalities that spread a bit of blame across the political spectrum: "chapuzas" (botched jobs) all around. Luis Royo Villanova wrote: "Bungling in the Ministry of the Marine, bungling in the War Ministry, bungling in the Office of the Budget, bungling in Foreign Affairs, everything botched."[137] The only bungling that Royo Vallanova failed to mention in his diatribe was that of broad sectors of the press that had fueled enthusiasm for a war that should never have taken place.

CONCLUSION

THE CONSEQUENCES OF the War of 1898 were sufficiently devastating and widespread to provoke a national debate about how best to remedy what was wrong with Spain. The aftermath of the war dominated periodical discussion as the topic of regeneration filtered through all realms of political, religious, and cultural discourses, eventually defining the whole era and its writers. But modern focus on the "Generation of '98,'" as it came to be labeled, dims the reality that Spain did not slide into a sudden decline after its military defeats in Cuba and the Philippines. In fact, Álvarez Junco points out that in the years following the war Spain's economy quickly and steadily recovered. The printing industry during and following the war saw many gains as well as losses. Many periodicals were disappearing, but some of those that remained, like *Blanco y Negro,* were experiencing continued success, and eventually new magazines, such as *La Esfera,* launched in 1914, were opening the nation up to more modern periodical ventures. The short stories and what *Blanco y Negro* called "novelas relámpagos" (lightning novellas) that together with the news replaced the serialized novel,[1] more and more lavishly illustrated advertisements, the distinctly entrepreneurial attitude of the new publishers, aggressive self-publicity campaigns required to subvent periodical production, appeals to multiple classes of people for the purpose of increasing subscriptions, the generous use of tri-color around the turn of the century, the elimination of lofty and metaphorical speech, the introduction of photography and field reporting, the installation of new factories with rolling presses, a diminished adhesion to a particular political party or institution—in other words, the adoption of the techniques of modern Western journalism—ensured the success of magazines such as *Blanco y Negro.* The social and general conditions that Josep Lluís Gómez Mompart and Enric Marín Otto list as minimal for the appearance of mass communication were then in place.[2] Botrel argues that the press at century's end was amazingly diverse and its players much more "active" than literacy figures would indicate, especially if one takes into account the myriad forms of minor literature and visual popular culture that flourished in large urban centers and in virtually every provincial town.[3]

Nevertheless, as some have argued, it is a misnomer to speak of a mass media in nineteenth-century Spain despite the success of periodicals like *Blanco y Negro* or successful newspapers like *El Imparcial.*[4] Before the 1868 Revolution, strict government-imposed restrictions on the press and poorly paid journalists working for two or more newspapers impeded the development of an independent press.[5] The liberalization of the press that followed the 1868 Revolution was very limited and lasted only a decade.[6] The December 1875 Decree of the Press (prepared by Romero Robledo under Cánovas del Castillo) prohibited any subversive speech relating to Spain's political

organization.[7] The restrictions and sanctions outlined in the decree made it easy for the press to understand its obligations but also for the government to control the press by suspending or denying licenses to papers critical of the government. The subsequent 1879 Law of the Press (also under Cánovas del Castillo) aimed at safeguarding the monarchical system of government and reaffirmed strict controls on the press, refining the list of infractions and penalties. The ensuing tight control over the press resulted in one of the greatest failures of the Restoration.

The 1883 Law Governing the Press, passed during the second Sagasta regime as part of revisions to the Penal Code, considerably liberalized the press by eliminating many of the sanctions incorporated into previous laws, and consequently the number of periodical publications increased precipitously in Spain from 1879 to 1883, from a total of 544 periodicals in 1879 to 1,347 by 1900.[8] But constitutional guarantees were time and again suspended or amended to serve political ends, especially during the "turno" (turn) of the more conservative of the two reigning political parties.[9] Constitutional guarantees of expression were suspended during an equivalent of more than twelve years between 1875 and 1923.[10] During the military campaigns of the end of the century, the government repeatedly pressured publishers to promulgate patriotic ideals in order to ensure national unity. And, as we have seen, magazines like *Blanco y Negro,* despite their occasional grumbling and avowed political neutrality, quickly fell in line with national priorities. The consensus was, in the words of Serge Salaün and Carlos Serrano, that dissension had to be curtailed during war years: "[A] series of measures more or less lasting restricted the freedom of expression in these years, because of the influence of a progressive militarism and the reactions

that it provoked, and because of the preoccupation of power to guard itself from the threats that anarchism and regionalism posed for social order and national unity."[11]

Other obstacles as well prevented Spain from producing what could indisputably be called a mass-circulation magazine or newspaper: even when official censorship abated, the telegraph, the lifeline of news media at the time, was tightly controlled and transmissions delayed, especially to those newspapers out of favor with the administration. Liberal papers were often censored through fines and suspensions, sometimes for weeks, and others were even denied a license to begin publication. Governmental ministries, the clergy, and local officials all had well-tested procedures to filter the news, some surreptitious, others through open censorship or the denial of licenses. Funding was sporadic, and failures endemic. The newspaper staff was generally underpaid and often inexperienced: "[T]he world of journalism was a bit the world of gossip and hustlers, in which cleverness and a stroke of luck could secure one's future and where many, the majority, failed."[12] According to Javier Fernández Sebastián and Juan Francisco Fuentes, corruption was rampant: "Governments and ministries, foreign embassies and secret services, political and economic leaders and institutions of all sorts did not hesitate to boldly influence public opinion, proceeding discretely in so doing, and not always employing legitimate means."[13] To this list, Salaün and Serrano add the misery and alcoholism of the underpaid journalists; the venality of certain periodicals, accustomed to blackmailing by threatening to publish calumnies; secret funds and official sinecures; and piracy of the competition's articles or those of the foreign press. All this, they conclude, was the "daily bread" of the press.[14] By 1900, freedom of expression in Spain

was still constantly under threat, at least as far as the press was concerned.

For all these reasons Spain's periodical press could not compare with the "new journalism" of the *Times* in England, or *The New York Times* in the United States, which had built a base of readership beginning in the 1830s and already by the 1870s could rightly be classified as mass-produced newspapers. Miguel Martínez Cuadrado's assessment that Spain's end-of-the-century Spanish newspapers like *El Imparcial, La Época, El Globo, El Siglo futuro, El Liberal, La Correspondencia* compare favorably with *The Times* of London or *Le Temps* of Paris[15] is accordingly somewhat optimistic. Spain simply lacked the resources, including the number of potential readers, to compare with these more industrialized countries.[16] Nor could its illustrated magazines, as popular and numerous as they were, compete with those such as *The Penny Magazine* that already had a circulation of 200,000 by 1833 or the more expensive *Illustrated London News* whose circulation had reached 300,000 by 1863.[17] The literacy rate of Spain during the period of the Restoration was far below the literacy rate of Europe and the United States, severely limiting the number of readers.[18] In a country where nearly three fourths of the population was agrarian, the bases for a mass press were lacking; the relatively small and economically unstable middle class, residual feudalism still intact in rural areas, low literacy rates, failed bourgeois revolution, shadowy pressure groups, deficient fiscal organization, underdeveloped industrial complex, and high public debt all worked against a mass-circulation press. Owing to the small percentage of readers, the delivery of information during the last decades of the century can most accurately be described as "a restricted system of elites for elites," in the words of Jesús Timoteo Álvarez.[19]

Defined quantifiably, a media of communication is mass if it communicates with a significant percentage of a population, as arguably was the case of *El Imparcial* and other dailies at the end of the century. "[I]n effect, one can speak of a mass press—increased numbers, thematic renovation, modest prices, a new language—as long as we do not give to this expression too definitive a meaning, that obscures the enormous differences of scale with the new journalism of the new generation of North American, French, or British periodicals."[20] *El Imparcial* of Madrid, which in 1885 had a circulation of 50,000, exceeded 100,000 in 1885 and 140,000 in 1900,[21] showing that Spain was moving steadily toward a mass-produced daily newspaper in terms of print runs. The ever more popular magazine *Blanco y Negro* boasted of 100,000 readers for a special issue published in 1900, and a regular circulation of 60,000 by 1901.[22] More important, however, is the kind of reading that is implied in the term "mass media." Celso Almuiña associates the dawn of the era of mass communication in Spain with the 1883 Law of the Press, which granted fuller freedom of expression to the press than had earlier been the case, even though this period can more aptly be called one of "a guarded freedom."[23] The 1883 Law was important because it transferred the power of control over the press to the judicial from the executive branch of government, a step that is essential in the establishment of a liberal press. But according to Juan Francisco Fuentes and Javier Fernández, the press still had not coalesced into what could accurately be called a mass media because it was still incapable of representing the masses to the governing elites.[24] It was not that technology lagged behind the demand; rather the lack of an extensive demand limited the production of media on a mass scale: "[T]he relation of investment augmentation of the

market is not proportional; in effect, the former ends up decreasing and adjusting to the capacity of the market."[25] Nevertheless, readers of daily periodicals, claims Josep Lluís Gómez Mompart, were starting to read *as if* they were members of a mass culture, by which he means that they were not reading papers in the old way: their tastes were more heterogeneous and secular than they had been previously, and they were expecting more gratification from their reading. "[T]hose 'new-readers' demanded more periodical alimentation, an informative-cultural plus beyond the simple ideological ration however proper and sensible this was."[26] Even though the "masses" were still not reading at the end of the century, Álvarez also believes that the material being read resembled that of the mass media of other countries.[27] If it is possible to sustain the category of mass culture by measuring the eclectic tastes of its readers, then an argument could be made that some weekly magazines succeeded in extending their markets beyond the narrow political interests of a given party or institution. Beginning in the 1880s, the "informative product," according to Bernardo Riego, was becoming a generalized consumer good that was unaligned with any particular party or ideology, attracting readers regardless of their political affiliation.[28] This policy of professed nonalignment, however, can give the false sense of editorial objectivity, something that, as we have seen with *Blanco y Negro,* was illusory.

Identifying the causes that resulted in the development of the magazine in the 1890s in the United States, Richard Ohmann defines mass culture as a simultaneously and frequently shared activity that is experienced as voluntary by an audience but that is produced by a relatively small number of capitalists whose aim is to shape audiences around common needs or interests

in order to produce profits.[29] The affordable prices and technological advances like halftone production that are involved in the mass production of magazines were not what spontaneously produced mass culture; rather, print media became the channel for the expression of mass culture. It was part of a process; a "conjunction of interests, needs, activities, and forces led to the invention and success of the modern magazine industry."[30] Ohmann's claim is that the industry met the needs of a growing industrial complex that needed to develop means of effective marketing, which had been haphazard before the establishment of mass media. Ambitious entrepreneurs, higher literacy rates, urbanization, cheaper paper, modern modes of production, and affordable prices were the stimuli, but all of them worked because there was a vision for their use, and it was this transformation in the social order that turned information and entertainment into instruments of marketing. In other words, capitalists needed mass-circulating magazines as a form of self-regulation that stabilized and fostered productivity. They subsequently became "engineers of consumption"[31] through improved marketing of products, which seemed to give everyone something new to want and was therefore the perfect mediator between industry and consumers.

Seen from this angle, Spanish magazines cannot easily be considered to operate as an instrument of mass media. In nineteenth-century Spain, most product advertising still appeared in the daily press or in advertising posters. In contrast to newspapers, Spanish magazines, even *Blanco y Negro,* which aggressively courted publicity, attracted relatively few publicists until 1905.[32] Self-advertisement, on the other hand, was very prominent in all magazines, with information about the binding of collections and the purchase

of subscriptions, back numbers, and special issues included in every issue. We have already seen that Torcuato Luca de Tena was indignant at being accused of producing a magazine for the purpose of advertising products. Luca de Tena's somewhat disingenuous protest was a product of the general negative attitude of magazine consumers, who deemed that advertising cheapened their leisure activity, and of publishers, who preferred to advertise products in which they held a personal economic interest. For example, by its tenth issue *Blanco y Negro* had already started to advertise Agua de Azahar (Orange Water), a product produced in Luca de Tena's own factories in Seville, and this product constituted its most repeated and glamorous advertisement for several decades.[33]

As competition between rival brands emerged in manufacturing sectors in Spain and abroad, the importance of brand recognition grew, and with it, the need to modernize advertisements by introducing a higher standard of artistic production. Around the turn of the century and for several decades following, it was the advertising poster that achieved the highest point of artistic refinement, not the magazine advertisement. Well suited to iconic reproduction on specialized paper, the poster attracted many artists, especially during the competitions for the best posters featuring Spanish products. Thousands of these turn-of-the-century posters stand out for their adroit combination of advertisement and modernist graphics selling Jaime Boix chocolates, La Palma and La Gloria cookies, Codorníu champagne, Perla Anisette, and many other products. Around the same time, advertising agencies were set up to meet the needs of producers who were beginning to recognize the need for brand recognition. The job of advertising editor became more complex as newspapers and eventually

magazines as well began to rely more heavily on advertising revenues. In 1895 most of *Blanco y Negro*'s magazine advertisements were for businesses selling a specific product such as phonographs, stoves, and baby buggies, but they did not specify brand names. By 1900, however, brand names were beginning to emerge in magazine advertisements: Singer sewing machines, Watt light bulbs, Sturgess and Foley steam engines, Laval turbines, Compañía Colonial chocolates, Hurí corsets, Royal Windsor hair treatment, Peugeot bicycles, Veloutine Fay face powder, Henri Garnier Cognac. Pharmaceuticals outweighed every other category, and these tended to be of Spanish origin—Magnesia Villegas, Sáiz de Carlos stomach elixir, Dr. Andreu cough pills, Jabón medicinal de Brea—while many of the beauty products had French names and provenance, such as Veloutine Fay and La Diaphane face powders. Some Spanish brands were becoming familiar, especially those of alcoholic beverages: Cognac Jiménez y Lamothe, Cognac Barceló y Torres, and Spanish producers of chocolates (such as Benedictine chocolates).

About the same time, the exotics of Chapter 1 that were still fashionable in the art pages of magazines were suddenly given a new role: to pose as consumers and hawkers of brand-name products, alongside smiling middle-class and bourgeois women whose "come-hither" poses also sold more than just their good looks. The connection between coins and women so favored by Orientalist genre painters was abandoned: now women were called on to represent all the new manufactured goods that money could buy.

A study of the evolution of *Blanca y Negro*'s format from 1890 to 1910 allows us to see that the turn of the century marks the conversion of the popular graphic magazine into an important advertiser of consumer goods during the

first decades of the twentieth century. The mass production of goods and the mass production of magazines coincided as a defining marker of modernity. The two were mutually dependent: the production of the magazine depended on advertising revenues, while the manufacturers of mass-produced goods depended on magazines to advertise their products in the most enticing way. And magazine advertisements and illustrations helped motivate future media enterprises to exploit women's bodies by portraying unrealistic representations of what desirable women should look like.

Notes

INTRODUCTION

1. Pierre Bourdieu, *Photography A Middlebrow Art,* 1.
2. The Restoration marks the period that began in 1874 after the First Republic collapsed and the Bourbon king Alfonso XII was restored to the throne. It ended in 1931 with the proclamation of the Second Spanish Republic. Its politics were at best murky, plagued with fraud and a predetermined rotation of Liberal and Conservative parties, but it also ushered in a period of relative stability and modernization. For a detailed history of the illustrated press before the Restoration, See Valeriano Bozal's *La ilustración gráfica del siglo XIX en España.*
3. Joan Ramon Resina, "The Concept of After-Image and the Scopic Apprehension of the City," 14.
4. Ibid., 13.
5. Eugenio Sellés, "Del periodismo en España," 138. All translations are by the author unless otherwise noted.
6. Roland Barthes, *Camera Lucida,* 98.
7. Sellés, "Del piodismo en España," 143.
8. Peter Galassi, *Before Photography: Painting and the Invention of Photography,* 12.
9. John Tagg, *The Burden of Representation: Essays on Photographies and Histories,* 37.
10. Ibid., 37.
11. Paul Aubert, "El acontecimiento," 54.

CHAPTER I

1. See Lou Charnon-Deutsch, *Fictions of the Feminine in the Nineteenth-Century Spanish Press,* for a discussion of the various classes of feminine portraits.
2. Bram Dijkstra, *Idols of Perversity,* viii.
3. Charles Baudelaire, "Le Peintre de la vie moderne," 713.
4. Baudelaire, "Le Peintre de la vie moderne," 714.
5. Baudelaire, "Le Peintre de la vie moderne," 717.
6. Bram Dijkstra, *Idols of Perversity,* 355.
7. Ibid., 400.
8. Dikjstra's sweeping controversial conclusion is that the decadent male-devouring woman was actually part of a long process of the ritualistic exorcizing of women:

> Thus, in an acute, lurid, antifeminine symbolism and a fashionable, loudly proclaimed espousal of evolutionist and eugenicist theories, men everywhere, of every possible political persuasion, declared their emancipation from the viraginous, decapitating sword of woman's regressive, degenerative concern for the real. By the first decade of the twentieth century, antifeminine attitudes, often accompanied by a wholesale espousal of misogyny, had become the rule rather than the exception in both Europe and the United States. Ordinary acts of love were seen as no more than the submission of the soul to the materialistic enticements symbolized by woman's hunger for gold, which in turn was dramatized by her hunger for man's head. (Dijkstra, *Idols of Perversity,* 398)

9. Arthur Schopenhauer, "On Women," 122.
10. Dijkstra, *Idols of Perversity,* 364.
11. Dijkstra, *Idols of Perversity,* 369. Dijkstra discusses woman in art and literature as lusting after gold, in his chapter "Gold and the Virgin Whores of Babylon; Judith and Salome: The Priestesses of Man's Severed Head," in *Idols of Perversity.* Images of Danae were especially rapacious:

> In 1891 Carolus-Duran painted Danae luxuriously leaning back while a shower of gold coins was beginning to drop out of the sky. In the same year Chantron showed Danae eagerly pulling aside a curtain to make sure that the coins would find their mark. In 1896 Antoine-Auguste Thivet depicted a particularly hungry-looking Danae as she opened her legs to a well-directed shower of gold. Across

the Rhine Carl Strathmann depicted a characteristically pudgy, Germanic Danae, far removed from her tower, marching among a riot of fertile flowers while a veritable cloudburst of gold coins all around her paid tribute to Zeus' extraordinary potency." (Dijkstra, *Idols of Perversity,* 369)

12. Gérard-Georges Lemaire, *The Orient in Western Art,* 270.

13. Todd Porterfield, *The Allure of Empire,* 10.

14. According to some critics Orientalism had not exactly run its course; rather, its subject had just expanded. Madeleine Reberioux, for example, points out that the latter part of the century saw the thematic expansion beyond the Orientalized southern Mediterranean region into Africa ("Ces demoiselles," 444).

15. The ethnic portrait was already a popular convention in the 1830s in France when the term "ethnographie" was coined at the founding of the Musée Ethnographique (Todd Porterfield, *The Allure of Empire,* 138). Porterfield reminds us that although Delacroix is associated with the highpoint of the Orientalist convention, with the advance in reproductive technologies of the late nineteenth century Oriental scenes flooded the market. That the tradition of Orientalism wanes after Delacroix's *Women of Algiers,* as some critics believe, is untenable in view of works like Matisse's *Odalisque in Red Trousers* that coincided with the Exposition Coloniale of 1922, "intended to glorify, justify, and expand the French empire" (Porterfield, *The Allure of Empire,* 145). "Far from moribund, Orientalism provided a clear and stable tradition that could unite the French, as it had in Delacroix's day, suppressing political differences at home while reasserting the moral and sexual chasm that separated them from their colonized peoples" (ibid., 147).

16. Anne McClintock, *Imperial Leather,* 73.

17. I have no intention of valorizing positively the notion of fetishism as would Sarah Kofman, who calls for a "fetishisme géneralisé" or generalized fetishism, which speaks to both a male and female spectator (see Emily Apter, *Feminizing the Fetish,* 109). Although I recognize that female spectators would be drawn to the images of the exotic subject, my contention remains—as I argued in *Fictions of the Feminine in the Nineteenth-Century Spanish Press*—that these images were geared to an overwhelmingly male audience. Judging from the occasional images and photographs that appear in the illustrated magazines studied here, the print shop, editorial room, and engraving studio were exclusively sites of male labor. See, for example, the 1893 photograph "Mesa de batalla de la redacción de 'El Imparcial,'" in Antonio Espina García's *El cuarto poder* (144) or the sketch entitled "Talleres de la *La Ilustración Española Española y Americana,*" in the same source (129).

We know also that the vast majority of painters who exhibited in salons were men, as were the members of the various art academies. Women viewed the images, and no doubt many enjoyed them, but their position vis-à-vis the image is always problematic. As Susanne Kappeler so aptly put it, "The systematic representation of women-objects is not a question of a single subject representing to himself another subject, who happens to be a pretty woman, as an object. In cultural historical terms, it is the male gender, unified by a common sense, who assumes the subject position: as the authors of culture; men assume the voice, compose the picture, write the story, for themselves and other men, and about women" (Susanne Kappeler, *The Pornography of Representation,* 57).

18. Dorothy M. Figuera, *The Exotic: A Decadent Quest,* 167.

19. Karl Marx, *Capital,* 1:165.

20. William Pietz, "The Problem of the Fetish," part 1, 9.

21. Karl Marx, *Capital,* 1:164–65.

22. Jean-François Botrel, *Libros, prensa y lectura en la España del siglo XIX,* 183. This and all other translations from the Spanish are mine. Spain was by this time manufacturing its own continuous, mass-produced paper, but the machinery for paper making was imported from abroad as late as 1911, leading Botrel to speculate that this was one of the reasons for the prolonged influence of France on the publishing industry in Spain (Botrel, *Libros, prensa y lectura en la España del siglo XIX,* 187). Spain also lacked the wood pulp required to produce abundant quantities of paper, and this limited production in comparison with France and other European countries (ibid., 194). In 1879 there were seven paper pulp factories, but the number had dropped to two by 1898. In 1890 Spain had 50 paper-making machines (compared to 525 machines in France), and the government's protectionist policies meant that at the turn of the century Spain was producing close to its modest need for paper at a relatively high price compared with other countries. By 1914 it was consuming three times as much pulp as it was producing (ibid., 197) and importing paper. See Botrel also for a discussion of the paper industry in Spain (ibid., 184–206).

23. *La prensa ilustrada en España,* 75.

24. Gómez de Aparicio, *Historia del periodismo,* 474. In 1900 in all of Spain there were 558 weeklies, 156 bimonthly, and 145 monthly magazines (Francisco Iglesias, "Reorganización de la prensa y nuevas empresas periodísticas," 43). See also Gisèle Cazottes, *La Presse périodique madrilène entre 1871 et 1885,* for a listing of Madrid periodicals published between 1871 and 1885.

25. W. J. T. Mitchell, *Iconology: Image, Text, Ideology,* 190.

26. Emily Apter, *Feminizing the Fetish,* 3.

27. The magazine was a kind of cheap substitute for the more costly *cabinet des antiquités* that formed part of

bourgeois home culture. Even if one lacked the resources to collect objects, collecting printed images of objects and people was possible, and magazines were lush with artistic renderings of collectibles. Nevertheless, it should be noted that even the modest 30 centimes would be far beyond the reach of the working class. In 1900 the price of a daily newspaper was 5 centimes (the same as a kilo of bread), which meant that most workers would consider even the daily paper an unaffordable luxury (Josep-Francesc Valls, *Prensa y burguesía en el XIX español*, 206).

28. Mitchell, *Iconology: Image, Text, Ideology*, 194.

29. Pietz, "The Problem of the Fetish," part 1, 6.

30. Claude Binet, "Le Fétichisme dans l'amour," 144–45.

31. Binet, "Le Fétichisme dans l'amour," 159.

32. Binet, "Le Fétichisme dans l'amour," 261.

33. Binet, "Le Fétichisme dans l'amour," 266.

34. See Robert Nye, "The Medical Origins of Sexual Fetishism," 30, for more on this.

35. As in the case of Alfred Binet, the roots of Freud's theory on fetishism are to be found in the work of Jean-Martin Charcot and Valentin Magnan, French psychiatrists who published papers on sexual perversions in the *Archive de Neurologie* in 1882. Charcot and Magnan associated fetishism with cultural decadence, a notion that, as we have seen, influenced Alfred Binet and other medical commentators who often used cultural manifestations as evidence. Freud's contribution was to see fetishism not so much as a biologically determined pathology or as a result of a degraded cultural ambiance but as a product of the castration complex.

36. Jeffrey Mehlman, "Remy de Gourmont with Freud: Fetishism and Patriotism," 85.

37. Henry Krips, *Fetish: An Erotics of Culture*, 57.

38. Anne McClintock, *Imperial Leather*, 202.

39. McClintock, *Imperial Leather*, 202.

40. McClintock, *Imperial Leather*, 203.

41. José Álvarez Junco, *Mater dolorosa*, 500.

42. Suren Lalvani, *Photography, Vision, and the Production of Modern Bodies*, 80.

43. *Ilustración Artística* 13 (26 February 1894), 137.

44. *Ilustración Artística* 13 (26 February 1894), 138.

45. *Ilustración Ibérica* 13 (23 November 1895), 744–45. The *guzla* or *gusle* was a one-stringed violin resembling a mandolin; it is associated in literature with itinerant bards of Turkey, Serbia, Montenegro, and Bosnia. Prosper Mérimée popularized the term in 1827, when he published a group of pseudo Dalmatian folktales under the title *Guzla*.

46. Readers familiar with psychoanalytic criticism will know that Freudian discourse of sexual avowal and disavowal has consistently aroused skepticism among both psychoanalysts and cultural critics. In fact, shortly after Freud's famous paper on fetishism, psychologists on the margins of the Freudian school were already suggesting the possibility that the fetish might represent female organs. Challenges continue today to be leveled at the Freudian model of phallic fetishism, most notably in recent works by Marcia Ian and Anne McClintock. Ian sees the Freudian insistence on Oedipal constructions as itself a fetishistic and patriarchal enterprise, and in *Imperial Leather* McClintock wonders why Freud interpreted the fetish object as a "substitute for the mother's (absent) penis, and not, say, as a substitute for the father's (absent) breasts" (Anne McClintock, *Imperial Leather*, 190). Even though in the end McClintock rejects both theories for explaining fetishism, she agrees with Linda Williams, who argues that Freud fell prey to a logic that is itself fetishistic because it centers on sameness, that is, on a kind of primal unity "fixating on a single, privileged fetish object, the penis" (McClintock, *Imperial Leather*, 190). In his challenge to the Freudian model, Charles Bernheimer describes Freud's fixation with castration fear as a decadent interpretation of sexual difference that was primarily the product of a nineteenth-century aesthetic fixation with decapitated heads of Medusa and John the Baptist rather than with a universal, primal phenomenon. We should interpret fetishes, according to Bernheimer, as a sort of denial of sexual difference. Concealing the refusal of difference, the "fetishist is characterized not by his incapacity to accept woman's lack but rather by his incapacity not to see woman as lacking" (Charles Berheimer, "Fetishism and Decadence," 81). As such, Bernheimer suggests that we cast the whole theory of castration onto the "compost heap of history." Similarly for Ian the fetishist betrays not a fear of lack but the desire for sameness: "That there is no distinction between the sexes may or may not be a 'primal fantasy'; who knows? It does appear, however, to be a fantasy inseparable from the hegemonic authority of patriarchy, which depends not only on compensating fantasmatically for what woman does not have, but also, and more important, on denying what woman does have" (Bernheimer, "Fetishism and Decadence," 91).

Still other readings of psychological fetishism are available to us and yet are inadequate to explain the full range of interpretive possibilities of exotic magazine portraiture. Henry Krips notes that in the twentieth century the fetishistic scopic regime is not always conservative, since it can undermine the ideological forms of dominant society, thereby revealing the material processes of modernization. Similarly, Apter argues that fetishistic portraits have the potential to reverse the objectifying gaze and thus challenge the erotic conditions of mastery, since it can be argued that the fetishist-collector becomes possessed by his morbid passion for collecting. Apter is also trying to develop a new way in which to read the masquerade of femininity apparent

in these images of overadorned women, a masquerade that focuses on feminine desire instead of feminine lack. For her part, Naomi Schor has called for a feminine fetishism, and Elizabeth Grosz wants to claim a lesbian fetishism; in both cases the impulse is to redress an omission in the founding discourse of fetishism that denied the existence of the female fetishist. (See Emily Apter, *Feminizing the Fetish,* 98.)

Although it is theoretically possible that the scopic regime could in some forms challenge dominant ideological forms, and the call to "wean gender theory from its fixation on feminine lack" is certainly refreshing, it is difficult to read the images studied here in a celebratory fashion either as subverting or as legitimating some kind of sexual mode of feminine being.

47. Marcia Ian, *Remembering the Phallic Mother,* 54.
48. Nye, "The Medical Origins of Sexual Fetishism," 13.
49. Ian, *Remembering the Phallic Mother,* 88.
50. *Ilustración Artística* 20 (8 November 1901), 749.
51. *Ilustración Artística* 16 (13 December 1897), cover.
52. *Ilustración Artística* 12 (19 June 1893), 395.
53. *Ilustración Artística* 12 (19 June 1893), 402.
54. Ian, *Remembering the Phallic Mother,* 84.
55. Pietz, "The Problem of the Fetish," part 1, 6.
56. Pietz, "The Problem of the Fetish," part 1, 12.
57. Pietz, "The Problem of the Fetish," part 1, 14.
58. Krips, *Fetish,* 5.
59. Walter Benjamin, "Little History of Photography," 510.
60. Haut bourgeois illustrated magazines were especially enchanted by the images of women draped in bells, jewelry, beads, reflecting bits of metal, and so on, from the 1870s (peaking in the 1890s) until just after the turn of the century, when such images gradually disappeared.
61. Catherine MacKinnon, "Feminism, Marxism, Method, and the State," 26.
62. MacKinnon, "Feminism, Marxism, Method, and the State," 26.
63. MacKinnon, "Feminism, Marxism, Method, and the State," 59. The relation between women and portraits of women in nineteenth-century Spanish fiction is a study in ambiguity. In Benito Pérez Galdós's *Tristana,* the protagonist don Lope claims to prefer real women to portraits. Disparaging his rival's mimetic talents, he claims: "I'm cured of such wonders, Pepe. I can't admire these painted females. I've always preferred the live ones" (1571). Lope believes that for the normal man, the real thing is superior to the masturbatory fantasy. And yet among the last possessions he relinquishes when he is on the brink of bankruptcy are his paintings of beautiful women that hung in his study. Tristana, on the other hand, trades in her real-life lover for a fantastical version that she creates in her mind during his absence.

64. *Ilustración Artística* 2 (1883), 154.
65. *Ilustración Artística* 2 (1883), 154.
66. *Ilustración Artística* 14 (22 April 1895), 295. The image was reprinted by Lily Litvak in her 1985 study of Spanish exoticism entitled *El jardín de Aláh.*
67. Arthur Schopenhauer, "On Women," 118.
68. Ibid., 119.
69. *Ilustración Artística* 14 (22 April 1895), 298.
70. Lily Litvak, *El jardín de Aláh,* 104. For Lily Litvak these clichés demonstrate the fascination of power that she associates with male sadistic pleasure:

There is an incontestable dominion over a person, and in the terrain of sensuality, the right to dispose of the other's body like an object in permanent submission and always dazzled by the caprices of the master. In the harem theme what stands out above all is the image of power, since the sultan discards when he wants and whom he wants, and although these exoticisms of the bazaar can make us smile, so conventional have they become, they reveal the theme of absolute control over the woman subject to the will of all. (Ibid., 108)

71. *Ilustración Artística* 5 (21 June 1886), 220.
72. *Ilustración Artística* 5 (21 June 1886), 218.
73. *Ilustración Española y Americana* 34 (30 June 1890), 409.
74. *Ilustración Española y Americana* 34 (30 June 1890), 410.
75. *Ilustración Española y Americana* 41 (30 April 1897), 264–65. The German artist Nathaniel Sichel (1843–1907) was perhaps the most popular of all foreign Orientalists in Spain, to judge by the number of reproductions of his works that appeared in dozens of magazines. His subjects included odalisques, harem women, Jews (both biblical and North African), Gypsies, slave women, and other exotics. Coins were one of his favorite props; for other examples, see the dreamy-eyed "Circasiana" (Circassian), *Ilustración Española y Americana* 41 (22 November 1897), 308; the "Joven Nubia" (Young Nubian) *Ilustración Artística* 4, 196 (28 September 1885), 308; and the "Reina de los gitanos" (Queen of the Gypsies), *Ilustración Española y Americana* 32 (8 March 1888), 160.
76. Litvak, *El jardín de Aláh,* 102.
77. *Ilustración Artística* 1 (3 July 1882), 245.
78. *Ilustración Artística* 1 (3 July 1882), 242.
79. Raymond Carr, *España, 1808–1939,* 257–58.
80. Krips, *An Erotics of Culture,* 32.
81. Krips, *An Erotics of Culture,* 101.
82. *Ilustración Ibérica* 10 (29 October 1892), n.p.
83. *Ilustración Ibérica* 10 (29 October 1892), 699.
84. *Ilustración Artística* 10 (20 April 1891), 245.

85. *Ilustración Artística* 10 (20 April 1891), 250.

86. *Pluma y Lápiz* (1893): 5.

87. Pietz, "Fetishism and Materialism," 147.

88. Quoted in Hal Foster, "The Art of Fetishism: Notes on Dutch Still Life," 252.

89. Silver coinage as well as paper money grew substantially as the use of gold diminished. From 1894 until the end of 1898, silver increased from 639 to 981 million pesetas, and banknotes grew from 994 to 1,592 by 1900 (Pedro Tedde, "La Economía española en torno al 98," 105). The bimetallist system that Spain had tried to maintain since 1848 became de facto a single-metal currency based on silver, because the price of the two metals fluctuated greatly. As a result, private individuals speculated intensely in metals, which destabilized the monetary system. Most European countries abandoned the bimetallist system when silver prices fell in the 1870s. Spain, on the contrary, tried to maintain the system, but because of the scarcity of gold and the overabundance of silver, a de facto silver standard was the result (Gabriel Tortella *The Development of Modern Spain,* 159).

90. Tedde, "La Economía española en torno al 98," 88.

91. *Ilustración Artística* 16 (8 November 1897), 729.

92. *Ilustración Ibérica* 4 (21 August 1886), 529.

93. *Ilustración Ibérica* 15 (3 April 1897), 217.

94. *Ilustración Artística* 16 (8 November 1897), 730.

95. *Blanco y Negro* 7 (27 March 1897). Práxedes Mateo Sagasta headed Spain's liberal government, which alternated with that of the conservative Antonio Cánovas del Castillo during the period known as the "turnos," a contrived alternating of governments.

96. *Blanco y Negro* 7 (27 March 1897), n.p.

97. Jordi Maluquer de Motes Bernet, "El impacto de las guerras coloniales de fin de siglo sobre la economía española," 106.

98. *Blanco y Negro* 6 (19 December 1896).

99. *Blanco y Negro* 6 (19 December 1896), n.p.

100. *Blanco y Negro* 6 (19 December 1896), n.p.

101. Marx, *Capital,* 1:176.

102. The Gypsy woman was never depicted in modern Spanish dress. Her attire often is indistinguishable from the harem women and other exotics in the "favorita" category.

103. McClintock, *Imperial Leather,* 188.

104. *Mundo Ilustrado* 2 (Cuaderno 21; 1879), n.p.

105. *Mundo Ilustrado* 2 (Cuaderno 21; 1879), 63.

106. *Mundo Ilustrado* 2 (Cuaderno 21; 1879), n.p.

107. *Mundo Ilustrado* 2 (Cuaderno 21; 1879), 670.

108. *Mundo Ilustrado* 2 (Cuaderno 21; 1879), 670.

109. *Mundo Ilustrado* 2 (Cuaderno 21; 1879), 670.

110. *Mundo Ilustrado* 2 (Cuaderno 21; 1879), 670.

111. Nissan N. Perez, *Focus East: Early Photography in the Near East (1839–1885),* 50.

112. *Ilustración Española y Americana* 41 (30 April 1897), 259.

113. S. Lalvani, *Photography, Vision, and the Production of Modern Bodies,* 81.

114. Said finds the Orientalist reductionist tendency to be unique in the vastness of its field (Edward Said, *Orientalism,* 50). More recently, feminists have begun to trace the similarities in the "tropes of othering" (Uzoma Esonwanne, "Feminist Theory and the Discourse of Colonialism," 234) between colonialist and gender stereotyping. Uzoma Esonwanne perceptively points out the pitfalls of the tendency to imagine a "singular transcendental theoretical paradigm or methodology for the critical analysis of the technologies of othering and strategies of power" (234). In such a transcendental practice, real differences can be erased and the materiality of women's lives obliterated (235). My purpose, then, of drawing this analogy between the "othering" of exotic peoples and the "othering" of native daughters is not in any way to collapse the differences between the hegemonic discourses impinging on relations of ethnicity and gender.

115. McClintock, *Imperial Leather,* 193.

116. *Mundo Femenino* 37 (26 June 1887), 4–5.

117. The majority of women's magazines struggled against this vision of the devouring woman. See, for example, *La Ilustración de la Mujer* (Barcelona, 1882–84).

118. Homi K. Bhabha, *The Location of Culture,* 74.

119. Bhabha, *The Location of Culture,* 75.

120. Bhabha, *The Location of Culture,* 81.

CHAPTER 2

1. See Botrel's statistical table of the Madrid Press from 1858 to 1909. What Botrel terms the "climax" of the periodical industry occurred following the 1883 "ley de Prensa," which resulted in a definitive liberalization of the press and a resultant jump in the number of periodicals of all types (Botrel, "Estadística," 30). Francesc Fontbona lists the last two decades of the nineteenth century as the "gran época" of the illustrated magazines (Fontbona, "Las ilustraciones y la reproducción de sus imagines," 75).

2. The *Ilustración Española y Americana* became a weekly in 1874.

3. To put into perspective the relative costs of the two weeklies, *Blanco y Negro,* which began charging 5 centimes, doubled its price by the end of the century to 10 centimes per issue. By that time *La Ilustración Española y Americana* was priced at 1 peseta, a true luxury in a country where the average daily salary at the turn of the century was 3 pesetas (P. López Mondéjar, *Historia de la fotografía en España,* 85). After the Civil War, *Blanco y Negro* was revived as a Sunday

supplement to the newspaper *ABC,* which still publishes it today. *ABC* was also founded by Luca de Tena, first as a weekly in 1903, and after 1905 as a daily, as it is still published today.

4. Quoted in Carlos Barrera, ed., *El periodismo español en su historia,* 108.

5. Estelle Jussim, *Visual Communication and the Graphic Arts,* 17.

6. Lee Fontanella, *Photography in Spain in the Nineteenth Century,* 7. By this time Daguerreotype excursions to "exotic" countries such as Egypt, Israel, Greece, and Spain were already popular in France. The Daguerreotype, however, was never widely practiced in Spain. The invention of collotype (also called Talbotype after its inventor, William Fox Talbot) in the 1830s, and later of the collodion process (using a wet method on glass plate negatives) in the 1850s, quickly replaced the more cumbersome Daguerreotype procedures. According to Fontanella, the Daguerreotype died out in Spain after the wet plate came into use in 1851 (Fontanella, *Photography in Spain in the Nineteenth Century,* 7).

7. Galassi, *Before Photography,* 29.

8. Bernardo Riego, *La construcción social de la realidad a través de la fotografía y el grabado informativo en la España del siglo XIX,* 307.

9. When photography was introduced in 1839, subjects were required to sit 15 minutes in bright sunlight. When by 1842 exposure times were reduced to 20–40 seconds, photography studios began sprouting up everywhere (Lalvani, *Photography, Vision, and the Production of Modern Bodies,* 46). Jean Sagne describes the ostentatious photography studios of Paris as "the temple[s] of photography" linking the pleasures and tricks of the theater with the photographer's art ("All Kinds of Portraits," 103).

10. Publio López Mondéjar, *Historia de la fotografía en España,* 79. The collodian process was a negative produced on glass. One advantage of this procedure was that it allowed for the duplication of prints.

11. Riego, *La construcción social de la realidad a través de la fotografía y el grabado informativo en la España del siglo XIX,* 356. R. P. Napper's images of Seville, Granada, and Gibraltar were exhibited in the 1860s. Other foreigners who traveled about Spain, in addition to Napper, are: Gustave de Beaucorps, Gaston Braun, Adolphe Braun, Louis-Constant-Henri-François Clercq, Charles Clifford, J. J., A. Clouzard, Frank Charteris, André-Adolphe-Eugène Disdéri, Jean-Jacques Heilmann, Jean Laurent y Minier, Farnham Maxwell Lyte, Alejandro Massari, Louis León Masson, Charles Maufsaise, Auguste Muriel, Hugh Owen, E. Pec, Charles Soulier, Edward King Tenison, Charles Thurston Thompson, Joseph Vigier, and Claudius Galen Wheelhouse (see more on this at http://www.portalmundos.com/mundoarte/noticias/exposiciones/paris.htm).

12. See Riego, *La construcción social de la realidad a través de la fotografía y el grabado informativo en la España del siglo XIX,*

228–31, for a discussion of the complicated issue of deciding authorship in the case of images engraved from photographs.

13. Traditional accounts of portrait photography emphasize the beneficent way in which it expanded access to the new technology that was once the privilege of the aristocracy (Lalvani, *Photography, Vision, and the Production of Modern Bodies,* 43), reflecting "the continuing middle-class challenge to the aristocratic monopoly of signs which Baudrillard has identified as central to the process of modernity" (44).

14. Lalvani, *Photography, Vision, and the Production of Modern Bodies,* 15.

15. By 1860, 33,000 people were employed in the photography industry in Paris alone (Sagne, "All Kinds of Portraits," 105).

16. Photographic *cartes de visite* were introduced in Paris by André Adolphe-Eugéne Disdéri in 1854, becoming instantly all the rage. In the 1860s they were popular items among the Spanish bourgeoisie (Riego, *La construcción social de la realidad a través de la fotografía y el grabado informativo en la España del siglo XIX,* 333). According to Lalvani (*Photography, Vision, and the Production of Modern Bodies,* 44), the photographic portrait cost one-tenth the price of a painted portrait. In "El portal del fotógrafo" (The Photographer's Showcase) (in *Blanco y Negro* 4 [3 November 1894], 695–97), José de Roure mentions three types of common photograph studio formats: "album, postcard, pocket size portrait" (695).

17. Bernardo Riego has set to rest the notion that most of the early photographers were previously sketch artists or painters: the professional training of most of these photographic pioneers is unknown, and many were likely drawn into the profession because of its lucrative potential (*La construcción social de la realidad a través de la fotografía y el grabado informativo en la España del siglo XIX,* 308).

18. Barthes, *Camera Lucida,* 30–31.

19. Riego, *La construcción social de la realidad a través de la fotografía y el grabado informativo en la España del siglo XIX,* 339.

20. *Blanco y Negro* 4 (3 November 1894), 695–97. See also Bernardo Riego's *Impresiones: la fotografía en la cultura del siglo XIX,* in which he reproduces earlier short stories on the topic: Enrique Fernández Iturralde's "El álbum de retratos" (Portrait Album), *El Museo Universal* (24 January 1869), 30–35, and (1 February 1869), 46–47; Jacinto Labaila's "Viaje alrededor de una tarjeta fotográfica" (Voyage Around a Photographic Carte de Visite), *La América* 1 (28 January 1871), 3–4, and (13 February 1871), 12–13; and Constantino Gil's "¡Maldita Fotografía!" (Damn Photograph!), *Los sucesos* (1 January 1867), 19.

21. *Blanco y Negro* 4 (3 November 1894), 696.

22. See numerous quotations attesting to this in Riego, *La construcción social de la realidad a través de la fotografía y el grabado informativo,* 338–42.

23. Riego, *La construcción social de la realidad a través de la fotografía y el grabado informativo,* 696.

24. Benjamin, "Little History of Photography," 510.

25. Jussim, *Visual Communication and the Graphic Arts,* 8.

26. As Jussim reminds us, "[W]e tend to confuse books whose illustrations mechanically reproduce 'photography' with those in which photographic prints are actually mounted. We think of them both as 'photographically illustrated.' The two are not the same" (*Visual Communication and the Graphic Arts,* 50).

27. Riego, *La construcción social de la realidad a través de la fotografía y el grabado informativo en la España del siglo XIX,* 27.

28. Black-line wood engraving, a process that cut grooves usually into a soft wood with the grain, predated xylography. Xylography used wood, but the image was cut crosswise on boxwood, which made for a more durable block from which more images could be obtained than by the traditional method.

29. In the 1880s various high-end magazines, the *Ilustración Ibérica, Ilustración Artística, Ilustración Española y Americana* among them, offered engravings made with new techniques of heliogravure and process halftone using the Meisenbach method, but as Fontbona notes, they often passed unnoticed: "[I]t would happen that they would be erroneously identified as variants of xylographic engraving" (F. Fontbona, "La ilustración gráfica: La técnicas fotomécanicos," 141). Xylography continued to be the choice for art graphics in these magazines: "[T]he superb wood engravings, many of them imported in the form of electrolized clichés, continued to have an extraordinary weight in the series of magazines to which I am referring" (437).

30. In France the first halftone engraving was introduced in 1877 in *Le Monde Illustré.* This process was perfected by Charles Guillaume Petit, Georg Meisenbach, and Frederic Ives, using zinc plates. It wasn't until the end of the century that halftones could be favorably compared with woodcuts or zincographs, according to Pierre Albert and Gilles Feyel, "Photography and the Media," 362

31. Heliographic techniques were refined in Spain beginning in 1875 with the creation of the Sociedad Heliográfica Española (Pilar Vélez i Vicente, "El libro como objeto," 554). This, according to Francesc Fontbona, resulted in "a rapid vulgarization of photoengraving in Spain, especially in illustrated magazines" ("La ilustración gráfica," 434). Heliography photographically reproduces an engraving on a prepared metal plate, eliminating the job of the illustrator and engraver. Its introduction meant that fewer plates needed to be imported from abroad (Marie-Loup Sougez, "La imagen fotográfica en el medio impreso, " 82), although many magazines still imported large numbers of plates from abroad even after the establishment of the Sociedad Heliográfica. For more information on the precise techniques of photographic as well as pre-photographic graphic processes, see Estelle Jussim's *Visual Communication and the Graphic Arts* and Bamber Gascoigne's *How to Identify Prints.*

32. Lithography was refined in the second half of the century and was used especially in the production of quality images that would be inserted in books and magazines on special paper. An early Spanish magazine that used the procedure with great success was *El Artista* (1835–36), a romantic and moderate magazine modeled after France's *L'Artiste* (Bozal, *La Ilustración gráfica del XIX en España,* 29). The first lithographic establishments in Spain were established in Madrid (1819) and Barcelona (1820), but not until the second half of the century did it become a common practice in magazine graphic production (28).

33. The invention of an electrolysis process ("galvanoplastía" in Spanish) that electrotyped an image on copper or other metal plates meant that multiple copies of intaglio plates could be issued. These plates, produced mostly in Northern Europe until the turn of the century, were purchased by the hundreds by most of the large-format Spanish magazine publishers. Among the important international firms that sold plates and processes to Spain are, in addition to Pannemaker: Meisenbach, Yves & Barret, and C. Angerer & Göschl, Boussod et Valadon, and Héliogravure Dujardin (Fontbona, "La ilustración gráfica," 439; Sougez, "La imagen fotográfica en el medio impreso," 77). These galvanized plates were significantly less costly than original woodblocks. The Pannemaker method, inaugurated in England in 1877, consisted of projecting an image onto a prepared woodblock, which the engraver would then use as his guide when cutting the image into the wood.

34. Fontbona, "Las ilustraciones," 75. During the middle decades of the century, etching processes were discovered (and patented) for the direct photographic transfer of information onto metal plates as well as for the copying of plates through an electrolysis procedure. Also being developed at this time was the procedure known as photography-on-the-block, which made it possible for an image to be directly transferred to wood. This process eliminated the work of the draftsman, which was slowly being phased out in some countries. French printing companies that sold to Spain in the 1870s and 80s were using both photography-on-the-block and heliogravure procedures in the production of plates and blocks, but they closely guarded their procedures, which further limited advances in the production of high-quality plates in Spain. The procedure known as goupilgravure, a type of heliogravure or photogravure, was, by the late 1870s, considered the highest standard for the compression of information (Jussim, *Visual Communication and the Graphic Arts,* 250). For more information on *La Ilustración*'s importation of foreign plates, see Jesusa Vega, "La estampa culta en el siglo XIX," 156–57. In 1872, *Ilustración Española y Americana* attempted to superimpose an image photographically on a prepared woodblock. The results were, according to Bernardo Riego, unsatisfactory, but toward the end of the century the periodical adapted a method for doing this that

had been successfully developed by Stéphane Pannemaker (Riego, *La construcción social de la realidad,* 376).

35. Heliogravure is a photomechanical reproduction process that produces an etched metal plate for intaglio printing. Because it is not type-compatible, it was a relatively expensive and time-consuming way of printing images, but its subliminal effects were superior to any other technique available. At the time the French held the patent on the photogravure (or heliogravure): a powder is dusted and then melted on a copper plate, after which the plate is covered with a gelatin-pigment paper that has been exposed to a transparency of the original. After being processed in warm water, the pigment paper is removed, while some of the gelatin sticks to the copper plate. The plate is then etched in an iron chlorine solution. The heliogravure produces a photo-like result with smooth tonal areas and good chiaroscuro. Later, in 1870, *La Ilustración Española y Americana* published several images using a similar procedure. However, neither the *Museo* nor its successor, *Ilustración Española,* capitalized on the new technology until the beginning of the nineteenth century, preferring to use xylographic methods (possibly the photography-on-the-block process, which produces a block with a superimposed negative image that is then hand engraved, or various chemical processes on metal plates), when heliography or halftone became the norm with some of its competitors. Xylography reached a very high degree of sophistication just in time to be superseded by process halftone procedures. The tonal white-line wood engraving that can be seen in many of the magazines' most elaborately executed images shows a wonderful tonality and clarity.

36. See Riego, *La construcción social de la realidad a través de la fotografía y el grabado informativo* and also his *La introducción de la fotografía en España,* for a more complete study of the early reception of photography in Spain. According to Riego, from the 1850s to the 1870s, Spanish intellectuals never tired of reflecting on its symbolic importance.

37. The diorama was the first three-dimensional exhibit. The image was housed in a large, circular cubicle, which, viewed through an aperture, gave viewers the impression of three-dimensionality.

38. *Museo Universal* 2 (August 1858), 115.

39. Laura Burd Schiavo, "From Phantom Image to Perfect Vision," 121.

40. Schiavo, "From Phantom Image to Perfect Vision," 114.

41. Journalists all over Europe and the United States enticed readers with vivid praise for the stereograph's mimetic fidelity and its advantages over the artistic sketch. According to one enthusiast writing in 1859:

The very things which an artist would leave out, or render imperfectly, the photograph takes infinite care with, and

so makes its illusions perfect. What is the picture of a drum without the marks on its head where the beating of the sticks has darkened the parchment? In three pictures of the Ann Hathaway Cottage, before us,—the most perfect, perhaps, of all the paper stereographs we have seen,—the door at the farther end of the cottage is open, and we see the marks left by the rubbing of hands and shoulders as the good people came through the entry, or leaned against it, or felt for the latch. It is not impossible that scales from the epidermis of the trembling hand of Ann Hathaway's young suitor, Will Shakespeare, are still adherent about the old latch and door, and that they contribute to the stains we see in our picture. (*The Atlantic Monthly* [3 June 1859], 738–48)

42. The nineteenth-century stereoscope was a handheld device with an arm holding a double photographic image extending outward from a viewing lens. The photographic images were shot using a twin-lens camera at two slightly different angles. The resultant double image, when viewed with the stereoscopic lens, produced a three-dimensional effect. Today's stereoscopic pictures are looked at through a View-Master, still available at some tourist spots and toy stores. Picatoste may also have been familiar with the British astronomer and photographer Charles Piazzi Smyth's 1856, 1857 album of stereoscopic images of Tenerife, entitled *Tenerife: An Astronomer's Experiment: or Specialties of a Residence Above the Clouds,* which sold 2,000 copies. Each copy sold with a stereoscope (Sougez, "La imagen fotográfica en el medio impreso," 70).

43. Sougez, "La imagen fotográfica en el medio impreso," 115.

44. In his 1882 *Manual de fotografía,* Picatoste was even more rapturous about the subject, claiming that photography "would alone be sufficient to immortalize the name of our century" (quoted in Riego, *Impresiones,* 82).

45. According to López Mondéjar, Jean Laurent and Charles Clifford were the two most important foreign photographers in the Court of Isabel II (*Historia de la fotografía en España,* 43). Juan Comba, considered the father of graphic journalism in Spain (82) also collaborated with *Ilustración Española y Americana* beginning in 1880. For more on Comba, see *La prensa ilustrada en España,* 100. For Clifford and Laurent, see Fontanella, *Photography in Spain in the Nineteenth Century,* 16, 22–23. For information on Jean Laurent's photos of traditional Andalusian dress, see Herranz Rodríguez. With their accomplished images of dams, triumphal arches, monuments, palaces, and railroads, photographers like Clifford were important promoters of government and institutional projects (Sougez, "La imagen fotográfica en el medio impreso," 70).

46. *Museo Universal* 2 (15 August 1858), 117.

47. *Museo Universa* 4 (5 February 1860), 18.

48. Riego, *La construcción social de la realidad a través de la fotografía y el grabado informativo en la España del siglo XIX,* 231.

49. Jean Laurent, *Coustumes et Coutumes d'Espagne: Études d'après Nature* (Madrid: Biblioteca Nacional 17-35-73)

50. *Ilustración Española y Americana* 24 (22 January 1880), 48. Laurent's "Spanish Types" by this time were a familiar photographic product. Around 1870, the popular establishment Casa de Laurent on Turco Street in Madrid displayed a poster with miniature versions of 100 Spanish types, among them the ones shown here. See a reproduction of this poster in Michel Frizot, ed., *A New History of Photography,* 116.

51. Fontanella, *Photography in Spain in the Nineteenth Century,* 22.

52. *Ilustración Española y Americana* 20 (15 July 1876), 24.

53. *Ilustración Española y Americana* 23 (15 November 1879), 304.

54. *Ilustración Española y Americana* 21 (30 January 1877), 69.

55. Alphonse Legros was born in Dijon, France, in 1837. He worked primarily in England, where he had considerable impact on drawing and printmaking and was an important member of the New English Art Club. Legros was a master producer of relief medallions and sketches, such as that of María, which was shown in a Paris Exhibition (in 1877?). His portfolio includes more than 700 sketches. This image displays his skill at evoking immediacy and three-dimensionality by using very traditional line techniques.

56. There were in addition ten sketches of smaller man-made artifacts. The next largest categories were twenty local color "tipos" and cartoons and eighteen formal portraits, nine fine-arts engravings, five renderings of political figures and royalty, and only two action and trauma shots and two sketches illustrating scientific advances.

57. Mary Price, *The Photograph: A Strange, Confined Space,* 34.

58. *Ilustración Española y Americana* 22 (22 April 1878), 257.

59. *Ilustración Española y Americana* 22 (8 August 1878), 76.

60. *Ilustración Española y Americana* 22 (15 October 1878), 220–21. The image reappeared in other illustrated magazines in subsequent years. See also *Ilustración de la Mujer* 1 (15 November 1883).

61. *Ilustración Española y Americana* 22 (15 October 1878), 215.

62. *Ilustración Española y Americana* 22 (15 October 1878), 215. The art editors for *La Ilustración de la Mujer,* where the same image appeared a few years later, expanded on the *Ilustración Española* gloss by speculating that this Mignon is looking out over the sea at her beloved Italy (*Ilustración de la Mujer* 16 [1884], n.p.).

63. Roland Barthes, *Image Music Text,* 17.

64. Riego, *La construcción social de la realidad a través de la fotografía y el grabado informativo en la España del siglo XIX,* 91.

65. Jussim, *Visual Communication and the Graphic Arts,* 289.

66. Jussim's conclusion to *Visual Communication and the Graphic Arts* is useful for reminding us of the falseness of photographic illusionism: "Since photography—as we describe it here—is posited as imitating the characteristics of human vision, with the notable and all-important distinction that it represents the world as flat rather than as three-dimensional, the recording made of a message about an original must be understood to be as much a coding of a message about an original as that used by any other graphic process. The difference is simply that photographic coding is subliminal" (Jussim, *Visual Communication and the Graphic Arts,* 299).

67. Price, *The Photograph: A Strange, Confined Space,* 7.

68. Richard L. Gregory, *Eyes and Brain: The Psychology of Seeing* (5th ed.; Princeton: Princeton University Press, 1997), 184 f.

69. Fontbona, "La Ilustración gráfica," 434.

70. For one example out of hundreds, see *Ilustración Española y Americana,* 37 (15 November 1893), 300.

71. See Angel Smith, "The People and the Nation: Nationalist Mobilization and the Crisis of 1895–98 in Spain," for a detailed account of the political motivations of these send-offs that Republicans were organizing in an attempt to destabilize the Restoration government. Smith's study details the various reasons that Carlists, Federalists, and Republicans all ended up supporting the war.

72. *Ilustración Española y Americana* 24 (22 February 1880), 117.

73. *Ilustración Española y Americana* 39 (30 May 1895), 329.

74. *Ilustración Española y Americana* 39 (30 May 1895), 329.

75. Galassi, *Before Photography,* 14. From his comparative study of oil sketches and photography, Galassi concludes that "landscape sketches . . . present a new and fundamentally modern pictorial syntax of immediate, synoptic perceptions and discontinuous, unexpected forms. It is the syntax of art devoted to the singular and contingent rather than the universal and stable. It is also the syntax of photography" (25). The fascination with detail and the contingent is, according to him, an artistic convention that was evolving before the invention of photography and that actually helped to create the demand for photography.

76. See Christopher Phillips's critique of Galassi's organic argument in "The Judgment Seat of Photography." According to Phillips, Galassi erred in ignoring the "multiple scientific, cultural, and economic determinations" (40) of photography, and overstating the importance of landscape portrait as the catalyst of the photography medium.

77. Barthes, *Camera Lucida,* 76.

78. *Ilustración Española y Americana* 38 (15 March 1894), 144.

79. Resina, "The Concept of After-Image and the Scopic Apprehension of the City," 11.

80. In 1907, the magazine's editors produced a retrospective that dwelled especially on its artistic and literary merits. At the same time, however, the magazine claimed to have been the first to overcome the technical difficulties involved in bringing images to the public only a day after an event: "[D]espite the material obstacles with which we struggled to exhibit them, in many cases they were thrust before the curious public a mere day after the great event had occurred" (*Ilustración Española y Americana* 47 [22 December 1907], 379).

81. *Ilustración Española y Americana* 49 (22 May 1905), 308.

82. *Ilustración Española y Americana* 49 (30 May 1905), 313.

83. The process by which Santa Catalina was produced is not entirely clear to me. It may have started out as a sketch rendering by an illustrator (who may have been sketching the original, a painted copy of the original, a previous sketch made by another artist-illustrator, or a photograph of the painting), which was then copied directly on a woodblock or photographically imprinted on the block and then engraved via the white-line method. Alternatively the procedure could have been a process of line engraving that used halftone process to produce mechanically an image of the hand-drawn sketch on a relief plate. Finally, it could have been created by a halftone process producing a plate that an engraver skillfully retouched directly on the plate. Even if such a relief process was used as in the last two cases, the hand-produced effects of a sketcher or engraver are still quite clear.

84. *Ilustración Española y Americana* 49 (8 July 1905), 12.

85. Riego, *La construcción social de la realidad a través de la fotografía y el grabado informativo en la España del siglo XIX,* 258. Bernardo Riego marks the launching of Angel Fernández de los Ríos's *La Ilustración,* and later *El Museo Universa* (and the demise of earlier picturesque magazines like *Semanario Pintoresco Español* and *El Laberinto*), as the era of the new national illustrated magazines that assumed the role of social integrator and diffuser of national prestige.

86. *Blanco y Negro* 5 (28 December 1895), n.p.

87. *Ilustración Española y Americana* 39 (15 December 1895), 353.

88. *Ilustración Artística* 16 (8 February 1897), 103.

89. *Ilustración Española y Americana* 41 (22 December 1897), 392.

90. *Ilustración Artística* 16.789 (8 February 1897), 103.

91. *Ilustración Española y Americana* 39 (22 November 1895), 293.

92. Jean-Michel Desvois, "El fin de las *Ilustraciones,*" 343. In the 1890s, *Blanco y Negro* installed photography laboratories in its new plant on Serrano Street. By using artificial light, images were projected on glass plates, and from them a positive image was projected onto zinc plates covered in acid in order to obtain a relief image. These zinc plates were then touched up by a technician and inserted in the press. In 1901, *Blanco y Negro* boasted that it was the first periodical to introduce the Max Levi (likely referring to Max Levy and his brother Louis Levy) halftone process "that offers such vigor and life to photoengravings" (*Blanco y Negro* 523 [11 May 1901], n.p.). The invention of the Levy black-line screen plate in 1890 made the endless production of continuous-tone photographs in magazines possible, vastly facilitating the mass production of images (Jussim, *Visual Communication and the Graphic Arts,* 68). The halftone process achieved continuous-tone effects through the use of a screen that produced dots of varying sizes on a page. The Levy brothers used high-quality optical glass with cross-ruled lines etched with hydrofluoric acid and then filled with an opaque material. The halftone image is made by exposing a metal plate with a light-sensitive emulsion on it to an original that is viewed through the screened plate. The American inventor Frederic Eugene Ives (1856–1937) is often credited with the invention of halftone technology in 1888. But a similar method was patented in Germany by Georg Meisenbach in 1882. Spanish printing houses bought plates or used the technology of Meisenbach, Riffarth, & Co., which was one of the most important graphic art printing houses in Europe.

93. *Ilustración Española y Americana* 22 (December 1907), reprinted in Riego, *Impresiones: La fotografía en la cultura del siglo XIX,* 171–75.

94. "El fin de las *Ilustraciones:* El caso de Madrid," 347.

95. Pedro Gómez Aparicio, *Historia del periodismo español.* 613.

96. *Ilustración Española y Americana* 35 (30 July 1891), 52–53. By the 1890s, the technologies for mechanical reproduction of images were expanding. For example, chromolithography, steel engraving, and steel facing of copper plates, electrotyping of woodblocks, and so on, were making speedy and cheap reproduction commonplace and allowing more uses for photography. The first "chromotypogravures" produced by the *Ilustración Española y Americana* were color photoengravings made by the firm C. Angerer & Groschl. Tricolor photoengravings first appeared in 1888 (Fontbona, "La ilustración gráfica," 441). In 1890, the magazine switched to the firm of Boussod, Valadon, & Cía (formerly Goupil) of Paris. The Galerie Boussod Valadon was founded in 1879 by Étienne Boussod; it specialized in Romantic, Barbizon, and academic artists and sponsored exhibitions of the work of Impressionists and Post-Impressionists such as Degas, Monet, Morisot, Pissarro, Gauguin, and Toulouse-Lautrec.

97. Fontbona, "La Ilustración gráfica," 458.

98. "El fin de las *Ilustraciones:* El caso de Madrid," 347. Eager to include color images in *Blanco y Negro,* Luca de Tena hired José Blass, a German specialist in cuadricolor techniques, who moved to Madrid. Luca de Tena also purchased the materials to produce the couché paper that would be necessary to publish the images (García Venero, 111).

99. See, for example, the Almanac included in the beginning of the bound volume for the year 1899. By 1900, however, there was a marked improvement in color production, and within the next decade, *Blanco y Negro*'s use of color was superior to most magazines of its kind.

100. In its early years (it began in 1894) the magazine had 25,000 subscribers by its second number (María Cruz Seoane, *Historia del periodismo en España,* 308), 70,000 by 1898 (310), and 90,000 by 1910 (*Prensa ilustrada,* 343), even though at the time in Spain there were dozens of well-financed illustrated magazines competing with it. The reason for its success is that it cost only 2 pesetas per trimester, compared with 10 per trimester for the *Ilustración Española y Americana,* its biggest rival.

101. Richard Ohmann identifies the same phenomenon in the consumption of magazines in the United States, comparing the popular appeal of *Munsey*'s magazine with *Harpers.* Though it had a strong circulation of 200,000, the cost and appeal of *Harpers* put it out of reach for many Americans, while *Munsey*'s carried information that reached across classes and was more affordable (Ohmann, *Selling Culture: Magazines, Markets, and Class at the Turn of the Century,* 6).

102. In its 11 May 1901 issue, *Blanco y Negro* commemorated its ten-year anniversary in a lengthy article in which it railed against creators of the legend that the magazine had been founded merely to publicize goods (*Blanco y Negro* 11 [11 May 1901], n.p.).

103. Claude Le Bigot, "Los retratos en *La Illustrción Española y Americana,* 145.

104. *Blanco y Negro* 4 (8 September 1894), 577.

105. *Blanco y Negro* 4 (9 June 1894), cover.

106. *Blanco y Negro* 11 (7 September 1901), n.p.

107. *Blanco y Negro* 15 (16 November 1895), n.p.

108. *Blanco y Negro* 5 (19 October 1895), cover.

109. *Blanco y Negro* 5 (30 November 1895), n.p.

110. *Blanco y Negro* 5 (30 November 1895), n.p.

111. *Blanco y Negro* 4 (7 July 1894), n.p. The image reappeared in 1899 in a color image on the cover of *Nuevo Mundo* 6 (5 April 1899).

112. Quoted in Seoane,. *Historia del periodismo en España,* 309.

113. *Ilustración Española y Americana* 51 (8 December 1907), 336.

114. *Ilustración Española y Americana* 49 (8 January 1905), 16. The presumed artist is José Sánchez Gerona, who served as director of Calcografaia Nacional y Escuela Nacional de Artes Graficas. The instructions accompanying the chromo-typogravure encouraged its removal from the magazine:

> In the current issue we offer our readers an extraordinary Supplement in color, a carefully executed facsimile reproduction of a handsome watercolor by our artistic collaborator Sánchez Gerona, titled *New Life.* The importance of the work has convinced us to give the copy the largest possible size, and therefore the margins have been eliminated. In this way those who prefer to insert it in a frame, in order to avoid the folds that framing would require, may place it on bristol board or passe par tout, as is the custom with this type of painting. (*Ilustración Española y Americana* 49 (8 January 1905), 15)

For more information on *Ilustración Española y Americana*'s conservatism, see Riego, *La construcción social de la realidad a través de la fotografía y el grabado informativo,* 245–59.

115. "Las ilustraciones," 75.

116. Cecilio Alonso, "La difusión de las *Ilustraciones* en España," 46.

CHAPTER 3

1. Walter Benjamin, "The Work of Art in the Age of Its Technological Reproducibility," 103. For a brief summary of the several meanings of Benjamin's concept of aura, see Price, *The Photograph: A Strange, Confined Space,* chap. 3.

2. Quoted in Galassi, *Before Photography,* 12.

3. As Raymond Carr pointed out, the middle class was neither socially nor politically coherent prior to the Restoration. It was made up of salaried workers earning between 5,000 and 8,000 reales (Carr, *España, 1808–1939,* 281).

4. Gabriel Tortella, *The Development of Modern Spain,* 73.

5. A. Elorza, "Con la marcha a Cadiz," 327.

6. Gómez Aparicio, *Historia del periodismo español,* 474.

7. Guillermo Carnero, ed., *Historia del periodismo español,* 26.

8. The first rotary printers made in Spain were produced by German companies that had established themselves in Spain. Not until 1901 did Spain produce its first rotary press, destined for the Barcelona Press of Vidal Hermanos (Vélez i Vicente, "La industrialización de la prensa," 546–47).

9. "Merced a la mecanización, el abaratamiento de los costes y a la masificación de la producción que esta mecanización permite, llega a ser algo normal y corriente la comunicación a través del material impreso, incluso para los que aparentemente quedan excluidos, por ejemplo los

analfabetos y la población rural" (Botrel, *Libros, prensa, y lectura en la España del siglo XIX,* 183).

10. Riego, *La construcción social de la realidad a través de la fotografía y el grabado informativo en la España del siglo XIX,* 214.

11. Augusto Martínez Olmedilla, *Periódicos de Madrid,* 70.

12. Martínez Olmedilla, *Periódicos de Madrid,* 67.

13. Riego, *La construcción social de la realidad a través de la fotografía y el grabado informativo en la España del siglo XIX,* 113.

14. Deborah L. Parsons, *A Cultural History of Madrid,* 68.

15. Parsons, *A Cultural History of Madrid,* 56.

16. Parsons, *A Cultural History of Madrid,* 37.

17. *Blanco y Negro* 20 (19 July 1910), n.p.

18. Desvois, *La Prensa en España,* 17: García Venero, *Torcuato Luca de Tena y Álvarez-Ossorio,* 66.

19. Gómez-Aparicio, *Historia del periodismo español,* 474.

20. The capital for *Blanco y Negro* came from Luca de Tena's profits from his oils and cosmetics businesses and also from his wife's fortune, according to Trenc (Eliseo Trenc, "Los modelos extranjeros, *The Illustraded London News* y *L'Illustration,*" 345). Torcuato Luca de Tena's father and uncle first established a chocolate factory on the premises of their country estate near Seville in 1863. That was followed by other factories for processing oils, manufacturing perfumes, and the famed Giralda de Azahar, which sold for many decades in Europe and America and was heavily advertised in *Blanco y Negro.*

21. Serge Salaün and Carlos Serrano, *1900 en España,* 41. *El Imparcial* purchased the first rolling press in 1875; it was capable of printing 16,000 newspapers an hour. (Gómez Aparicio, *Historia del periodismo español,* 251). By this time the newspaper's circulation was 45,000, the largest in Spain.

22. Jesús Timoteo Álvarez, *Restauración y prensa de masas,* 178.

23. For a brief summary of periodical advertising in the nineteenth century, see Alonso, "El auge," 562–65.

24. "[P]eriódico para anuncios publicándolo sin ellos," *Blanco y Negro* 11 (11 May 1901), n.p.

25. The "anuncios telegráficos" were classified ads after the popular feature in newspapers such as *El Liberal,* which began selling advertising and personal space at 1 real per line in 1879 (Gómez Aparicio, *Historia del periodismo español,* 412).

26. Even at these low prices, *Blanco y Negro* would have remained beyond the means of many workers whose average salary ranged around 12 reales a day (Carnero, "Introducción a la primera mitad del siglo XIX español," 47). The price of the magazine rose slowly over the next decade. In 1892 it was 20 céntimes and by 1901 it was 30, "a quantity that no one, given the conditions of our publication, finds exorbitant" (*Blanco y Negro* 11 [11 May 1901], n.p.).

27. Foreign subscribers paid 6 pesetas for a half-year subscription and 10 for a full year. At the end of its first six months of publication, the editors announced several improvements and features for 1892, but proudly announced that despite the increased costs of the proposed reforms, the price would continue in the following year to be 15 centimes, "thanks to which our magazine has become, in its short duration, the illustrated periodical with the greatest circulation in Spain" (*Blanco y Negro* 1 [27 December 1891], 542). By 1893, nevertheless, the price for a single issue increased to 20 centimes, and subscription costs also increased:

	trimester	semester	year
Madrid, regular edition	2.5	5	9
Madrid, deluxe edition	5	10	19
Provinces, regular edition	3	6	11
Provinces, deluxe edition	5.5	11	21
Abroad, regular edition	5	9	17
Abroad, deluxe edition	7.50	14	27

28. *Blanco y Negro* 1 (21 June 1891), cover.

29. *Blanco y Negro* 1 (10 May 1891), 3.

30. *Blanco y Negro* 1 (6 September 1891), 275.

31. *Blanco y Negro* 2 (7 February 1892), 82.

32. *Blanco y Negro* 2 (7 February 1892), 82.

33. Nilo María Fabra was a journalist who in 1865 founded the first Spanish news agency, which he called the Centro de Corresponsales. He later went on to be a deputy in 1876 and a senator in 1890. "El problema social" also appeared in La *Ilustración Española y Americana* and was reedited in 1890 by Fernando Fe. Its second edition, published in Madrid by Sucesores de Rivadeneyra (1802), includes a preface on socialism by Emilio Castelar.

34. *Blanco y Negro* 2 (20 March 1892), 178.

35. *Blanco y Negro* 2 (17 April 1892), 248.

36. *Blanco y Negro* 5, 198 (16 February 1895), cover.

37. The Bilbao artist Alvaro Alcalá Galiano was a popular painter of rural and working types; he was well represented in the National exhibitions.

38. *Blanco y Negro* 5, 198 (16 February 1895), cover.

39. *Blanco y Negro* 5, 198 (16 February 1895), cover.

40. *Blanco y Negro* 4 (29 December 1894), 858.

41. *Blanco y Negro* 4 (8 September 1894), 577.

42. Lou Charnon-Deutsch, *Fictions of the Feminine,* 134.

43. Álvarez Junco, *Mater dolorosa,* 559.

44. "Todo es obscuro en él: familia, cuna, cálculos, profesión, arribo, historia" (*Blanco y Negro* 2 [9 October 1892], 643).

45. Álvarez Junco, *Mater dolorosa.* 454.

46. *Blanco y Negro* 2 (9 October 1892), 643.

47. *Blanco y Negro* 2 (9 October 1892), 645.

48. Álvarez Junco, *Mater dolorosa,* 454.

49. *Blanco y Negro* 2 (14 February 1892), 106–7.

50. *Blanco y Negro* 2 (28 August 1892), 553–54.

51. Juan Pérez Zúñiga was a well-known satirical writer who, in collaboration with the sketch artist Joaquín Xaudaró, wrote *Viajes morrocotudos (En busca del Trifinus Melancholicus)* (Very Important Voyages [In Search of Melancholic Crossroads]), a parody of then-popular adventure travelogues such as those by Rudyard Kipling and Jules Verne.

52. *Blanco y Negro* 2 (25 September 1892), 612–13.

53. *Blanco y Negro* 2 (25 September 1892), 612.

54. See, for example, *El Museo Universal* (7 August 1864), 253, the grouping of inhabitants of the island of Fernando Poo, or in the same magazine the group of Brazilian natives after a photograph by Castro (*El Museo Universal* 7 [15 February 1863], 53). Both were hand-sketched engravings that were made after a photograph. Ethnographic sketches after photographs were by the late 1890s being replaced by photo-engravings reproduced in halftone. See, for example, *Blanco y Negro* 6 (19 September 1896), n.p., the grouping of fifteen images of Filipino natives, or *Ilustración Artística's* grouping of Filipinos in 17 (6 June 1898), 364.

55. *El Gato Negro* 1 (26 March 1898), 4.

56. *El Gato Negro* 1 (36 March 1898), 4.

57. See *Barcelona Cómica* 9 (1 January 1896), 126, and *Barcelona Cómica* 9 (28 March 1896), 339.

58. *Nuevo Mundo* 10 (18 February 1903), n.p.

59. *Ilustración Artística* 22, 109 (30 March 1903), 223.

60. *Ilustración Artística* 22, 109 (30 March 1903), 223.

61. For a discussion of the Gypsy in magazine art, see Lou Charnon-Deutsch, *The Spanish Gypsy: The History of a European Obsession,* chap. 5, "'Our' Gypsies."

62. *Blanco y Negro* 3, 34 (23 September 1893), cover.

63. *Blanco y Negro* 3, 34 (23 September 1893), cover.

64. *Blanco y Negro* 3 (1 November 1893), 723.

65. *Blanco y Negro* 2 (4 September 1892), 567.

66. *Blanco y Negro* 3 (9 December 1893), 809.

67. Álvarez Junco, *Mater dolorosa,* 519.

68. Álvarez Junco, *Mater dolorosa,* 519.

69. *Blanco y Negro* 2 (4 September 1892), 564.

70. *Blanco y Negro* 4 (23 June 1894), 401.

71. *Blanco y Negro* 3 (27 May 1893), 61.

72. *Blanco y Negro* 5 (30 March 1895), n.p.

73. *Blanco y Negro* 5 (17 August 1895), n.p.

74. *Blanco y Negro* was not alone in these late predictions that seemed to go against all odds. See, for example, the image published in *Don Quijote* 8 (8 April 1898), 2, with a Spanish sailor tugging on Uncle Sam's hair to teach him the lesson on the blackboard—a list of Spain's former victories in Navas de Tolosa, San Quintín, Trafalgar, Callao, Lepanto, Otumba, and Bailén. By October 1898, predictably, *Don Quijote's* cartoonist had recognized that Spain was not to be one of the captors of "lady" Cuba, who is shown as a damsel being tugged at by a glaring black Mambise and a corpulent Uncle Sam (*Don Quijote* 7 [21 October 1898], 3).

75. *Blanco y Negro* 5 (2 November 1895), cover.

76. *Blanco y Negro* 5 (27 April 1895), n.p.

77. *Blanco y Negro* 5 (4 May 1895), n.p.

78. *Blanco y Negro* 5 (4 May 1895), cover.

79. *Blanco y Negro* 5 (25 May 1895), cover.

80. *Blanco y Negro* 5 (20 July 1895), cover.

81. *Blanco y Negro* 5 (14 September 1895), cover.

82. *Blanco y Negro* 5 (19 October 1895), cover.

83. *Blanco y Negro* 5 (16 March 1895), n.p.

84. *Blanco y Negro* 6 (14 March 1896), n.p.

85. *Blanco y Negro* 6 (11 January 1896). The feud between the two magazines lasted the entire year, ending with a notarized statement or *acta notarial* about its circulation and a denunciation of *Nuevo Mundo* in official proceedings. The rivalry did not end that year, however, *Nuevo Mundo* sought repeatedly to draw away *Blanco y Negro* readers. For example, in summer 1901, a full-page announcement advertised in large letters a "Revolution" in publishing: its weekly supplement *Por esos mundos* (Round the World) would now cost only 20 centimes, which would come to one centime per page, in contrast to *Blanco y Negro,* which had just raised its price to 30 centimes and therefore cost one-third more. The paper also boasted that its *Por esos mundos* section would imitate the format of other "great monthly magazines" such as *La Lecture pour tous, Strand, Pearson,* and *Munsey. Nuevo Mundo,* founded by the Cuban-born José del Perojo, began publication in 1900 and lasted until 1917, but despite what it advertised were to be its "translations of novels and adventures and extracts of articles on more or less rare and extravagant things" it never garnered the subscriptions of the rival *Blanco y Negro.*

86. *Blanco y Negro* 6 (29 August 1896), n.p.

87. Luca de Tena's fortune came from a lucrative business in cosmetics and cooking oil, which he pooled with his wife's money to form the economic basis of the publishing house. Many admired his entrepreneurial success, but for some it was an unwelcome "capitalistic type of intrusion" (Desvois, "El fin," 345).

88. *Blanco y Negro* 9 (4 February 1899).

89. *Blanco y Negro* 9 (4 February 1899), n.p.

90. *Blanco y Negro* 9 (4 February 1899), n.p.

91. According to Desvois, Luca de Tena was known for being the first impresario to pay his workers a living wage, "requiring in exchange a greater professionalism than was currently the norm" (Desvois, "El fin," 345).

92. *Blanco y Negro* 9 (4 February 1899), n.p.

93. *Blanco y Negro* 9 (4 February 1899), n.p.

94. *Blanco y Negro* 9 (4 February 1899), n.p.

95. *Blanco y Negro* 9 (4 February 1899), n.p.

96. *Blanco y Negro* 9 (16 April 1899), n.p.

97. *Blanco y Negro* 9 (27 May 1899), n.p.

98. Ramón del Valle Inclán, *Las galas del difunto,* 1108. Machaquito was a renowned bullfighter whose real name was Rafael González (1880–1952). "La Imperio" probably refers to Pastora Imperio, the famed flamenco entertainer.

99. *Blanco y Negro* n.p.

100. *Blanco y Negro* 20 (10 July 1910), n.p.

CHAPTER 4

1. Alda Blanco, "El fin del imperio español y la generación del 98," 7.

2. Nancy Membrez, "Yanquis, filibusteros, y patriotas: prensa y teatro en la España del 98," 123. Some examples of *género chico* studied by Membrez include *Cádiz* (1886), by Javier de Burgos, *La marcha de Cádiz* (The Cadiz March, 1896) by Celso Lucio and Enrique García Álvarez, and *¡Aún hay patria, Veremundo!* (There's Still a Country, Veremundo! 1898) by Eduardo Navarro Gonzalvo. The musical piece "Marcha de Cádiz" composed by Federico Chueca and Joaquín Valverde for the zarzuela *Cádiz* became a national rallying hymn that the government used in its fund-raising functions organized to equip the troops (Membrez, 132). See also Membrez, 139–40, note 6, for a list of other titles of related interest. Silvia Hilton has argued that the success of these pro-military pieces was minimal (Hilton, "The Spanish American War," 79) and that the "Spanish public was not overwhelmingly moved by the rhetoric of the stage or the press" (Hilton, "The Spanish American War," 79).

3. Sebastián Balfour, "The Impact of War Within Spain: Continuity or Crisis?" 180. See Angel Smith, "The People and the Nation," for other popular manifestations of patriotic sentiment, in the zarzuelas and local fund-raising activities.

4. See Sam Keen's *Faces of the Enemy: Reflections of the Hostile Imagination,* for a survey of nineteenth- and twentieth-century graphic depictions of the enemy.

5. Álvarez Junco, *Mater dolorosa,* 570.

6. Álvarez Junco, *Mater dolorosa,* 587.

7. One way the government fostered working-class support for the war was by reminding workers that winning the war was important because their jobs were at stake (Aurea Matilde Fernández Múñiz, "Las quintas: Sistema de reclutamiento: explotación para unos y negocio para otros [1868–98]," 557). Opposition to the war was strong among working-class women; in Saragossa, Cadiz, and other cities women marched to protest the conscription of their sons. Valencia and Barcelona also were sites of antiwar protests (Fernández Múñiz, 557–58).

8. This phrase was first spoken by Secretary of State John Hays under Theodore Roosevelt, in 1898. See Virginia Marie Bouvier, *Whose America?* 73.

9. In the four months of fighting, Americans lost only 460 soldiers in battle, casualties that seemed insignificant compared to those suffered in the recent American Civil War. By some accounts, the ambassador to England wrote to his friend Teddy Roosevelt calling the conflict "a splendid little war."

10. Álvarez, "Opinión," 248.

11. Cartooning in Spanish periodicals had by this time a long history. See Bozal's excellent survey of cartoons in early satirical magazines in *La ilustración gráfica del XIX en España.*

12. *El Gato Negro* 1 (2 April 1898), n.p.

13. Richard Goldstein, "Cartoon Wars," 7.

14. Goldstein, "Cartoon Wars," 7.

15. *Blanco y Negro* 5 (16 November 1895), n.p.

16. *Blanco y Negro* 5 (16 November 1895), n.p.

17. *Blanco y Negro* 5 (28 November 28), 1895.

18. *Blanco y Negro* 5 (28 November 1895), n.p.

19. Elorza, "Con la marcha de Cadiz," 372.

20. *Blanco y Negro* 5 (18 May 1895), n.p. According to the *Diccionario de la real academia,* the term *filibusteros* originally signified a "freebooter" or an invading marauder in the seventeenth century. In the nineteenth century it came to mean an American who fomented revolutions and military adventurers (*Webster's Third New International Dictionary*). Today the term *filibuster* has evolved to mean the use of dilatory tactics to stall legislative decisions, as in the U.S. Senate.

21. *Blanco y Negro* 6 (25 April 1896), n.p.

22. *Blanco y Negro* 6 (21 March 1896), n.p.

23. Louis A. Perez, *The War of 1898,* 11.

24. *El Gato Negro* 1 (23 April 1898), cover.

25. Elorza, "Con la Marcha de Cadiz," 385.

26. Miguel Rojas Mix, "Usted ponga los dibujos; Yo pondré la guerra," 19.

27. *Ilustración Española y Americana* 40 (22 February 1896), 107.

28. *Ilustración Española y Americana* 40 (22 February 1896), 108.

29. *Ilustración Española y Americana* 40 (22 February 1896), 108.

30. Quoted in Pierre Vilar, "Estado, nación patria en España y en Francia, 1870–1914," 13.

31. *Ilustración Española y Americana* 40 (22 April 1896), 235.

32. *Ilustración Española y Americana* 40 (22 April 1896), 235.

33. *Ilustración Española y Americana* 40 (22 April 1896), 235.

34. *Ilustración Española y Americana* 40 (22 April 1896), 236.

35. For more on this topic, see the chapter titled "The White Man's Burden," in Albert Katz Weinberg, *Manifest*

Destiny: A Study of Nationalist Expansionism in American History; see also Thomas F. Gossett, "Imperialism and the Anglo-Saxon," in *Race and U.S. Foreign Policy from the Colonial Period to the Present*, 230–35.

36. Louis A. Pérez Jr., *The War of 1898*, 47.

37. The acquisitions of formerly Spanish territories (Florida, California, and Mexico), and more recent American interventions in the Anglo-Venezuelan dispute, of course belie this ideological stance.

38. *Harpers Weekly* 42 (12 March 1898), 241.

39. *Blanco y Negro* 8 (18 June 1898), n.p.

40. William H. Walker's "The White (?) Man's Burden" appeared in *Life* 33 (16 March 1899). The provenance of the cartoon entitled "What the United States Has Fought For" is unknown; it was taken from the Socialist Studies help site: http://www.socialstudieshelp.com/USRA_Imperialism_Justify.htm. [Internet]. (Cited 12 December 2006). "Taking Up the First Installment of the White Man's Burden" first appeared in *Saint Paul Pioneer Press* and was reprinted in the *American Monthly Review of Reviews* (21 April 1900).

41. For a further discussion of racial issues during the Spanish-American War, see John Offner, "United States Politics and the 1898 War over Cuba," 18–21.

42. *Nation* 66 (28 April 1898), 396.

43. Louis A. Perez, *The War of 1898*, 13.

44. *Broad Axe* (Saint Paul, Minn.) (9 March 1899).

45. See this image in *The New York Herald* (7 August 1898), 1.

46. See this image in *The New York Herald* (25 November 1898), 3.

47. See this image in *Harpers Weekly* (15 October 1898), 1012–13.

48. See this image in *Harpers Weekly* 42 (10 September 1898), 893.

49. *Ilustración Española y Americana* 40 (8 March 1896), 150.

50. *Ilustración Española y Americana* 40 (8 March 1896), 150.

51. *Ilustración Española y Americana* 40 (8 March 1896), 150.

52. *Ilustración Española y Americana* 40 (8 March 1896), 143.

53. *Ilustración Española y Americana* 40 (8 March 1896), 146. The Latin translation of the two catch phrases is "The end crowns the work" and "Fortune favors the bold."

54. *Blanco y Negro* 8 (4 June 1898), n.p.

55. *Don Quijote* 7 (9 December 1898), n.p.

56. *Gedeón* 4 (2 June 1898).

57. *Ilustración Ibérica* 13 (21 December 1895), 801.

58. *Barcelona Cómica* 9 (25 January 1896), 3.

59. *Madrid Cómico* 17 (2 January 1897), 13–14.

60. *La Campana de Gracia*, founded by Innocenci López Bernagosi, inaugurated its first issue in 1870 with a run of approximately 3,000, eventually reaching 20,000–30,000 and up to 40,000 for special issues. Together with *La Esquella de Torratxa* (begun in 1872), it was one of the longest and most popular satirical periodicals. (Bozal, *La ilustración gráfica del XIX en España*, 188).

61. *La Campana de Gracia* 26 (24 August 1895).

62. Elorza, "Con la marcha de Cadiz," 328.

63. *La Campana de Gracia* 26 (8 March 1895), cover.

64. *La Campana de Gracia* 29 1 January 1898), 7.

65. Sylvia Hilton, "The United States," 55, 60.

66. Hilton also asserts the common argument that Socialist and anarchist papers exploited the war to rail against American imperialist capitalism (Hilton, "The United States," 55).

67. *Ilustración Española y Americana* 40 (8 March 1896), 149.

68. The article is in reference to the complicated political career of Pinckney Benton Stewart Pinchback, member of the Louisiana senate and the state's first black governor.

69. *Blanco y Negro* 8 (1 June 1898), n.p.

70. *Blanco y Negro* 8 (1 October 1898), n.p.

71. Quoted in Álvaro Armero, *Fragmentos del 98*, 61.

72. Félix Santos, *1898: La prensa y la Guerra de Cuba*, 12.

73. Hilton, "The Spanish American War," 77, and, Rosario Sevilla Soler, *La Guerra de Cuba y la memoria colectiva*, 163. Hilton references the suspicion that Sagasta's government used the press to justify its decision to go to war knowing that Spain would be defeated (Hilton, "The Spanish American War," 80).

74. Santos, *1898: La prensa y la Guerra de Cuba*, 18.

75. Àlvarez Junco, *Mater dolorosa*, n.p.

76. *Don Quijote* 7, 16 (22 April 1898).

77. *El Correo Español* (10 March 1898). Quoted in Armero, *Fragmentos del 98*, 63.

78. *lustración Ibérica* 2 (16 March 1895), 162.

79. *El Motín* 18 (23 April 1898).

80. *El Motín* 18 (2 April 1898), 2.

81. *Gedeón* 4 (16 March 1898), cover.

82. Quoted in Álvaro Armero, *Fragmentos del 98*, 25

83. The satirical magazine *El Motín* published this quote from the *Correspondencia Militar*, noting gloomily how untruthful the official reports of the war were with regard to Spanish victories (*El Motín* 18 [9 July 1898], 2).

84. Kristin Hoganson, *Fighting for American Manhood*, 123.

85. John Offner, "United States Politics and the 1898 War over Cuba," 18.

86. John Offner, "United States Politics and the 1898 War over Cuba," 24.

87. Hoganson, *Fighting for American Manhood,* 140.

88. *Nation* 66 (21 April 1898), 296.

89. See Offner, "United States Politics and the 1898 War over Cuba," 25, and Louis A. Pérez Jr., *The War of 1898,* 19.

90. Louis A. Pérez, *The War of 1898,* 114.

91. Theodore Roosevelt, "The Monroe Doctrine," 233.

92. It should be remembered that despite the media nationalist discourse, opposition to the war was also common. According to John Offner, "large numbers continued to resist the war spirit; for instance, many national guardsmen, particularly in the South but also some in the North, refused to join the US Army and sat out the war" (Offner, "United States Politics and the 1898 War over Cuba," 24).

93. *The New York Herald* (19 June 1898), 2.

94. See this image in *Cartoons of the War of 1898 from Leading Foreign and American Papers.*

95. See this image in Charles Nelan, *Cartoons of Our War with Spain.*

96. *New York Journal* (February 1897).

97. See this image in *The New York Herald* (22 June 1898), 9.

98. *Harpers Weekly* 42 (18 June 1898), 604.

99. *Blanco y Negro* 6 (17 October 1896), n.p.

100. *Diario de la Sesión de las Cortes* (2 April 1895), 2521.

101. *Blanco y Negro* 6 (16 May 1896), n.p. This image originally appeared in the Buenos Aires satirical magazine *La Bomba.*

102. *El Gato Negro* 1 (23 April 1898), 11.

103. *El Gato Negro* 1 (7 May 1898), n.p.

104. *El Gato Negro* 1 (4 June 1898), n.p.

105. *Blanco y Negro* 6 (7 March 1896), n.p.

106. *Blanco y Negro* 7 (29 May 1897), n.p.

107. According to the Mormon interpreter of Christian writings, Alonzo Gaskill. (Available from http://deseretbook.com/mormon-life/news/story?story_id=902. [Internet]. (Cited 23 December 2006). "[T]he perception of the pig as a symbol for hypocrisy 'was revealed by God/Allah/Yahweh to his several prophets' in at least three major traditions—Christianity, Islam, and Judaism. Even the ancient Egyptians occasionally thought of the souls of the wicked as being brought to the place of condemnation in the disgraceful form of swine. As Richard Lobban has shown, these ideas regarding swine symbolism existed in many, if not most, cultures of antiquity." In the 1960s the term *pig* became an epithet hurled at the police by antiwar protesters in the United States. In 1898, however, its meaning was slightly more ambiguous. The pig was stupid and easily slaughtered. Uncle Sam rides the pig at his peril. Nancy Membrez also reminds us that the pig as a symbol was related to the term *marrano,* a racial insult that derided the converted Jews who refused to eat pork products (Membrez, "Yanquis, filibusteros, y patriotas: prensa y teatro en la España del 98," 125).

108. *El Gato Negro* 1 (4 June 1898), 11.

109. *El Gato Negro,* 1 (21 May 1898), 8.

110. *Blanco y Negro* 6 (11 April 1896), n.p.

111. See Hilton, "The United States," 55, for a more complete list of the antiwar press. *El Socialista* was founded by Pablo Iglesias and *El Nuevo Régimen* by Pi y Margall, both of whom persistently objected to the war. Blasco Ibáñez was one of the principal writers for *El Pueblo,* published in Barcelona. For more information about these satirical magazines, see also Bozal, *La ilustración gráfica del XIX en España,* 171–221.

112. Hilton, "The Spanish American War," 82.

113. Jaime Carrera Pujal, *Historia política de Cataluña en el siglo XIX,* 6:181.

114. Jaime Carrera Pujal, *Historia política de Cataluña en el siglo XIX,* 6:181–82.

115. During the Spanish-Cuban war and the Spanish American War, more than 200,000 troops were mobilized and sent out to Cuba and the Philippines, drawn, as Sebastián Balfour points out, from the poorer classes who could not afford to buy exemptions from military service (Balfour, "The Impact of War Within Spain: Continuity or Crisis?" 109). Men were drafted at the age of nineteen, and it was these youngest and least experienced soldiers who were assigned to ultramar posts, while veteran soldiers remained in Spain (Molina Martínez, "Granada y la repatriación de soldados de ultramar," 447).

116. Carrera Pujal, *Historia política de Cataluña en el siglo XIX,* 6:187–89.

117. Carrera Pujal, *Historia política de Cataluña en el siglo XIX,* 6:188.

118. Carrera Pujal, *Historia política de Cataluña en el siglo XIX,* 6:339.

119. *La Campana de Gracia* 29 (7 July 1898), 5.

120. Elorza, "Con la marcha de Cadiz," 327.

121. Carrera Pujal, *Historia política de Cataluña en el siglo XIX,* 6:200.

122. Quoted in Armero, *Fragmentos del 98,* 110.

123. Quoted in Elorza, "Con la marcha de Cadiz," 353.

124. Vilar, "Estado, nación patria en España y en Francia, 1870–1914," 26.

125. *El Motín* 18 (23 April 1898), front page. *El motín* was published in Madrid beginning in 1881 by Imp. de M. Romero.

126. *Blanco y Negro* 8 (30 July 1898), n.p. Mambi, plural Mambises, was the name given to insurgents during the 1868 Cuban uprising. It became generalized as well during the 1895–98 conflicts when it carried a pejorative connotation.

127. Alas's story first appeared in the collection *Cuentos Morales* in 1896. Writing during the same years, Emilia Pardo Bazán also offered her readers sad tales of the nefarious consequences of an unjust conscription and the steep cost of

indemnification for the poor. She gave her 1899 story "Elección" (Election) a twist designed to heighten the pathos of a poor family forced to sell its only possession of value, prized oxen, in order to purchase the indemnity necessary to keep the only son from being drafted and sent abroad; "it's either the oxen or the young man, one or the other"—Emilia Pardo Bazán, "Elección," 55. In the end, the family loses both son and oxen. See also Pardo Bazán's story "Oscuramente" (Darkly), in the same collection, in which a young man is sent off to war in what the story suggests is a travesty since he is unsuited to be a soldier because of his effeminate nature.

128. Vilar, "Estado, nación patria en España y en Francia, 1870–1914," 30.

129. Elorza, "Con la march de Cadiz," 383.

130. *La Campana de Gracia* 29 (24 September 1898), 5. Pellicer Montseny was one of a group of Catalan caricaturists who were refining and standardizing the political cartoon. According to Valeriano Bozal, "their linearity, their sense of the moment, and, at the same time, in paradoxical contradiction, their sense of the decorative, opened the way for modernism" *(La ilustración gráfica del XIX en España,* 197).

131. Miguel Molina Martínez "Granada y la repatriación de soldados de ultramar," 448.

132. *El Motín* 18 (16 July 1898), 2.

133. Quoted in Sevilla Soler, "La crisis" del 98 y la sátira en la prensa sevillana," 532.

134. *El Socialista* 14 (27 January 1899), n.p.

135. *Ilustración Española y Americana* 42 (8 September 1898), 135.

136. *Blanco y Negro* 8 (3 September 1898), n.p.

137. *Blanco y Negro* 8 (24 September 1898), n.p.

CONCLUSION

1. Cecilio Alonso, "La lectura de cada día," 576.

2. The list includes: a certain grade of development and/or penetration of monopolistic capital; a notable demographic concentration in the cities; a bourgeois political system; an augment in the index of literacy; the development of transport and means of communication; the application of new energies: electricity, combustible engine, petroleum, gasoline; and the technological renovation in the terrain of communication (linotype, telegraph, telephone, teletype, phonograph, radio, and cinema) (Gómez Mompart, "Elements," 85).

3. Botrel, "Construcción de una nueva cultura del libro y del impreso en el siglo XIX," 35.

4. See, for example, Jesús Timoteo Álvarez, *Restauración y prensa de masas,* and Guillermo Carnero, "Introducción a la primera mitad del siglo XIX español."

5. Raymond Carr, *España, 1808–1939,* 281.

6. See Bozal, *La Ilustración gráfica del XIX en España,* 29–32, for information about earlier decrees in relation to the press and for a fuller examination of the post 1868 reforms and restrictions.

7. Gómez Aparicio, *Historia del periodismo español,* 270–71.

8. David Ortiz, *Paper Liberals,* 6.

9. Serge Salaün and Carlos Serrano, *1900 en España.* One of the defining political arrangements of the period of the Restoration was the agreement of the two main political parties to abandon power to each other at regular intervals, each one taking its turn *(turno).*

10. Paul Aubert, "La presse et le pouvoir en Espagne sous la Restauration (1875–1923)," 38.

11. Serge Salaün and Carlos Serrano, *1900 en España,* 34.

12. Álvarez, *Restauración y prensa de masas,* 172.

13. Juan Francisco Fuentes and Javier Fernández Sebastián, *Historia del periodismo español: prensa, política, y opinión pública en la España contemporánea,* 103.

14. Salaün and Serrano, *1900 en España,* 46. See also Valeriano Bozal, *La ilustración gráfica del XIX en España,* 16–17

15. Miguel Martínez Cuadrado, *Restauración y crisis de la monarquía (1874–1931),* 127.

16. Carnero, "Introducción a la primera mitad del siglo XIX español," 48.

17. Eliseo Trenc, "Los modelos extranjeros," 58. By 1854 *The Illustrated London News* circulation was 70,000 and Paris's *L'Illustration* was 25,000 (Alonso, "Antecedentes," 29).

18. Carnero lists the illiteracy rate in 1860 as 77.10%, falling to 69% in 1877 and to 66% in 1887 (Carnero, "Introducción a la primera mitad del siglo XIX español," 47). According to Martínez Cuadrado, the figure in 1877 was 72%, falling to 63.8% in 1900 and 44.4% 1940. By contrast in 1900 the illiteracy rate of the United States was 10.7% and that of France 16.5% (Martínez Cuadrado, *Restauración y crisis de la monarquía [1874–1931],* 488).

19. Álvarez, *Restauración y prensa de masas,* 205.

20. Fuentes and Fernández, *Historia del periodismo español,* 147.

21. Martínez Cuadrado, *Restauración y crisis de la monarquía,* 127.

22. *Blanco y Negro* 4 (29 December 1901), n.p. Exact figures on *Blanco y Negro* runs are difficult to determine because of the magazine's tendency to inflate its production figures, especially when it was feuding with its rival *Nuevo Mundo*. Fuentes and Fernández mention that the magazine had runs of 70,000 by 1899 (Fuentes and Fernández, *Historia del periodismo español,* 151).

23. Celso Almuiña, "Prensa y poderes en la España tardoliberal, primer tercio del XX," 40.

24. Fuentes and Fernández, *Historia del periodismo español*, 147.

25. Josep-Francesc Valls, *Prensa y burguesía en el XIX español*, 206.

26. Josep Lluís Gómez Mompart, "Prensa de información: Prensa de opinión," 88. However, see also his article "¿Existió en España prensa de masas? La prensa en torno a 1900," in which he categorically states: "Despite the fact that our newspapers during the Restoration already presented some characteristics of what we commonly understand as a mass press . . . neither their function nor their forms and content permit us to classify them as such before the nineteenth century" (28). There still was a great difference between the Spanish press and its American, British, and French counterparts (28–29).

27. "Jesús Timoteo Álvarez, "Decadencia del sistema y movimientos regereracionistas," 20

28. Bernardo Riego, *La construcción social de la realidad a través de la fotografía y el grabado informativo en la España del siglo XIX*, 101.

29. Richard Ohmann, *Selling Culture: Magazines, Markets, and Class at the Turn of the Century*, 14–16.

30. Ohmann, *Selling Culture: Magazines, Markets, and Class at the Turn of the Century*, 32.

31. Ohmann, *Selling Culture: Magazines, Markets, and Class at the Turn of the Century*, 57.

32. Miguel Ángel Pérez Ruiz, *La publicidad en España*, 40.

33. Ads for Agua de Azahar continued until the second decade of the twentieth century.

Bibliography

Alas, Leopoldo (Clarín). "El sustituto." In *Doña Berta y otros relatos,* edited by José María Martínez Cachero, 138–61. Estella (Navarre): Salvat Editores, Alianza Editorial, 1969.

Albert, Pierre, and Gilles Feyel. "Photgraphy and the Media." In *A New History of Photography,* edited by Michel Frizot, 358–69. Milan: Könemann, 1998.

Almuiña, Celso. "Prensa y poderes en la España tardoliberal, primer tercio del XX." In *Presse et pouvoir en Espagne. 1868–1975: Colloque International de Talence, 26–27 Novembre 1993,* edited by Paul Aubert and Jean-Michel Desvois, 39–54. Bordeaux: Maison des Pays Ibériques; Madrid: École des Hautes Études Hispaniques, 1996.

Alonso, Cecilio. "Antecedentes de Las *Ilustraciones.*" In *La prensa ilustrada en España: Las* Ilustraciones, *1850–1920,* 13–41. Montpellier: Université Paul Valéry, 1996.

———. "La difusión de las *Ilustraciones* en España." In *La prensa ilustrada en España: Las* Ilustraciones, *1850–1920,* 45–61. Montpellier: Université Paul Valéry, 1996.

———. "El auge de la prensa periódica." In *Historia de la edición y de la lectura en España, 1472–1914,* edited by Víctor Infantes, François López, and Jean-François Botrel, 559–70. Madrid: Fundación Germán Sánchez Ruipérez, 2003.

———. "La lectura de cada día." In *Historia de la edición y de la lectura en España, 1472–1914,* edited by Víctor Infantes, François López, and Jean-François Botrel, 571–79. Madrid: Fundación Germán Sánchez Ruipérez, 2003.

Álvarez, Jesús Timoteo. *Restauración y prensa de masas: Los engranajes de un sistema (1875–1883).* Pamplona: Ediciones Universidad de Navarra, 1981.

———. "Decadencia del sistema y movimientos regeneracionistas." In *Historias de los medios de comunicación en Espana: Periodismo, imagen, y publicidad (1900–1990),* 11–26. Barcelona: Ariel, 1989.

———. "Opinión pública y preopaganda bélica al incicio de la contienda." In *1895: La guerra en Cuba y la España de la Restauración,* edited by Emilio de Diego, 247–61. Madrid: Editorial Complutense, 1996.

Álvarez Junco, José. *Mater dolorosa: La idea de España en el siglo XIX.* 5th ed. Madrid: Taurus, 2003 (2001).

Amaraglio, Jack, and Antonio Callari. "Marxian Value Theory and the Problem of the Subject: The Role of Commodity Fetishism." In Emily Apter and William Pietz, eds., *Fetishism as Cultural Discourse,* 186–216. Ithaca: Cornell University Press, 1993.

La Andalucía del siglo XIX en las fotografías de J. Laurent y Cía. Almería, Spain: Consejería de Cultura, 1998.

Andalucía y América en el siglo XIX: Actas de las V jornadas de Andalucía y América. Edited by Bibiana Torres Ramírez and José Jesús Hernández Palomo, 307–40. Seville: Universidad de Santa María de la Rábida, 2000.

Apter, Emily. *Feminizing the Fetish: Psychoanalysis and Narrative Obsession in Turn-of-the-Century France.* Ithaca: Cornell University Press, 1991.

———, and William Pietz, eds. *Fetishism as Cultural Discourse.* Ithaca: Cornell University Press, 1993.

Armero, Álvaro. *Fragmentos del 98. Prensa e información en el año del desastre.* Madrid: Comunidad de Madrid, 1998.

Shortened titles in the notes, and occasionally in the text, refer to titles in this bibliography.

Aubert, Paul. "El acontecimiento." In *La prensa de los siglos XIX y XX: Metodología, ideología, e información: Aspectos económicos y tecnológicos,* edited by Manuel Tuñón de Lara, Carmelo Garitaonaindía Garnacho, and Jesús Timoteo Álvarez, 47–71. Bilbao: Servicio Editorial, Universidad del País Vasco, 1986.

———. "La presse et le pouvoir en Espagne sous la Restauration (1875–1923)." In *Les Moyens d'information en Espagne.* 9–65. Bordeaux: Maison des Pays Ibériques, Université de Pau, Presses Universitaires de Bordeaux, 1986.

Balfour, Sebastián. "The Impact of War Within Spain: Continuity or Crisis?" In Angel Smith and Emma Dávila-Cox, eds., *The Crisis of 1898: Colonial Redistribution and Nationalist Mobilization,* 180–94. New York: St. Martins, 1999.

Barrera, Carlos, ed. *El periodismo español en su historia.* Barcelona: Ariel, 2000.

Barthes, Roland. *Image Music Text.* Translated by Stephen Heath. New York: Hill and Wang, 1977.

———. *Camera Lucida; Reflections on Photography.* Translated by Richard Howard. New York: Hill and Wang, 1982.

Baudelaire, Charles. "Le Peintre de la vie moderne." In *Oeuvres completes,* edited by Claude Pichois, 2: parts 10–12, 713–22. Paris: Gallimard, 1976.

Benjamin, Walter. "Little History of Photography." In *Selected Writings.* Vol, 2: *1927–1934.* Translated by Rodney Livingstone and others. Edited by Howard Eiland, Gary Smith, and Michael W. Jennings, 507–30. Cambridge: Belknap Press of Harvard University Press, 1999.

———. "The Work of Art in the Age of Its Technological Reproducibility." In *Selected Writings.* Vol. 4: *1938–1940.* Translated by Edmund Jephcott and others. Edited by Howard Eiland and Michael W. Jennings, 101–33. Cambridge: Belknap Press of Harvard University Press, 2003.

Bernheimer, Charles. "Fetishism and Decadence: Salome's Severed Heads." In Emily Apter and William Pietz, eds., *Fetishism as Cultural Discourse,* 62–83. Ithaca: Cornell University Press, 1993.

Bhabha, Homi K. *The Location of Culture.* New York: Routledge, 1994.

Binet, Claude. "Le Fétichisme dans l'amour." *Revue Philosophique de la France et de l'Étranger* 12 (1887): 143–67, 252–74. Reprint; Nendeln, Liechtenstein: Kraus Reprint, 1967.

Blanco, Alda. "El fin del imperio español y la generación del 98: Nuevas aproximaciones." *Hispanic Research Journal* 4.1 (February 2003): 3–18.

Botrel, Jean-François. "Estadística de la prensa madrileña de 1858–1909, según el Registro de Contribución Industrial." In Manuel Tuñón de Lara, Antonio Elorza, and Manuel Pérez Ledesma, eds., *Prensa y sociedad en España (1820–1936),* 25–45. Madrid: Editorial Cuadernos para el Diálogo, 1975.

———. *Libros, prensa, y lectura en la España del siglo XIX.* Translated by David Torra Ferrer. Madrid: Fundación Sánchez Ruipérez, Ediciones Pirámide, 1993.

———. "Construcción de una nueva cultura del libro y del impreso en el siglo XIX." In *Orígenes culturales de la sociedad liberal. España siglo XIX,* edited by Jesús Antonio Martínez Martín, 19–36. Madrid: Biblioteca Nueva, Editorial Complutense, Casa de Velázquez, 2003.

Bourdieu, Pierre. *Photography: A Middlebrow Art.* London: Polity Press, 1990.

Bouvier, Virginia Marie. *Whose America? The War of 1898 and the Battles to Define the Nation.* Westport, Conn.: Praeger, 2001.

Bozal, Valeriano. *La ilustración gráfica del XIX en España.* Madrid: Comunicación, 1979.

Burd Schiavo, Laura. "From Phantom Image to Perfect Vision: Physiological Optics, Commercial Photography, and the Popularization of the Stereoscope." In *New Media, 1740–1915,* edited by Lisa Gitelman and Geoffrey B. Pingree, 113–37. Cambridge: MIT Press, 2003.

Campbell, Joseph. *Yellow Journalism: Puncturing the Myths, Defining the Legacies.* Westport, Conn.: Praeger, 2001.

Carnero, Guillermo. "Introducción a la primera mitad del siglo XIX español." In *Historia de la literatura española: Siglo XIX (I),* edited by Guillermo Carnero, xvii–c. Madrid: Espasa Calpe, 1996.

———, ed. *Historia de la literatura española: Siglo XIX (I),* Madrid: Espasa Calpe, 1996.

Carr, Raymond. *España, 1808–1939.* Translated by Juan Ramón Capella, Jorge Garzolini, and Gabriela Ostbert. Edited by J. Romero Maura. Barcelona: Ediciones Ariel, 1970.

Carrera Pujal, Jaime. *Historia política de Cataluña en el siglo XIX,* Vol. 6: *De la Restauración al desastre coloonial.* Barcelona: Bosch, 1958.

Carrete Parrondo, Juan, Jesusa Vega González, and Francesc Fontbona. *El grabado en España: Siglos XIX*

y XX. In *Summa Artis: Historia General del Arte,* Vol. 32. Madrid: Espasa-Calpe, 1994. Reprint (1988).

Cartoons of the War of 1898 from Leading Foreign and American Papers. Chicago: Belford Middlebrook, 1898.

Cazottes, Gisèle. *La Presse périodique madrilène entre 1871 et 1885.* Montpellier: Université Paul Valéry, 1982.

Charnon-Deutsch, Lou. *Fictions of the Feminine in the Nineteenth-Century Spanish Press.* University Park: The Pennsylvania State University Press, 1995.

———. *The Spanish Gypsy: The History of a European Obsession.* University Park: The Pennsylvania State University Press, 2000.

150 años de fotografía en la Biblioteca Nacional: guía-inventario de los fondos fotográficos de la Biblioteca Nacional. Edited by Gerardo F. Kurtz and Isabel Ortega. Madrid: Ministerio de Cultura, Dirección General del Libro y Bibliotecas, Ediciones El Viso, 1989.

Desvois, Jean-Michel. *La prensa en España (1900–1931).* Madrid: Siglo XXI, 1977.

———. "El fin de las *Ilustraciones:* El caso de Madrid." In *La prensa ilustrada en España: Las* Ilustraciones, *1850–1920,* 343–48. Montpellier: Université Paul Valéry, 1996.

Dijkstra, Bram. *Idols of Perversity: Fantasies of the Feminine Evil in Fin-de-siècle Culture.* New York: Oxford University Press, 1986.

Elorza, Antonio. "Con la marcha de Cadiz." *Estudios de Historia Social* 44–47 (1988): 327–86.

Esonwanne, Uzoma. "Feminist Theory and the Discourse of Colonialism." In *ReImagining Women: Representations of Women in Culture,* edited by Shirley Neuman and Glennis Stephenso, 232–55. Toronto: University of Toronto Press, 1993.

Espina García, Antonio. *El cuarto poder: Cien años de periodismo español.* Madrid: Libertarias/Prodhufi, 2001.

Fernández Múñiz, Aurea Matilde. "Las quintas: Sistema de reclutamiento: explotación para unos y negocio para otros (1868–98). *Estudios de Historia Social* 44–47 (1988): 553–59.

Figuera, Dorothy M. *The Exotic: A Decadent Quest.* Albany: State University of New York Press, 1994.

Fontanella, Lee. *Photography in Spain in the Nineteenth Century.* Dallas: Dalhunty Gallery; San Francisco: Fraenkel Gallery, 1983.

Fontbona, Francesc. "La ilustración gráfica: Las técnicas fotomecánicas." In Juan Carrete Parrondo, Jesusa Vega González, Francesc Fontbona, and Valeriano Bozal, eds., *El grabado en España: Siglos XIX y XX,*

32:427–608. In *Summa Artis: Historia General del Arte.* Madrid: Espasa-Calpe, 1994. Reprint (1988).

———. "Las Ilustraciones y la reproducción de sus imágenes." *La prensa ilustrada en España: Las* Ilustraciones, *1850–1920,* 73–79. Montpellier: Université Paul Valéry, 1996.

Foster, Hal. "The Art of Fetishism: Notes on Dutch Still Life." In Emily Apter and William Pietz, eds., *Fetishism as Cultural Discourse.* 251–65. Ithaca: Cornell University Press, 1993.

Frizot, Michel, ed. *A New History of Photography.* Milan: Könemann, 1998.

Fuentes, Juan Francisco, and Javier Fernández Sebastián. *Historia del periodismo español: prensa, política, y opinión pública en la España contemporánea.* Madrid: Editorial Síntesis, 1997.

Galassi, Peter. *Before Photography: Painting and the Invention of Photography.* New York: Museum of Modern Art, 1981.

Gallego Venero, Maximiano. *Torcuato Luca de Tena y Álvarez-Ossorio: Una vida al servicio de España.* Madrid: Editorial Prensa Esapñola, 1961.

García Venero, Marimino. *Torquato Luca de Tena y Álvarez Ossorio.* Madrid: Prensa Española, 1961.

Gascoigne, Bamber. *How to Identify Prints.* New York: Thames and Hudson, 2004.

Goldstein, Richard. "Cartoon Wars." *Nation* (21 February 2005): 6–8.

Gómez Aparicio, Pedro. *Historia del periodismo español.* Vol. 2: *De la Revolución de Septiembre al desastre colonial.* Madrid: Editora Nacional, 1971.

Gómez Mompart, Josep Lluís. ¿Existió en España presna de masas? La prensa en torno a 1900." In *Historias de los medios de comunicación en España: Periodismo, imagen, y publicidad, 1900–1990,* 27–40. Barcelona: Ariel, 1989.

———. "Prensa de opinion: Prensa de información: Los diarios españoles en la conformación de la sociedad-cultura de comunicaión de masas." In *Presse et pouvoir en Espagne, 1868–1975: Colloque International de Talence, 26–27 Novembre 1993,* edited by Paul Aubert and Jean-Michel Desvois, 83–95. Bordeaux: Maison des Payus Ibériques; Madrid: École des Hautes Études Hispaniques, 1996.

———, and Otto Marín. "Elements per a una caracterizació de l'inici de la premsa diària de masses." In *La prensa de los siglos XIX y XX: Metodología, ideología, e información: Aspectos económicos y tecnológicos,* edited

by Manuel Tuñón de Lara, 83–97. Bilbao: Servicio Editorial Universidad del País Vasco, 1986.

Gossett, Thomas. "Imperialism and the Anglo-Saxon." In *Race and U.S. Foreign Policy from the Colonial Period to the Present: A Collection of Essays,* edited by Michael L. Krenn, 230–35. New York: Garland Science, 1998.

La gráfica política del 98. Cáceres, Spain: CEXECI (Centro Extremeño de Estudios), 1998.

Herranz Rodríguez, Concha. "Laurent y su visión de la indumentaria andaluza." In *La Andalucía del siglo XIX en las fotografías de J. Laurent y Cía,* 219–35. Almería: Consejería de Cultura, 1998.

Hilton, Sylvia. "The Spanish American War of 1898: Queries into the Relationship Between the Press, Public Opinion, and Politics." *Western Historical Quarterly* 25.1 (spring 1994): 71–87.

———. "The United States Through Spanish Republican Eyes in the Colonial Crisis of 1895–1898." In *European Perceptions of the Spanish-American War of 1898,* edited by Sylvia L. Hilton and Steve J. S. Ickringill, 53–70. New York: Peter Lang, 1999.

Historia de la edición y de la lectura en España, 1472–1914. Edited by Víctor Infantes, François López, and Jean-François Botrel. Madrid: Fundación Germán Sánchez Ruipérez, 2003.

Hoganson, Krisitn. *Fighting for American Manhood: How Gender Politics Provoked the Spanish-American and Philippine-American Wars.* New Haven: Yale University Press, 1998.

Ian, Marcia. *Remembering the Phallic Mother: Psychoanalysis, Modernism, and the Fetish.* Ithaca: Cornell University Press, 1993.

Iglesias, Francisco. "Reorganización de la prensa y nuevas empresas periodísticas." In *Historias de los medios de comunicación en Espana: Periodismo, imagen, y publicidad, 1900–1990,* 41–49. Barcelona: Ariel, 1989.

Juan, Adelaida de. "El 98 y Cuba: caricatura de una independencia." In *La gráfica política del 98,* 21–24. Cáceres, Junta de Extremadura: Consejería de Cultura y Patrimonio, CEXECI (Centro Extremeño de Estudios y Cooperación con Iberoamérica), 1998.

Jussim, Estelle. *Visual Communication and the Graphic Arts: Photographic Technologies in the Nineteenth Century.* New York: R. R. Bowker, 1974.

Kappeler, Susanne. *The Pornography of Representation.* Minneapolis: University of Minnesota Press, 1986.

Katz Weinberg, Albert. *Manifest Destiny: A Study of Nationalist Expansionism in American History.* Chicago: Quadrangle Books,

Keen, Sam. *Faces of the Enemy: Reflections of the Hostile Imagination.* San Francisco: Harper and Row, 1986.

Krips, Henry. *Fetish: An Erotics of Culture.* Ithaca: Cornell University Press, 1999.

Lalvani, Suren. *Photography, Vision, and the Production of Modern Bodies.* Albany: State University of New York Press, 1996.

Laurent, Jean. *Coustumes et Coutumes d'Espagne: Études d'après Nature.* N.p., n.d. (Madrid: Biblioteca National, 17-35-73).

Le Bigot, Claude. "Los retratos en *La Ilustración Española y Americana:* Tretas y tramoyas de un género." In *La prensa ilustrada en España: Las* Ilustraciones, *1850–1920,* 146–61. Montpellier: Université Paul Valéry, 1996.

Lemaire, Gérard-Georges. *The Orient in Western Art.* Cologne: Köneman, 2001; Paris: Mengès, 2000.

Litvak, Lily. *El jardín de Aláh: Temas del exotismo musulmán en España, 1880–1913.* Granada: Don Quijote, 1985.

López Mondéjar, Publio. *Historia de la fotografía en España.* Barcelona: Lunwerg Editores, 1997.

MacKinnon, Catherine. "Feminism, Marxism, Method, and the State." In *Feminist Theory: A Critique of Ideology,* edited by Nannerl O. Keohane, Michelle Z. Rosaldo, and Barbara C. Gelpi. Chicago: University of Chicago Press, 1982.

———. "Feminism, Marxism, Method, and the State." In *Feminist Theory: A Critique of Ideology,* edited by Nannerl O. Keohane, Michelle Z. Rosaldo, and Barbara C. Gelpi. Chicago: University of Chicago Press, 1982.

Maluquer de Motes Bernet, Jordi. "El impacto de las guerras coloniales de fin de siglo sobre la economía española." In Pedro Tedde, ed., *Economía y Colonias en la España del 98,* 101–21. Madrid: Ed. Síntesis, 1999.

Martín Corrales, Eloy. *La imagen del magrebí en España: una perspectiva histórica, siglos XVI-XX.* Barcelona: Edicions Bellaterra, 2002.

Martínez Cuadrado, Miguel. *Restauración y crisis de la monarquía (1874–1931),* Vol. 6: *Historia de España.* Edited by Miguel Artola. Madrid: Alianza, 1991.

Martínez Martín, Jesús A. *Lectura y lectores en el Madrid del siglo XIX.* Madrid: Consejo Superior de Investigaciones Científicas, 1991.

Martínez Olmedilla, Augusto. *Periódicos de Madrid: Anecdotario.* Madrid: Editorial Aumarol, 1956.

Marx, Karl. *Capital,* Vol. 1. Introduction by Ernest Mandel. Translated by Ben Fowkes. New York: Vintage, 1977.

McClintock, Anne. *Imperial Leather: Race, Gender, and Sexuality in the Colonial Contest.* New York: Routledge, 1995.

Mehlman, Jeffrey. "Remy de Gourmont with Freud: Fetishism and Patriotism." In Emily Apter and William Pietz, eds., *Fetishism as Cultural Discourse*, 84–91. Ithaca: Cornell University Press, 1993.

Membrez, Nancy. "Yanquis, filibusteros, y patriotas: prensa y teatro en la España del 98." *Cincinnati Romance Review* 10 (1991): 123–45.

Mitchell, W. J. T. *Iconology: Image, Text, Ideology.* Chicago: University of Chicago Press, 1986.

Molina Martínez, Miguel. "Granada y la repatriación de soldados de ultramar." In *Andalucía y América en el siglo XIX: Actas de las V jornadas de Andalucía y América,* 435–53. Seville: Universidad de Santa María de la Rábida, 1985.

Moorjani, Angela. "Fetishism, Gender Masquerade, and the Mother-Father Fantasy." In *Psychoanalysis, Feminism, and the Future of Gender,* edited by Joseph H. Smith and Afaf M. Mahfouz. Baltimore: Johns Hopkins University Press, 1994.

Moreno Fraginals, Manuel. *Cuba/España, España/Cuba: Historia común.* Barcelona: Crítica, 1995.

Nelan, Charles. *Cartoons of Our War with Spain.* New York: Frederick Stokes, 1898.

Nye, Robert. "The Medical Origins of Sexual Fetishism." In Emily Apter and William Pietz, eds., *Fetishism as Cultural Discourse,* 13–30. Ithaca: Cornell University Press, 1993.

Offner, John. "United States Politics and the 1898 War over Cuba." In Angel Smith and Emma Dávila-Cox, eds., *The Crisis of 1898: Colonial Redistribution and Nationalist Mobilization,* 18–44. New York: St. Martins, 1999.

Ohmann, Richard. *Selling Culture: Magazines, Markets, and Class at the Turn of the Century.* New York: Verso, 1998.

Ortiz, David Jr. *Paper Liberals: Press and Politics in Restoration Spain.* Westport, Conn.: Greenwood, 2000.

Pardo Bazán, Emilia. "Elección." In *Cuentos Dramáticos,* 53–58. Barcelona: Bígaro Ediciones, 1998. *Cuentos Dramáticos* originally published as *En tranvía,* in *Obras Completas* 23; Madrid: Renacimiento, 1899.

———. "Oscuramente." In *Cuentos Dramáticos,* 205–9. Barcelona: Bígaro Ediciones, 1998.

Parsons, Deborah L. *A Cultural History of Madrid: Modernism and the Urban Spectacle.* New York: Berg, 2003.

Pérez, Louis A., Jr. *The War of 1898: The United States and Cuba in History and Historiography.* Chapel Hill: University of North Carolina Press, 1998.

Perez, Nissan N. *Focus East: Early Photography in the Near East, 1839–1885.* New York: Harry N. Abrams, 1988.

Pérez Galdós, Benito. *Tristana.* In *Obras completas, 5: Novelas,* edited by Federico Carlos Sainz de Robles. Madrid: Aguilar, 1961.

Pérez Ruiz, Miguel Ángel. *La publicidad en España: Anunciantes, agencias, y medios (1850–1950).* Madrid: Fragua, 2001.

Phillips, Christopher. "The Judgment Seat of Photography." In Richard Bolton, ed., *The Contest of Meaning; Critical Histories of Photography.* Boston: MIT Press, 1989.

Pietz, William. "The Problem of the Fetish," parts 1, 2, and 3a. *Res* 9 (spring 1985): 5–17; 13 (spring 1987): 23–45; 16 (autumn 1988): 105–23.

———. "Fetishism and Materialism: The Limits of Theory in Marx." In Emily Apter and William Pietz, eds., *Fetishism as Cultural Discourse.* 119–51. Ithaca: Cornell University Press, 1993.

———, and Emily Apter, eds. *Fetishism as Cultural Discourse,* 119–51. Ithaca: Cornell University Press, 1993.

Porterfield, Todd. *The Allure of Empire: Art in the Service of French Imperialism, 1798–1836.* Princeton: Princeton University Press, 1988.

La prensa ilustrada en España: Las Ilustraciones, 1850–1920. Montpellier: Université Paul Valéry, 1996.

Price, Mary. *The Photograph: A Strange, Confined Space.* Stanford: Stanford University Press, 1994.

Reberioux, Madeleine. "Ces demoiselles." In *L'Exotisme: Actes du colloque de Saint-Denis de la Réunion dirigé par Alain Buisne, Norbert Dodille, et Claude Duchet, 7–11 mars 1988,* 443–55. *Cahiers CRLH-CIRAOI* 5. Paris: Didier-Erudition, 1988.

Resina, Joan Ramon. "The Concept of After-Image and the Scopic Apprehension of the City." In *After-Images of the City,* edited by Joan Ramon Resina and Dieter Ingenschay, 1–22. Ithaca: Cornell University Press, 2003.

Riego, Bernardo. *La introducción de la fotografía en España.* Girona, Spain: CCG Ediciones, 2000.

———. *La construcción social de la realidad a través de la fotografía y el grabado informativo en la España del siglo XIX.* Santander: Universidad de Cantabria, 2001.

———. *Impresiones: La fotografía en la culturea del siglo XIX (Antología de textos).* Girona: CCG Ediciones, 2003.

Rojas Mix, Miguel. "Usted ponga los dibujos; Yo pondré la guerra." *La gráfica política del 98,* 15–20. Cáceres, Junta de Extremadura: Consejería de Cultura y Patrimonio. CEXECI (Centro Extremeño de Estudios y Cooperación con Iberoamérica), 1998.

Roosevelt, Theodore. *A Strenuous Life.* New York: Review of Reviews, 1910.

———. "The Monroe Doctrine." In *American Ideals, and Other Essays, Social and Political,* 220–37. New York: Putnum, 1902.

Sagne, Jean. "All Kinds of Portraits." In *A New History of Photography,* edited by Michel Frizot, 102–22. Milan: Könemann, 1998.

Said, Edward, *Orientalism.* New York: Pantheon, 1978.

Salaün, Serge, and Carlos Serrano. *1900 en España.* Madrid: Espasa Calpe, 1991.

Santos, Felix. *1898: La prensa y la Guerra de Cuba.* Barcelona: Asociación Julián Zugazagoitia, 1998.

Schopenhauer, Arthur. "On Women." In *Studies on Pessimism, t*ranslated by T. Bailey Saunders. New York: Somerset, 1970. (London: Swan Sonnenschein, 1893.)

Sellés, Eugenio. "Del periodismo en España." In Carlos Barrera, ed., *El periodismo español en su historia,* 127–46. Barcelona: Ariel, 2000.

Seoane, María Cruz. *Historia del periodismo en España,* Vol. 2: *El siglo XIX: 1898–1936.* Madrid: Alianza, 1992 (1983).

Sevilla Soler, Rosario. "La crisis del 98 y la sátira en la prensa sevillana." In *Andalucía y América en el siglo XIX; Actas de las V jornadas de Andalucía y América,* 507–40. Seville: Universidad de Santa María de la Rábida, 1985.

———. *La Guerra de Cuba y la memoria colectiva: La crisis del 98 en la prensa sevillana.* Seville; EEHA, 1996,

Smith, Angel. "The People and the Nation: Nationalist Mobilization and the Crisis of 1895–98 in Spain." In Angel Smith and Emma Dávila-Cox, eds., *The Crisis of 1898: Colonial Redistribution and Nationalist Mobilization,* 152–79. New York: St. Martins, 1999.

———, and Emma Dávila-Cox, eds. *The Crisis of 1898: Colonial Redistribution and Nationalist Mobilization.* New York: St. Martins, 1999.

Sougez, Marie-Loup. "La imagen fotográfica en el medio impreso: Desarrollo de la fotomecánica y aproximación a los inicios en España." In *150 años de fotografía en la Biblioteca Nacional: guía-inventario de los fondos fotográficos de la Biblioteca Nacional,* edited by Gerardo F. Kurtz and Isabel Ortega. Madrid: Ministerio de Cultura, Dirección General del Libro y Bibliotecas; Ediciones El Viso, 1989.

Stratton, Jon. *The Desirable Body: Cultural Fetishism and the Erotics of Consumption.* Urbana: University of Illinois Press, 2001.

Tagg, John. *The Burden of Representation: Essays on Photographies and Histories.* Amherst: University of Massachusetts Press, 1988.

Tedde, Pedro. "La economía española en torno al 98." In Pedro Tedde, ed., *Economía y Colonias en la España del 98,* 73–99. Madrid: Ed. Síntesis, 1999.

Tortella, Gabriel. *The Development of Modern Spain: An Economic History of the Nineteenth and Twentieth Centuries.* Translated by Valerie J. Herr. Cambridge: Harvard University Press, 2000.

Trenc, Eliseo. "Los modelos extranjeros, *The Illustrated London News* y *L'Illustration.*" In *La prensa ilustrada en España: Las Ilustraciones, 1850–1920,* 57–61. Montpellier: Université Paul Valéry, 1996.

Tuñón de Lara, Manuel, Antonio Elorza, and Manuel Pérez Ledesma, eds. *Prensa y sociedad en España (1820–1936).* Madrid: Editorial Cuadernos Para el Diálogo, 1975.

Tuñón de Lara, Manuel, Jesús Timoteo Álvarez, and Carmelo Garitaoriandía, eds. *La prensa de los siglos XIX y XX: Metodología, ideología, e información: Aspectos económicos y tecnológicos.* Bilbao: Servicio Editorial, Universidad del País Vasco, 1986.

Valle-Inclán, Ramón del. *Las galas del difunto: Obras escogidas.* Prologue by Gaspar Gómez de la Serna. Madrid: Aguilar, 1967.

Valls, Josep-Francesc. *Prensa y burguesía en el XIX español.* Barcelona: Anthropos, 1987.

Vega, Jesusa. "La estampa culta en el siglo XIX." In Juan Carrete Parrondo, Jesusa Vega González, Francesc Fontbona, and Valeriano Bozal, eds., *El grabado en España: Siglos XIX y XX,* 21–243. In *Summa Artis: Historia General del Arte,* Vol. 32. Madrid: Espasa-Calpe, 1994. Reprint (1988).

Vélez i Vicente, Pilar. "La Industrialización de la prensa." In *Historia de la edición y de la lectura en España, 1472–1914,* edited by Víctor Infantes, François López, and Jean-François Botrel, 545–51. Madrid: Fundación Germán Sánchez Ruipérez, 2003.

———. "El libro como objeto." In *Historia de la edición y de la lectura en España, 1472–1914,* edited by Víctor Infantes, François López, and Jean-François Botrel, 552–58. Madrid: Fundación Germán Sánchez Ruipérez, 2003.

Vilar, Pierre. "Estado, nación patria en España y en Francia, 1870–1914." *Estudios de Historia Social* 28–29 (1984): 7–41.

Weinberg, Albert Katz. *Manifest Destiny: A Study of Nationalist Expansionism in American History.* New York: AMS Press, 1979.

Index